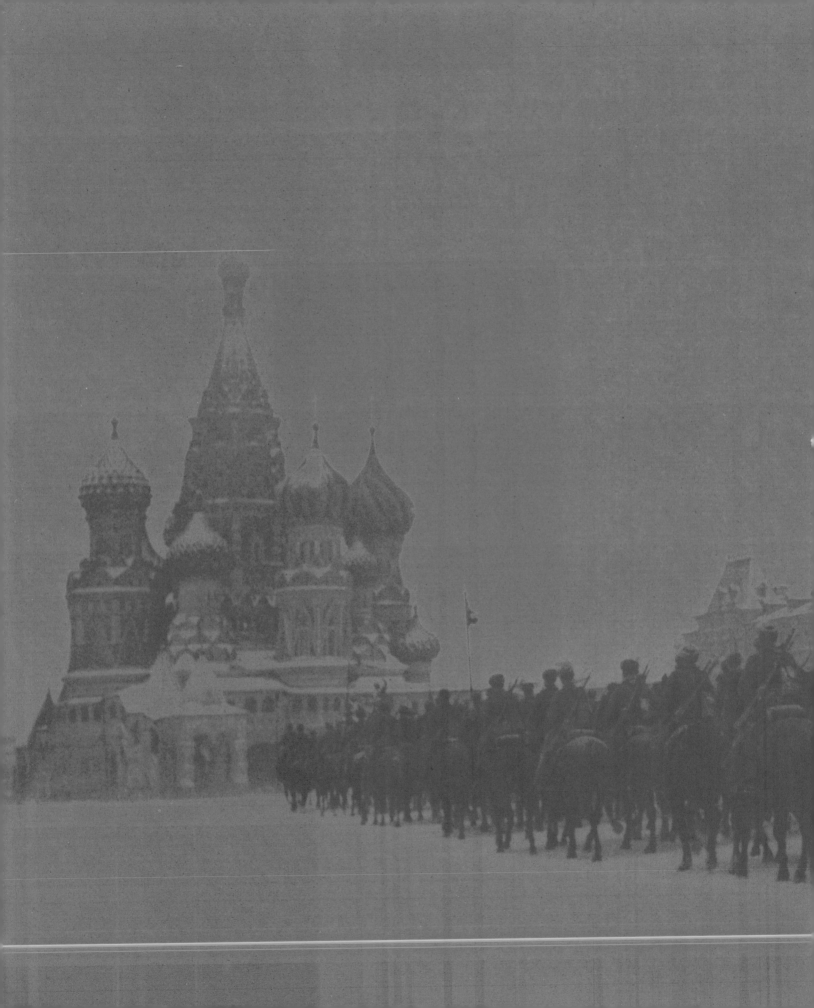

faces

of a

nation

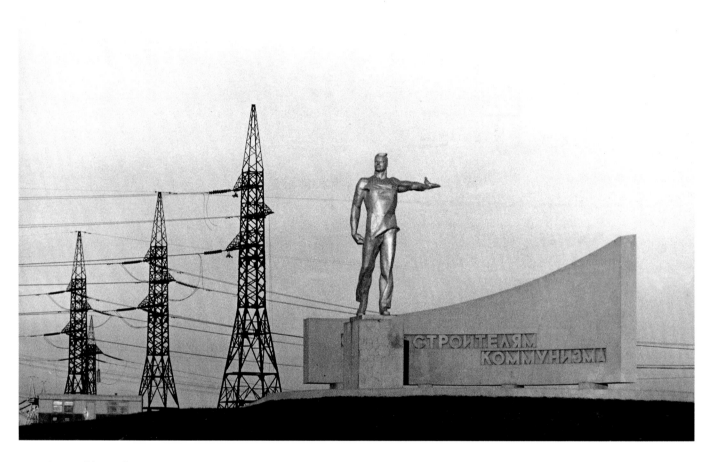

For the Builders of Communism
 (Electricity Generating Plant
 Near Volgograd)

faces of a nation

The Rise and Fall of the Soviet Union, 1917–1991

Photographs by Dmitri Baltermants

Text by Theodore H. Von Laue and Angela Von Laue
Introduction by Tatiana Baltermants

FULCRUM PUBLISHING
GOLDEN, COLORADO

Cover Image: "Sportsman's Parade," 1961
Front Cover Stamp: Official Seal of the Soviet Union
Book Design by Jay Staten

Library of Congress Cataloging-in-Publication Data

Baltermants, D. (Dmitri)
 Faces of a nation : the rise and fall of the Soviet Union, 1917–1991 /
photographs by Dmitri Baltermants ; text by Theodore H. Von Laue and Angela
Von Laue ; introduction by Tatiana Baltermants.
 p. cm.
 Includes bibliographical references and index.
 ISBN 1-55591-262-1 (hbk)
 1. Soviet Union—History—Pictorial works. I. Von Laue, Theodore H.
(Theodore Hermann). II. Von Laue, Angela. III. Title.
DK266.B23 1996
947—dc20 96-13748
 CIP

Printed in Korea by Sung In Printing Company

0 9 8 7 6 5 4 3 2 1

Fulcrum Publishing
350 Indiana Street, Suite 350
Golden, Colorado 80401-5093
(800) 992-2908 • (303) 277-1623

Contents

Acknowledgments

This book is a collective venture. The initiative came from Paul Harbaugh, a photography collector in Denver, Colorado, who discovered Baltermants's photographs on a trip to Moscow. He persuaded a friend, Robert Baron, President of Fulcrum Publishing in Golden, to commemorate Baltermants's art in a book. At Fulcrum, Sam Scinta assisted with the text, with admirable solicitude and efficiency, helped by Associate Publisher Jay Staten and Assistant Editor Daniel Forrest-Bank.

Thanks also to Michael Brainerd, a friend to all parties involved and a supporter of all aspects of the project from its inception; Dmitri Gershengorin for his hours of translation and historical interpretation; photographic printers Jay and Dutch Walla; Rich Clarkson; Dmitri Voronov; Timor and Zina Zelma; photographer Yvgeni Khaldai, who shared his memories and knowledge of Soviet photography and history; the staff at *Ogonyok,* who allowed for hours of research and interviews in the middle of their busy schedule; Teresa Gabriel Harbaugh, who understood; Elizabeth Dolgikh; and G. Ray Hawkins. Finally, much gratitude and thanks to Tatiana Baltermants, who provided access to the Baltermants archive, furnished invaluable details on her father's life, and gave unwavering support to the completion of this book. Credit for this book belongs to all the participants in this exciting project.

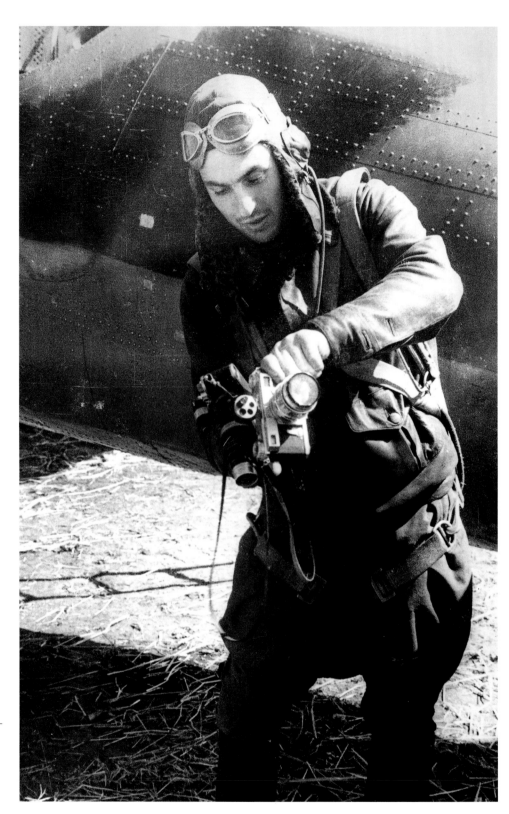

Baltermants at the Front, 1941—
*The earliest surviving photograph
of Baltermants as a photographer,
he is shown here preparing his
equipment for a bombing raid.*

Introduction

Tatiana Baltermants

In order to appreciate Dmitri Baltermants's work as a photographer, we need to be aware of the immense adversities under which he labored. Like millions of other people living in the vast expanses of the Soviet Union, my father was subjected to the Communist experiment conceived by Vladimir Lenin and dictated by Joseph Stalin. This experiment aimed at mobilizing a backward country, gearing it for political survival and human happiness in the ruthlessly competitive world of the twentieth century. Russia was doomed to live seventy-odd years under the weight of a utopian concept that would never fulfill its dreamers' reality.

From its inception, constant internal, social, and political challenges tore at the fragile Soviet framework, but none tested the Communist system more than World War II, beginning with Hitler's attack in June of 1941. Baltermants, as a soldier and a photographer, pointed his lens and rifle into harm's way, becoming a courageous witness of time and recording the tragic impact of the Fascists' efforts to enslave his country. He captured intolerable human suffering and a nation's heroic resistance, images that only now haunt our minds. As a photojournalist, Baltermants's career transports us through the postwar decades of the Soviet Union, reminding us of the aspirations of its leaders and allowing us a glimpse into the mundaneness of the lives of its citizens.

Through the photographs presented in this volume, Baltermants transforms the people of the Soviet Union—kept for a long time distant from the West by geography and ideology—into men and women with whom we, students of yesterday and readers of tomorrow, can communicate. By looking into the eyes of these men and women, Baltermants's images convey better than words the depth

of our common nature, bringing us closer to the painful changes and raised hopes which the people of Baltermants's country experienced during the long days of the "Soviet" century. Perhaps the West, with the aid of Baltermants's life work, can now better understand the people of yesterday's Soviet Union as we enter the new world order of the twenty-first century.

Dmitri Nickolaevich Stolovitski Baltermants was born in 1912 in Warsaw, Poland, which at that time was part of the Russian Empire. His father, Grigory Stolovitski, was an officer in the tsar's army, while his mother came from a family of Polish intellectuals. Dmitri's parents divorced when he was three years old. Shortly after the divorce, his mother married a lawyer, Nikolai Baltermants, who adopted Dmitri and gave him the Baltermants name. World War I claimed the life of Dmitri's father and drove the Baltermants family out of Poland. In 1915 the new family took up residence in Moscow.

As a child, Baltermants lived uncomprehendingly through World War I. The tsarist empire, which stretched from Europe to the Far East, was swept away; the very survival of the Russian state and its people's security from foreign domination was at stake. Dmitri spent his childhood amidst civic dissolution, revolution, civil war, and a drastic reorganization of state, property, and society. His family's privileged status as members of the intelligentsia was gone, his stepfather exiled to forced labor. The 1917 Revolution had swept away century-old traditions and shattered moral principles, creating a new social and political order comprised of peasants and workers and free from old prejudices.

As a result of the new social order, single-family apartments became multiple-family dwellings. Such was the fate of my father. Living in cramped communal quarters with his mother, he attended school during the cruelest years of Stalin's efforts to transform the ill-educated and backward masses of his country into effective citizens of a modern industrialized society. Baltermants began working to help support his mother, who, like most intellectuals, was destitute. While his mother, a well-educated woman who was fluent in several European languages, worked as a typist at the Foreign Literature Publishing House, Dmitri contributed to the family by working first as a copyist and then as a metal grinder. After leaving secondary school he obtained a variety of jobs, including rendering of architectural drawings, a cinema mechanic, and an apprentice printer at the Izvestiya Printing House. His interest in photography was kindled. Shortly afterward the printing house sent him to study at the prepatory department for workers at Moscow State University. In 1939 he graduated from the Mechanical Mathematical Department, was assigned to teach mathematics at the Higher Military Academy, and received the rank of captain.

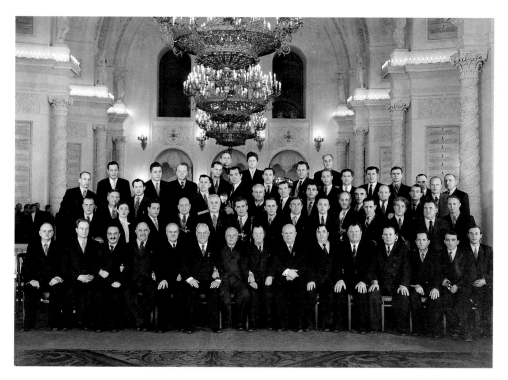

Baltermants and Other Promi-
nent Photographers, 1954—
*Baltermants (middle row, seventh
from left, with camera around
neck) is shown gathered with
photographers and the Soviet
leadership. Among the leaders are
Anastas Mikoyan (bottom row,
third from left), Lazar Kaganovich
(fourth from left), Vyacheslav
Molotov (fifth from left), Nikolai
Bulganin (sixth from left), Kliment
Voroshilov (seventh from left),
Nikita Khrushchev (seventh from
right), and Georgi Malenkov (sixth
from right). Among the other
photographers included are Dmitri
Chernov, TASS (top row, sixth
from left); Konstantin Riyshentsev
(middle row, ninth from right);
Alexander Ustinov,* Pravda *(fourth
from right); Fedor Kislov, TASS
(second from right); Alexander
Sergeev,* Red Star *(bottom row,
second from right); and Nikolai
Litkin ((first from right). Many
members of the KGB are also
interspersed with the group, an
indication of the tight controls
placed on Soviet photographers by
the government.*

A few months later Baltermants received a call from *Izvestiya,* the Com-
munist Party newspaper, requesting him to go to western Ukraine to cover the
Soviet invasion of Poland. The secret Molotov-Ribbentrop Pact of 1939 had di-
vided Poland between Germany and the Soviet Union, and western Ukraine,
which had been part of Poland, was designated to the Soviets in the agreement.
Photography had already sparked Baltermants's interest; all he had to do was
pick up a camera. Although no photographic material concerning that trip has
survived, one positive thing did come from the experience—his future as one of
the greatest practitioners of Soviet photography had begun.

From the earliest years of Soviet rule, film and photography had been ac-
corded a prominent place at Lenin's urging. He had recognized the potential of
these media for agitation, propaganda, and education among a largely illiterate
population. "It is a very good idea to record history through the lens," Lenin said.
"History in photos is clear and comprehensible. No painter is able to depict what
the camera sees." Poster-size photographs and montages with simple slogans spread
throughout the country to inform and educate. With official encouragement pho-
tography became a powerful and socially committed means of communication.
In 1936 "socialist realism" became the only permissible approach in photography.
Its purpose was to serve the state, to reflect the policies of the party, and to edu-
cate the masses in the spirit of socialism. Party policy dictated a fairly limited

repertoire of subjects—party conferences, parades, meetings, workers, collective farms, heroes of the nation, schoolchildren, the Red Army, and industrial and social achievements. Ideology also dictated the manipulation of reality in optimistic and idealistic images.

Publication of photographs was controlled by the wartime demands of Soviet propaganda. Images of devastation and death were censored lest they depress morale. The focus of the press was meant to raise the nation's spirit and to assure the Soviet people of ultimate victory, rather than illustrate the war's tragic losses. In November of 1941 action was within earshot of Moscow and photographers routinely made trips to the front by automobile; Baltermants's photograph *On the Road of War* was taken twenty kilometers from the capital. Like many of Baltermants's wartime pictures, it was not published at that time. Neither was the now-famous image of *Attack,* in which soldiers, bayonets at the ready, leap across a trench directly over the photographer's head. This photograph is slightly out of focus conveying a dramatic sense of action and speed, and is cropped so that only part of a body and the flying legs and feet of the soldier nearest the camera can be seen. "What is that?" demanded the political board. "Half a man running?" Many years later, during the period of relative freedom under Khrushchev, Baltermants revisited his wartime archive. He began printing images unseen before—images of war that would bring him worldwide recognition.

In the winter of 1942 Baltermants served in the eastern Crimea where he took a series of photographs on a barren plain covered with corpses of peasants massacred by the retreating Germans. Among the bodies, women are seen searching for their husbands, brothers, sons, and relatives. One image from this series is the well-known photograph *Grief* or *Sorrow,* in which a woman, in deep agony, bends over the body of a loved one. Exhibited anonymously during the 1960s throughout the Soviet Bloc, as part of a larger exhibition titled "What Is Man?", *Grief* was considered by the viewing audiences to be the best photograph of the exhibition, becoming a symbol of the universal tragedy of war. Only then was the photograph published in the Soviet Union. Following the publication of *Grief,* during the Brezhnev regime, Baltermants wanted to publish an album of these photographs. The Communist authorities did not approve of the idea, as the album would begin to show the extent of our tragic losses during the war.

Baltermants used to say that his generation didn't know how to photograph combat and that he wished they didn't have to learn. Nevertheless, it was the Soviet photographers who contributed most to the collection of World War II images. These photographs can be divided into two general categories: images that show various war episodes, and photographs that have acquired a certain symbolic meaning. Georgi Zelma, for instance, is known among world photogra-

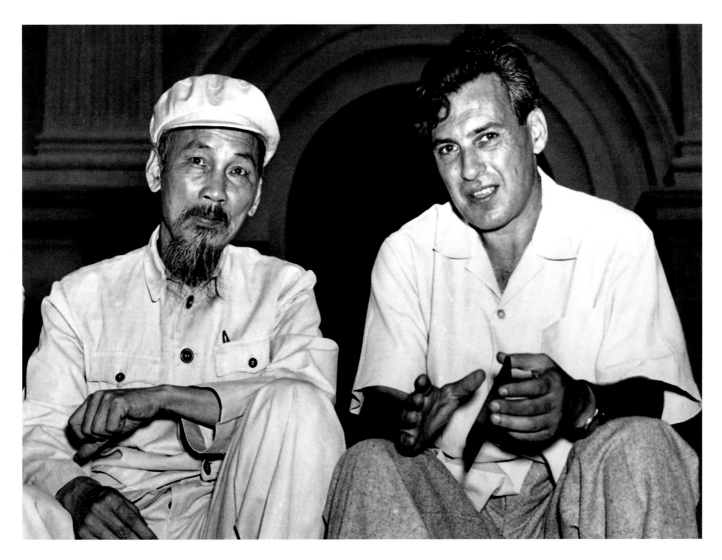

Baltermants with Ho Chi Minh,
Hanoi, July 1955

phers as a chronicler of the battle of Stalingrad. Evgeni Khaldei shot the capturing of the Reichstag. And Baltermants's collection of wartime photographs contained those images that showed war as a universal tragedy.

Only as recent as 1985 did I learn one of my father's best kept secrets of the Soviet period. I assume this was due to the fact that "in Soviet families parents preferred to conceal such facts from their children. ... for the simple reason that [information] was dangerous." In 1942 Baltermants was preparing for publication photographs from the early days of the Battle of Stalingrad. At the same time he made prints of earlier images of German prisoners taken during the assault on Moscow. His editor selected one of these earlier photographs for publication under the impression that it was a Stalingrad image. The blunder was revealed and Baltermants became the scapegoat. I also learned that, when the authorities

arrived, my mother ran out into the cold night, wearing only her nightgown and slippers, to see if the car was taking him to NKVD (later the KGB) headquarters in Lubyanka. In fact, he was taken to a military department. He was stripped of rank and sent again to the Stalingrad front, this time as part of a penalty battalion.

Penalty battalions existed on all the fronts and were formed of criminals, people suspected of disloyalty to the Soviet system (mostly representatives of the republics annexed to the Soviet Union by force), and other individuals who were granted an opportunity "to wash away their guilt with their blood." Baltermants's company consisted mainly of Uzbeks, who knew little Russian. He was the only Muscovite and was nicknamed "Moscow," as nobody could pronounce his name.

Poorly trained and often ill-equiped, each soldier was issued a rifle, one hundred cartridges, two grenades, and one hundred grams of spirits and sent into battle. Few survived, but Baltermants was lucky; he was severely wounded in the leg and carried from the battlefield. Medical students from Moscow who operated on him felt sorry for their fellow Muscovite and decided not to amputate his leg. He was later sent back to Moscow where he spent most of 1943 convalescing.

Following his recovery, Baltermants returned to the front line as a correspondent and photographer for the army newspaper, *Na Razgrom vraga* ("To Destroy the Enemy"), documenting the Soviet army's march through Germany. While in Germany, he took another memorable photograph entitled *Tchaikovsky,* in which a group of Russian soldiers standing in the shattered living room of a ruined house are gathered around a miraculously unharmed upright piano, listening to a soldier playing. It is a moment of calm toward the end of a war that had destroyed twenty million people in Baltermants's country. It shows that the ravaging Red Army had human sensibilities, and that beauty could be found in the midst of destruction.

The year 1945 brought both the joy of victory and the grief of losses. Historians believe that Russia lost at least twice as many people in the war as the official claim of 20 million. But it is very difficult to estimate the exact number since the general census of the population in 1939 was facilitated on Stalin's orders, as the regime was trying to conceal the number of people kept in rehabilitation camps.

Baltermants returned home, and with his reputation established as one of the brilliant young generation of war photographers, he became a photographer for the illustrated magazine *Ogonyok* ("Touch of Light"). One of the first Soviet magazines to be published in color, *Ogonyok* began printing colored pictures as far back as the late 1940s. These photographs were frequently clipped and used by readers to decorate their apartments. Through his work at *Ogonyok,* Baltermants's name became quite well known. He traveled far and wide across the Soviet Union to show the courageous work of Soviet people in restoring the devastation of the war and the achievements of Communist construction.

Dmitri and Tatiana Baltermants,
during his last personal
exhibition, Kuopio, Finland,
August 1989

Photography in the Soviet Union had never been regarded as an art. It played a decorative role and reflected the achievements of the Soviet people. Nevertheless it had to abide by the rules of socialist realism. A common Soviet phenomenon was the combination of photojournalism and staged photography. For instance, if a photo shoot was to take place at a factory, the workers had to change into white shirts and neckties. Baltermants's portrait of a steelworker with beads of sweat on his face was banned by a censor because it showed that work in the Soviet Union was not only a source of joy but that it was also difficult. Baltermants justly considered himself an expert in staged photography as he was fond of "playing with negatives," adding details to photographs from other stills. A classic example is the photograph *Grief,* in which threatening, black clouds in the background were superimposed from another negative. His clear-cut stills, perfect compositions, expert use of color, and masterful manner and plasticity proved him to be an unsurpassed master of socialist realism, garnering him praise from both the authorities and the Soviet public.

Khrushchev's era and his exposure of Stalin's cult of personality, brought many contradictory elements into the country's life. People gradually lost their fear of political reprisals, but ideology remained unchanged. "Underground" art began to develop, but socialist realism reigned as official art, with Khrushchev ruthlessly suppressing the attempts of unofficial artists to exhibit their works. Nevertheless, the "iron curtain" to the outside world was slightly opened, allowing Soviets to see the latest achievements in international art, primarily in photography. It was the beginning of a process by which both sides gained—the world discovered Soviet photography while Soviet photographers became acquainted with the works of their American and European counterparts. Baltermants began to travel abroad quite often, as *Ogonyok* was permanently accredited to all government meetings and conferences within the country and all government visits abroad.

In 1964 Khrushchev was forced to retire by members of the Central Committee. This change of power inevitably led to a subsequent change of personnel in all key business posts, including editors-in-chief of central newspapers and magazines. The new editor-in-chief of *Ogonyok* was an officially recognized playwright and poet who had strong connections to the authorities. With his appointment, the magazine's prestige increased. Baltermants was made a member of the magazine's editorial board and appointed head of the photography department while also remaining an active photojournalist. Baltermants's travels outside and within the Soviet Union, and the many rolls of film that he shot helped him to put together an "exhibition portfolio." His first personal exhibits, in London in 1964 and in New York in 1965, were met with wide public acclaim. These were

followed by numerous personal exhibitions around the world, with new photographs being added all the time. In spite of comparative inner freedom, Baltermants, like all Soviet people, had his own inbred censor, which wouldn't permit him to go beyond the framework of the recognized ideological norms. Nevertheless, his prestige in the world of photography kept growing, and for several years he was invited to sit on the jury of the World Press Photo Organization. During the many years he served as president of the photography department of the Society of Friendship with Foreign Nations, he represented the Soviet Union at various international photo gatherings.

The whole world welcomed Gorbachev's coming to power in 1985 as the nation began to undergo rapid and dramatic reforms, giving Soviet citizens renewed optimism and hope. *Ogonyok* received a new editor-in-chief, Vitali Korotich, who practically changed the entire staff. Although already well advanced in age, Baltermants remained on the editorial board and at his post as head of the photography department. The level of his skill was such that he was not affected by the political upheavals in his own country.

The new openness under perestroika changed Baltermants's outlook on life, and he spent his free time reviewing his archives and looking back on his life. He added to his portfolio previously unpublished photographs of Soviet statesmen. Prior to 1985, only official photographs of Soviet leaders were published, since the public at large was not allowed to see their leaders in a relaxed manner. Baltermants, who had worked for more than forty years at *Ogonyok,* found much interesting material in his archives. The last in this series was a 1987 photograph of Gorbachev and Ronald Reagan taken during their third summit in Washington, D.C. This would be Baltermants's last trip abroad as a photo correspondent. In the next two years, he would have exhibits in Finland and France.

The last five years of my father's life saw a definite uplift in his work. *Ogonyok,* which had scarcely changed format during the more than forty years that Baltermants had worked for it, opened up in the Gorbachev era, with a livelier layout, investigative journalism, letters from readers, and more news from the outside world.

In June 1990 my father suddenly became very ill from a kidney infection and died a week later, just before he was scheduled to travel to the United States for a personal exhibition. He was seventy-eight. Since my father's passing, his entire collection has been in my possession. Here, finally, I can share with others some of the finest images to come out of this long and fulfilling career. To the end of his days my father remained a handsome, charming, witty, and life-loving person, loved and admired by all. He had many plans. As his daughter I have thought a great deal about his death, and I have realized that it is good his passing saved

him from old-age infirmities and artistic impotence. I don't believe he could have come to terms with that.

Now that the end of the cold war has permitted a new mental openness toward Russia, we can combine appreciation of my father's work with an understanding of the harrowing crises that shaped the circumstances of his life. And we can catch a glimpse of Soviet artistic creativity sparkling even under the strains of the Communist effort to create a secure and self-confident state in the largest country in the world.

faces

of a

nation

Tsar Nicholas II and Family, 1916—*In power since 1896, Nicholas believed in a system of government more akin to eighteenth- and nine-teenth-century autocracy than to the more progressive, "democratic" system of government taking hold throughout the world. In 1905, as a result of the "Bloody Sunday" massacre, Nicholas capitulated, forming the Duma, a representative governing body. Reform, however, was too little, too late. Revolutionary ferment continued, and the tsar and his family soon became victims of the violent upheaval that embraced Russia in 1917.*

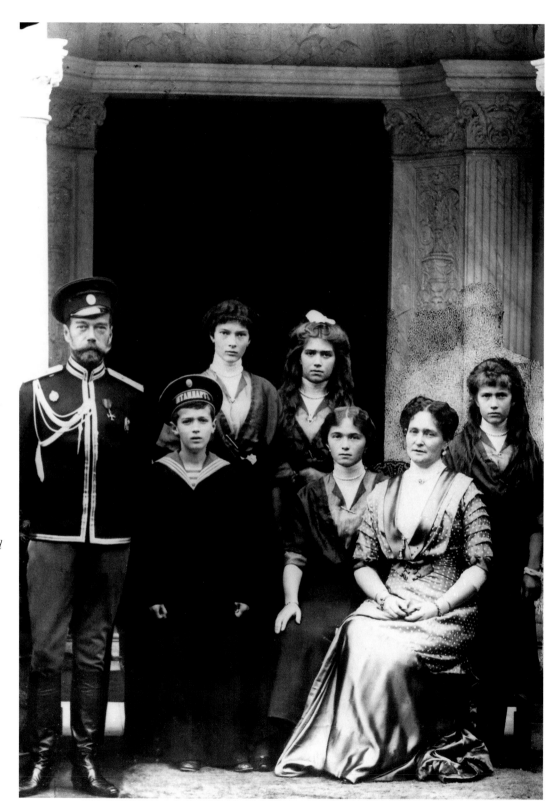

The Fragile Russian Empire

Dmitri Baltermants was born in 1912 a citizen of the Russian Empire, the largest state in the world and, behind its splendid facade of palaces and cathedrals, the most handicapped by circumstances beyond human control. His whole life, indeed the fate of his country, was determined by the discrepancy between the pride inspired by his country's impressive size and the humiliation caused by its pervasive backwardness. No country in western Europe, let alone North America, has experienced such harrowing adversities. Examining the conditions under which he and his fellow Russians worked, we cross a profound cultural barrier, facing realities utterly strange or even repulsive to us. In order to appreciate his work, we have to adjust our feelings to the wide-ranging historic circumstances shaping his life and reaching even into the present.

I.

At the time of Baltermants's birth, imperial Russia, with a population of about 130 million, extended over eleven time zones from its capital St. Petersburg in the west across the vast lands of what is often called Eurasia* to the Bering Straits in the east. Russia covered a huge open territory devoid of geographic barriers; the Ural Mountains, often considered Europe's eastern border, offered no obstacles to travel and transport. The only secure boundary to the outside lay in

* "Eurasia," employed throughout to describe the geographical extent of the Russian Empire and the Soviet Union, perhaps plays down the creative role of Russian state and society. But in an overall view stressing the problems of state building in that huge landmass, the term Eurasia seems justified—with due compassion for those highly educated Russians, who associate themselves with Europe while still tied to their Eurasian fellow citizens.

the north along the ice of the Arctic Circle. Everywhere else insecurity or uncertainty prevailed.

Russia's western borders with Sweden, Germany, and Austria-Hungary were politically determined after centuries of bitter warfare over territories inhabited by anti-Russian Poles, Ukrainians, Baltic peoples, and Finns, all of the territories a source of perpetual conflict. No safe borders existed in the Far East. Seven years before Baltermants's birth, Russia, trying to control Korea, had been defeated on land and sea by Japan, a rising threat across a narrow stretch of ocean.

The empire's southern borders presented risky opportunities for expansion. Intervention in the Balkans led in 1856 to Russia's humiliating defeat by England and France in the Crimean War. But in the Caucasus Mountains and beyond, Russian troops conquered the many local ethnic groups, and captured Georgia and Armenia from the Ottoman Turks and Persia as well. Further east, the steppes of Central Asia, inhabited by nomadic peoples, lay wide open to Russian penetration, as did the colorful oases along the Silk Road to China that were ruled by small khanates.

While the territorially secure western European countries had built colonial empires across the seas, the landbound Russians had continued their expansion into the neighboring openness of Eurasia. Imposing their style of government and enforcing an element of unity and even interdependence, they had created, by the end of the nineteenth century, an empire impressive by its magnitude but imperiled by its very size and diversity of peoples. According to the first census of the Russian Empire in 1897, 56 percent of the population were non-Russian, all living according to their own customs and speaking their own languages. Diversity also prevailed in religion; Muslims dominated the Central Asian regions.

The variety of peoples and creeds, their intense localism, and poor means of communication inhibited civic interaction. Harsh climates, famines, local tensions, wars, and pervasive poverty prevented the rise of the humane civility that had shaped state and society in the privileged environment of western Europe. In their isolation, the common people treated all outsiders, Jews especially, as enemies. Human lives were cheap and expendable, human minds untrained. In 1894 the Russian writer Anton Chekhov described the peasant masses in these grim terms: "These people lived worse than cattle, and it was terrible to be with them; they were coarse, dishonest, dirty, and drunken; they did not live at peace with one another but quarreled continually, because they feared, suspected, and despised each other. ... But yet, they were human beings, they suffered and wept like human beings, and there was nothing in their lives for which one could not find justification." Shaped by adversities unknown in western Europe, they pos-

sessed remarkable creativity in their crafts, folklore, music, and skills of individual survival, though not in respect for human life and large-scale civic cooperation.

But the educated minority, including the intelligentsia, was hardly more civilized in its human relations, as may be seen, for instance, in Chekhov's play *Uncle Vanya.* All layers of Russian society lacked the subconscious human accommodation traditional in English-speaking societies. As the poet Yevgeny Yevtushenko recently observed: in Russia "Intolerance ... is ... a habit of habit." Through no fault of their own, the people of Russia were poor raw material for effective Western-style citizenship.

II.

How indeed could this huge country be effectively governed in times of ever-intensifying rivalry for power in Europe and around the world? This question has persisted to the very present. Ever since Peter the Great moved the Russian capital from Moscow to St. Petersburg at the beginning of the eighteenth century, the guidelines for Russian statecraft had been driven from the power struggles in western Europe. Peter himself had visited France, England, and Holland—tiny, well-defined countries compared with his own. The Russian tsars (their title representing the Slavonic version of Caesar) were related by marriage to Western monarchies and tied, like their most privileged subjects, to Western lifestyles and ambitions. To this day the baroque splendor of their palaces and residencies in and around St. Petersburg, often called "the window to the West," is a source of Russian pride.

Yet inevitably, the un-European realities to Eurasia shaped the style and quality of tsarist rule. The tsars were autocrats more dictatorial than the European monarchs; only strict centralization under one will could guarantee a measure of unity in the Eurasian vastness. Autocratic rule shaped state and society, with the help of a powerful hierarchical bureaucracy and, even more crucially, a strong army. How else could the country be held together and defended along its endless borders except by force of arms more frequently and brutally employed than anywhere in Europe? Army officers and bureaucrats were drawn from a privileged aristocracy with close cultural ties to Europe and therefore out of touch with the peasant masses, who were kept, until 1861, in abject servitude. The tsars, forever trying to uphold their country in the ceaseless competition for security and prestige among the world's great powers—a concern far above their subjects' comprehension—lacked a sound popular base of patriotic commitment.

Even their privileged subjects, hierarchically stratified by pedigree and education, proved unreliable. Travel, education, and commerce took privileged Russians to western Europe. On return, they could not help comparing the prosperity

and creativity they had observed in the West with the crudeness and poverty of their own country. And as the ideals of freedom, equality, and democratic government advanced around Europe and North America, Western influence subverted tsarist practice and loyalty to the country. In the clash of Western civilization with Russian backwardness, thoughtful Russians did not know where they belonged. The ever-more-visible contrast between Russia and the West became a source of profound cultural disorientation. Europe-oriented Russians wanted to be proud of their fatherland. But what in their country could inspire them?

In order to stimulate his country's pride, Tsar Nicholas I in the 1830s had proclaimed an official ideology of Russian superiority (retained until the collapse of tsarist rule). It asserted the preeminence of the Orthodox Church (the official state church), of autocracy, and of Russian nationality. The tsarist regime, like any government, needed to be propped up by collective confidence in its institutions. Patriotic unity had to be not only artificially created but also enforced by indoctrination, censorship, and repression of dissent. These practices, constantly refined, were part of the tsarist response to powerful challenges.

The superior attractions of "the West" (a term first coined by Russians) divided the educated elite. The westernizers were eager to transform their country by Western standards, hoping to liberate it from the debilitating tsarist repression. Yet among the quarrelsome Russians, freedom embedded in the social cohesion of Western society was a force of anarchy, justly dreaded by the tsars. Another school of thought, inspired by German romantics, was Slavophilism. It glorified the Slavic soul, throbbing among an idealized Russian peasantry opposed to tsarist regimentation. Pan-Slavism, an offshoot of Slavophilism more acceptable to the tsar, advocated the union of all Slavic peoples—including the Serbs in the Balkans—for their greater glory in the world.

Suspended among these rival orientations derived from contact with the West, Russian writers—Alexander Pushkin, Fyodor Dostoyevsky, and Leo Tolstoy among them—developed a unique inward-oriented sensibility. Manifesting the existence of impressive literary talent amidst the harshness of Russian life and aided by its slower pace, they radiated an emotional depth lacking in the fast-moving—and thus, by their standards, superficial—West. Their books became a source of Russian pride and even a sense of mission. As Dostoyevsky, taking his cue from Western nationalism, observed: "Every great people believes, and must believe if it intends to live long, that in it alone resides the salvation of the world, that it lives in order to stand at the head of the nations, to affiliate and unite all of them, to lead them in a concordant choir toward the final goal preordained for them." Unfortunately, Dostoyevsky could give no practical advice on how to achieve such ultimate human salvation amidst the adversities of Russia's backwardness.

III.

The Russian Empire's stability, like the lives—and aspirations—of its subjects, depended on the government's ability to mobilize its material and human resources against the other great powers in Europe. Defeat abroad inevitably led to reforms at home. After losing the Crimean War, the tsarist government under Alexander II cautiously broadened its political base according to Western practice: serfdom was abolished, allowing the peasants a measure of personal freedom; the judicial system was reorganized; towns gained some administrative autonomy. Russia thus appeared to be more European. In substance, however, it still remained backward compared with the rapid social, economic, and political progress in Europe, where politics now reached down to the masses. Why, young Russian intellectuals asked, should their country remain behind? Thus the Russian Empire entered an era of profound crisis.

In the 1870s secret revolutionary groups sprang up, trying to foment popular discontent while battling the autocratic system. In 1881 terrorists assassinated Tsar Alexander II. His successor, Alexander III, repressively reaffirmed autocracy as the only guarantee against anarchy. That conviction also prevailed under his son, Nicholas II, a kindly person but hostile to the political drift of the times, who came to power in 1894. During his reign the police subtly perfected their fight against the revolutionaries, pioneering modern methods of crime detection to infiltrate the subversive organizations. The police thereby also apprenticed their victims in the dirty tricks of undercover work. As for the tsarist prisons where many of the revolutionaries served time, Tolstoy commented: "All sorts of violence, cruelty and inhumanities are not only tolerated, but even sanctioned by Government when it suits its purpose." These were ominous practices, well remembered into the future.

Meanwhile concern arose within the government, because Russia lagged far behind the industrial progress of England, Germany, and the United States. In 1900 Russia's minister of finance, Sergei Witte, addressed an ominous warning to the young Tsar Nicholas II: "International competition does not wait. If we do not take energetic and decisive measures so that in the course of the next decades our industry will be able to satisfy the needs of Russia and of the Asiatic countries which are—or should be—under our influence, then the rapidly growing foreign industries will ... establish themselves in our fatherland and in the Asiatic countries mentioned above. ... Our economic backwardness may lead to political and cultural backwardness as well." Yet how could an effective industrial society emerge from a people whom Witte called "coarse and unenlightened in their medieval frame of mind"? Nicholas II, like many Russians high and low, had his doubts about rapid industrialization.

In line with his industrialization policy, Witte pushed the construction of the Trans-Siberian Railroad, which reached the Far East by 1903, despite great technical obstacles. In comparison, Americans had been able to take a train from New York to San Francisco since 1870, and by 1900 the United States had more railway mileage than the rest of the world combined. Meanwhile Russia slowly expanded railway transport in its western regions, at a time of rising civil unrest.

After the turn of the century, peasants rebelled and workers went on strike. An increasing number of influential professional people attacked the government, calling for a liberal constitution. The minister of the interior at the time, V. K. Plehve, had hoped to buttress autocracy with the help of a "small victorious war" before he was assassinated in 1904. At that time the Russian government was waging a losing war with Japan. Defeat brought the widespread discontent to a dramatic climax—the "Revolution of 1905," which produced a new triumph of westernization.

In January 1905 a peaceful procession of exploited workers, planning to put their demands before the tsar, was butchered by tsarist guards. That "Bloody Sunday" stirred up Russian society to its roots. The urban elites joined workers, peasants, and non-Russian minorities in impressive antigovernment demonstrations. Russia experienced a touch of mass politics, leading to a general strike paralyzing the country in October. Workers in St. Petersburg formed a *soviet* (a council) which subsequently became a symbol of revolution. Faced with chaos, Nicholas II issued a constitution establishing a representative body called the *Duma*. Yet bitter fighting over crucial details continued for another two years, with the tsar trying to preserve as much power as possible.

By 1907 the country had quieted down. Autocracy was still in charge, but under some restraint by moderate liberals who dominated the Duma. Order was restored, with special opportunities offered to the peasants. In order to promote modernization, the tsar's reformist prime minister, Peter Stolypin, wanted to transform the Russian peasants, still tied to their peasant communes, into enterprising modern farmers. Unfortunately, most peasants clung to the security of their communal traditions. Like Witte, Stolypin failed to achieve his good intentions (in 1911 he was assassinated). At any rate, for several years after 1907, Russia experienced a brief era of calm, graced by a measure of political freedom, economic prosperity, open contact with Europe, and opportunities for popular education. These were the country's most civilized years in the entire twentieth century, nostalgically remembered, like the tsar and his family, to the present day. At the height of this peaceful interlude Dmitri Baltermants began his life.

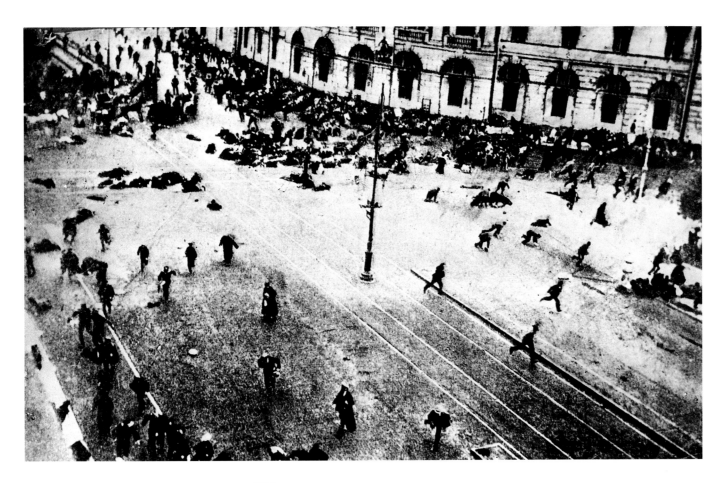

IV.

The First Revolution, 1905

Yet over the horizon a devastating storm was brewing. Led by the states-men of Europe (including Russia), the peoples of the world were ignorantly en-tering the age of global politics. This totally new era set off unprecedented calamities, with wars and revolutions spreading havoc deep into the twentieth century. As a result of Western expansion by trade and colonial empire building, the world had become a single battlefield for political ambitions. The British, masters of the largest empire, were setting the pace. Ambitious leaders in other countries followed suit, foremost among them the newly united Germany, which eagerly claimed a place in the sun of global preeminence.

Megalomania was spreading around the world. From St. Petersburg the German ambassador reported in 1895 that "In everything I hear, [people] pro-claim with one voice that it is Russia's mission to gain in due time the mastery of the world." In India at the turn of the century, Narendranath Datta Vivekananda proclaimed: "This is the great ideal before us and everyone must be ready for it— the conquest of the whole world by India. ... Up India, and conquer the world

9

with your spirituality." And by 1902, Vladimir Lenin, a Russian revolutionary in exile, envisioned "the Russian proletariat as the vanguard of the international revolutionary proletariat," which would, as he later argued, lead to a world revolution by all oppressed peoples. Obviously, the future was bound to witness fierce bids for empire and world power. Meanwhile an arms race was in progress, with a major war widely considered inevitable—its scope and consequences totally unknown.

The fragile Russian Empire was poorly prepared for such an unprecedented storm. By its very size, inadequate communications, backward industries, and, above all, the dubious loyalty of its peoples, Russia was patently at a disadvantage. As the events of 1905 had shown, defeat even in the distant Far East had led to an explosive rebellion among the bulk of the population who were persuaded by Western democratic ideals to seek liberation from autocratic repression. In addition, political agitation for freedom and self-determination among non-Russians had long been brewing. The Poles, who had staged two major uprisings in the nineteenth century, certainly would secede if given a chance. Other non-Russian peoples on the empire's western borders or in Central Asia were likewise eager to escape Russian domination, as were the conquered peoples of the Caucuses area.

The government in St. Petersburg doubted it could hold the empire together under the strains of a major world war. In case of defeat, so a high-ranking official predicted, popular discontent would explode: "Russia will be flung into hopeless anarchy, the issue of which cannot be foreseen." Yet protected by the autocratic traditions still dominant in his court, Nicholas II could offer no leadership for his country as the devastating storms of war began to rage around the world.

V.

On June 28, 1914, in Sarajevo, the capital of Bosnia, a Serb terrorist assassinated Archduke Francis Ferdinand, heir to the throne of the multinational Austro-Hungarian Empire. That murder set off World War I. By August 4, Russia, France, and England ("the Allies"), confronted Germany and Austria-Hungary ("the Central Powers"). All were inspired by patriotic fervor and expected easy victory in a conflict which soon spread around the world.

In 1917 the Allies scored their biggest gain when, on April 20, the United States declared war on Germany. Safe from attacks on its territory, the United States contributed crucial manpower and equipment, together with political support from some Latin American countries. More essentially, the entry of the Americans gave the Allied cause an ideological goal: democracy. By 1918 nearly the whole world was

involved in the first *world* war—on land, on the oceans, and even in the air over western Europe.

The American mobilization, though of relatively short duration, illustrated the ominous trend to the times which reached eventually into the Soviet Union: for the sake of victory for democracy, the United States did not hesitate to suspend its traditional freedoms. Determined to train his nation for war, President Woodrow Wilson threatened: "Woe to the man that seeks to stand in our way on this day of high resolution." His Committee on Public Information monitored public opinion, ferreting out disloyalty and attacks on the Constitution, the flag, and military uniforms. Eugene Debs, a prominent socialist and opponent of the war, was sentenced to ten years in prison. Anti-German attitudes were rampant; German breweries were denounced. Meanwhile the War Industries Board coordinated American industry, the Food Administration mobilized agriculture, and the Nation War Labor Board enrolled the workforce. In this embattled way, the United States moved toward victory.

By contrast, the vulnerable Russian Empire fared most catastrophically. In August 1914, amidst patriotic enthusiasm, the Russian armies advanced into East Prussia. By September they were driven back, retreating ever thereafter. Defeat inevitably stirred up political agitation at the Russian capital (now Russified as Petrograd). Already in May 1915, after a humiliating military setback in Galicia, the progressive members of the Duma and their followers in Russian society had tried to mobilize popular support for the war effort. Nicholas II, however, would not tolerate interference with his autocratic control. In September he personally assumed command of the armies, leaving his utterly incompetent wife, eager to uphold the autocratic tradition, in charge at the capital.

By that time the Germans had conquered the Polish parts of Russia, permitting Poland to declare its independence in 1916. In September of that year, the Russians suffered an especially disastrous defeat, losing a million men, which left their armies demoralized and discontented. Fortunately for Russia, the Germans also had to fight in France, which slowed their advance.

On November 18, 1916, as the German armies advanced along the Baltic coast, the Duma predicted disaster, but found its warning suppressed by the order of the tsar. Even Russia's allies now had reason to be alarmed. On January 17, 1917, the British ambassador, Sir George Buchanan, tactfully approached the tsar: "Your Majesty, if I may be permitted to say so, has but one safe course open to you, namely to break down the barrier that separates you from your people and to regain their confidence." Whereupon the tsar drew himself up: "Do you mean that I am to regain the confidence of my people or that they are to regain my confidence?"

Within less than two months, the people of the capital proved that the tsar had lost their confidence. On March 8*, strikes and riots broke out. Two days later, the troops ordered to suppress them mutinied. On March 12 the members of the Duma established a Provisional Government, while the local soldiers, sailors, and workers, remembering the uprising of 1905, rebelliously formed a soviet of their own. On March 15, 1917, the tsar humbly abdicated. The centuries-long autocratic empire had crashed to the ground, utterly discredited by military defeat. After this rather peaceful revolution, the empire began to dissolve while the war still continued. Liberated from autocracy, the peoples in the Russian Empire began to assert their anarchic divisiveness. No chance existed under these conditions for liberal constitutionalism.

The Provisional Government, representing the westernized elements in Russian society, wanted to continue the war. In May it started an offensive against the Austro-Hungarian army. The Petrograd Soviet, on the other hand, wanted peace, and was supported by rapidly multiplying local soviets. When the offensive failed, the Petrograd Soviet tried to overthrow the Provisional Government, even though, according to their leaders, the time was not ripe. In August the reactionaries made their counterbid for a military dictatorship. As their soldiers marched toward the capital, agitators sent out by the Petrograd Soviet recruited them for their own cause. The Provisional Government was left in nominal charge but it could not prevail against the aroused masses guided by the Bolsheviks and their professional revolutionary leader Lenin, the prophet of world revolution.

During the fall of 1917 political agitation in the name of freedom stirred up the masses as never before. The lid of autocratic control was off, and the accumulated resentments of centuries could at last be vented. Forget the war. What counted was the freedom to settle old scores: soldiers against officers, peasants against landlords, workers against capitalists, the common people against the *burzhui* (the bourgeoisie), the exploited against the privileged, the soviets against the Provisional Government. It hardly mattered at the moment that the membership of the soviets was divided among Mensheviks (soft-line Marxists), Lenin's hard-line Bolsheviks, and the more loosely organized and politically less sophisticated Social Revolutionaries. As living conditions worsened and lawlessness spread, Lenin knew that his time had come.

On November 7, in what seemed a rather minor incident amidst the elemental popular rebellion, the Bolsheviks under the command of Leon Trotsky staged the second revolution of 1917, subsequently glorified as the Russian Revolution.

* All dates are here given by the Gregorian calendar, introduced into Russia only on January 31, 1918. By the traditional Julian calendar, the overthrow of the tsar occurred in February.

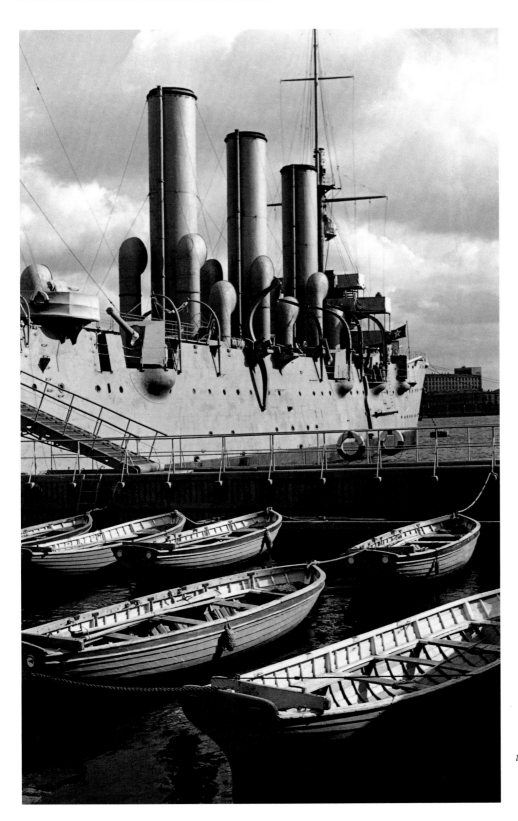

The Cruiser *Aurora*, 1957—
On October 24, 1917, the Aurora
docked at Petrograd (renamed
Leningrad after the Revolution,
and currently St. Petersburg),
carrying Bolshevik troops. That
evening, blank shots were fired
from the ship, signaling the attack
on the tsar's Winter Palace. Within
two days, the Bolsheviks took over
the palace, winning a major victory.
This photograph was taken for the
40th anniversary of the Revolution

Quickly seizing power in Petrograd, they ousted the Provisional Government; in Moscow they gained control after a week of fighting. Meanwhile a legislative body called the Constituent Assembly was elected under plans originally prepared by the Provisional Government for establishing a democratic government. The elections, however, revealed the ominous truth: the Russian electorate had no use for liberal democracy. Four-fifths of the elected delegates were tied either to the Social Revolutionaries or to the Bolsheviks, both of which were oriented toward the Russian masses (the Bolsheviks under the leadership of Lenin constituting only a minority). After a brief clash with the Social Revolutionaries, the Bolsheviks high-handedly dissolved the Constituent Assembly and set up their own government in the name of the All-Russian Congress of Soviets, which they dominated. In this manner Lenin's unrepresentative Soviet government, more ruthlessly ambitious and more aware of the global dynamics released by the war than any of its Russian rivals, had accomplished a revolutionary change.

Yet Lenin's government was patently incapable of preventing the disintegration of the former Russian Empire. Poland had already declared its independence in 1916. After the Bolshevik coup, the Ukrainians on November 20, 1917, proclaimed the Ukrainian People's Republic. A week later Estonian claimed independence, followed by Finland in early December and by Moldova (along the Romanian border) later that month. In January 1918 Latvia split off. As the German army approached Petrograd, the Bolsheviks relocated their capital to Moscow in the Russian heartland, conceding defeat in the war. In early March, breaking Russia's ties to the Allies, they concluded peace with Germany in the Treaty of Brest-Litovsky on exceedingly humiliating terms. Russia officially surrendered Poland, the Baltic coast from Lithuania to Finland, the Ukraine, and Transcaucasia, where Georgia, Armenia, and Azerbaijan declared their independence in April. Thus "our socialist fatherland," as Lenin called the now defunct Russian Empire, lost vital industries and mineral resources, its best agricultural lands, and almost one-third of its population. The Germans now had free access to Russia's riches. Russia was in danger of becoming a German colony.

Meanwhile the Allies, increasingly alarmed by Lenin's revolutionary propaganda, encroached on Russian territory. In the north they occupied the harbors of Murmansk and Arkhangel'sk, setting up a puppet North-Russian government. In the south they protected Russian ports on the Black Sea from the Germans and looked for oil along the Caspian Sea. In the Far East, Japan occupied the port of Vladivostok and, together with English and French forces, moved west in order to liberate Czech prisoners of war (captured earlier from the Austro-Hungarian army) who had seized control of the Trans-Siberian Railroad. Never before had Russian lands been so open to foreign penetration.

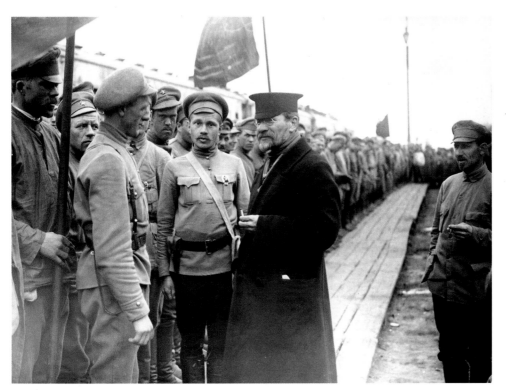

Kalinin Visiting a Communist Battalion in Alatyr, 1919—*Mikhail Kalinin (1875–1946) was an early revolutionary and ally of Lenin, serving as the mayor of Leningrad following the revolution. From 1919 to 1938 Kalinin headed the Soviet Central Executive Committee, and in 1938 he became the chairman of the Presidium of the Supreme Soviet. Although critical of the extent of the Stalinist purges in the 1930s, Kalinin was himself not purged and died a natural death in 1946.*

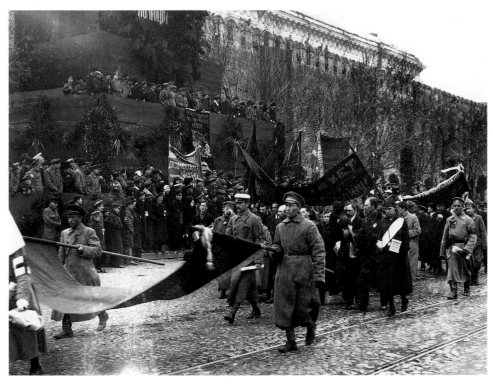

Soldiers and Workers March Through Red Square, Moscow, May 1918

And never before had they been so torn by internal violence. A month after the Bolshevik seizure of power, the Cossacks, militant tradition-minded frontier guards, had set up an independent anti-Soviet republic along the Don River, starting an embittered civil war. Thereafter the Whites, the defenders of the old order, battled the Reds, representing the Bolshevik Soviets, who in turn fought the Social Revolutionaries. Independent peasants from the Ukraine, called the Greens, set up their own armed units. The civil war spread around the country, including the Urals, where the imperial family had been confined in the city of Ykaterinburg. To prevent their liberation by the advancing Czechs, the local Bolsheviks murdered the tsar, his wife, and daughters, on July 16, 1918. On August 30 Lenin himself, at odds with the Social Revolutionaries, barely escaped assassination. In the fall, White forces under Admiral A. V. Kolchak, who called himself the "Supreme Ruler of Russia," set up an independent Siberian government. His troops marched west to link up with the North-Russian government. All along, the Muslim peoples, loosely united since May 1917 in the All-Russian Muslim Congress, stirred in Central Asia. Tatar, Bshkir, Kazakh, and Kirghiz clamored for autonomy.

VI.

The surrender of the Central Powers in November 1918 ended World War I and the German threat. Lenin even hoped for a Communist revolution in Germany. Yet the Russian civil war continued. In the fall of 1919 General A. I. Denikin led a powerful White army from the south toward Moscow, while a weaker White force threatened Petrograd. In the end the Red Army prevailed, helped by postwar fatigue which had curtailed Allied interventions. By 1920 the civil war drew to a close, but then the new Soviet Russia fought a disastrous war with Poland that extended the Polish borders still further into Russia. Finally in 1921, amidst a deadly famine, rebellious peasants, striking workers, and a mutiny at the hitherto loyal Kronstadt Naval Base near Petrograd, the country's economy collapsed. If an American relief organization under President Herbert Hoover had not come to the rescue, millions of Russians would have died of starvation. These were terrible years, deeply ingrained in the memory of Lenin and his Bolsheviks.

There was no hiding the fact that the storm of global war had utterly devastated the Russian Empire. No other belligerents had passed through such degrading ordeals. The country had lost vital territories, and was now cut off from direct contact with Europe by Poland and the Baltic states. It had experienced drastic catastrophes in its government, economy, and society. Russia's casualties in the war exceeded those of the other belligerents; with the addition of the untold victims of the civil war, the human costs had been staggering. With a few exceptions the most enlightened and professionally competent westernized citizens,

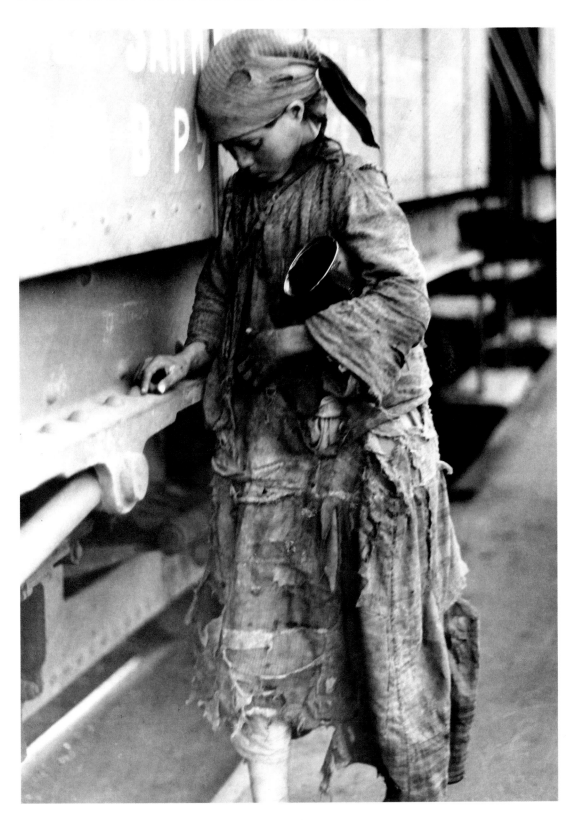

Peasant child begging for food at a railroad station, 1920— *The Soviet Union emerged from World War I with a new government and dynamic leadership. The war, however, had devastated the nation. By the end of 1921 the economy had collapsed, leaving millions dead and many citizens poor and on the verge of starvation.*

together with the tsarist aristocracy, had been wiped out or driven away. What was left, for all practical purposes, were the backward masses of Russian Eurasia further brutalized by bloodshed and material deprivation in war and civil war.

And what brutality! At one point during the civil war the sailors at the Black Sea Naval Base of Sevastopol seized anyone with clean fingernails and shot him dead as burzhui. Maxim Gorky, who before the revolution had risen from dire poverty to literary fame, explained "the cruel manifestations of the revolution in terms of the exceptional cruelty of the Russian people." He reported even worse inhumanities:

> In Tambov Guberniya [a province southeast of Moscow] Communists were nailed with railway spikes by their left hand and left foot to trees a metre above the soil, and [the peasants] watched the torments of these deliberately oddly-crucified people.
>
> They would open a prisoner's belly, take out the small intestine and nailing it to a tree or telegraph pole they drove the man around the tree with blows, watching the intestine unwind through the wound. Stripping a captured officer naked, they tore strips of skin from his shoulders in the form of shoulder straps, and knocked in nails in place of pips. They would pull off the skin along the lines of the sword belt and trouser stripes—this operation was called "to dress in uniform."

These were by no means unusual scenes. They all illustrate the primitive, barbarous, and semi-Asiatic features of the human raw material from which the successors of the tsars had to build a new order in the aftermath of the greatest political storm in history. Acquainted only with the civilized aspirations of the Russian intelligentsia, Westerners remained generally blind to the grimness of life among the aroused masses, or even to the marked intolerance among Russian intellectuals. The latter (with certain exceptions such as Chekhov or Gorky) have always been reluctant to acknowledge the violence and brutishness of their society; it was too humiliating for their self-esteem. The cold-bloodedly realistic Leninists, however, were ready to face the historic challenge: how to raise from the turbulent anarchy of the collapsed tsarist empire a state capable of proudly holding its own in the stormy competition for global power, whatever the human costs.

Consider the brutalizing effects of that four-year war. By current estimates roughly ten million were killed and twenty million wounded, at the ruinous material price to the survivors of $180 billion, all willingly paid for by the participating countries. The war set the tenor of statecraft for decades ahead. What did

human lives and prosperity count when the survival of the country in the race for global power was at stake? Never before had the masses of people been so intensively mobilized and propagandized for patriotic sacrifice in total war, all for the sake of national glory. According to President Wilson, the American aim in joining its allies was "to make the world safe for democracy," thus globalizing the American experience. Always following the Western lead, Lenin wanted to make the world safe for the superior Soviet version of communism.

Admittedly, in the United States as in Britain and France, victory preserved the traditional forms of government and human values, although they were tarnished by postwar unrest. The victors radiated their ideals of freedom and democracy worldwide, causing widespread political turmoil in countries of different political traditions. All of Europe, indeed the whole world, emerged from the war in a tense mood. The democratic ideal and the preeminence of Western power spread storms of violence far and wide. Taking the long view in 1919, Wilson predicted "with absolute certainty that within another generation there will be another world war."

The age of world wars penetrated with special fury into the utterly unprepared lands of the former Russian Empire now dominated by Lenin's Bolsheviks.

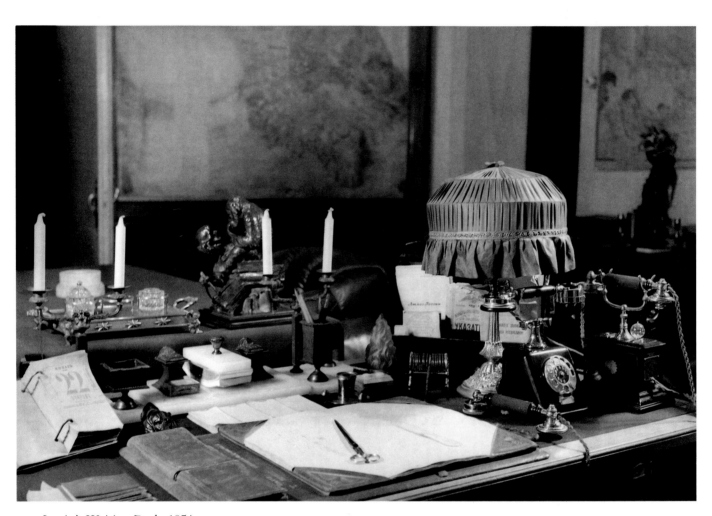

Lenin's Writing Desk, 1954

Lenin Creates the Soviet System

The raw Russian realities under which the young Baltermants grew up will now be examined more closely and probed more deeply. By 1921–1922 the Soviet government guided by Lenin and his Communists had assumed responsibility, amidst the postwar tensions, for reviving and strengthening the defunct Russian Empire. What skills had enabled the Communists to prevail in the civil war? What superior resources could they rally as the new masters of the Eurasian lands and its 147 million peoples?

I.

They certainly had been well apprenticed by the hardships of the revolutionary movement in the last decades of tsarism. Advocating the liberation of the suppressed masses by overthrowing autocracy, they had been treated like criminals by the secret police. Under those conditions their goals obviously could not be achieved by the humane means of free speech and voluntary agreement. What counted from the start was survival in the treacherous revolutionary underground with the help of like-minded conspirators.

In this setting the Bolsheviks were a small group, inspired by Karl Marx and thereby tied to Western European socialists and their wider perspectives. At the same time, the Bolsheviks put their faith in their patently underdeveloped Russian working class. They were westernizers, yet with Marxist opposition to capitalism. Russians at heart, they adapted the more peaceful Western Marxism to the coarse Russian realities. Yet their Russified Marxism also took up the longings expressed by Dostoyevsky: "to stand at the head of the nations … to lead them in a concordant choir toward the final goal preordained for them"—according to Karl Marx.

The leader of the hard-line Marxists, Vladimir Ilyich Ulyanov, known as Lenin, was born into a privileged family in 1870. His maternal grandfather was a Jewish physician converted to the Russian Orthodox Church. His father, a director of schools in a provincial center, had been promoted into the hereditary nobility. Vladimir and his older brother Alexander, products of the tensions in Russian society, turned into revolutionaries. Alexander, while studying at the University of St. Petersburg, was hanged in the repression following the assassination of Tsar Alexander II. Vladimir was trained as a lawyer and gifted with immense intellectual energy and revolutionary determination.

Exiled as a revolutionary to Siberia in 1895, Vladimir—now Lenin—put his enforced leisure to good use, translating Western books of interest to Russian Marxists and staying in touch with like-minded friends, while writing an impressive scholarly tome, *The Development of Capitalism in Russia*. He married Nadezhda Krupskaya, a woman revolutionary, well educated like himself. She became his lifelong devoted assistant, but bore him no children. But how could they have raised a family while pursuing a perilous revolutionary career in which, as Lenin once observed, you might get your hand bitten off while kindly stroking someone's head? Released in 1900, Lenin and Krupskaya soon moved to western Europe, comfortably supported by family funds and political contributions from fellow Marxists and sympathizers in Russia and abroad. Shifting from country to country they remained Russian patriots in Marxist disguise, intensely preoccupied with events worldwide.

II.

In 1902, while living in London, Lenin published a seminal essay, *What Is to Be Done?*, outlining the responsibilities of Marxist revolutionaries such as himself. Revolution in Russia posed a profound intellectual challenge. Western European experiences did not apply to what Lenin called the tsarist "monster." If there was to be a successful Russian revolution, the preconditions had to be carefully studied. Lenin thus pioneered the exploration of revolutionary opportunities not only in the Russian Empire but also around the world. In keeping with the times, Lenin's perspectives and ambitions became global.

His key insight was contained in the sentence: "Without revolutionary theory there can be no revolutionary movement." Lenin was inspired by Marxism and its pseudoscientific assurance of an inevitable historic progress toward human perfection. It offered a sophisticated analysis of modern society and, like a religion, a basic psychological assurance. Marxist theory, however, needed to be adjusted to Russian conditions. That adjustment provided a crucial opportunity for Lenin, who aspired to leadership on the merit of his superior insight into the

ever-changing political scene; nobody else could match his sensitivity toward Russian reality. As a theorist exploring, with a charismatic touch, the prospects for revolution in Russia, Lenin inspired his followers to become the revolutionary vanguard. This ran contrary to Marxist assumptions, since Russia was a society where the working masses were not ready to take the initiative. In backward Russia the necessities of gaining and holding power took priority over Marxist theory. Lenin's Marxism was but an updated version of Russian nationalism, tough and even brutal, but also inspired by an idealistic vision of a perfect society realized under communism. It raised the country above its capitalist rivals.

The dedicated professional revolutionaries had an even larger assignment: the fundamental recasting of Russian society according to an alien ideology of cultural superiority with the help of a disciplined secret organization. Such organizational work called for much practical experience in modern mass politics. The revolutionaries' top priority, therefore, was effective organization perilously conducted under the threat of the tsarist police and the unpredictability of events.

III.

Temporarily lured back to Russia by the uprisings in 1905, Lenin advocated mass terror, but without success. Returning to western Europe in 1907, and more than ever dedicated to ruthless tactics, he commented: "Revolution is a difficult matter. It cannot be made with gloves and manicured fingernails. ... A party is no girls dormitory. Party members should not be measured by the narrow standard of petty-bourgeois morality. Sometimes a scoundrel is useful to our party precisely because he is a scoundrel." In short, exalted ends justified even employing the scum of humanity.

From western Europe, Lenin busily propagated his hard line in endless and often mean-spirited polemics about the dialectics of the class struggle. He talked at conferences and wrote widely distributed articles and essays secretly passed into Russia as well. Assiduously following the news from around the world, he sensed revolutionary opportunities even in the Orient after the overthrow of Chinese imperial rule in 1912. Could there eventually be a world revolution?

World War I found an impoverished Lenin in Switzerland, distressed that the working classes had patriotically supported their exploiters on both sides of the conflict, but anticipating their eventual rebellion. All along he watched the course of the war, in which the British lost, on a single day in 1916, sixty thousand men killed or wounded, while the total casualties of the Battle of Verdun rose to almost a million. In March 1917 his anger exploded: "The war shackled ... the belligerent groups of capitalists, ... the slave-owners of the capitalist slave system, to each other with chains of iron. One bloody clot—such is the social and political

life of the present moment in history." The human sacrifice of the war certainly left its mark on Lenin and his revolutionaries. What did human lives count when great causes were at stake?

Willing to use any means to further his end, Lenin, the Russian revolutionary patriot, not only accepted German help in returning to his fatherland but also secretly received German subsidies for carrying out his mission. According to his German sponsors, a cataclysmic Russian revolution would help Germany win the war. According to Lenin, it might lead to the triumph of his Bolsheviks. He felt no moral qualms about betraying the Russian war effort. Thus he arrived in Petrograd soon after the abdication of the tsar, transformed from a revolutionary apprentice into a farsighted revolutionary practitioner with an ear close to the ground.

IV.

As Lenin looked ahead during the next few months, the prospects seemed promising indeed. A low-key revolution had blown off the lid of autocratic regimentation. The liberals in the Provisional Government had no chance, nor did the moderate socialists. The future belonged to the hard-liners, as the age-old anger among "the proletariat and the poorest peasants" was heating up to an elemental anarchic explosion. Lenin therefore had no scruples advocating the slogan: "All Power to the Soviets." Thus he introduced into his country the practice of mass politics, involving the raw majority of the population in the fierce domestic power struggles.

But aware that "the large masses who have just awakened to political life" were unprepared for effective revolutionary action, he openly aimed at a Soviet dictatorship controlled by his Bolsheviks. That dictatorship, Lenin ominously prophesied, would created a huge state apparatus and a militia embracing the whole population. Mass politics in Eurasia was to be a brutal process, utterly different from Western democratic practice.

At the same time Lenin, the former émigré always looking abroad, speculated that after three years of worldwide war a world revolution was maturing. It called for the formation of a Revolutionary International, recruited among the revolutionaries in the advanced countries and the oppressed nations, all eager to end imperialist warfare and exploitation. The Russian Revolution had to draw additional strength from foreign support, and it had to boost Russian pride to counter Russia's impending military defeat. But what mattered at the moment was the seizure of power, as the Bolsheviks gained support among the aroused masses.

After the Bolshevik coup on November 7, Lenin trumpeted the historic significance of that rather inconspicuous event: " ... the oppressed masses will of

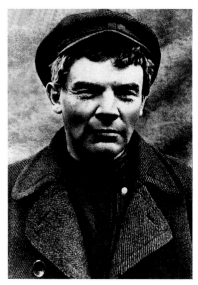

Lenin in Disguise, 1917

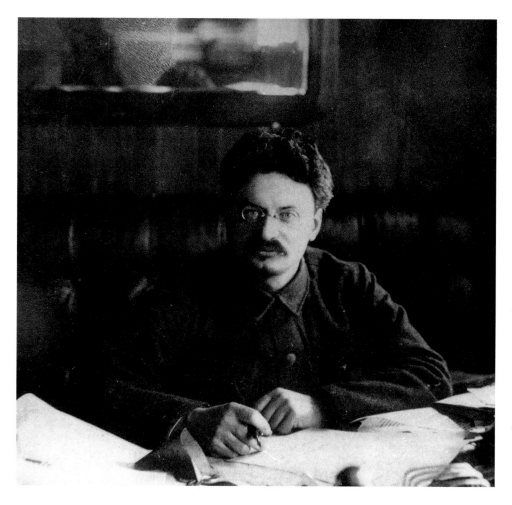

Trotsky in His Study, 1917—
*Leon Trotsky (1879–1940) was the
second most prominent revolution-
ary, next to his colleague Lenin.
Although they had disagreed on the
strategy of a revolution (Trotsky
was much more extreme than
Lenin), the two formed a critical
bond during the 1917 Revolution,
with Trotsky in charge of the
assault on the Winter Palace.
Serving initially as the People's
Commissar for Foreign Affairs,
Trotsky was soon appointed as the
People's Commissar for Military
Affairs, charged with the task of
forming the Red Army. Following
Lenin's death in 1924, Trotsky,
because of his arrogance, soon fell
out of Communist Party favor.
Exiled in 1927 and deported in
1928, Trotsky was killed in Mexico
in 1940 on Stalin's orders. His
assassin smashed an icepick into the
back of Trotsky's head (Photo
courtesy of Agency Novosti.)*

themselves form a government. The old state machine will be smashed into bits
and in its place will be created a new machinery of government by the soviet
organizations. From now on there is a new page in the history of Russia." In fact
it was not the Soviets but Lenin himself who created a new government, called
the Council of People's Commissars, led by himself. After announcing the end of
the war and turning all agricultural land over to the peasants (who were seizing it
on their own), Lenin began to face the harsh realities of building state power. In
December he established the Cheka, the notorious secret police charged with purg-
ing "the Russian lands of all kinds of harmful insects," the diverse enemies of the
embryonic regime. Next he created the Red Army under Trotsky's command,
another key agency building up strength in the war-torn country.

In January 1918 Lenin showed his true colors in denouncing "the rich, the
crooks, the idlers and hooligans," including the bourgeois intellectuals, all to be
put into prison cleaning latrines and wearing yellow tickets to identify them as

people under surveillance. Most ominously, "one out of every ten idlers" was to be "shot on the spot." Soon thereafter he decreed compulsory labor service for the rich, thus starting the infamous *Gulags* (labor camps). "Merciless mass terror," recommended by Lenin in August 1918 just before he bravely escaped assassination, was an inevitable instrument of survival in "the bloody clot" of war, civil war, and military defeat. In this vile hell, hardened Bolsheviks had no use, as Trotsky put it in 1920, for "Kantian-clerical, vegetarian Quaker chatter about the sanctity of human life." Thus emerged in the Soviet Union what the Russian novelist Alexander Solzhenitsyn has called the "wolf-tribe."

In March 1918, while peace with Germany was being concluded, the Bolsheviks transformed themselves into the Communist Party. Aware that extreme times call for extreme visions, the Bolsheviks unfolded the red flag of communism adorned with hammer and sickle, the symbols of the proletariat and the poorest peasants. Under this banner they proclaimed the ultimate human perfection as envisaged by Marx, attracting many idealists disillusioned with capitalism or opposed to worldwide Western domination. Yet, as Lenin's admiration for German discipline—and the widespread longing for the material comforts of Western life—proved, the Western model still held sway over the Bolshevik revolutionary universalism. Lenin's ideology advocated anti-Western westernization.

But alas, even socialism, the preparatory stage for raising the standard of living on the way to communism, was a distant goal. Soon after the Bolshevik revolution the great banks had been nationalized and industry put under a Supreme Economic Council in anticipation of a centrally planned socialist economy. But administrative implementation was impossible. More disturbing was that even after the Bolshevik seizure of power and intensified propaganda, the people were not ready. By any realistic assessment the cultural level of the Russian masses, in whose name the Communists had introduced their most advanced kind of government, was deplorably low. Lenin admitted that "the Russian is a bad worker compared with people in the advanced countries." For that reason he warned that "working out new principles of labor discipline by the people ... [was] ... a very protracted process." It required no less than the adoption of the capitalist techniques of industrial production as advocated by Frederick W. Taylor, the American pioneer of scientific management. And in 1920 Lenin called for the countrywide development of electric power (a far cry from the hammer and sickle), declaring that "Communism is Soviet power plus the electrification of the whole country. ... a model for future socialist Europe and Asia." Raising extravagant visions was an essential Communist technique for motivating the sluggish workers.

But Lenin was still a realist. Brought down from his ideological clouds by the perils of political survival, he conceded that it was "extremely stupid and

absurdly utopian to assume that the transition from capitalism to socialism is possible without coercion and without dictatorship." Indeed, "we must combine … iron discipline while at work with unquestioning obedience to the will of a single person, the Soviet leader." Typically, Lenin saw no contradiction between this policy and his earlier contention that the Soviet regime represented the will of the masses. As he had boasted in late 1918: "Proletarian democracy is a million times more democratic than any bourgeois democracy." Despite all its shortcomings he considered the Soviet system superior.

After catching up to the Western calendar—the old Russia had been thirteen days behind—the Communists adopted many progressive causes from western Europe and the United States. Their socialism demanded a society that was free of class distinctions and poverty. It provided free social services and education, and access for all workers to the best of contemporary civilization. They also enacted legal equality for women, liberating them from "domestic slavery" and subjugation to their husbands, facilitating divorce, and permitting abortion. In regard to sexual liberation as advocated by some female socialists, however, they took a hostile stance, considering it "bourgeois filth"—dedicated proletarians should work for the revolution, not indulge in sex. True love, however, was permissible. While married to Krupskaya, Lenin was in love with Inessa Armand, an impressively gifted, warmhearted woman with three children. He had met her during his exile in 1910. Their close relationship, tolerated by Krupskaya, lasted until Armand's death in 1920, having somewhat cooled off because of Lenin's growing preoccupation with revolution and civil war. Bourgeois puritanism, associated with a deliberately spartan lifestyle, was part of the Communist identity. But in regard to religion, Marxist atheism prevailed. The Russian Orthodox Church was a source of backwardness, and its spiritual message of loving kindness an invitation to political disaster. In his personal conduct, however, Lenin generally preserved the good manners of his upbringing.

V.

By the time the civil war drew to a close, the Communists had fashioned impressive assets under Lenin's guidance not only for overcoming their rivals in the brutal competition among the aroused masses, but also for coping with their country's backwardness. To their bewildered peoples they held out a universal vision of human perfection which, however utopian, could rally new energies for patriotic reconstruction at home. What could be more inspiring, asked the young poet Alexander Blok, then "to remake everything: to organize things so that everything should be new, so that our false, filthy, boring, hideous life should

become a just, pure, merry, and beautiful life?" A fellow poet, Vladimir Mayakovsky, known as the "drummer" of the revolution, placed his art at the service of the masses; his propagandist verses enjoyed great success during the civil war.

Abroad, the disorientation of the postwar years prompted short-lived local Communist regimes in Germany and Hungary. The Bolshevik revolution enlisted Western idealists. As the American journalist Lincoln Steffens observed after a visit to Soviet Russia in 1919: "I have seen the future, and it works." In addition, communism began to enroll ambitious followers in the developing countries. The Third (or Communist) International (also called Comintern), established in 1919, was designed to rally sympathizers around the world.

Lenin thus provided organization support for the worldwide resentment against the elemental Western global outreach, paying foreign Communist millions in hard currency at a time of extreme need at home. According to his Marxist creed (and his Russian eagerness for matching Western superiority), international communism would eventually replace capitalism on the way to universal salvation. Admittedly, the Communist anticipation of ultimate victory over capitalism also aroused deep hostility, especially among Americans dedicated to their own universal mission.

American anticommunism, sharing some similarities with its ideological enemy, emerged immediately after the war, when labor unrest, racial tensions, and Communist propaganda created the Red Scare. The Federal Bureau of Investigation (FBI) was established, under J. Edgar Hoover, eager to track down all traitors. In January 1920 Attorney General Mitchell Palmer even staged a major raid against socialists and Communist sympathizers, putting four thousand people into overcrowded jails without benefit of counsel. What did civil rights count in the traditionally most secure country when touched by fear of subversion? Fortunately postwar normalcy restored the American sense of security, though the FBI overzealously remained on guard against communism for the next seventy years.

Western fears of communism produced one advantage for the new Soviet Russia: despite its frailty, it was a country to be reckoned with, endowed with a new sense of pride. The ideological claim to superiority lessened or even eliminated in Russian minds the traditional subversive comparison with the West. Under communism the Russian people supposedly were secure in their self-esteem, at least as long as contact with the outside could be prevented.

Anti-Western ideological indoctrination and prevention of comparison with the West, however, depended on effective organization controlling life in all Eurasia. In this crucial aspect of state power the Communists, carrying political agitation into the raw masses, had sharply advanced beyond tsarist practice. At

the core of their system stood the Communist Party, highly centralized under Lenin's leadership. It called for dedicated personal commitment and disciplined loyalty, both closely watched. From the party, Communist discipline was radiated into all Soviet agencies, and from them into daily life—promoting in art and literature as well as in all the media the proper "Soviet socialist consciousness." The economy was subject to government control, with the workers held to strict industrial discipline. Civic conformity was imposed upon all aspects of life. Obviously, in all layers of society, Soviet organization was as yet rudimentary, even in the party. But the basic principles were laid out, monitored by Lenin himself with the help of the secret police ready to use raw force.

The supreme goal of the all-pervasive organization was escape from backwardness, generally with the help of electrification and industrial modernization. If socialism was to be achieved, if the people (including party officials) were to become more civilized, the standard of living had to be raised to Western levels. Thus the Soviet leadership resumed the policies laid out by Sergei Witte under the last tsar. To strengthen industrial efficiency Lenin even argued in favor of employing bourgeois specialists, however suspect their political loyalty. The proletariat obviously did not possess the necessary qualifications.

Increased prosperity might even help solve another major problem facing the new government: the rise of national separatism. At the end of the war the drive for national self-determination had threatened to dissolve the Russian Empire, which the Communists certainly wanted to preserve. How could they cope with this difficult problem? After much discussion, which also involved Stalin as People's Commissar for Nationalities, they settled for a cautious recognition of separate national identities. Their Communist message could be spread only with the help of native languages, which implied acceptance of the speakers' native cultures. The cultural separateness, however, was transcended by the Communist ideological claim that, regardless of their nationality, people were proletarian comrades inheriting the world together. On this questionable basis—and with the help of the Red Army—the secessionist nationalities were integrated into the federal Union of Soviet Socialist Republics (USSR). If the Communist Party could supplement proletarian unity with material advance, the nationalist issue might be solved. In any case, the unity of the tsarist empire was more solidly preserved in the new Soviet Union.

Thus the basis was laid for restructuring the tsarist empire as a potent new factor in world politics. It was another asset of Lenin's Communists that they were geared to global prospectives. As Russian patriots they were keenly aware of the country's disastrous defeat in World War I. They knew in their bones that without territorial security there could be no effective development of domestic

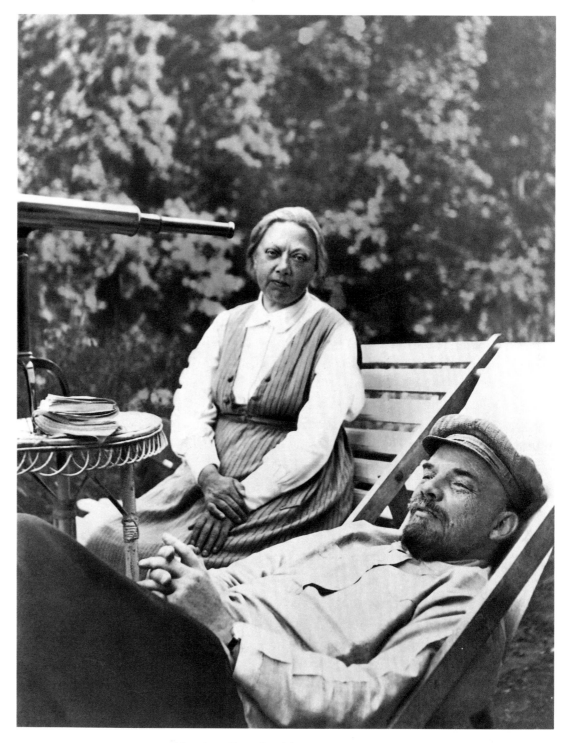

Lenin at Rest Outside Moscow, 1922—
*Shown with his wife, Nadezhda Krupskaya. After suffering a stroke in 1921,
Lenin's health declined through 1922 and 1923, and he died in January 1924.*

order and unity. As Russian revolutionaries they also helped to attract novel sources of external support. Admittedly, the prospect of world revolution was fading, but as long as its specter haunted the Western leaders, the Communist presence in the world proclaimed a universal countermodel to capitalism.

All these accomplishments substantiated Lenin's statement of 1902: "What is to a great extent automatic in a politically free country must in Russia be done deliberately and systematically by our organizations." The powerful Western countries had attained their superiority over a long stretch of time. They were ruled by effective governments based on voluntary civic cooperation. Now the Russian Communists, faced with the near collapse of their country, were determined to match these Western advantages in short order by their deliberate and systematic organization, substituting compulsion for the spontaneous conformity prevailing in the West. The Leninist revolution with its global perspectives thus proceeded entirely above the comprehension of the common people. Nothing like it had been attempted anywhere in human history.

By 1921 Lenin himself had been forced to scale down his expectations in the face of grim reality. Soldiers and workers, hitherto strong supporters, revolted in the spring of that year. The Communist regimentation had only produced misery and lost the support of the Soviet masses. Thus began the era of the New Economic Policy (NEP), more open and more humane after the dictatorial compulsions decreed earlier. Now the country was opened, with some foreign assistance, to a measure of free enterprise designed to restore at least the prewar standard of living. Yet, just because of this retreat, Lenin insisted that more discipline was needed, foremost within the quarrelsome Communist Party.

But Lenin himself, although only in his early fifties, had reached his limits. As the sole authority at the head of the Soviet dictatorship, he was overworked, irritable, and isolated from his associates. In May 1922 he suffered a stroke, which led to further breakdowns before he died in January 1924. Relieved of responsibility in his last years he took a sober view of what he had accomplished. He admitted for instance that "We have political power and a host of economic and other resources; we have everything you want *except ability* [italics added]." Or more pointedly: "We are now confronted with the task of laying the foundations of socialist economy. Has this been done? No, it has not." Lenin's revolutionary theory had taken him far ahead of reality. The Communist experiment, obviously, was to take a long time.

VI.

The Leninist vision imposed a superhuman burden upon both his followers and the Soviet people. The obstacles were huge. Deeply rooted traditional

ways of life had to be recast, at profound pain to the bulk of the population and especially to sensitive intellectuals. Consider the testimony of the Russian writer, Boris Pasternak. As he commented in his novel, *Doctor Zhivago,* on the rise on the Soviet system: "It was then that falsehood came into our Russian land. The great misfortune, the root of all evil to come, was the loss of faith in the value of personal opinions. People imagined that it was out of date to follow their own moral sense, that they must all sing the same tune in chorus and live by other people's notions, the notions that are being crammed down everybody's throat. ..." What was lost, according to Pasternak, was creative spontaneity, the true source of human progress. "Soviet socialist consciousness" imposed an uncomprehended alien way of life upon the common people and upon refined writers. The Leninist social discipline, enforced by compulsion from the top down, stifled popular creativity. At heart, the bulk of the population remained unreformed—and therefore subject to continued relentless indoctrination. The gap between the party line and indigenous spontaneity remained a permanent flaw in the Soviet system. But could the Soviet regime—determined to build a strong government—permit a revival of the inherent anarchism of popular spontaneity?

And did Pasternak have any idea of the social and political context in which he pursued his intensely personal search into the depths of the human experience? His poetic explorations indeed prevented any civic alertness and sensibility. Inward-oriented Russian culture could produce human marvels in various fields of art and science, but not in outward-oriented civic insights scaled to the country's survival in times of world wars. Lenin and his émigré associates were an exception. Pasternak, in his blindness toward the full contexts of his life, was hardly entitled to hold Lenin and the Leninists responsible for their ruthless policies. In the face of such revolting atrocities, where then should we put the blame that human nature craves to cast upon somebody?

In the light of dispassionate analysis the ultimate responsibility does not fall upon individuals or human beings generally. It belongs to circumstances beyond human control: the vastness of multinational Eurasia, the raw human attitudes unavoidably created in the course of its violent history, and the competition for global power which swept over the world as a result of World War I. No Western country has had its history shaped by similar adversities. Can Westerners therefore judge Lenin's ambition and policies—or their consequences—by their own standards?

And yet, something in our Western minds protests: is there no place for loving kindness anywhere in the Russian Eurasian condition? Indeed even Lenin had his soft spots. Angelica Balbanova, a close associate but also a humanitarian,

observed him at Inessa Armand's funeral: "I never saw any human being so completely absorbed by sorrow, but the effort to keep it to himself. ... Not only his face but his whole body expressed so much sorrow. ... He seemed to have shrunk, his cap almost covered his face, his eyes seemed drowned in tears held back with effort." Yet she added that "this mood did not influence in the least his activity as statesman and strategist of the workers' movement of the world. From the funeral he went straight back to his desk." In times of extreme crisis the pressures of political leadership and the conditions of life militate against humanitarian softness (without, however, eliminating it altogether).

Under Lenin's successor, Joseph Stalin, the inhumanity of creating a Communist society in Eurasia escalated still further.

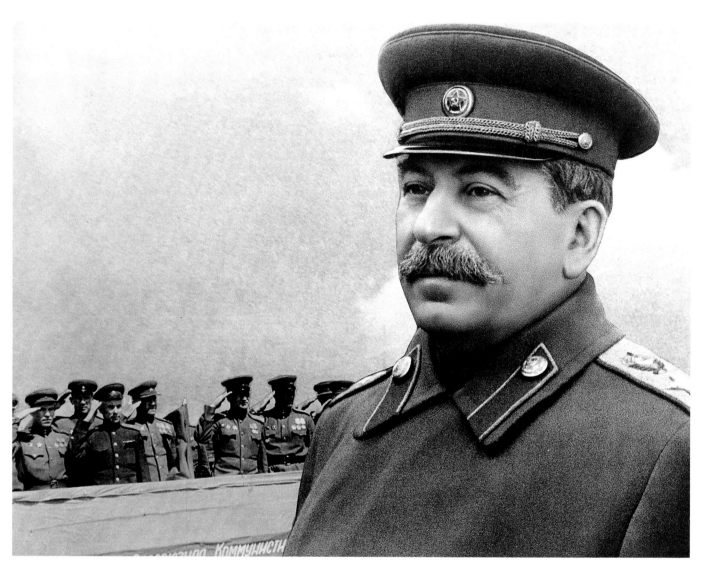

Stalin, 1945—*Taken from a specially prepared
album containing images of the
Great Patriotic War, Baltermants's photo of
Stalin in front of adoring troops is a master-
piece of "fixed" photography, making the
short-legged Stalin appear larger than life.*

Stalin: Mobilization for Survival

Stalin is one of the greatest—and most controversial—figures of the twentieth century. As the political leader who shaped Baltermants's life and career—let alone the fate of multitudes in his country and around the world—Stalin deserves detailed attention. As a dictator determined to give reality to the Leninist vision, he employed methods of government utterly repulsive to Western sensibilities. But, in trying to liberate his anarchic peoples in treacherous times from the inferiority of backwardness, he dealt with adversities unknown in Europe or America. Our effort to understand him takes us into the depths of Eurasia.

I.

Stalin was born Iosif Vissarionovich Dzhugashvili in 1879. He came from a semiliterate family of peasant origin residing in a small town near Tiflis (Tbilisi), the capital of Georgia, which was part of the Russian Empire but had a historical identity of its own. His father, a shoemaker, was a violent drunkard killed in a barroom quarrel. His long-suffering mother took loving care of Iosif, the only survivor of her four children. Impressed by his ability, she steered him into the best education available, enrolling him at the Tiflis Theological Seminary, where he gave early signs of his ambition. As his biographers tell us, he wanted to be like Koba, the hero of a popular novel about Caucasus mountaineers fighting the Russians. But he also loved to read historical and political literature that enlarged his perspectives. His rebellious temperament soon introduced him to revolutionary Marxism among the budding Georgian working class. Expelled from the seminary, he became part of the revolutionary underground in Georgia. Known now as Koba, he was arrested and sent to Siberia, from which he escaped back to Georgia several times, whenever possible studying Marxist theory. By 1905 he was a confirmed

Bolshevik, briefly meeting Lenin abroad at Russian Marxist conferences. With Lenin's help in 1912 he was co-opted into the Bolshevik Central Committee.

By that time he had turned into a Russian revolutionary patriot, seeking the largest stage available for his ambition and operating henceforth under the name of Stalin, the "Man of Steel." In 1913, after another meeting with Lenin in Vienna, he wrote an essay, *Marxism and the National Question,* which established his reputation among Russian Marxists. Arrested again in 1913, he spent the first three years of World War I in Siberia, escaping military service because of a withered left arm. Released after the overthrow of the tsar, he arrived in Petrograd in March 1917.

Advancing into the Bolshevik inner circle, he assumed routine responsibilities. Dealing with the aroused masses as Trotsky did was not his style, but, like Lenin, Stalin was keenly alert to the ever-changing circumstances facing the Bolsheviks; he was not a dogmatic Marxist. After the Bolshevik seizure of power, he assumed the post of People's Commissar for Nationalities, dealing with one of the key issues of Soviet power: how to keep the rebellious non-Russians, including the Georgians, within the new Soviet state. As a member of Lenin's inner circle, Stalin also ruthlessly performed other crucial functions in the civil war, clashing with Trotsky over military strategy. By tacit agreement in 1922, Stalin became the Bolshevik Party's general secretary, in charge of managing the party's personnel (approaching half a million by 1924) according to the Leninist ethos. At the age of forty-three he had risen from obscurity to be the most powerful figure next to Lenin in the new Soviet system.

II.

Despite Stalin's Georgian accent and rather unattractive appearance—a pockmarked face, bad teeth, and rather short stature (five foot four)—he nevertheless left his mark on his fellow revolutionaries. Admittedly, he could not match the émigrés' cosmopolitanism, but he was familiar with the rawness of life in Eurasia. He could hold his own among the party's theoreticians in all debates about Marxism or political conditions in Russia and abroad, but he also knew how to talk to the public in simple language. Solidly committed to his responsibilities and of humble disposition, he benefited from his seemingly unlimited energy, superb memory, political savvy, and sheer infinite capacity for handling administrative detail amidst the chaos of the new order. He also possessed an instinctive sense for the unquestioning loyalty he craved among his associates. These assets conferred upon him a personal power, which none of the top-ranking Bolsheviks could match.

At the same time, while the pressures of political responsibility left their mark upon him, he still remained a human being. In 1919 he had married Nadezhda (Nadya) Alliluyeva, a bright young woman half his age. It was his second marriage, his first wife having died while he was still in the revolutionary underground. Nadya participated in party work, hosting lively gatherings of friends and relatives at their dacha outside Moscow. They had two children, a son, who like Stalin's son from his first marriage never won his father's affection, and a daughter Svetlana, of whom he was very fond during her early years. Family life was strained, because politics took precedence, and ever more urgently as Stalin rose above his rivals to become Lenin's successor, despite misgivings on Lenin's part.

In his "Testament," the ailing Lenin had given somewhat mixed advice about Stalin. Saying that Stalin was "too rude," he added that "This fault [is] fully tolerable in our midst and in relations among us Communists," but for the post of general secretary "somebody more tolerant, more loyal, more polite and considerate of comrades, less capricious" was needed. Stalin's rudeness might lead to serious trouble when the party had to select a successor.

In fact, after Lenin's death no fatal rift developed. In the intrigue-ridden relationships among top Communists, Stalin's competitors could not measure up to his crafty competence and political alertness. Trotsky, the most prominent rival but of a haughty intolerant temperament, absented himself in the critical days after Lenin's death, pleading indisposition. Stalin, by contrast, stepped forward as Lenin's heir with a series of popular lectures entitled, *The Foundations of Leninism.* Other rivals lacked Stalin's remorseless willpower, his ideological flexibility, and his overriding ambition to build a strong Soviet state. In charge of the Communist Party organization, he always enjoyed majority support at crucial party meetings despite the fractional fights that arose along his path to supreme power.

III.

The major dispute arose over the future of the New Economic Policy. One faction, led by Nikolai Bukharin, argued that the Soviet Union had to rely on its own resources, its peasants, who constituted more than three-quarters of the population. Encouraged by Bukharin's slogan: "Enrich Yourselves," the most enterprising peasants, commonly called *kulaks* (fists), would somehow prepare the resources for industrial development. Yet could a socialist regime dedicated to quick progress allow capitalist peasants to dictate the course of the country's future?

The Bukharinites were opposed by a faction led by Grigori Zinoviev and Lev Kamenev (the "Man of Stone," originally Rozenfeld) and backed by Trotsky.

They gave priority to industrialization, arguing that the necessary resources should be gained at the expense of the peasantry. Temporary impoverishment of the population was inevitable for the future benefits of socialism. The hardships might be offset by help from the Western proletariat, since Trotsky and the industrializers had not surrendered their hope for international revolution. Yet could the party—and the people generally—afford to wait for the socialist superiority which Trotsky predicted might happen within only fifty or a hundred years?

The infighting over these issues within the top party ranks turned bitter, Russian-style. At one point, Zinoviev enlisted Lenin's widow, Krupskaya, to testify against Bukharin, whereupon Bukharin called on Lenin's sister to denounce Krupskaya for her incorrect interpretation of Leninism and her defiance of party directives. Everybody then remembered Stalin's crude joke that the party had to appoint a new widow for Lenin. All along Stalin, modest and statesmanlike, maneuvered his way among the rival factions, building up his own position which he buttressed, as usual, with quotations from Lenin.

At first Stalin sided with Bukharin against his bitter enemy Trotsky and his associates. By reformulating Bukharin's emphasis on the priority of domestic economic development, Stalin developed his own call for "socialism in one country." Under his guidance the Communist Party resolved in 1925 to transform the USSR into "an independent economic unit built in the socialist manner," without, however, exploiting the peasants. Trotsky, Zinoviev, and Kamenev were dropped from the party in 1927, with Trotsky—in Stalin's eyes the most treacherous enemy—exiled to Central Asia and in 1929 expelled from the country altogether. From abroad Trotsky attacked Stalin until he was assassinated, on Stalin's order, in 1940.

Thereafter, it was the turn of the Bukharinites to be ousted. The kulaks were rebellious; by withholding grain from the market, they limited the food supply and thereby sabotaged Stalin's promise to raise his country above the level of industrial production in the leading capitalist countries. By April 1929, after embittered controversy, he succeeded in ousting the Bukharinites from power. Now Stalin was the confirmed successor to Lenin. He was the socialist dictator in the largest country in the world, shaping in his own style an unprecedentedly novel political system. In December the party staged a lavish demonstration of popular support for him on the occasion of his fiftieth birthday.

Henceforth Soviet Eurasia was ruled by its homegrown human raw material. At the top, the rude upstart Stalin, the master of mass politics in a backward country, had to work with the anarchic multitudes below—people long brutalized by history and geography. And inevitably, his—and the Communists'—elevated perspectives about their country's weakness in the global power competi-

tion had no place in the minds of the common people. While committed to working with the masses for the common good, the Soviet leadership under Stalin had to reshape them, against the grain of their indigenous spontaneity, into enlightened citizens. The Stalinist mobilization for collective survival, therefore, was bound to be far more extreme than the Western mobilization in World War I. Stalin reinforced the Leninist heritage with his own totalitarian revolution, the revolution of reculturation, an experiment without precedent in human affairs. It implied no less than a war against the Russian past in the name of a glorious future.

IV.

Stalin, the Russian revolutionary patriot, was determined to lead his country out of the inferiority that had haunted it for centuries. His pursuit of that impossible goal has seemed to some observers an act of megalomania. But megalomania had become part of the times; World War I had globalized political ambitions around the world. Lenin, unwittingly inspiring the Fascist leaders, had formulated a grandiose vision that copied, consciously and unconsciously, the worldwide sway of Western imperialism, with special respect for American industrial efficiency. As a result, the United States, however venomously denigrated for its capitalist degeneracy, enjoyed an invisible presence in Soviet communism. As the gigantic pacesetter for Soviet ambition it thereby became an unwitting accomplice in the Soviet system. To cite a typical example: in honoring Lenin in 1924, Stalin boosted American efficiency, "that indomitable force which neither knows nor recognizes obstacles; which with its businesslike perseverance brushes aside all obstacles; which continues at a task once started until it is finished, even if it is a minor task; and without which serious constructive work is inconceivable." If only the Soviet people could be persuaded to work with equal dedication!

Stalin is often compared with Benito Mussolini and Adolf Hitler, two other totalitarian monsters of the same era. Yet by contrast with their aggressive expansionism, Stalin's megalomania was essentially defensive. He wanted to rescue the largest of all countries from ruinous foreign aggression, the collapse of civil war, and the psychological humiliation of inferiority. He also dealt with conditions far more backward than those prevailing in Italy or Germany, and that demanded far more extreme measures. Only when the Soviet Union was securely established could it serve as a universal model. Under Stalin, the Communist revolutionary outreach receded into the background (though it was still dreaded in the West).

Top priority had to be given to building up Soviet strength. In 1931 Stalin pounded out the guidelines of his statecraft in his most emphatic style and significantly in non-Marxist terms:

One feature of the history of old Russia was the continual beatings she suffered for falling behind, for her backwardness. She was beaten by the Mongol Khans. She was beaten by the Turkish beys. She was beaten by the Swedish feudal lords. She was beaten by the Polish and Lithuanian gentry. She was beaten by the French and British capitalists. She was beaten by the Japanese barons. All beat her—for backwardness, for cultural backwardness, for political backwardness, for industrial backwardness, for agricultural backwardness. She was beaten because to beat her was profitable and went unpunished. … Do you want our Socialist fatherland to be beaten and to lose its independence? If you don't want that, then you must abolish its backwardness and develop a really Bolshevik pace in the establishment of its Socialist economy. … We are fifty or a hundred years behind the advanced countries. We must make good this lag in ten years. Either we accomplish this or we will be crushed.

Ten years later came Hitler's attack on the Soviet Union.

Forever on guard, Stalin carefully monitored the major threats in world politics of the 1930s: the Japanese expansion into Manchuria and eventually into China, the rearmament of Germany under Hitler, Mussolini's conquest of Ethiopia, the Spanish Civil War, and the German annexation of Austria and the Sudetenland in 1938. These were ominous years, underscoring Woodrow Wilson's prediction of 1919 about the inevitability of another world war. With similar farsightedness Stalin dreaded his country's weakness in the case of imperialist aggression, without, however, surrendering his Bolshevik defiance of the capitalist enemies. In January 1933, for instance, he praised his close associate Molotov for a speech he had just given on foreign affairs: "The confident, contemptuous tone with respect to the 'great powers,' the belief in our own strength, the delicate but plain spitting in the pot of the swaggering 'great' powers—very good. Let them eat it." In the inner circles of the party Stalin could afford to show his true feelings.

But all along he was aware of the domestic insecurity of his dictatorship. Insecurity had been part of his life from the moment he joined the revolutionary underground. Who could be trusted? Who was a police spy? As a Russian proverb argues: "The more friends, the more enemies. Fear your friend as you fear your enemy." Wherever he looked, Stalin saw enemies. The distrust was heightened after he rose to political prominence and the issues at stake grew bigger. In their bitterly divided country ambitious Bolsheviks engaged in incessant ideological and personal infighting, Russian style. The tensions even reached into Stalin's marriage; in 1932 his wife committed suicide, in part because of her opposition to his policies.

In all countries the emotional strain on political leaders in time of crisis has always been great. In Stalin's case the psychic burden of leadership was superhu-

man. Yet he bore it remarkably well, convinced that he alone had a realistic perception of the dangers facing his country. Only in his last years did his rationality decline. In order to strengthen his leadership, he created, along Leninist lines, a ruthless apparatus of sophisticated indoctrination and rigid conformism.

His resolve echoed Wilson's wartime threat: "Woe to the man that seeks to stand in our way in this day of high resolution." But unlike the American president, Stalin had to reshape the civic identity of his recalcitrant subjects by trying to totally control, through the Communist Party and its allied wolf-tribe, their lives and thoughts from the cradle to the grave. Patriotic solidarity was to be achieved by a common faith in Marxism-Leninism as a secular religion; foreigners and their culture were a subversive influence. In pursuit of "socialist realism," artists were turned into "engineers of the human soul." The task of writers was to promote social consciousness through the writing of proletarian literature. Socialist realism dictated that the subject matter be idealized Soviet life, industrialization, collectivization, and the building of socialism. Soldiers, steelworkers, collective farmers, and commissars were to be the new heroes. The needs of the party and the state—not human life and love—were paramount.

Despite these strictures, in the early Stalin years Mikhail Sholokhov produced a masterpiece, *The Quiet Don*. This Cossack family chronicle, set in the Don steppes during the war and the first years of the Soviet state, is an outstanding historical epic. Sholokhov broke some of the rules—not all the Reds are heroes and not all the Whites are villains. In addition he included a generous amount of human life and love. The book made him the most popular writer in the Soviet Union.

Yet what counted more than human sensibility was the survival of the country and the victory of socialism, which called for no less than the creation of a "new man" more skilled and civilized than the Western capitalists. No failures were to be admitted; no doubts voiced. Victories were needed in order to foster dedication, raise confidence, and above all preserve the vital upward thrust toward socialist superiority.

Ideological indoctrination, psychological manipulation, enforced discipline, and outright terror reaching as deep into the human subconscious as possible—all within a complex institutional framework—became key features of the Stalinist system. And in the face of the inevitable disorientation caused by the imposition of an alien way of life, ever more sophisticated compulsions had to be invented. Whatever the Western abhorrence, Soviet totalitarianism was a remarkable creative accomplishment. The conditions of statecraft in Eurasia were utterly different from those in the privileged secure West which inspired Stalin's precipitous effort to lead his country out of backwardness.

Pity the few artists and intellectuals surviving from pre-Soviet days and preserving their refined sensibilities in the face of the monstrous changes! They were the most tragic victims.

V.

Whatever the human cost, Stalin pressed ahead with the transformation of his huge country's human multitudes (numbering 147 million in 1926 and increasing to 170 million in 1939) into a modern urban industrial society. What had been achieved in the West over a long time, had to be accomplished in the Soviet Union hurriedly and beyond popular comprehension in a deliberately planned manner. The Soviet system was proudly socialist; socialism was the preliminary stage on the way to communism. Private enterprise, permitted under the NEP, was outlawed. The state, representing the working masses and aiming at social justice, was henceforth in full charge of economic development. Yet Marxist theory notwithstanding, building socialism in practice amounted to painful experimentation with totally unknown social, economic, and political realities. Soviet totalitarianism set off a near-chaotic process of drastic change, with many unforeseen consequences. What counted under these conditions was Stalin's adamant will and determination, operating through the network of the Communist Party and its agencies, all disjointed by intrigue and abuse of power.

In 1928 Stalin decreed the First Five-Year Plan, spelling out in 1929 his exorbitant goals: "We are advancing full steam ahead, along the path of industrialization—to socialism, leaving behind the age-old 'Russian backwardness.' We are becoming a country of metal, an automobilized country, a tractorized country. And when we have put the USSR on an automobile, and the *muzhik* [peasant] on a tractor, let the esteemed capitalists, who boast of their civilization, try to overtake us." Expectations ballooned sky-high, arousing among young Communists a deep idealistic commitment. Stalin, after all, was a master of psychopolitics as a tool of drastic change. But overtaking the West demanded not only unexpected human sacrifice, but also, considering the urgency of industrialization and the preoccupation with technology, utter disregard for the natural environment. Neither he nor his advisers were prepared for the immense obstacles.

Planned industrialization demanded the tight coordination of virtually all economic activities. This posed a profound challenge considering the size of the country, the inadequacy of communications, the scarcity of supplies, the lack of a trained workforce, and the absence of administrative experience at the very top and everywhere below. Vital resources, such as imported machinery, were wasted. Worker turnover was high and productivity low. Bureaucratic rigidity impeded badly needed flexibility, while political controversies simmered at all administrative

levels. Passivity or even resistance to the enforced change of life was natural.

Inevitably under these conditions, discipline had to be tightened—in the party, at the place of work, and in society generally. In addition, labor output had to be raised by pay differentials or public honors for the heroes of work. Soviet society, hitherto boasting of its egalitarianism, became more hierarchical; it thereby also became more contentious. By 1932–1933 disorganization prevailed. The propaganda targets of the Five-Year Plan were not met. The standard of living declined. Contrary to all promises, industrialization proceeded at the expense of popular welfare. The agonies were further aggravated by the disasters of forced collectivization.

Alarmed in late 1929 by the inadequate peasant performance, Stalin, who rarely visited the countryside and thought that peasants were scum, suddenly commanded enforced collectivization. Separate peasant lots were to be joined into large-scale farms collectively managed by the peasants. Assisted by motor tractor stations, the collective farms were to make prescribed deliveries of their crops to the government. In this manner, agriculture was to become part of the planned economy, while the peasants (who were allowed to keep tiny plots of their own) were transformed into socialized citizens.

The official victims of the collectivization drive were the kulaks, the most resourceful peasants widely hated for their capitalist selfishness. They were to be "liquidated as a class." Uprooted from their customary life they were exiled to Siberia. The human misery defied description. Those who resisted or rose in revolt were slaughtered without mercy. The horror of collectivization broke the spirit of some hardened officials. One police colonel on a train tearfully confessed to a fellow passenger, "I am an old Bolshevik. I worked in the underground against the tsar and then I fought in the civil war. Did I do all that in order that I should now surround villages with machine guns and order my men to fire indiscriminately into crowds of peasants? Oh, no, no!"

Following collectivization, agricultural output plummeted. By 1932–1933 famine stalked the Ukraine and Volga regions, killing several million people and spreading misery over the countryside for years to come. The victims of the collectivization drive numbered around 14.5 million. Meanwhile, the urban population had less food to eat and paid more for it.

Thus under Stalin's First Five-Year Plan and forced collectivization, the Soviet Union passed through catastrophic times. The standard of living fell below the level of the mid–1920s, as familiar ways of life perished. Luckily for Stalin, the envied West was trapped during the same years in the Great Depression, a point duly stressed by Soviet propaganda and attracting some foreign idealists to the Communist cause.

By 1933 a more rational Second Five-Year Plan was drafted. Stressing consolidation, it proved the Stalinist system's capacity—and the people's readiness—for learning from experience. From 1934 to 1936 economic conditions improved and the collective farms slowly began to take shape. The Soviet Union was launched as an industrial state. Yet, in Stalin's apprehensive mind, the economic progress did not produce the political stability needed for survival in the mounting global competition.

VI.

In 1934 Stalin had reason to be alarmed. At the Seventeenth Party Congress in the spring, a quarter of the delegates, looking back over the miseries of the previous years, expressed their dissatisfaction with his policies. His popularity sagged, while attention shifted to Sergei Kirov, the popular head of the Leningrad party organization who was temperamentally more in tune with Lenin's preference for an effective party leader. But on December 1 Kirov was assassinated. Despite intense research, no documentary proof has been found of Stalin's involvement. His responsibility, however, is commonly assumed. Could he ever surrender his mission or his ruthlessness in pursuing it?

Instinctively apprehensive about political disunity in his violence-prone society, Stalin now began to use terror as an instrument of building personal power and strengthening public commitment to his aims. Kirov's murder intensified his drive for monolithic political unity, hitting Leningrad with special fury. Under the banner of patriotic Marxism-Leninism, he intensified fear of foreign subversion, internal treason, and another war—fears generally accepted by the population. Careless talk, inefficiency at work, or even hints by a nasty neighbor might lead to arrest, forced labor, torture, and execution. The poet, Osip Mandelstam, read his poem "Stalin Epigram" to a small circle of friends:

> *All we hear is the Kremlin mountaineer,*
> *The murderer and peasant slayer.*
> *His fingers are fat as grubs*
> *And the words, final as lead weights, fall from his lips.*

One of the friends betrayed him and he was exiled. Rearrested during the purges in 1938, he died in a transit camp.

No one was safe from denunciation, especially when the terror reached its climax in 1937 and 1938. By Stalin's insight, only terror penetrating into the depths of individual motivation could sustain the leadership needed to transform, in the shortest time possible, a slow-paced and quarrelsome backward people into a fast-

moving urban-industrial society which would guarantee the country's survival. By personal experience and rational calculation what counted in Stalin's mind was not individual human lives but the survival, under firm leadership, of the country as a protection for the masses of its inhabitants in the grim competition for global power.

Fear-inspiring purges, which politicized the traditional brutalities of life in Eurasia, had been part of Communist rule from the start. The purges were publicized in well-staged court trials, such as those conducted against treacherous foreign experts in 1928 and Menshevik saboteurs during the First Five-Year Plan. After Kirov's murder, the Bolshevik old guard, known for its earlier opposition to Stalin, came under attack. In 1935 Zinoviev and Kamenev were arrested and jailed. Under greater publicity, the next year they were retried for organizing, with a number of fellow conspirators, a terrorist Trotskyite center. They confessed to that imaginary crime and were executed.

By 1936 the terror, as a merciless method of preventing popular unrest and enforcing collective discipline, reached its climax. That year, bad weather had reduced the harvest. Productivity slowed down or even declined, causing widespread rumors of conspiracy, subversion, and treachery. A penchant for suspicion was widespread in Soviet society, haphazardly increasing the number of victims, most of them innocent of any crime against the state. Under these conditions N. I. Yezhov, the meanest figure among Stalin's wolf-tribe, rose as the chief prosecutor. With Stalin's approval Yezhov's sadistic wolfishness was readily absorbed into the cruelties common in popular culture, from the party center down to the lowliest guards at the Gulags and, under little Yezhovs (or Stalins), out into society generally.

In 1937 the terror struck the military high command, when Marshal M. N. Tukhachevsky, the most capable officer in the Red Army, was accused of treason (on fabricated evidence). He and 35,000 high-ranking officers were shot, with disastrous consequences for the coming war. Finally, in March 1938 Yezhov staged the most dramatic trial of all, prosecuting the "Anti-Soviet Bloc of Rights and Trotskyites," with Bukharin as the leading criminal. For some time Bukharin courageously refused to acknowledge his guilt, until persuaded by threats to his family to confess. All members of that faked conspiracy were executed, including G. G. Yagoda, Yezhov's predecessor. Their families and relatives, if they survived, were exiled, because treason was a collective responsibility. Not long after, Yezhov himself shared Yagoda's fate. Charged in 1939 with plotting Stalin's assassination, Yezhov was executed in 1940. Under his successor, Lavrenti Beria, the terror, which had threatened to get out of control, was scaled back.

The results of the terror, by a preliminary rough estimate, were horrifying. By 1938 eight million people had been put into labor camps, where two million of them

died. In 1937–1938 alone seven million were arrested, one million of them destined for execution. After the Soviet archives were opened, these estimates were reduced somewhat. Anyway, what did human lives count when the survival of their country was at stake? Though carefully concealed, the terror exacted a high price: the army high command was liquidated and economic productivity suffered.

Typically for Stalinism the terror proceeded under the umbrella of a new Soviet constitution put into effect in late 1936, "the only thoroughly democratic constitution in the world." It declared that socialism had been achieved. The Soviet Union, a federal state composed of eleven union republics and united by the Communist Party, recognized no class distinctions. It granted universal suffrage and secret elections. Guided by fundamental rights and duties, its citizens were guaranteed freedom of conscience, free speech, privacy of correspondence, and personal inviolability. In part the new constitution was designed for reasons of foreign policy, since Stalin wanted to ally his country with the Western democracies against the Fascist threat. At home the guarantees of freedom, while provoking subversive cynicism, would help to inspire the young idealists on whom Stalin put so much hope.

Within this framework the carefully cultivated image of Stalin as the all-knowing and all-caring leader took hold. A master of psychological manipulation among disoriented masses, Stalin, like other totalitarian leaders, cleverly built up his role as a human source of security and assurance. His was an image of a positive force for social cohesion amidst the agonies of uncomprehended change.

In March 1939, at the Eighteenth Party Congress, Stalin (then in his sixtieth year) assessed the achievements of his country during the past five years in the context of the current danger. With Japan and Nazi Germany bent on conquest, the second imperialist war was already under way. The Soviet Union was "working very seriously to increase the preparedness" of its army and navy. As Stalin always reminded his people: "We are surrounded by a capitalist world" promoting "espionage, assassination, and wrecking in our country." But there was cause for confidence. The moral and political unity of Soviet society had been strengthened under its new democratic constitution. Even more important: "We have outstripped the principal capitalist countries as regards technique of production and rate of industrial development. That is very good, but," Stalin warned, "it is not enough. We must outstrip them economically as well," which, however, would still take a long time. In any case, Soviet agriculture was now "the most mechanized in the world."

As for the purges, Stalin admitted that grave mistakes had been made, more than expected. But the purges had cleared the party of dross, especially of the old-timers who had their eyes on the past. Stalin favored the young, who looked to the

future. Even the young, however, needed persistent training in "the Marxist-Leninist science of society," which called for a strong state, especially under present international conditions. He praised the socialist intelligentsia, a new social category added in the 1930s to workers and peasants. But he also admonished intellectuals to rise above immersion in their specialty. A Leninist must be "keenly interested in the destinies of his country." What counted was the global overview.

Stalin concluded his speech, sermonlike, with his familiar pleas: improve the composition of the party, have fewer meetings and do more practical work, and raise the theoretical level and the political schooling of our cadre. After hearing him exclaim: "Long live the Communist Party of the Soviet Union!" the delegates rose, shouting: "Hurrah for our beloved Stalin!"

VII.

At this point it is no longer possible to ignore the moral protest over the inhumanities committed by Stalin and Stalinism in these years. The brutalities of Stalinist totalitarianism and the miseries they entailed have shaped the image of Stalin as a paranoid monster. We read with compassion Solzhenitsyn's three-volume *Gulag Archipelago* (written thirty years later), tracing the degradation of the prisoners or of the run of peoples destroyed by the Stalinist system, and we cannot help but feel outraged. Russians, too, and foremost those who, like Solzhenitsyn, shared the humaneness of the Christian tradition, were anguished by the suffering of kulaks or the victims of the terror—men, women, and children. Everywhere individuals were crushed, some of them displaying heroic moral integrity to the bitter end. From the accounts of the survivors, we catch sight of the human cost of Stalinism as perceived by sensitive observers from their ground-floor perspectives.

Once, however, Solzhenitsyn rose to a higher insight. He probed into the source of the inhumanities committed by the managers of the Gulags, or by the Stalinists generally, and asked: "Where did this wolf-tribe appear from among our people? Does it really stem from our roots? Our own blood?" And he devastatingly answered: "It is our own." This, however, was an admission too humiliating to Russian pride and therefore left unexplored by Solzhenitsyn and other critics of the Soviet system. But it was true. The methods of government employed by Lenin and Stalin for rebuilding their country were the product of the Eurasian wolf-tribe. The Gulags, the secret police, and the system as a whole were run by people long conditioned to brutality. Now they were persuaded that their brutality was needed for the good of the country.

Thus we touch the central nerve in all considerations of Stalin and Stalinism. How valid in Eurasia are any judgments based on the Western experience of a

solid civil society, secure statehood, and pride in cultural superiority? Approaching Russian Eurasia we come up against a profound cognitive barrier. Lacking experiential insight, we have to make a mental effort to reach across, trying to see the other side from within—a disturbing challenge undermining the righteousness of our most cherished convictions. But we cannot escape the challenge of history and geography. In assessing Stalinism we confront the tragedy of a traditionally insecure country driven, at a time of heightened external danger, to overcome its weakness by trying, through whatever means, to imitate the pacesetting Western model. In Eurasia the political mobilization set off by the global storm of World War I took the most monstrous form.

VIII.

Behind his overwhelming public image Stalin led a surprisingly unpretentious life. In his personal tastes, he was remarkably uncorrupted by power. What counted was control over the vast machinery of government, which stretched his energies to the limit. Reasonably sociable among loyal supporters, he still maintained the midnight gatherings at his dacha, never indulging in any personal extravagance, except perhaps in his unusual work schedule. Like Dostoyevsky he worked through most of the night, sleeping late into the following morning. According to his daughter, he felt uncomfortable when showered with public adulation. Yet aware of his own fallibility, he craved private reassurance, which made him increasingly rely on Beria's reckless counsel.

But as he had indicated in his speech at the Party Congress in 1939, there was cause for satisfaction. The Second Five-Year Plan had scored impressive achievements, recording reassuring economic growth rates. Admittedly, in the later 1930s productivity had slowed down, in part because of the terror, but in regard to the basic tools of industrialization and the manufacture of weapons the Soviet Union had achieved self-sufficiency. In addition, vital industries had been established in the Urals, safe from hostile attack. Transportation had been improved, technical education advanced, and labor discipline strengthened. With the help of a more efficient working class, the standard of living had been slightly raised. Stalin enjoyed a surprising measure of public approval.

And despite the havoc of the terror, life offered many patriotic satisfactions. Impressive factories were built; Soviet explorers reached the North Pole; tractors plowed the fields in collective farms; men and women excelled in sports. There was evidence of impressive human effort everywhere, publicized as propaganda and yet part of Soviet reality. For most people life continued in satisfactory ways. Public support of the Soviet system ran high. In addition, a measure of intellectual

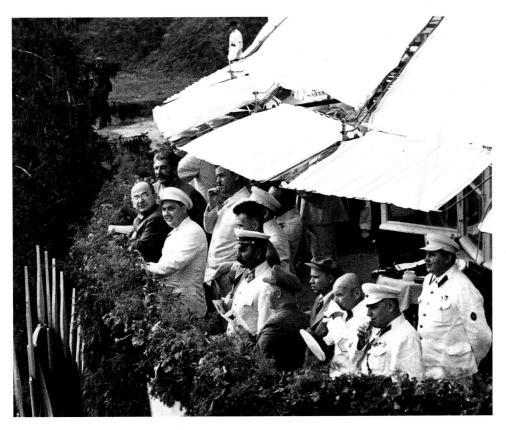

Stalin at Tushino, 1940—*In Baltermants's first professional photo, Stalin and his inner circle are seen enjoying an air show at the Tushino airfield. Lavrenti Beria (1899–1953) is at Stalin's left, in the pince-nez glasses. As head of internal security and Minister of the Interior, Beria, after 1938, curtailed the Stalinist purges of the 1930s. After directing the Soviet atomic effort in the postwar years, Beria himself was executed in 1953. Georgi Malenkov (1902–1988) standing next to Beria, was a close associate of Stalin and served as the Deputy Premier of the Soviet Union, the top member of the Secretariat after Stalin. Upon Stalin's death in 1953, Malenkov was appointed as Soviet Premier and head of the Secretariat. By 1955, due to his ineffectiveness, he was replaced in both posts by Nikita Khrushchev (fourth from right, looking forward); in 1957, after taking part in the attempt to oust Khrushchev, Malenkov was expelled from the party and spent the rest of his life as manager of a hydroelectric plant in Kazakhstan.*

and artistic freedom had continued. When the time came, physicists were ready to build an atomic bomb. Writers such as Pasternak survived and Dmitri Shostakovich composed his symphonies, while the young Baltermants advanced in his study of mathematics (a safe subject), before turning to the art of photography. Baltermants was fortunate to serve his country in a pursuit that allowed him some independent creativity.

The Soviet Union was still far from overtaking the developed countries, but at least Stalin had permitted some continuity of Russian cultural life and, in addition, rallied public support for continuing sacrifice. He had successfully compelled the utterly confused anarchic peoples of the Soviet Union to pass through a brutal process of reculturation sustained by the exalted vision of communism. Let us never forget that behind the daily agonies of Soviet socialism there glowed the promise of a superior society instilling pride in the Soviet Union's superiority. That Communist creed, with Lenin and Stalin as its prophets, had many sincere followers. It contributed to the country's survival in the war Stalin had long foreseen.

Thus the stage was set for the ultimate testing of Stalin's totalitarian mobilization in World War II, as well as for the inconspicuous Dmitri Baltermants's rise to prominence as a Soviet photographer.

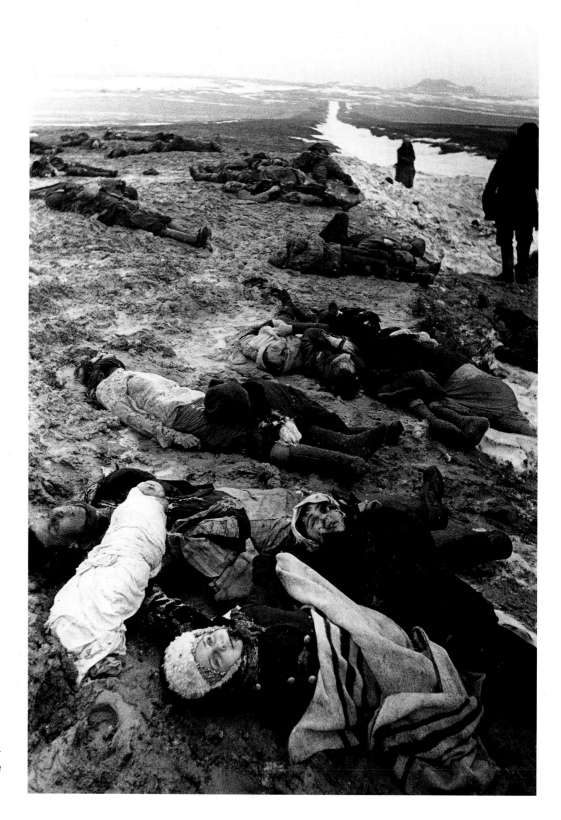

Grief, January 1942—
One of the series of photo-
graphs taken on the Kerch
Peninsula.

The Great Patriotic War, 1941–1945

The war was fought over the very existence of the Soviet state. Hitler, in the post–World War I megalomania outlined in *Mein Kampf,* had envisioned German eastward expansion as the only way to acquire the territory needed for transforming Germany into a world power: "Only an adequately large space on this earth assures a nation of freedom of existence. … Only Russia and her vassal border states" offers the necessary soil for the German people.

In March 1941, at the height of German victories in Europe, Hitler affirmed his original design when he informed his military commanders about the nature of the forthcoming war against the Soviet Union. It was to be a life-and-death struggle between two races and ideologies: Germans versus Slav, national socialism versus Jewish bolshevism. In this contest German soldiers were not bound by the laws of war or any trace of chivalry. Communist Russia was to be wiped out in a fight to the finish, opening the Russian space for eventual German global domination. In the light of Hitler's ferocious ambitions, Stalin certainly had not exaggerated in 1931 the necessity of updating his country's resources within ten years.

On June 22, 1941, Hitler's armies, backed by an Italian declaration of war, invaded the Soviet Union, joined by troops from Finland, Hungary, and Romania fighting for their own aims. Now the inhumanities of a war without mercy exceeded the brutality of the Stalinist revolution. Thanks to Stalin, the Soviet peoples were able to sustain the unprecedented sacrifice that led, after remorseless fighting, to victory. By the end of the war the Soviet armies had advanced deep into Germany; no Russian state had ever penetrated that far westward. The supply of war materials from the United States and England, as well as the Allies' attack on Germany from the west, provided essential support, but the Soviet peoples

bore the brunt of the fighting throughout. In Baltermants's photographs we can witness their agonies, endurance, and patriotic resolve in those terrible years.

I.

Stalin had certainly tried to postpone the inevitable war, since the Soviet Union needed time to build up its strength. Considering the tensions in Soviet-Western relations after World War I, his diplomatic efforts for that purpose called for constant maneuvering in the ever-shifting international scene. Practical considerations had long promoted some measure of cooperation between the ideological enemies. Already in 1922 Germany and Soviet Russia had established contacts for their common political and economic benefit. These continued during the Great Depression, when the Soviets needed industrial assistance during the First Five-Year Plan and the Germans wanted foreign markets. Keeping on good terms with the Germans was the reason Stalin, listing in his 1931 speech the beatings Russia had suffered, had omitted the most recent and well-remembered German aggression. The need for industrial expertise mandated friendly relations with any Western country.

Maintaining peace became even more important in response to Japanese aggression in the Far East and the rise of Nazi Germany associated, after 1936, with Mussolini's Italy. For that reason, the Soviet Union joined the League of Nations in 1934, concluded in 1935 an alliance with France, and instructed the Communist International to support, contrary to its ideology, the capitalist countries. In a further bid for Western goodwill the Soviet Union in 1936 adopted "the most democratic" constitution in the world, while also supplying the republicans in the Spanish Civil War with weapons and advisers. Yet could the Western statesmen really trust the Communists?

Stalin in turn, at the height of Soviet terror in 1938, had reason to be suspicious of the English and French, when they peacefully agreed to Hitler's annexation of Austria and the dismemberment of Czechoslovakia. Cooperation with Hitler implied Western hostility toward the Soviet Union. Not surprisingly, therefore, Stalin explored cooperation with Hitler, at the expense of Poland, a country created after World War I from German and Russian territories. The Nazi-Soviet pact of late August 1939, so shocking to both the Western public and Communist sympathizers, again divided Poland, allowing the Soviet Union to reclaim lands that had formerly belonged to the Russian Empire. Hitler's invasion of Poland on September 1 led to war with France and England, a boon from Stalin's point of view: let the capitalists destroy themselves.

The year 1940, however, turned the tide in Hitler's favor. A minor border war with Finland in the winter had revealed the weakness of the Red Army,

while Hitler scored impressive victories in western Europe and from the Balkans down to Greece. In the fall he secretly prepared the invasion of the Soviet Union for the following year, while Stalin still supplied him with essential raw materials in return for German industrial equipment. In the spring of 1941 the British, subsequently supported by other sources, warned Stalin of the forthcoming attack. It was just the kind of misinformation, Stalin suspected, that the British would plant to turn him against Hitler in order to prevent Soviet support for a German invasion of England.

Meanwhile Stalin positioned his armed power on the western border, to take advantage of German weakness in the event of a war with England (and possibly the United States). Ever ready to shift sides, he expected to gain time for preparing his country more fully against the inevitable German onslaught. He had already stepped up industrial productivity and lengthened work hours, while also beginning to reorganize the Red Army. But how could he catch hold of Hitler's intentions? Having discounted all warnings, Stalin and his country were utterly unprepared for the well-planned German attack.

II.

When the news of the invasion came on June 22, 1941, on a relaxed Sunday morning, Stalin was caught completely by surprise. The German invasion virtually destroyed the Soviet air force and wiped out large units of the Red Army in the first critical days. When the scale of the disaster became apparent, Stalin was disabled, according to widespread opinion, by psychological shock. Sufficiently recovered by July 1, he presided over a new State Defense Committee, at last organizing the Soviet response to the rapid German advance.

On July 3, twelve days after the outbreak of war and chastened by his disastrous lack of foresight, Stalin addressed his people. Speaking slowly with a strong Georgian accent, he humbly appealed to their goodwill: "Brothers and sisters! ... I am addressing you, my friends ... "—what a change from his previous dictatorial aloofness! In a dull, low voice he now prepared all the diverse peoples of the Soviet Union, carefully listed by their nationalities, for a merciless patriotic war against fascist enslavement. Areas likely to be overrun by the Germans were to be scorched, and partisans were to fight the Germans in occupied areas. And resuming his pro-Western policies of the mid–thirties, he welcomed British and American aid. His people would have powerful allies in a united front "for democratic liberties." Yet at the same time he also promised at home a "ruthless fight against all disorganizers of the rear, deserters, panic-mongers, rumormongers, ... spies, diversionists, and enemy parachutists." He had good reasons: desertion apparently was widespread. As he admitted on July 16: "On all fronts there are numer-

Protecting the Harvest, 1941—
A fine example of the socialist
realist style that dominated Soviet
art, this photo exhibits not only an
idealistic image of the military, but
emphasizes the importance of grain
production to the Soviet people.

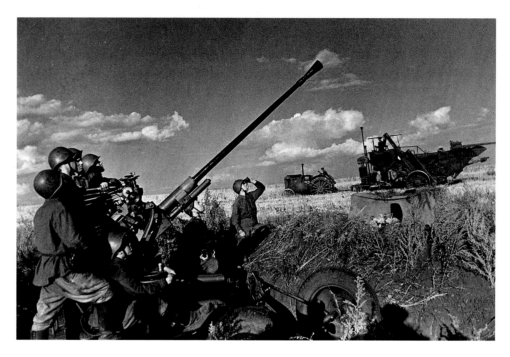

ous elements who even run to meet the enemy and throw down their arms at the first contact with him."

Not surprisingly, he soon resumed his familiar style, enforcing discipline and obedience by terror. Subversive characters in prison and labor camps were shot. And the general in command of Stalin's misconceived military buildup on the western border, who had not been able to prevent the German breakthrough, was condemned as a traitor and executed (a fate in store for many other military men as the war progressed). Stalin never trusted his people; failure implied disloyalty. The crises of the war increased his disregard for human lives. In October 1941, for instance, he ordered the destruction, in the rear of the German armies, of Russian villages and towns without concern for the fate of their inhabitants. The dangers to the country called for further Stalinist regimentation and human sacrifice among uneasy people still ignorant of the miseries ahead.

On that fateful Sunday, June 22, the one day of leisure in the week, the people in the streets of Moscow had listened unbelievingly to the news. The hardworking masses in the whole country were psychologically unprepared for war, innocent victims of the megalomaniac contest between two dictators, one aiming at world domination, the other defending the largest state in the world. Pity the Soviet peoples, soon to be trapped amidst burning cities, ruined villages, and devastated fields, all littered with the corpses of men, women, and children. Pity especially the Jewish people to be exterminated en masse, except for a few who saved their lives by timely flight. While the big war raged in the western parts of

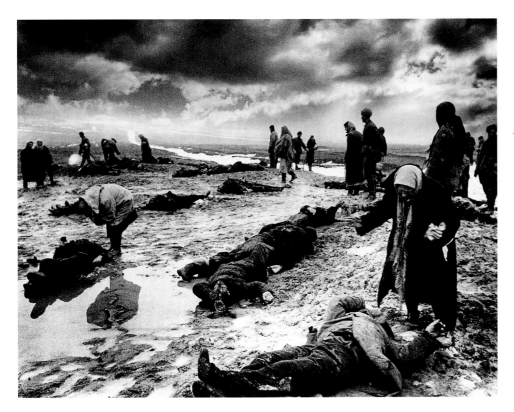

Grief (The Dead Won't Let Us Forget), January 1942— *While the Germans advanced deep into the Soviet Union, the horrors of war increased. Here, a woman grieves over a loved one, lost in the Kerch Peninsula. By superimposing the dark, heavy clouds at the top of the photo, Baltermants enhanced the somberness of the image. This photograph remained unpublished until 1965, when it appeared in* Ogonyok *magazine.*

the Soviet Union (as elsewhere in the world), the unknown little people on the ground floor of life were tested to the utmost in the face of death, mutilation, starvation, and uprootedness. The men served in the army and the women worked on collective farms, in factories, or in hospitals, while the children were left to fend for themselves. We catch glimpses of the misery in Baltermants's photographs. Designed to inspire fortitude and patriotic loyalty, they sometimes also revealed the human depths of grief amidst the unspeakable horrors of war.

III.

After June 22, the German troops, divided into three army groups, stormed into the Soviet Union with remarkable speed over long distances, spurred by Hitler's prediction: "You have only to kick in the door, and the whole rotten structure will come crashing down." Obviously he had nothing but contempt for Stalin's Soviet system; the progress of his armies seemed to justify his expectations. Within a month the Central Army Group had reached the city of Smolensk, more than halfway toward Moscow. On September 4 the Northern Army Group began bombarding Leningrad. Two weeks later the Southern Army Group conquered Kiev, the Ukrainian capital, capturing some 600,000 Soviet soldiers (of whom only three percent survived German captivity). Stalin had ordered the defense of the city at all

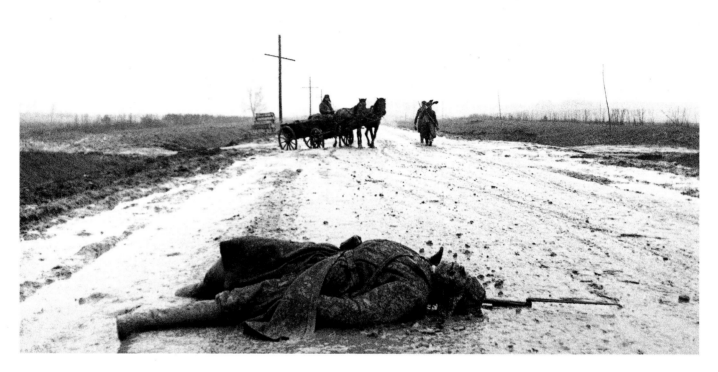

On the Road to War,
Smolensk Front, 1941—
*While the Germans had many
casualties, the Soviets suffered even
greater losses. Like many photos
taken during the war, this one was
censored, as the Soviet government
did not want the public to
see the great extent of destruction
and death.*

costs, thereby preventing timely evacuation of troops urgently needed elsewhere.

In early October, less than four months into the war, the Central Army Group started its offensive against Moscow, the seat of Stalin's government, confident of capturing it before the onset of winter. By mid-October the Southern Army Group had reached the Black Sea port of Odessa. By the end of the month, it had moved into the Crimea, ready to jump from the Kerch Peninsula toward the Caucasus Mountains. On the Kerch Peninsula they massacred some seven thousand people, their bodies found strewn on the barren ground when Soviet troops, with Baltermants as their photographer, temporarily recaptured the area.

In less than five months Hitler's troops had not only kicked in the door of the Soviet Union, but also demolished its densely populated western sections up to the very centers of the Soviet state. They had not only occupied key agricultural

areas, reducing the food supply for the Soviet war effort, but also dangerously diminished Soviet military power. According to German estimates, the Red Army lost about two and a half million men, plus vast quantities of weaponry. In addition, Soviet coal production was down by one-third, while steel production was down by three-quarters. By the end of 1941 Soviet industrial productivity had reached its lowest point. During the winter vital industries were moved, under the command of Nikita Khrushchev, eastward out of German reach, in conditions of extreme hardship. Production did not recover until late 1942.

While the Soviet state did not cave in under the adversities of defeat, the human misery in the battle zones was appalling. Men were torn from their tearful families, never to return. Women and children fled from the invaders, with mothers carrying their babies in their arms desperate to survive, all amidst ruined villages darkened by the smoke of burning cottages.

In late September an English correspondent stationed in Moscow visited the battlefields in the vicinity of Smolensk. Under a black sky he saw villages razed to the ground, not a fragment of a house left standing among a few shattered trees. At one spot he found a tin samovar abandoned on the ground, the only remnant of a human settlement. Among unharvested oat fields trampled down by soldiers in hand-to-hand fighting, trenches dug by German and Soviet soldiers joined with craters left from exploded bombs. In what seemed like a lunar landscape an old woman tottered around, barefoot, dressed in a few rags, and carrying a rusty pail and a tattered sheepskin. Demented by the destruction everywhere, she muttered only one word: *chërty*—devils.

As Stalin had indicated, disloyalty was not uncommon. As approvingly detailed in Solzhenitsyn's *Gulag Archipelago,* collective farmers in the Ukraine welcomed the German army. So did a thousand young people in Leningrad, who went to the woods waiting for the Germans. In August a whole regiment of the Red Army, led by a dissident major, deserted, joined by many Russian prisoners of war, all hoping to create a liberation army for overthrowing Stalin. They found themselves shockingly disillusioned, reduced to slave labor by the German conquerors. At the same time, loyal soldiers fought as partisans behind the German lines, supported by the remaining local population putting their lives at risk. As the war progressed, violence spread in the embattled countryside.

The German troops themselves were under stress. Long distances hampered communications and diminished vital supplies. Incessant mobility and insufficient rest exhausted the soldiers, who in addition were brutalized by the bloody sacrifice of life all around. To the Germans' surprise, as the war progressed the Russians fought to the death. Under these conditions the helpless local civilians, members of an avowedly inferior race, were robbed of food, clothing, and equipment.

Prisoners of war were quickly shot for efficiency's sake. Brutalization increased as the winter approached, encouraged by Hitler himself. As he commented on October 17 at his headquarters: "We're absolutely without obligation as far as these people are concerned. …There's only one duty: to Germanize this country by the immigration of Germans, and to look upon the natives as Redskins." Inevitably, the Redskins, seeing no alternative, tightened their resolve to defend themselves; their morale hardened. The war thus assumed an extraordinary pitch of ruthlessness, intensified on the German side by cultural contempt.

Most Germans had always considered the Russians, let alone the peoples of Eurasia, as backward or even subhuman *Untermenschen*, an attitude confirmed by the impressions of German soldiers as they moved eastward. Their sense of superiority was confirmed by Nazi racist indoctrination, which was intensified as morale began to sag—the Redskins need not survive. And as for the Jews and gypsies, the *Einsatzkommandos*, the special units trained for genocide, were ready for action. Admittedly, the Russians themselves were not entirely innocent of large-scale murder. After occupying eastern Poland in 1939–1940, they had shot about fifteen thousand Polish officers, the elite of the Polish army, held at Katyn near Smolensk (as the Germans discovered in 1943). But these numbers paled in comparison with the German atrocities.

In any case, arrogant cultural incomprehension prevented the Germans from taking advantage of the anti-Stalinist discontent simmering in the Soviet Union. If the Germans had treated the conquered peoples respectfully, they might have gained a major advantage and possibly even won the war. But the cultural prejudice separating Germans and Russians was too deeply rooted, especially in Hitler's mind. It made the war increasingly more Eurasian and barbaric: *chërty, chërty, chërty.*

Fortunately, on the Russian side the bloodshed narrowed the gap between high strategy and lowly individual survival. The peoples of the Soviet Union recognized that their own lives were linked to the survival of their homeland. The war truly became a patriotic war, while in the wartime mythology Lenin joined the venerated heroes of the Russian past. And with Stalin's permission, people now flocked to the Orthodox Church for spiritual support. Although by the end of September Soviet losses were huge, the "rotten structure" that Hitler had expected to collapse, was still standing. It was put to the most harrowing test in the winter of 1941–1942.

IV.

The people most cruelly—and heroically—tested were the three million inhabitants of Leningrad. Their city was the most westernized urban community in the Soviet Union (and therefore always under suspicion by Eurasian Muscovites such as Stalin). It displayed the tsarist heritage at its most magnificent in its palaces,

cathedrals, and museums full of artistic treasure. The summer residence of the Empress Catherine the Great located in Pushkin just outside Leningrad was a special treasure, featuring a room covered entirely with golden amber. Leningrad also was the home of many prominent intellectuals and artists, who maintained, even under Stalinism, a measure of independent creativity. In addition, it was an industrial center, producing one-tenth of the Soviet Union's industrial output, highly important for the war effort. And now the German armies were approaching, while the Leningraders were unprepared for the ordeals to come.

The Leningrad party boss, Andrei Zhdanov, a close associate of Stalin, had advised cooperation with Hitler. Zhdanov was on a holiday at the Black Sea when the Germans started the war. Rushing home five days after the first German air raid, he worked day and night to mobilize the city's population. He set up a People's Volunteer Corps, enlisting 160,000 people, including 32,000 women, to prepare the city's defense. All citizens were drafted for obligatory labor, such as digging antitank trenches, sewing camouflage nets to cover the city's command center and theaters, and camouflaging the tower of the Admiralty Building, one of the city's landmarks. More ominously, food rationing was introduced in July (panic buying of food had begun on June 22).

At the same time, measures were taken to protect the city's most valuable artistic resources. The treasures of the Hermitage Museum, crucial industries, famous artists, and multitudes of frightened civilians were evacuated, until in August transport to the outside was cut.

When, throughout August, the enemy moved closer, the approaches to the city were mined and street barriers set up, including huge concrete blocks to stop the tanks. Major buildings were prepared to be blown up if the Germans captured the city. Neighborhood defense groups were formed, again including many women. Posters appeared everywhere—"The enemy is at the gate"—recruiting more volunteers, especially among the Young Communists. All were put to work under the Council of Defense of Leningrad formed on August 20.

Eight days later, on August 28, the city was under attack by the Germans in the south and the Finns in the north; the siege had begun. On September 8, the city suffered the first intense air raid. The next day the Germans reached the southwestern tip of Lake Ladoga, the large body of water to the east of the city, cutting off railway contact with the rest of the country. Fortunately at this point Stalin dispatched to Leningrad a capable commander, Marshal Georgi Zhukov, to take charge of its defense. Zhukov faced a terrifying challenge, considering the lack of resources—or even of political support from Moscow. People suspected that Stalin was ready to surrender Leningrad in order to concentrate all military strength on saving Moscow.

In the face of utter crisis, Zhukov acted with the ruthlessness of desperation, threatening all soldiers: "Either advance or be shot." There was to be no withdrawal. On September 10, German bombs wiped out the central Leningrad food storage center with all its valuable contents. Two days later began the intense artillery barrage that lasted until November. The battle for control of the city reached its climax on September 17, when Zhukov repeated his order: attack or die. On the 19th, squadrons of German planes bombarded Leningrad. The composer Shostakovich, sharing the widespread heroism, boldly stayed in his quarters, while working on his Seventh Symphony. He was evacuated to Moscow in October.

On the 21st the threat of an all-out German attack diminished, when Hitler, like Stalin concerned foremost with Moscow, transferred some German units to the Moscow front, leaving the isolated city of Leningrad to rot and its inhabitants to die of starvation. As Hitler stated on September 22, he was determined to "raze the city from the face of the earth. … After the defeat of Soviet Russia there will be not the slightest reason for the further existence of this large city. … All calls for surrender … will be refused." Driving home Hitler's point, on the 27th two hundred planes bombed the city in the worst air attack yet, followed in the next few months by equally destructive bombardment. In addition, German guns mercilessly pounded the city from the ground, setting fires, destroying buildings, interrupting basic services, and killing or wounding thousands of people. All along, German troops devastated the splendid tourist residences outside Leningrad, looting their riches (including the amber, which has never been recovered).

Meanwhile food rations were sharply reduced. On October 1 fewer than three weeks' supply of flour for bread remained for the ever-more-hungry Leningrad people, who only received a monthly allowance of five and one-quarter pounds of nonbread foods. Was it surprising that horses, dogs, cats, pigeons, and even rats disappeared from sight? Or that meatballs sold on the black market contained human flesh? Or that ration cards were stolen or forged? The loss of a ration card was a death sentence.

Early in November the city had been entirely cut off from outside food supplies, as the Germans had advanced far to the east, seizing a vital railhead from which supplies had been transported to Lake Ladoga and then, over the ice, to Leningrad. Now the Russians had to build a road two hundred miles long further east through frozen wilderness to reach the transshipment point on the lake. A thousand trucks were lost on that road. In the city rations had to be cut even further. Some 11,000 people died of hunger. In December, fortunately, the Red Army retook the crucial railhead, so the Ladoga ice road once again functioned in full force, at arctic temperatures, with sixty tracks across the ice.

The German stranglehold on Leningrad tightened ever more cruelly as

the winter progressed. On October 31 the first snow had fallen, introducing the coldest winter on record, with heavy snowfalls and icy winds. Temperatures dropped to 20 degrees below zero Fahrenheit (minus 28 degrees Celsius). There was no fuel to keep warm, so people burned books and furniture, or wood from trees felled by young girls, in makeshift stoves that all too readily set houses on fire, adding to the blazes set by the bombardment. There was no water to extinguish the fires, and the fire department had long ceased to exist. So had the police, replaced on November 15 by an internal defense administration which shot anybody caught stealing food. Until early December Leningraders could go to concerts; but no longer thereafter. Trolley car service had stopped, and electricity was unreliable—at night the city was dark. During the day you would see people on the main streets pulling a children's sled loaded with water, wood, or a corpse on the way to a cemetery. But soon the bodies were left where they had dropped, on their beds in the apartments, or on the street buried in the snow.

What harrowing sights and smells around the filthy city with its unwashed citizens! Dead bodies piled up higher every day, some wrapped in rugs or curtains, some in sheets, and sometimes between them an infant's corpse tied in paper with a leg or an arm protruding (with occasional evidence of cannibalism). A woman collapsed; someone tried to help her, hearing her mutter a word that sounded like "soup" before she fell down dead. And imagine a small child in a freezing apartment watching its parents die one by one, with a rat gnawing on a corpse's face. Long lines of women made their way, around dozens of corpses covered with snow, to holes in the ice-covered Neva River to fill their buckets with water. Some who slipped never rose again.

Such was life in Leningrad during the winter of 1941–1942. Five thousand three hundred skeletonlike people died in December, three to four thousand every day in January, and more in February. Fortunately, the bombardment diminished during the winter. From December onward the food supply improved slightly, but, nonetheless, the death rate rose to its peak in April, while the spring thaw uncovered piles of putrefying corpses.

But then consider also the impressive resilience of the remaining people (shrunk down now to slightly over one million). The *Leningrad Pravda* had missed publication on only one day in January for lack of electricity; the public library remained open throughout the winter; schools and academic instruction continued; the radio almost continuously broadcast life sustaining messages. The Kirov Works, a major industrial center near the front line, continued production. A measure of civic order was preserved. Embattled Leningrad, even after its worst bombardment in the summer of 1943, survived its nine hundred days of siege. It was liberated in January 1944, the symbol of unparalleled patriotic endurance.

V.

By comparison with Leningrad, Moscow suffered less under the German onslaught. It was more effectively defended, due to its significance as the center of the Soviet government and the symbol of Russian state power. Its historic sites were as famous as those of Leningrad.

In the center of the city towered the tall brick walls and pointed guard towers of the Kremlin, an ancient fortress and residence of the tsars until Peter the Great. A historic monument, it was well preserved under Soviet rule, the high domes of its Renaissance cathedrals still radiating their golden glow. The ornate Great Kremlin Palace, built in the nineteenth century as the tsar's Moscow residence, now housed the gatherings of top Communists. Nearby, high officials, including Stalin, worked in their offices, well guarded within the Kremlin walls.

Outside lay the spacious Red Square and the colorful multidomed St. Basil's Cathedral, built in the sixteenth century, another cherished Moscow site. Yet what counted most, below these Kremlin's walls was Lenin's tomb, its austere squareness contrasting with the architectural splendor surrounding it. From its balcony Stalin and other high officials regularly watched the demonstrations of military power celebrating Communist holidays, a prominent feature of Soviet propaganda.

All around the Kremlin stretched the far-flung city, the Soviet Union's capital with its residences of foreign diplomats and famous theaters, a hub of industrial productivity as well. It still displayed many attractive buildings from tsarist days and, towering on the skyline, the modern Moscow University. Parks and city squares were enlivened by statues of historic figures and contemporary heroes. One of the most flamboyant sculptures showed a male factory worker and a female collective farmer storming triumphantly forward side by side, brandishing a hammer and sickle over their heads. A more practical showpiece was the conspicuously modern Moscow subway system started in the 1930s. It boasted some extravagantly decorated spacious underground stations—public splendor had to compensate for the miserable housing of the hardworking people in this overcrowded city of four million inhabitants. Toward that Soviet capital the German armies now advanced. If they conquered it, the Soviet Union would collapse.

Under this fatal threat Moscow suddenly became elevated to global relevance. Its prewar anti-Western stance turned pro-Western, with its embattled Red Army the major challenge to the Fascist aggressors, at a critical time in the ever-expanding war. While the Italians battled in East Africa, the Germans had overrun the Balkans; in North Africa they were moving toward Egypt. Allied with Finns, Hungarians, Italians, and Romanians, the Germans were now headed for the riches of the western Soviet Union and the oil wells beyond the Caucasus Mountains. The Soviets had

only one secure supporter: the British, who found themselves unexpectedly but irreversibly joined to a uncongenial and distrusted ally.

Although no longer in immediate danger from a German invasion, the British were still vulnerable to air attack (reduced after June 22). Yet fortunately they enjoyed increasing support from the United States. In March the U.S. Congress had passed the Lend-Lease Act, promising goods and services to any deserving country. In May President Franklin D. Roosevelt, alarmed by Hitler's successes, had declared a state of emergency. When, on the day of the German invasion of the Soviet Union, the British prime minister, Winston Churchill, sensing a decisive opportunity, instantly offered British help, he could be sure of American support.

After the outbreak of the war, foreign affairs thus assumed a new importance in Moscow. In response to Churchill's offer, Stalin asked for economic aid and, even more urgently, for a second front in western Europe to draw German troops away from Soviet territory, a move obviously beyond British capacity. At the end of July, Harry Hopkins, representing President Roosevelt, arrived in Moscow and was presented by Stalin with a big request for weapons and industrial materials. The overriding common need to defeat Hitler lowered the ever-present ideological and cultural barriers. Hopkins felt that Stalin could be trusted. He was impressed both by Stalin's calm competence in all matters under discussion and his confidence in his country's strength. Thereafter British and American support for the Soviet Union increased.

In late August Britain and the Soviet Union peacefully occupied Iran in order to secure a vital supply line for war materials from the Persian Gulf into Soviet territory. And, more crucially, on September 29 the Anglo-American team of Lord Beaverbrook and Averell Harriman arrived in Moscow to negotiate the details of the support promised earlier. After friendly discussion the two Western democracies agreed to deliver a wide variety of arms, raw materials, and machinery, in return for certain Russian raw materials. The agreement, creating "a mighty front of freedom-loving peoples" (as Stalin's Foreign Minister Vyacheslav Molotov put it), raised morale in Moscow, just as Hitler started what he considered the final drive against the Soviet capital.

Meanwhile the Muscovites had increasingly faced the hardships of war. On July 2 air raids had begun. The city was dark at night, the sky filled with antiaircraft balloons, shop windows were sandbagged, the streets turned lifeless, and food began to be rationed. In August the Kremlin was camouflaged, but the theaters still played to audiences now crowded with soldiers. As air raids increased, fires became more menacing. They were fought by volunteers, including many girls. A heavy air raid hit the industrial areas on August 8. Yet on the following Sunday the hardworking Muscovites still flocked to the amusements offered in the Moscow parks, with plenty

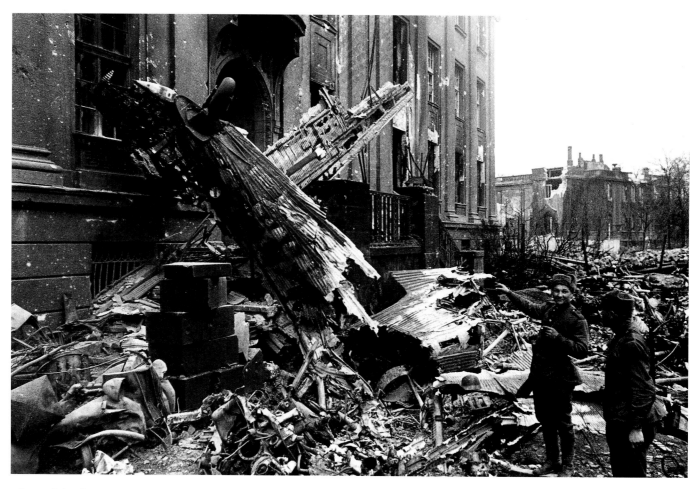

One of the first German planes
shot down, 1941

of candy for sale. But by the end of the month cigarettes were in short supply. While people were under strain, symphony concerts continued, and in September the ballet season opened. As for the political mood, an English journalist heard cheers when Stalin appeared on the screen at a movie theater.

On October 4 Hitler launched his attack on Moscow. Five days later Marshal Zhukov, transferred from Leningrad, took charge of Moscow's defense (and later of Soviet military operations through the end of the war). Attitudes hardened toward everything German. On October 13 the Moscow party organization declared Moscow "in danger." Calling for iron discipline, it enlisted twelve thousand volunteers in "Communist battalions" ready to die for the city's defense. In addition, hundreds of women were sent out to dig antitank trenches, and were sometimes strafed by German planes. Meanwhile a large number of government offices were transferred to Kuybyshev (now Samara), a city more than halfway to the Urals, while factories were evacuated and people fled on their own. And on October 16, after the rumor of a German breakthrough, panic broke out and people desperately tried to get away at

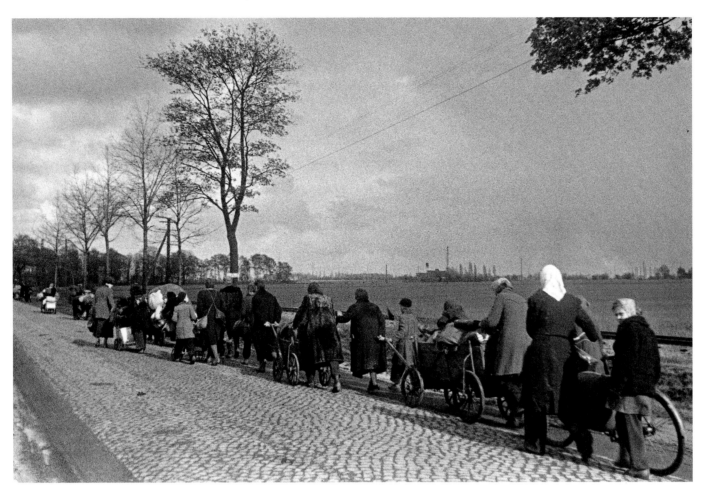

all costs. But the next day the radio announced that Stalin would remain in Moscow, restoring calm and testifying to the leader's psychic power. The Germans were held at bay in brutal fighting less than fifty miles from the city, where life slowly returned to its essential routines, including the celebration, with traditional fanfare, of the twenty-fourth anniversary of the Bolshevik revolution.

Evacuation of Moscow, October 1941—*In anticipation of a German attack, residents of Moscow fled the city but soon returned.*

On November 6 Stalin, aware of his crucial role, stepped forward with a reassuring speech. Despite some unfavorable conditions, the Soviet Union was stronger than ever; the attack had transformed "the family of the peoples of the USSR into a single inviolable camp." Endorsing the aims of the Atlantic Charter, he thanked England and the United States for their support, calling them "genuine democracies," whereas the Germans were "wild beasts." In conclusion, he again urged a more effective war effort among all his peoples. On the next day, saluting the parading soldiers from Lenin's tomb while guns rumbled in the distance, he sounded an even more exalted note: the enslaved peoples of Europe were looking to the Red Army and Red Navy as liberators. For patriotic support

65

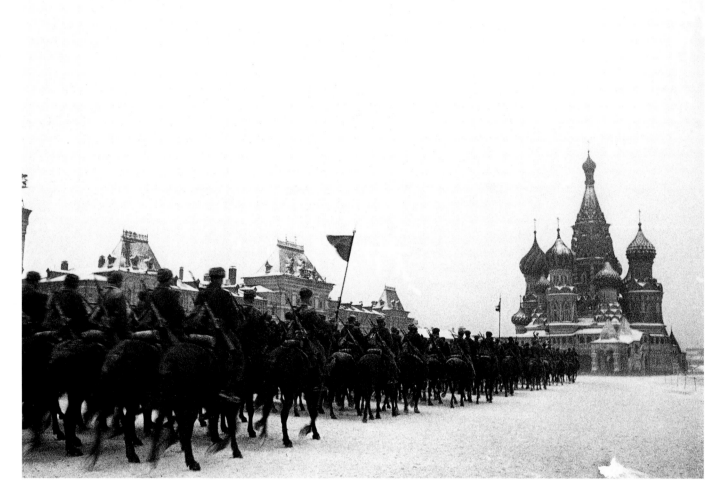

On Their Way to the Front, November 7, 1941—Mounted troops enter Red Square for ceremonies commemorating the 24th anniversary of the Bolshevik Revolution. The celebration was held despite the danger of a German attack on Moscow. The troops went directly from Red Square to the front, some twenty kilometers away.

he also enlisted the great heroes of the Russian past from the times of the Tatar yoke to the victory over Napoleon, telling his soldiers: "May you be inspired by the gallantry of our great ancestors." As in his 1931 speech, he infused Russian nationalism into the party line. In the spirit of the Great Patriotic War he hailed his snow-covered soldiers (seen in Baltermants's photograph): "Under the Banner of Lenin—onward to victory!"

In fact, it was onward to another fierce battle, as the Germans, who had been mired in mud on the road to Moscow, resumed their offensive in mid-November. They were stopped, at one point barely fifteen miles from their goal, by desperate resistance and murderous frost. At last in early December the Red Army mounted its counterattack, which kept the Germans at a safe distance from the city until their retreat in 1943. As the news spread of the Japanese attack on Pearl Harbor and the American entry into the war as a Soviet ally, the evacuation of Moscow ended. Produc-

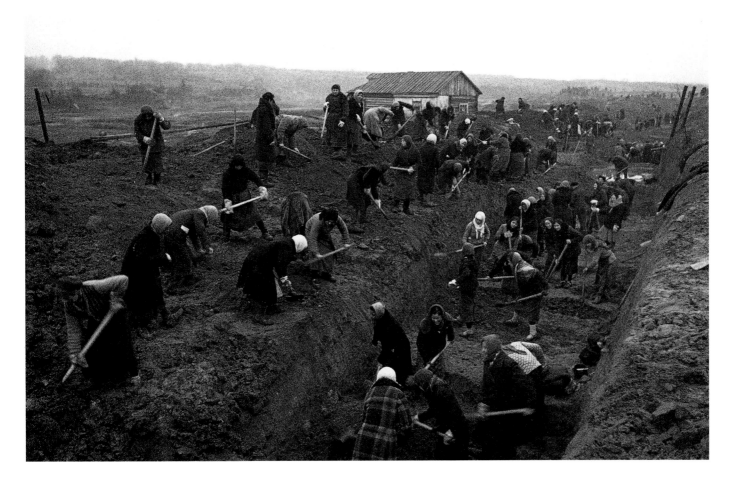

tion of war materials was resumed and even intensified. Public confidence hardened under the impact of the ceaseless battle within earshot.

Never before had there been such remorseless fighting as on the Moscow front. The fate of the Soviet Union and of Hitler's ambitions was at stake. The resources of each side were strained to the utmost. Although the Russian T-34 tanks were superior to their German rivals, there were not enough of them. Neither were there sufficient numbers of the impressive Katyusha rocket mortars. Airplanes, trucks, and ammunition were in short supply. Fortunately, fresh and well-equipped Siberian troops arrived to support the exhausted frontline units. Soviet industry, however, could not match the German superiority in military gear. The deficiency was overcome by relentless human sacrifice, glorified, for instance, in the case of the Panfilov antitank unit. Equipped with antitank rifles, hand grenades, and Molotov cocktails, the unit's men fought one by one to the

Digging Antitank Trenches Near Moscow, October 1941—
As German troops approached Moscow in the fall of 1941, mobilization began, drafting all citizens in an effort to protect their city. Here, Soviet women, men too old to fight, and children dig a line of trenches to protect Moscow from the approaching Germans. More than 100 miles of these trenches were dug.

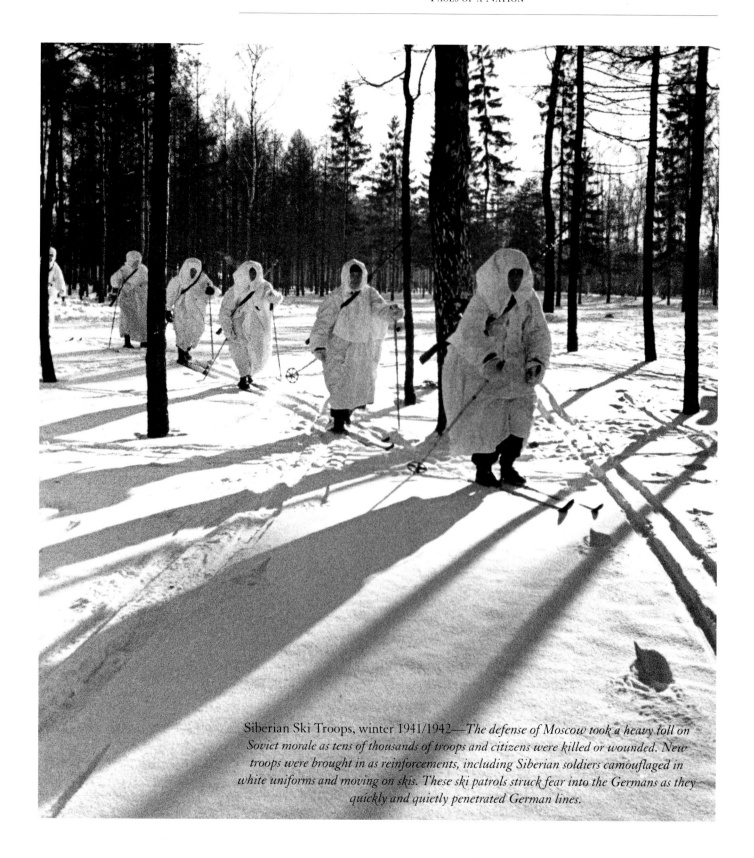

Siberian Ski Troops, winter 1941/1942—*The defense of Moscow took a heavy toll on Soviet morale as tens of thousands of troops and citizens were killed or wounded. New troops were brought in as reinforcements, including Siberian soldiers camouflaged in white uniforms and moving on skis. These ski patrols struck fear into the Germans as they quickly and quietly penetrated German lines.*

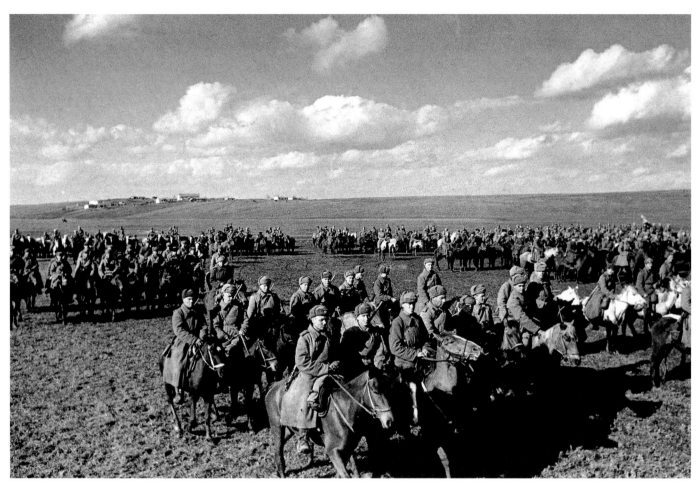

death, while their leader, with hand grenades strapped to his body, flung himself under a German tank to blow it up. Zoya, an eighteen-year-old girl, was another role model. She had set fire to German military stables and after being tortured was hanged, her body—and her story—recovered during the Soviet counteroffensive. These heroes showed the way to save the Soviet fatherland.

On the German side the battle was equally ferocious. The superiority of equipment did not overcome the uncertainty of supplies over long distances, lack of contact with family and home, and frustration over not being able to celebrate victory in Moscow. The fierceness of Soviet resistance was matched by the mercilessness of the winter. Temperatures in December fell disastrously (by some German accounts to minus 60 degrees Celsius). The German troops lacked sufficient water and clothing. Deprived of warm food, they suffered from intestinal disorders. Some of them froze to death while on guard duty. Thus brutalized, they mercilessly robbed, looted, and killed Russian civilians, burning their homes, and prominently hanging partisans on gallows. At the same time, the Germans suffered

Cavalry, September/October 1941—*Although not as technically advanced as the Germans, the Soviet command could count on the resilience and skills of its citizens to counter the Nazis. The cavalry constituted a tradtional source of strength for the Russian army, and was considered the finest cavalry in the world. Harassing the enemy and easily breaking through German lines, the cavalry played a necessary role in the Soviet war effort due to the lack of motorized transport in the early days of the war.*

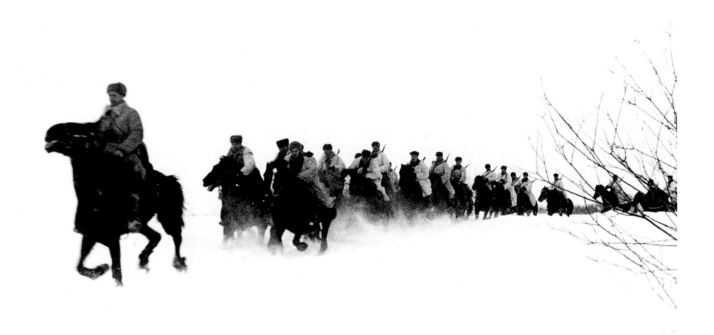

Behind Enemy Lines, First Guards Cavalry Corps, November/December 1941— By December 7, 1941, the temperature around Moscow had dropped to minus 20 degrees Fahrenheit. Like Napoleon before them, the Germans soon discovered that the bitter Soviet winters, coupled with the difficulty of maintaining their supply lines, slowed their advance into the country. This photograph shows a cavalry detachment in the rear of the German advance.

huge losses themselves: fifty-five thousand men dead and more than one hundred thousand wounded and frostbitten, as well as their weapons destroyed. By all estimates, the Soviet losses were even higher.

Yet the human sacrifice turned even more shocking and the fighting more ruthless, as the German armies in 1942 moved toward Stalingrad.

VI.

The Soviet counteroffensive that had saved Moscow petered out February 1942 for lack of military equipment, while the Germans, counting on their superiority, prepared another major campaign for the summer. They planned to move east, through Kharkov, as far as Stalingrad (now Volgograd) on the Volga River and, with that city in their hands, turn north to capture Moscow from the rear. At the same time they were to move southwest toward the Caucasus Mountains and beyond to the strategic oil wells on the Caspian Sea. If they achieved these aims, they had won the war. By May they had retaken the Kerch Peninsula in the Crimea, and in early

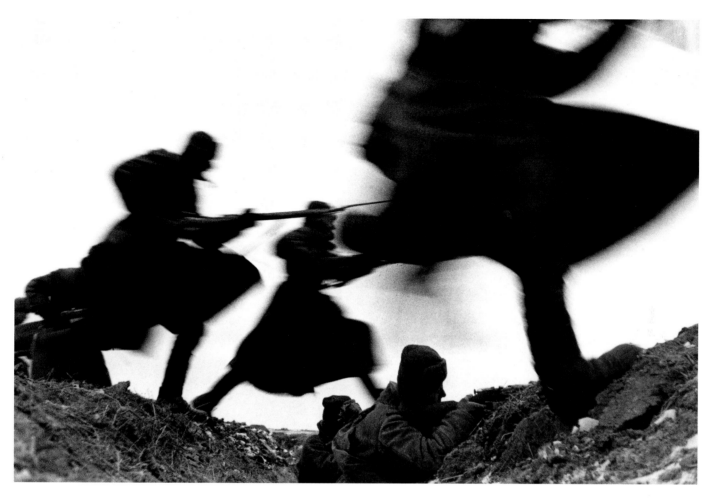

July stormed the Soviet naval base at Sevastopol, which had heroically withstood a nine-month siege. In late July they seized the city of Rostov, the gateway to the Caucasus area. Sweeping east on their central front, they reached Stalingrad on August 23, cutting off all access to the city, except from across the Volga River.

The German victories caused a mood of profound desperation in Moscow. It was the low point of the war. Could the country survive? Disaffection pervaded the army. In mid-July Andrei Vlasov, a general of distinction in the defense of Moscow, was captured by the Germans. Disillusioned with Stalin, he was allowed to recruit Soviet prisoners of war to fight on the German side to rid his country of communism. The "Vlasov Army" caused further concern on Stalin's part over popular loyalty.

Fortunately, hatred of the Germans, now known among the frontline soldiers as the *Fritzes,* had reached a new pitch. Stalin endorsed the hatred with a thundering admonition to his troops after they had abandoned the city of Rostov in a panic: "Not a single step backwards. … You have to fight to your last drop of

Attack, November 1941—
By the end of November 1941 the Germans had already suffered 250,000 casualties in Russia. In December the Russians began their counterattack. When first published, Baltermants's photo of charging soldiers was criticized as it depicted "half-a-man," and was thus inconsistent with socialist realism. It has since become one of the most enduring war photos ever taken.

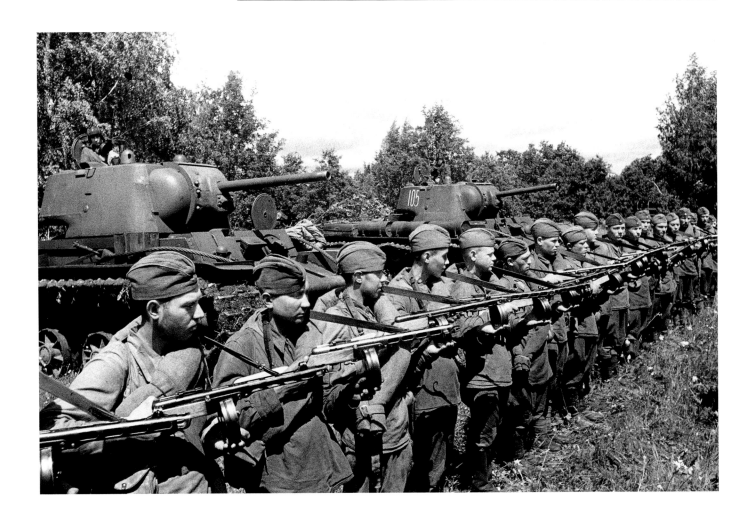

Penalty Battalion, 1943—
Soviet men convicted of criminal activities or hostile to official ideology were often placed in penal battalions, fighting in the front lines. Equipped with poor weapons and ill-fitting uniforms, these soldiers were expected to pay for their crimes with their blood. Baltermants was placed in one such battalion after a newspaper editor erroneously published one of his photos showing German POW's near Moscow, under the impression that the picture had been taken near Stalingrad. Baltermants had to take the blame for the editor's mistake.

blood, to defend every position, every foot of Soviet territory." At the same time he permitted a major reorganization of his armies' command structure, reducing the authority of the party commissars and advancing the responsibilities of the officer corps, boosting its prestige and increasing the discipline of the troops. Henceforth, officers would wear uniforms decorated, as in tsarist times, with gold braid (imported from England). As a result, the efficiency and morale of the armed forces improved, matching German standards. It was high time, as the German Sixth Army—with over a quarter-million men supported by thousands of late-model airplanes, tanks, and guns under the command of General Friedrich von Paulus—penetrated the outskirts of Stalingrad.

The city's traditional name, Tsaritsyn, was changed in 1925 to honor Stalin. Stalingrad was a modern city stretching for about twenty-five miles along the bluffs on the west bank of the mile-wide Volga River. With more than three hundred thousand inhabitants, it was the product essentially of the five-year plans. It

contained three major industrial complexes surrounded by housing and recreational facilities, all located on the city's northern side. In the center, tall concrete office buildings towered over empty streets. As the Germans approached, city life stopped. After a heavy air raid that killed forty thousand civilians and set the city on fire, most of the surviving inhabitants fled across the Volga. The siege of Stalingrad, unlike that of Leningrad or Moscow, did not involve civilians; it was a purely military battle—of unprecedented ferocity.

From the start the besieged city, a shrinking stretch of buildings above the Volga, was under constant German bombardment and attack by armored forces. The heroic defenders had to rely on support from the extensive army base across the river, from which heavy artillery and rocket launchers, always suffering from limited ammunition, could shoot at the enemy. Under constant enemy fire, that base also provided food and hospital service and replaced wounded or dead soldiers. Crossing the river, however, was always dangerous, as was landing on the piers in the city, which were the targets of German thrusts toward the river.

In their first air raid the Fritzes had burned down the wooden houses on Stalingrad's outskirts, leaving nothing but a bleak forest of stone chimneys. Next they advanced toward the central business district, most of which they occupied by September 24. At this moment of crisis, General Vasli Chuikov, an energetic leader admired by his troops, assumed control over the defense of Stalingrad. He was urgently needed. The Germans had just broken through to the city's main pier, dividing for a time the Russian army. Fortunately, the river flotilla, keeping the Germans off that vital artery, continued to operate. Upriver a footbridge resting on empty barrels was strung from bank to bank; cross-river traffic, however perilously, continued. But Chuikov could not prevent further German gains, street by street. Of those bitter days Chuikov tells a story typical of the Stalingrad defenders' heroic sacrifice. A battalion (a military unit of several hundred men), just driven out of the main railway station and entrenched in a neighboring building, was reduced to six survivors. Though badly wounded and without food for three days, these *frontoviks* spent their remaining ammunition while fighting their way back to the river, where they were picked up by an antiaircraft crew and taken to a hospital. For all the others in that battalion, alas, there had been no such happy ending; but they had lived up to Stalin's command to fight to the last drop of their blood.

From the city's commercial center the fighting shifted north to the industrial area, where the most critical battle was fought on October 14. General Chuikov recounted that day amidst the perpetual deafening roar of explosions as:

> … a battle unequaled in its cruelty and ferocity throughout the whole of
> the Stalingrad fighting. … There were three thousand German air sorties

that day. They bombed and stormed our troops without a moment's respite. The German guns and mortars showered on us shells and bombs from morning till night. ... Our dugouts were shaking and crumbling up like a house of cards. ... The command and observation posts of regiment and divisions were being smashed by shells and bombs. ... The guards scarcely had time to dig the officers out of the smashed dugouts of the Army H.Q. By midnight it was clear that the invaders had surrounded the Stalingrad Tractor Plant, and that fighting was going on in the workshops. We reckoned that the Germans had lost forty tanks during the day, and around the Tractor Plant there were 3,000 German dead. We also suffered very heavy losses that day. During the night 3,500 wounded soldiers and officers were taken across the Volga; this was a record figure.

The German offensive, somewhat reduced, continued into early November. The Russians, heavily outnumbered, fought house to house, room to room, having developed a special technique for coping with the enemy under those cramped conditions. As Chuikov advised his soldiers:

> Get close to the enemy's positions; move on all fours, making use of craters and ruins; dig your trenches by night, camouflage them by day; make your build-up for the attack stealthily, without any noise; carry your tommy-gun on your shoulder; take ten or twelve grenades. Timing and surprise will then be on your side. ... There is one strict rule now—give yourself elbow room! At every step danger lurks. No matter—a grenade in every corner of the room, then forward! A burst from your tommy gun around what's left; a bit further—a grenade, then on again! Another room—a grenade! A turning—another grenade! Rake it with your tommy-gun! And get a move on! ... Act more ruthlessly with your grenade, your tommygun, your dagger, and your spade! Look sharp!

A German lieutenant engaged in these fights recorded his own impressions:

> The front is a corridor between burnt-out rooms; it is the thin ceiling between two floors. ... From storey to storey, faces black with sweat, we bombard each other with grenades in the middle of explosions, clouds of dust and smoke, heaps of mortar, floods of blood, fragments of furniture and human beings. Ask any soldier what half an hour of hand-to-hand struggle means in such a fight. And imagine Stalingrad: eighty days and eighty nights of hand-to-hand struggles. The street is no longer measured by metres but by corpses.

The streets by now were barely recognizable, blocked by piles of rubble underneath crumbling walls of skeletal tall buildings. Tanks could hardly pass. Soldiers took cover under the ruins, moving mostly at night for fear of snipers.

During lulls in the fighting, the snipers took over, indistinguishable in their camouflage uniforms from the chaos around them. They hid for hours or days on the ledges of burnt-out windows on the top floors of crumbling buildings; or they crawled underneath the rubble through ruined basements, in search of enemy snipers. One Russian sniper, Nikolai Kulikov, survived to tell the tale of one encounter. Tracing an enemy sniper for several days, he finally spotted him and his rifle equipped with telescopic sights, which had just wounded Kulikov's comrade. As the enemy's hideout was safely covered by a metal sheet, how could he be hit? But Kulikov knew how to trick him. Putting his helmet on a stick, he raised it above his own cover just high enough so that the enemy could see it. The Fritz promptly shot at it and Kulikov howled loudly, pretending to be hurt. Whereupon the enemy in triumph raised his eyes above the metal sheet—to be hit in the forehead that instant. There was opportunity amidst the general carnage for individual gambles of death.

On November 11 the Germans launched their last offensive, breaking through in some spots to the Volga before being repelled. Ice floes imperiled relief from across the river, aggravating the hardships of the defenders. Under these conditions the fighting again turned desperate. Prisoners were no longer taken; the combatants had little hope of survival. In the hand-to-hand engagement, tanks and airplanes, the source of German strength, were of little use. What counted among soldiers half-starved, without drinking water, holed up in stinking cellars, was raw guts. Sustained by alcohol and drugs, unshaven and exhausted by lack of sleep or relief for days, they, in the words of one commentator, "had lost all sense of motive and purpose, save the ultimate obsession of close combat—to get at one another's throats." In this spirit the fighting continued for weeks at the edge of the Volga.

By November little indeed was left of the once proud Stalingrad. The Germans had reduced the Russian-held parts to their smallest size, a sliver of barely five miles along the river and never more than one thousand yards deep. It was a nightmarish sight. Bleak ruins towered over antlike soldiers who crawled toward hidden enemies, shooting at them or throwing grenades, amidst decomposing German and Russian corpses and their abandoned weapons, all covered with a thin layer of white snow under dense clouds of black smoke.

On November 19, however, the exhausted defenders had been cheered by the thunder of gunfire in their enemy's rear. At last powerful relief was on its way. After careful preparation, a huge Soviet army had been moved secretly at night

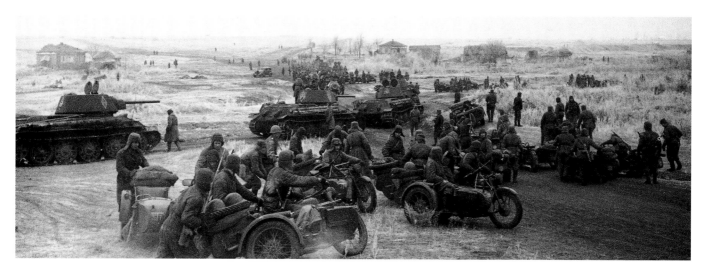

Massing for the Offensive at Stalingrad, November 19, 1942—*Once the Germans had been halted at Leningrad and Moscow, they turned toward Stalingrad in hopes of capturing the Soviet Union from the south. The German offensive began on June 28, 1942, followed by a Soviet counteroffensive in November 1942, which ended with Soviet victory in February 1943. Although the city lay in ruins, the Soviets had taken the upper hand in the war.*

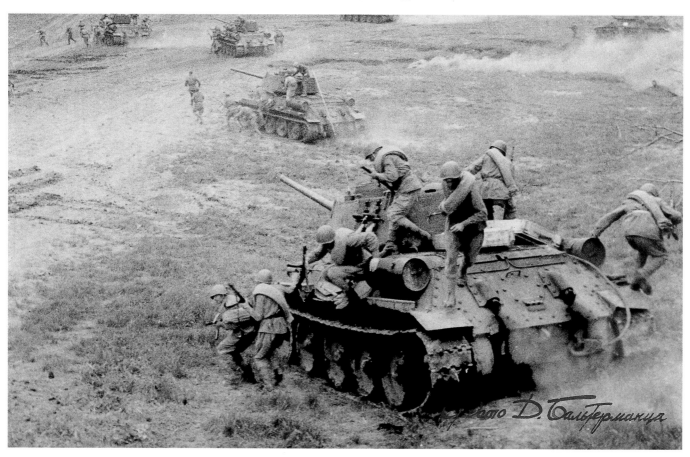

into positions encircling the attacking Germans, whose flanks were poorly protected by Romanian troops. For the first time the Soviet forces possessed overwhelming superiority: a million infantry, nine hundred tanks, field artillery, and rocket launchers. Despite the counteroffensive, bitter fighting continued within the city. As the weather grew colder and the Volga froze over, cross-river traffic was resumed, easing the lot of Chuikov's troops defending their last hold on the city, while desperately waiting for help from their comrades in the rear of the Germans.

As the Soviet noose around General Paulus's army tightened, reducing its resources but hardly its fighting spirit, the struggle continued to the very end of January 1943. The surviving Germans gave up their resistance only after the encircling Soviet armies, on January 25, had cut off all contact with their bases further west. On January 31, 1943, General Paulus, just promoted by Hitler to the highest military rank of *feldmarschall* in order to boost his endurance, abjectly

Romanian Prisoners from the Battle of Stalingrad, November/ December 1942—The Germans had enlisted the support of Romanian troops in their assault on Stalingrad. Many of these soldiers, the first POW's captured at Stalingrad, were not released until 1955. Note the cossack hats; Baltermants's photo was used to show the humane treatment of the POW's to the world.

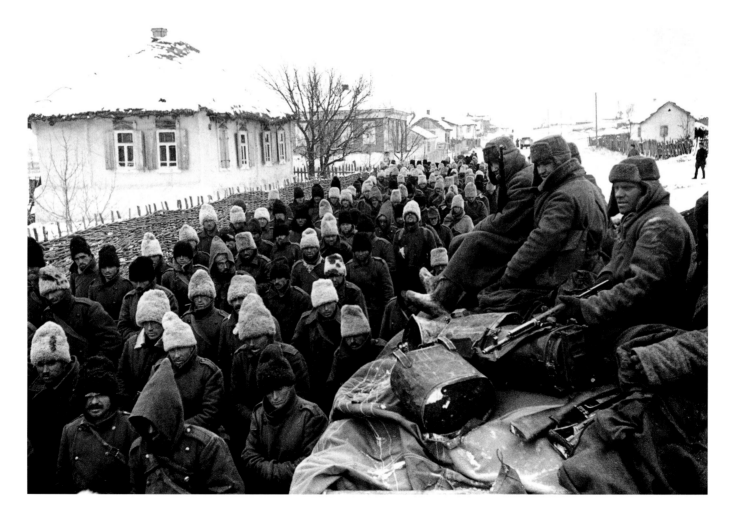

surrendered, together with 91,000 soldiers. Those were the remnants of the 330,000 soldiers that had, by a Russian estimate, come to destroy Stalingrad (and of the 91,000 only 6,000 survived Soviet captivity). Thus ended, deep inside the Soviet Union at the city named in Stalin's honor, the most ferocious battle of the entire war. For five months the steellike wills of two all-powerful dictators and their dedicated soldiers had clashed head-on, endowing refined military technology with raw human fury. It was the most brutal military encounter on record, soul-shaking even in retrospect over half a century later.

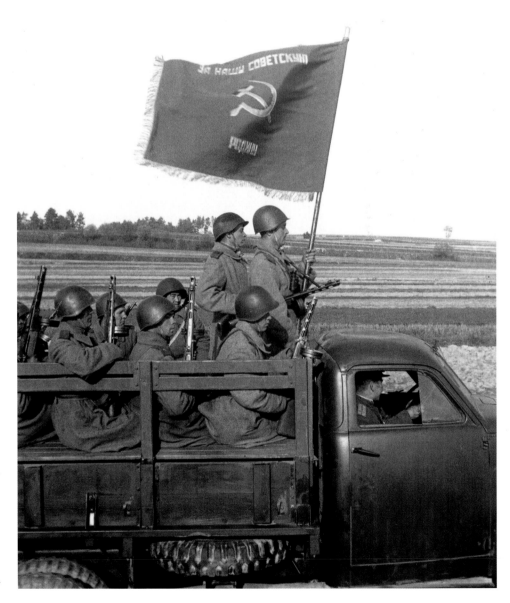

For Our Soviet Motherland, 1943—*This heroic image, showing Soviet troops racing toward the front in an American truck, exemplified the primary goal of Soviet wartime photography, in which vigor and optimism were displayed at times of great adversity.*

The victory at Stalingrad obviously prompted a mood of optimism in Moscow; the Fritzes could be defeated. Stalin, always eager to consolidate his public image, was praised as a military genius. He now changed from his simple garb into a marshal's tunic. The officer corps rejoiced in its gold-braided uniforms studded with medals—even more than in the 1930s medals were used as rewards for patriotic exertion. The military professionals had gained increased prestige even in Stalin's eyes. Morale among the soldiers improved. Throughout the Soviet Union people breathed easier, while working still harder under continued wartime adversity.

VII.

The German defeat at Stalingrad turned the tide of war in favor of the Soviet Union. Yet the country still faced more than two years of continued bloodshed as the Soviet armies moved toward Germany. None of the battles along the way equaled the human intensity of the defense of Leningrad or Moscow, or the desperation prevailing at Stalingrad. The strain and sacrifice, however, were still immense, even if sustained by growing military resources and anticipation of eventual victory. The territories to be reconquered were vast.

In early 1943 the Germans still controlled vital parts of the Soviet Union. The battlefront ran deep inside the country along a line stretching from Leningrad in the north past Moscow to the Volga near Stalingrad, and thence to the eastern

War on the Black Sea, 1942

coast of the Black Sea and the Caucasus Mountains in the south. The distances to be traversed by the Red Army were enormous, about thirteen hundred miles, for instance, from Stalingrad to Berlin. As Soviet troops advanced westward, they encountered not only non-Russian peoples but also bourgeois life with its consumerist temptations; they moved into alien cultures. And finally, as the Soviet armies advanced, differences of outlook and political interest between the Soviet Union and its Western allies began to reassert themselves. The prospects of victory were confusing.

At any rate, after its triumph at Stalingrad, the Soviet Union faced its enemy with greater confidence. Despite continued hardship, industrial productivity steadily improved. Soviet arms output was satisfactory at last, supported under grim conditions by newly opened coal mines, power stations, blast furnaces, and factories, often worked heroically by women and adolescents. After the outbreak of war, the Soviet engineering industry had lost about half of its potential, but by 1943 recovery was on the way, with impressive results. Thirty-five thousand airplanes were produced in that year, twenty-nine hundred per month; the best Soviet fighter planes outmatched their German rivals. The production of tanks likewise was reassuring: sixteen thousand, all generally superior to the run of their German equivalents. In addition, Russian factories produced one hundred thirty thousand guns, with sufficient ammunition to match German firepower.

As for agricultural supplies, although 42 percent of Soviet cropland was under German control by 1942, soldiers and workers in the war industries were reasonably well fed. By 1943 the United States contributed additional food, together with shoes and clothing, and, even more important, jeeps, trucks, and industrial raw materials such as rubber, aluminum, and tin. Thus strengthened, the Soviet armies were ready to face not only their enemy's vigorous resistance but also the utter devastation of their country by the German conquerors.

Forced to retreat, the Germans were determined to leave behind a wasteland. As the Soviet troops advanced westward from Moscow, they encountered villages and towns almost completely destroyed. A large part of the population had died, many of them shot or provocatively hanged in public places, while others starved to death. Still others had been deported as slave labor, unless they had escaped to join the growing partisan forces. Churches and cherished historical monuments had been demolished as well as factories, railways, and bridges. Thousands of land mines and booby traps lay hidden in the rubble. In the countryside all farming equipment had been smashed, orchards cut down, crops ruined, cattle slaughtered or carried away, barns and huts burned, the women raped, and children abused. Soviet soldiers were especially shocked by the evidence of mass shootings of prisoners of war.

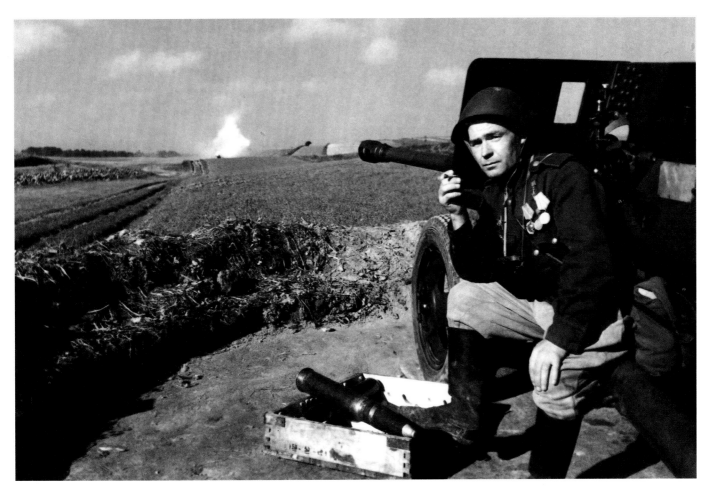

Amidst this misery the Soviet advance continued, slowly driving the Germans westward, with occasional setbacks. The biggest battle of the entire war took place in July around a Soviet salient protruding into German-held territory near the city of Kursk (not quite three hundred miles southwest of Moscow). This salient was to be the jumping-off point for offensives to the northwest and southwest. Here for months the Soviet army had built up a massive striking force, including more than two thousand tanks and twenty thousand pieces of artillery, supported by equivalent air power, plus tens of thousands well-armed infantry. It was the biggest concentration of Soviet military might yet achieved. Aware of the Soviet threat, the Germans prepared an offensive of their own, attacking the Soviet salient from the north and the south in order to annihilate their trapped enemy. The Germans too amassed an unprecedented number of tanks and other military equipment, emboldened by Hitler's message to his soldiers: "Your victory will show the whole world that resistance to the power of the German Army is hopeless." Hitler needed a victory, as the Allied forces were preparing to invade Sicily.

The Artillery Commander, Summer 1942—*A great example of socialist realism, this Soviet artillery commander is shown in complete control of the situation although chaos reigns around him. In the censored world of the Soviet press, pictures such as this were preferred for the images of heroism and authority they conveyed.*

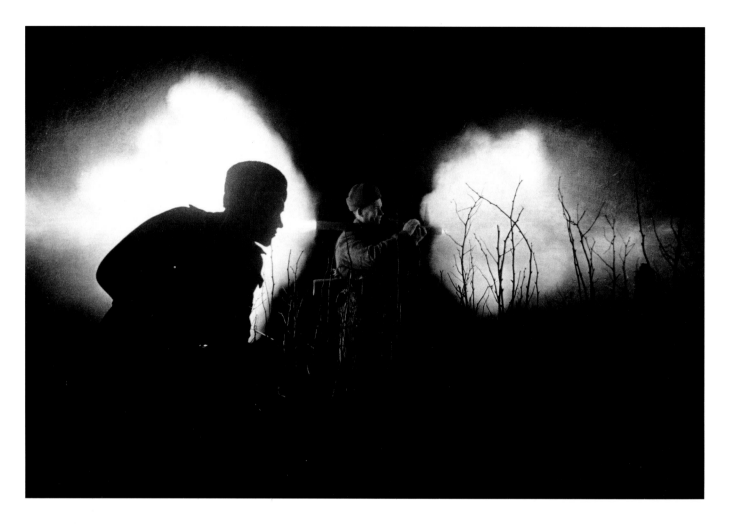

Fighting at Night (Captured German Weapons), late 1942— *The Soviets were able to turn the captured artillery from the Germans into their own offensive weapons.*

Thus began, on July 4, the biggest tank battle in history. It involved about six thousand tanks and lasted for a week amidst a ceaseless barrage of gunfire, aerial bombings, exploding mines, and infantry attacks. By July 12 the battlefield was a hideous desert, not a tree or bush left standing, with hundreds of burnt-out tanks, crashed planes, and half-buried corpses littering the bare earth—the worst military carnage in World War II. Hearing the news of the Allied invasion of Sicily, Hitler at last ordered his men to retreat from the battle in which they had been clearly defeated. According to the Russians, the Germans had lost about seventy thousand men, more than two thousand tanks, some thirteen hundred planes, and other equipment. Russian losses were hardly less heavy. But after Stalingrad, the battle of Kursk confirmed the inevitability of the Soviet victory. The backward Russians had clearly matched Germany's military technology.

As the Soviet soldiers advanced westward, they were cheered by their liberated compatriots. They entered Orel, a small city west of Moscow, to the sound

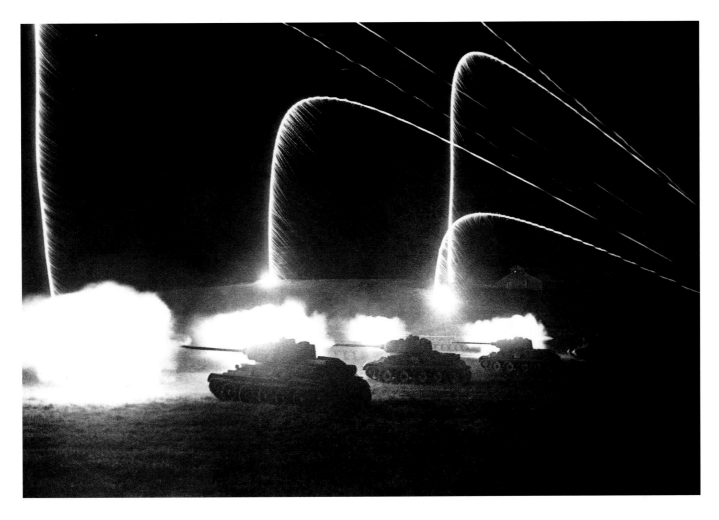

Tank Battle at Night, 1943—
On July 4, 1943, almost 6,000 German and Russian tanks clashed near Kursk for the greatest tank battle in history. The Russians claimed victory in the last German offensive. The "backward" Soviets, and specifically their T-34 tanks, had defeated German technology.

of the "L'Internationale" and other patriotic tunes broadcast from an armored car, while the fighting was still going on. Land mines were exploding all around, but old women and children were enthusiastically passing out flowers and kisses to the soldiers, who were appalled by the desolation around them. Of Orel's original 114,000 inhabitants only 30,000 were left; more than half of their dwellings had been destroyed. The joy of liberation was matched by the growing awareness of how immense had been the destruction wrought by the Germans. Anger mounted, as the Soviet troops passed through the wanton devastation left behind by the Germans.

The damage, admittedly, varied. In some cases the fleeing Germans did not have time to carry out their "desert policy." Yet everywhere the survivors told their horror stories of the German occupation. Only in the Ukraine, considered a German agricultural colony, did the Germans treat the local population with some restraint. But even Kharkov, the major city in eastern Ukraine, had suffered bit-

terly. When they briefly retook the city from the Germans in February 1943, the Soviet forces found only three hundred fifty thousand people left of the original nine hundred thousand. In the center of the city most of the high-rises were burned out, the undamaged ones heavily mined. The Germans had tried to wipe out the local intelligentsia, closing all educational institutions except some elementary schools. From this city, terrorized by public hangings, thousands of men and women had been deported as slave labor; sixteen thousand Jews had been killed. Ukrainian nationalists enjoyed no sympathy, despite their hostility to the Soviet Union. Launching a local counteroffensive revenging their defeat at Stalingrad, the Germans soon reconquered the city, somewhat muting their arrogance—after Stalingrad they wanted more cooperation from the local population. Yet when they arrived, they murdered two hundred patients and burned down their hospital.

German cruelties were at their worst in the killing of Jews in Kiev. Soon after they had taken the capital of the Ukraine in the fall of 1941, they marched some thirty-four thousand Jews—men, women, and children—to a ravine known as Babi Yar at the city's outskirts, stripped them naked and machine-gunned them to death. Soon thousands of others—Communist officials and prisoners of war— were added. Before they abandoned Kiev in the fall of 1943, the Germans employed slave labor to burn the putrefying corpses in huge pyres, in the hope of covering up one of their worst crimes. Horrifying indeed was the evidence of German contempt for the Untermenschen in their conquered eastern lands. Yet by the end of the year two-thirds of the German-occupied territories (including Kharkov) were liberated.

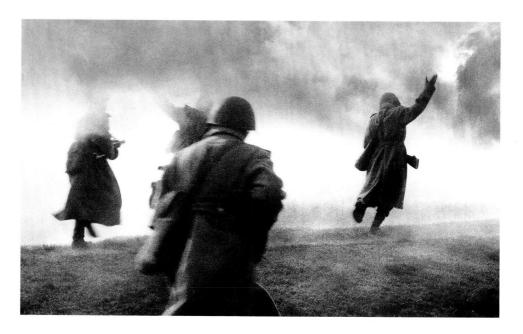

Forward, 1943

VIII

Nineteen forty-four was "the year of ten victories" by the Red Army, now numbering seven million soldiers. The first victory accomplished the liberation of Leningrad after its nine-hundred-day siege. Here again the Red Army staged a massive military buildup, greater than at Stalingrad. In 1943 the long-suffering Leningraders, now shrunk in numbers to six hundred thousand, had somewhat improved their lot with the help of American food supplied through a new access route, while still suffering from heavy bombardments. Now they recovered from their anguish, while the German retreat revealed the pilfering and destruction of the splendid tsarist palaces on the city's outskirts. Despite the heavy damage to their city and their continuing hardship, the survivors were determined to celebrate their heroism. They proudly planned a renaissance for their Western-oriented famous city—which eventually got them into trouble with Moscow-based Stalin.

In February Germany's final catastrophe on Soviet soil took place at Korsun, a small town fifty miles south of Kiev. Here the Red Army troops encircled a German force of eighty thousand men. They were forced into a narrow valley, where their equipment was shattered by tanks. Then, as the commanding officer described it, the Cossack cavalry, brandishing sabers, finished them off. "We let the Cossacks cut up as long as they wished. They even hacked *off* the hands of those who raised them to surrender." Thereafter the Soviet forces raced west through the deep spring mud toward Romania. In April and May other Soviet units took Odessa on the Black

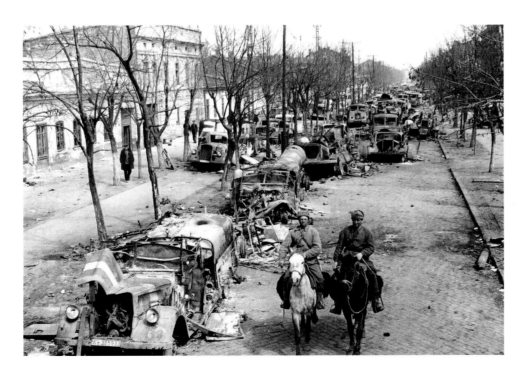

Inspecting the German Losses on
the Outskirts of Odessa, 1944

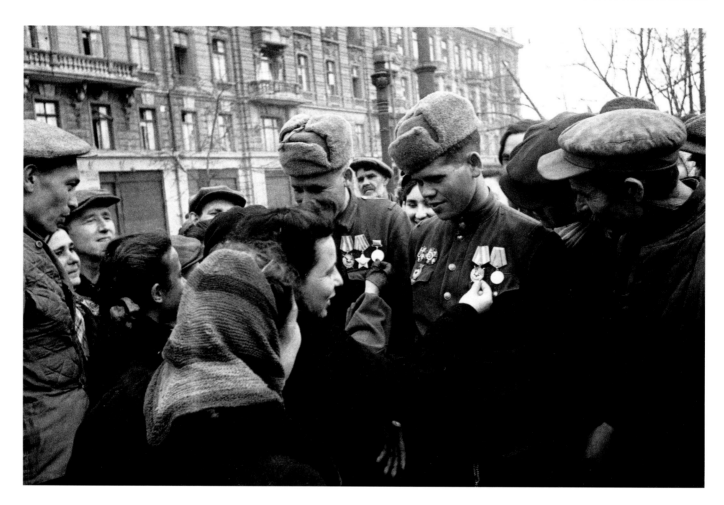

Inspecting the Heroic Troops
Near Odessa, 1944—
*Under German control since 1941,
Odessa and the Crimea were
liberated by the Red Army in April
and May of 1944. After seeing their
city devastated by the German
occupation and the Soviet counter-
offensive, the citizens of Odessa
happily welcomed their liberators.*

Sea and drove the enemy from the Crimea, one of Hitler's favorite areas which he wanted defended to the last drop of blood. In early June the Allies at last opened the second front, urged by Stalin since the fall of 1941. They landed on the Normandy coast in the biggest amphibious operation on record. Thus encouraged, the Soviet armies moved into Belorussia, reduced by the Germans to a "desert zone." Soon they advanced into Poland to the gates of Warsaw. Meanwhile in the north the Finns had been defeated and the Baltic states of Estonia and Latvia reconquered. In the south the Soviet troops took over Romania, advancing by the end of the year into Hungary and eastern Czechoslovakia.

These victories continued to exact a high toll of men and weapons, as the Germans desperately fought back. In addition, the Soviets now moved into non-Russian territories, where anti-Russian sentiments were traditional. In the Ukraine, nationalists bent on Ukrainian independence fought the Russians well into 1947. In Poland likewise, anti-Russian forces survived. And what of the Soviet soldiers' reaction to the bourgeois style of living in the conquered territories? When they

entered the department stores in Bucharest, the capital of Romania, they could not help drawing comparisons with the empty shelves in their homeland; party watchdogs had cause for concern. At the same time voices in Moscow questioned the loyalty of their British ally: would it not be to Churchill's advantage to conclude a separate peace with Hitler in order to keep the Communists out of Europe? As they advanced, the Soviet troops, like Soviet opinion, confronted the cultural differences dividing Eurasia from the West.

Two events of that year merit special attention, both related to the Soviet move into Poland. In July the Red Army discovered the German extermination camp at Maidanek, a sophisticated death factory equipped with six gas chambers, each able to hold more than two hundred people at one time, and with furnaces nearby to burn the dead bodies (and cabbages grown on the ashes). Witnesses also reported that on a particular day in November 1943, ten thousand Jews had been shot in the neighboring woods. The stench of their bodies was still noticeable. The belongings and clothes of the victims had been carefully collected for shipment to Germany. Altogether about one and a half million lives had been wiped out in a carefully designed ruthlessness which shocked the Russian soldiers already familiar with German brutality. Maidanek was the first German death camp discovered in the war, but the Western media refused to accept the evidence reported in the Soviet press. With these sights in mind, Soviet soldiers moved on toward Warsaw.

Here they ran into fierce German resistance and a major political controversy. During the entire war Poland had been a divisive issue: where should Poland's eastern boundaries run? The Polish state created after World War I had included territories belonging to the Russian Empire, while the Nazi-Soviet Pact of 1939 had restored the losses to the Soviet Union. Which boundaries should now prevail? Polish patriots based in London claimed the original boundaries with Churchill's support. Soviet-sponsored Poles in the Soviet Union insisted on the 1939 settlement. Both factions maintained their own armed forces, prepared for civil war. Now as the Soviet armies closed in, patriotic Poles staged an uprising, hoping to liberate their capital from the Germans before the Russians arrived. Unfortunately the Germans crushed the uprising, destroying about nine-tenths of the city and killing three hundred thousand people before being driven out in January 1945.

Why then had the Soviet army, poised on the city's outskirts, not come to the rescue? Was it because Stalin wanted the anti-Russian Polish patriots to be defeated by the Germans before his troops dominated their country? The Soviet high command pleaded innocence, saying it had not been consulted by the Warsaw Poles. In addition, the Red Army, engaged in bitter fighting in the Balkans, did not have enough troops for successfully attacking the well-entrenched German defense of Warsaw. True enough. But did the disaster of the Polish patriots

in Warsaw not also suit Soviet interests? The issue has simmered ever since.

Meanwhile, on the highest level of international relations far above the sound of battle, the long road to victory was smoothed by several significant events. The first of which was the dissolution of the Communist International in May 1943. During the war international communism had exercised no influence, so its demise was more of a symbolic than organizational significance. What counted was the need for Anglo-American support. Next, in late November, came the Teheran Conference in Iran, the first wartime gathering of the three crucial heads of state—Churchill, Roosevelt, and Stalin; the latter, for once, was willing to leave his country. At Teheran the three leaders demonstrated their unity, agreeing to political cooperation after the war under a European Advisory Commission foreshadowing Soviet membership in the United Nations. Stalin was assured that a second front would soon be opened in Europe. His goodwill was secured by the American promise of a $7 billion loan after the war (never delivered), but the Polish issue was left unresolved. When victory came in sight, a still more important conference was held in February 1945 at the recently liberated Crimean resort of Yalta. Here, on his home territory, Stalin enjoyed one advantage: the Anglo-American second front, started in June 1944 and now entering Germany, was held up by the Battle of the Bulge, while the Soviet armies stormed ahead. Would they be the first to reach Berlin? Relations were nevertheless remarkably cordial. Agreement was reached over the unconditional surrender of Germany, the eradication of German militarism and Nazism, and German reparations to both the Western powers and the Soviet Union. Stalin accepted Roosevelt's terms for Soviet membership in the United Nations, gaining in return recognition of eastern Europe, including Poland, as a Soviet sphere of influence. Satisfied with this major concession, Stalin also agreed to Soviet participation in the war against Japan, rewarded with minor territorial gains in the Far East. He had now emerged as a major figure in world affairs.

Both at Teheran and Yalta the Western statesmen observing him closely gathered rather favorable impressions. Stalin shared the peculiarly Russian capacity for radiating goodwill to foreigners, acting as an even-tempered and skillful negotiator. By displaying a fine sense of humor, he also manifested the power of his personality. His command of detail astonished the Western military experts. At Yalta he regularly worked five hours after midnight to keep in touch with his generals. In the company of Churchill and Roosevelt he certainly matched their stature, while thanks to Soviet victories his country had risen to a new preeminence in the anti-German coalition. The Yalta Conference marked the high point in wartime cooperation between the Soviet Union and its Western allies. Thereafter the differences again asserted themselves, as the Soviet armies moved into Germany.

IX.

After three years and eight months of bitter fighting, the Great Fatherland War was now carried to its conclusion on German soil and among the German people. How were the Soviet soldiers to treat their enemy? As the leading Soviet journalist in Moscow, Ilya Ehrenburg, declared, when the Red Army crossed the border: "Not only divisions and armies are advancing on Berlin. All the trenches, graves and ravines filled with the corpses of the innocents are advancing on Berlin, all the cabbages of Maidanek and all the trees of Vitebsk on which the Germans hanged so many unhappy people. … We shall forget nothing. As we advance … we have before our eyes the devastated, blood-drenched countryside of Belorussia …; the hour of revenge has struck." And so the Red Army stormed into East Prussia, destroying factories, killing people, and raping the women. No German woman was safe from the Soviet soldiers. Aware of their vulnerability, German women committed suicide as the Red Army approached. Venereal disease became widespread.

Fun Break at the Front on the March Toward Berlin, 1945

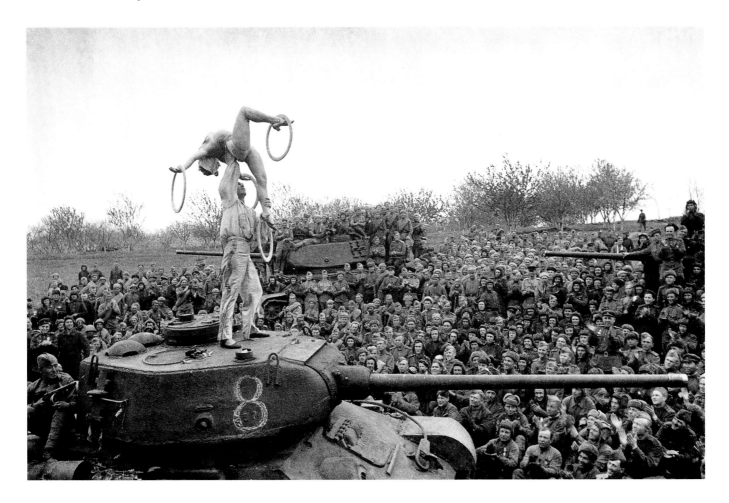

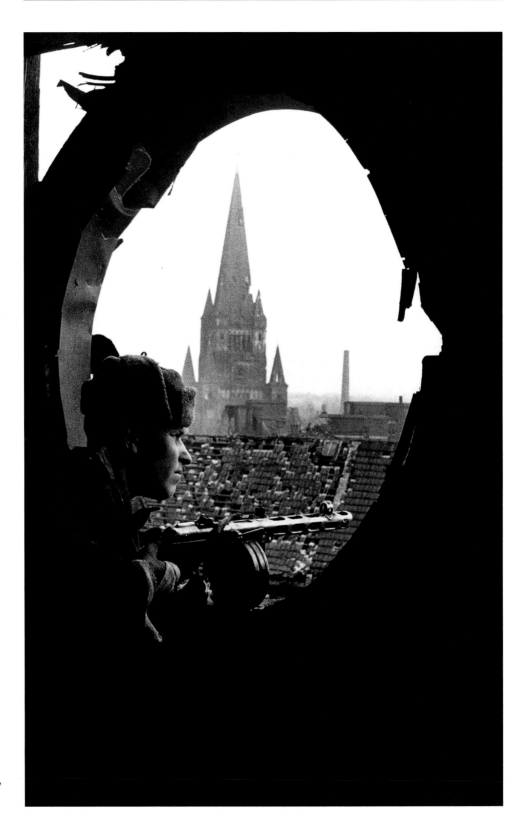

Guarding the Captured Town,
Germany, 1945

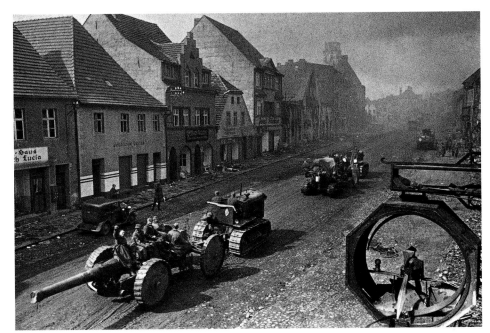

On the Road to Germany, 1945—
*The image of time played a central role
in several of Baltermants's photographs.
As the Red Army advances toward
Berlin, a destroyed clock face is visible,
symbolic of time halted in this devas-
tated village.*

Fording the Oder River, December
1944—*By late 1944 the Red Army had
repelled the Germans from Soviet soil.
The Soviets took the offensive, driving the
Germans across Poland in a final push
toward Berlin and German surrender, a
goal they attained within six months. The
crossing of the Oder, the major river on
the way to Berlin, was as symbolic as the
American photo of U.S. soldiers planting
the flag on Iwo Jima.*

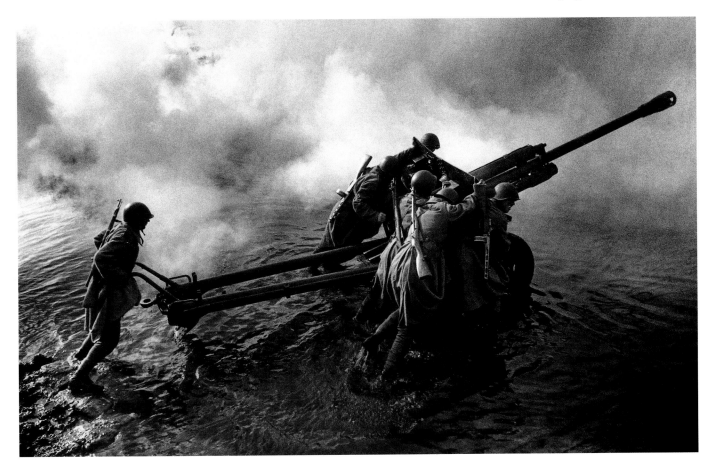

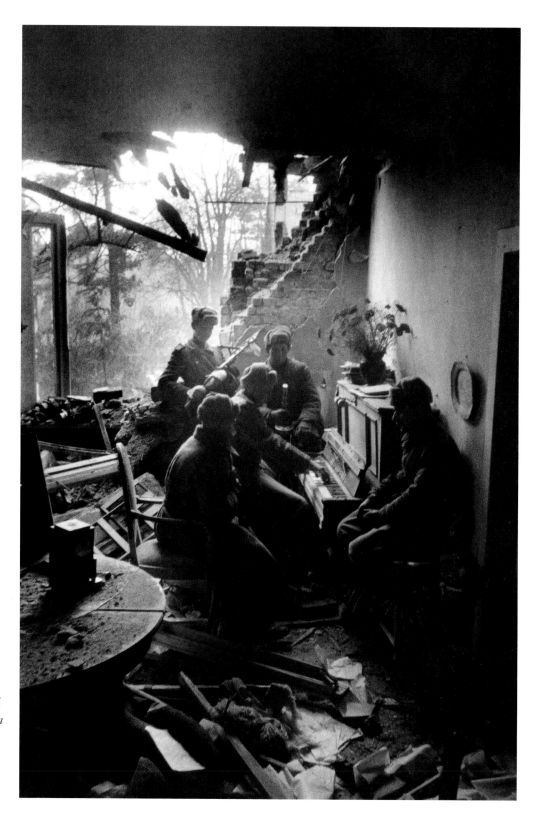

Tchaikovsky, 1945—
*In a moment of calm toward
the end of a war that claimed
over twenty-seven million lives,
a group of Soviet troops is
shown listening to music played
on a piano, the only survivor in a
ruined house. Baltermants was
able to capture an image of
beauty in the midst of the death
and destruction of war.*

Yet attitudes in Moscow soon changed. The rampage of the Soviet troops, compared with the more humane conduct of British and American soldiers, stirred up traditional anti-Soviet prejudices. In addition, Stalin realized that he needed German resources for both rebuilding his country and supporting his troops abroad. Repaying the Germans in kind did not serve Soviet interests. Thus the Soviet revenge was controlled. Soviet soldiers began to appreciate the amenities of life in eastern Germany. Stalin himself eventually introduced a conciliatory note, proclaiming: "Hitlers come and go, but the German people and the German state go on."

In the spring of 1945, however, Hitler was still holding out in Berlin, fanatically defended by loyal troops against the overwhelming Soviet onslaught. The battle for Berlin surpassed all previous battles in fury, involving—according to the official Soviet history—3.5 million people on both sides, plus 50,000 guns, 8,000 tanks, and more than 9,000 planes. The Red Army alone lost more than 300,000 men, while the German casualties were much higher, not counting the 450,000 prisoners captured during the fighting. The bombardment of Berlin was the biggest ever, devastating the center of the city with its historic buildings and administrative offices, and killing one hundred thousand civilians. At the height of the battle, on April 30, Hitler committed suicide. On May 1 Soviet soldiers hoisted the Communist red flag, complete with hammer and sickle, over the burned-out Reichstag, the most impressive building dominating Berlin's smoldering ruins. On the next day the Soviets captured seventy thousand Germans soldiers left in Berlin.

Six days later, the Germans officially surrendered. The Great Patriotic War had ended in a triumphal victory, officially celebrated in Moscow fortissimo, with fireworks, speeches, and public spectacles the following month. Stalin, now calling himself Generalissimo, presided at the victory parade, in which General Zhukov reviewed the troops. Stalin, the Russian patriot, had already praised the Russian people as "the most remarkable of all the nations of the Soviet Union." Despite the many mistakes made by the government during the war, the Russian people had remained loyal, bearing the brunt of the war to the end. Now he also paid tribute to "the small people," "the little screws and bolts" without which the war machine could not have achieved victory. Did he say this in the midst of the bemedaled gold-braided officers in order to put them down (as many listeners suspected), or, more humanely, to convey at this historic moment a sense of an all-inclusive community so urgently needed among his quarrelsome people?

Amidst the continuing hardships, the joyful mood prevailed for a few months. People felt immense relief from the miseries of war (the unfinished war against Japan had little effect on public opinion). They took pride in the victory they had achieved—yet at what an appalling price! For the Soviet Union, the

This Way to Berlin, 1945— *All Soviets were expected to participate in the war effort against Germany. Although primarily used as workers in wartime factories, women, like their American counterparts, also served in the army due to the large losses of men in the first part of the war.*

Resetting the Hands of Time, 1945—*In May 1945 the Germans, defeated and demoralized, finally surrendered to the Soviet army. To symbolize their victory, clocks were reset to Moscow time.*

Victory in Europe Celebration, Red Square, May 9, 1945

The Victor (The Superior Race), 1945—*A Soviet soldier stands mockingly in front of an armored German knight. For all the rhetoric about the supremacy of the Aryan race, the Germans were ultimately destroyed by the multiethnic Soviet army.*

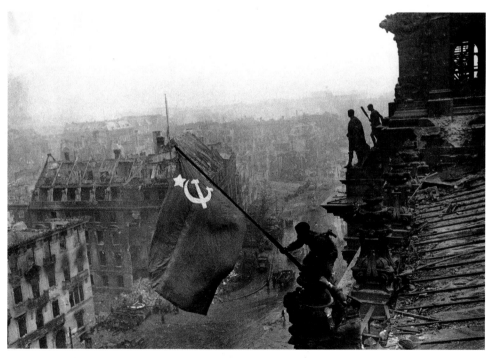

Soviet Soldiers Hoisting the Soviet Flag Over the Reichstag, 1:45 P.M., April 30, 1945 (Photo by Yevgheny Khaldai)

costs of war had been stupendous. By a rough account, 7.5 million soldiers had been killed in battle, while the overall loss of human lives is now estimated at twenty-seven million, the majority of them civilians. In addition vital parts of the country had been devastated, the survivors dislocated, their lives upset. Vital routines in education, health service, and family care had been disrupted. The cruelty of war had permeated all of society, in this vast poor country further impoverished by the war.

X.

After the superhuman effort of the war years, the Soviet people expected continuing gratitude from Europe and America. After all, they had broken the back of the German forces and made the Allied victory possible. But Europeans had their own problems, and Americans characteristically forgot the details of the war once the soldiers were home. Postwar relations between the Soviet Union and the West swiftly

Soviet and Allied Commanders Meet Near the Elbe River, April 1945—*The Soviets and the Allied powers recognized that the defeat of Germany was essential; for the Soviets, it was necessary for national survival, while the Allies were motivated by the desire to destroy Hitler's European dominion. To this end, a friendship was forged. Within one year, however, the alliance between the Soviets and the Allies began to unravel as both sides attempted to assert their power over a world devastated by war. The cold war had begun.*

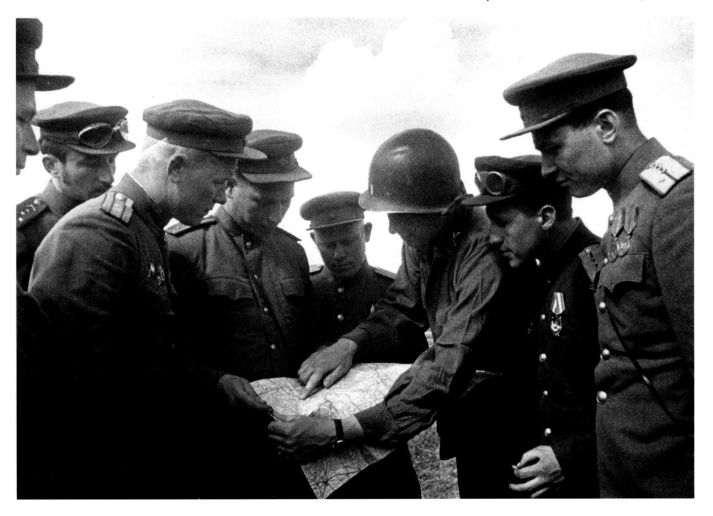

Father's Sacrifice for the Home-land, 1946—*Though ultimately victorious, the Soviet Union had been devastated by the war, suffering more casualties than any other nation. In the midst of this loss, Stalin urged the citizenry to move forward. In this poignant scene, the characteristics of an ideal Soviet home are displayed (the pet cat, the son playing violin, the grandparents), but there is no father. He gave his life to ensure the survival of the motherland and to preserve family life and Russian culture.*

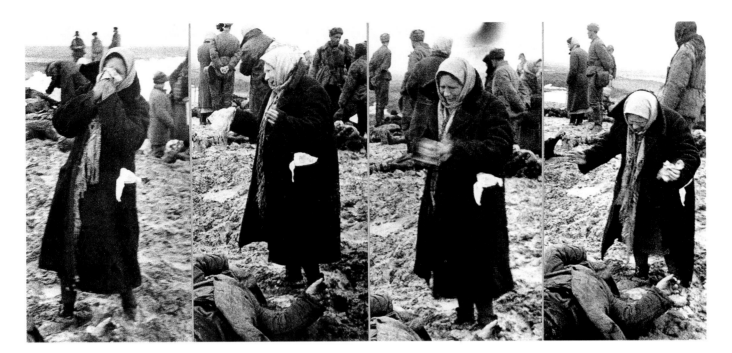

eroded all residual Allied friendship. Fifty years later, in 1995, the Russians remembered the war as their central experience of the twentieth century, but only 49 percent of Americans were aware that the two countries had fought on the same side, let alone remembered the sacrifices that Russians had made.

No other belligerent had suffered so much. The United States, physically unharmed by the war, counted 292,000 soldiers killed in battle, plus some 920,000 wounded or otherwise disabled, the majority of them in the war against Japan. The English people had suffered 140,000 casualties from German bombardment, but their combat casualties amounted only to some 244,000. The Germans naturally paid a much higher price. Their battle casualties in the Soviet Union are estimated at three and a half million, part of their total war losses of nine million. Nearly one hundred of their major cities had been reduced to ashes. In addition, masses of Germans long resident in eastern Europe were murdered, with two million still unaccounted for; of the survivors, seven million sought refuge in Germany. There was no limit to the barbarism of war. All told, the number of people destroyed in World War II is estimated at 55 million, with the Soviet share, the biggest of all, reckoned at about 49 percent of the total.

Viewed from a detached perspective, the high price paid by the Soviet Union for its victory justified Stalin's panicky experiment with precipitous mobilization in the 1930s. What, by comparison, would have been the fate of his country, if Hitler had reduced it to a German colony inhabited by despised Untermenschen? The German atrocities during the war provided the convincing answer: Stalin

Grief (Series), January 1942—
"War is, above all, grief. War is not for photography. If, however, heaven forbid, I had to photograph war again, I would do it quite differently. I agonize now at the thought of all the things that I did not photograph."
(Dmitri Baltermants)

Zhukov and Stalin, November 7, 1946—*Marshal Georgi Zhukov (1896–1974) was the greatest Soviet military commander of World War II, leading the Red Army in the successful defense of Leningrad and Moscow, and coordinating the advance into Germany. Named a Hero of the Soviet Union four times during the war, he became a marshal in 1943. After the war, Zhukov was removed from his military command, as Stalin viewed him as a "popular" threat. After Stalin's death, Khrushchev appointed him Minister of Defense in 1957. A supporter of Khrushchev during the attempted ouster by Malenkov and others in 1957, Zhukov ensured key military support for the embattled Khrushchev. Nonetheless, he was removed from his post soon afterward.*

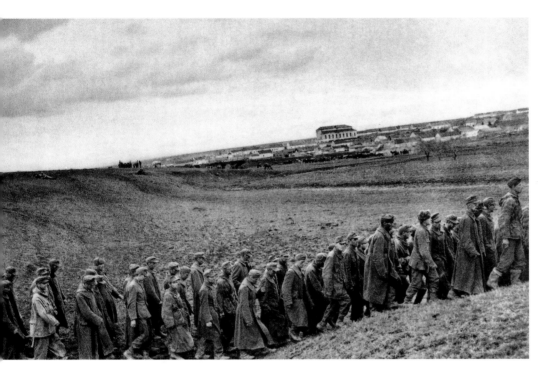

German Prisoners, 1942—
*Baltermants's photo of captured
German troops is actually a
composite image of several pictures
taken in sequence. By photograph-
ing a smaller group over time,
Baltermants was able to make the
line of German soldiers appear
larger than it actually was.*

The Victors of the
Great Patriotic War, 1945

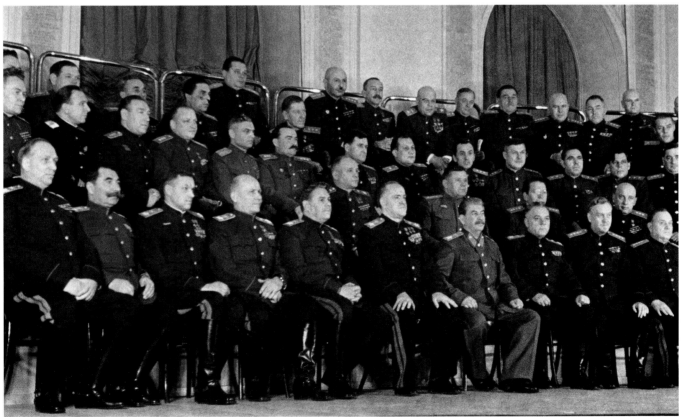

had been right. The price of a German conquest would have been infinitely worse than Stalin's terror.

This argument leads to the question: How did Stalin's atrocities compare with Hitler's? Hitler proceeded from an aggressive claim of racist superiority, deliberately employing large-scale murder in his quest for global power. By contrast Stalin, concerned with the survival of the largest country in the world, acted defensively among an anarchic and brutal people endangered by foreign conquest. What did individuals count when the fate of their country was at stake? How much, anyway, did they count in the Eurasian vastness? The cruelty of the Gulags was partly the product of extreme poverty, harsh climates, and the ruthlessness of life generally. The war added further inhumanity.

From the start, World War II in eastern Europe had produced an orgy of brutality among all participants, beginning with the German invasion of Poland in 1939, during which the Poles, in retaliation, killed nearly sixty thousand Germans long settled in their country. Under the Eurasian style of warfare, no side adhered to the rules of the Geneva Convention. History and geography did not supply the supportive human values.

The treatment of the prisoners of war by both Soviets and Germans was a disgrace. Of the 91,000 Germans captured at Stalingrad, only 18,000 survived the long trek to their prison camp in Central Asia; only 6,000 eventually found their way home. Of the 3 million Germans in Soviet captivity, only 1.9 million were repatriated. The fate of the Soviet prisoners in Germany—more than five million of them by May 1944—was even worse. By the end of the war 60 percent had perished from various forms of maltreatment. And pity those who returned; they were imprisoned in Gulags, accused of disloyalty for surrendering rather than fighting to the end.

Stalin's dictatorial impatience certainly contributed to the wastage of human lives. When setting certain goals for his generals, he commanded: "This task must be carried out regardless of losses." What counted for him, as for Hitler too, was the indomitable will for victory, regardless of the prevailing military reality. In the fall of 1941, for instance, Stalin ordered his troops, in defiance of his military advisers, to cling to Kiev then encircled by the Germans. Timely evacuation would have saved six hundred thousand Soviet soldiers. Throughout the war Stalin used terror to discourage disloyalty or lack of discipline. And woe to the ethnic minorities who might be tempted to cooperate with the Germans—Tatars in the Crimea, Chechens and other mountain tribes in the Caucasus, or the Volga Germans settled in Russia since the eighteenth century. All were chased east and north into Central Asia. Ever suspicious and overwhelmed with his responsibilities, Stalin

tended to deal with abstract categories of people, rarely with individuals—like Hitler in regard to Jews, Gypsies, or Russian Untermenschen.

The Great Fatherland War, the longest and most brutally conducted military encounter in World War II, was part of the cruel Soviet experience, but with a positive outcome. The Soviet Union, now reaching into central Europe, enjoyed greater territorial security and global prestige than at any time in the long history of the Russian Empire. And at the July/August 1945 Potsdam Conference that wrestled with the innumerable details of the decisions taken at Yalta, Stalin emerged as the only wartime statesman still in power. Roosevelt had died in April, succeeded by Harry Truman, while Churchill was unseated during the conference by the election victory of the Labour Party and his chair at Potsdam taken by Clement Attlee. But despite his new preeminence, Stalin's task as the Soviet leader was far from finished. The Great Patriotic War was but a glorious interlude in the bitter evolution of Stalinism. Victory in that war had not overcome the deepest insecurities of state and society in the Eurasian vastness. The aging Stalin, his health affected by the tensions of the war, had to continue his effort to help his country overcome its backwardness.

Stalin's Last Years

Despite the glories of victory and the impressive force of the Red Army, Stalin was still keenly aware of his country's continued weakness. Throughout the battle zone, towns and cities were in shambles. The countryside was devastated, with food production critically low, having been aggravated by widespread drought in 1946. Industrial productivity had fallen below prewar levels. In the workforce, and in society generally, women greatly outnumbered men. Children grew up without fathers. Wherever one looked, the conditions of life were miserable, especially since President Truman had canceled American wartime assistance, including vital food supplies, immediately after the end of the war in Europe.

At the same time—and worse from Stalin's perspective—the elation over the end of the war induced widespread yearning for relaxing the harsh political controls; with victory achieved, were they still necessary? People felt tempted to assert again their hopes for a better life, craving above all material comfort, better food, and more comfortable housing. Increased contact with Western lifestyles in the occupied countries whetted Soviet appetites. Milovan Djilas, an ascetic Yugoslav Communist, was dismayed by the luxurious self-indulgence of Soviet missions stationed in Belgrade. The reports of returned soldiers intensified the trend. American films drew admiring audiences. The unavoidable opportunities for envious comparison with Western life undercut all indoctrination about Soviet superiority. And in Moscow how arrogantly the wives of high-ranking army officers displayed their social preeminence! More alarmingly, the popularity of their husbands was a threat to Stalin's preeminence. Inevitably Stalin, suffering from the heightened insecurity of advancing age, dreaded the effects of contact with

Twenty-fifth Anniversary of Lenin's Death, Bolshoi Theater, 1949 (opposite page)

the outside world. He was determined to raise again the protective political and ideological fences mandatory in the Soviet system.

I.

The postwar years revived Stalin's deepest prewar fears as Soviet relations with its wartime allies deteriorated. The expansion of Soviet power into eastern and central Europe caused apprehension among Western statesmen afraid of communism. They were eager to limit Stalin's control over the states occupied by the Red Army, counting on the political clout gained by the American atomic bombs dropped over Japan. In February 1946 Stalin openly admitted that under the persistence of capitalist imperialism another war threatening the Soviet Union was likely sometime in the future. Preparing for it, he not only stepped up work on Soviet atomic weapons but also revived the vision of a Communist world revolution under Soviet auspices.

In the same month, responding to that challenge, George Kennan, a high-ranking American diplomat stationed in Moscow, warned his government that the Soviet Union represented "a political force committed fanatically to the belief that with the U.S. there can be no permanent modus vivendi, that is desirable and necessary that … our traditional way of life be destroyed, the international authority of our state be broken." And a month later, in March 1946, Churchill declared to an American audience that "An iron curtain has descended across the [European] Continent," separating Communist Eastern Europe from the Western democracies and threatening military confrontation.

Thus, early in 1946, the stage was set for the cold war, pitting the two mightiest countries, soon called superpowers, against each other, each representing a universal vision of peace and social harmony. The West, led by the rich United States, promoted the worldwide application of its guiding values. The Soviet Union, comparatively disadvantaged, propagated its Communist ideals as the best solution for the world's ills.

Tragically, the leaders of both camps were utterly ignorant of the complex political and psychological dynamics at work among their opponents on the other side of the impenetrable ideological and cultural divide. Their fear-driven incomprehension aggravated the cold war. Yet they shared one common conviction: a hot war fought with atomic weapons would destroy both countries, which, however, did not keep their rivalry from escalating. Every gain on one side in weapons or political power had to be matched by the other side, as the confrontation spread around the world. With the rise of the Soviet Union as a superpower, global politics acquired a new intensity.

The cold war rivalry rapidly escalated year by year. In July 1947 the United States launched the Marshall Plan, financing the economic recovery of Western Europe. In October the Soviet Union promoted cooperation among the European Communist parties through a new Communist Information Bureau. In 1948 economic, social, and military consolidation in Western Europe progressed under the auspices of Britain, France, and the Benelux countries, while the Soviets imposed their totalitarianism on their Eastern European satellite countries (except for Tito's Yugoslavia, which broke away from Stalinist communism).

In July of that year a bitter contest arose over Berlin, located within the Soviet zone of occupation yet divided into West Berlin, governed by the Western Allies (the United States, Britain, and France), and East Berlin under Soviet rule. Determined to control all of Berlin, the Soviets suddenly barred the Western powers from overland access to West Berlin, forcing them to organize a year-long airlift into the city. The confrontation led in 1949 to the establishment of the Western-oriented Federal Republic of Germany and the German Democratic Republic under Communist rule. Meanwhile the Soviet-dominated Council for Mutual Economic Cooperation tried to match among the Soviet satellites the benefits of the Marshall Plan.

Even more significant in 1949 was the creation of the North Atlantic Treaty Organization (NATO), a power bloc joining the United States and Canada in North America with England, France, Italy, Portugal, Denmark, and Norway. Meanwhile in the Far East Mao Zedong's Communists had taken control of China, boosting the worldwide appeal of communism (with some misgivings on Stalin's part). In 1950 the North Korean Communists invaded American-backed South Korea, starting the Korean War. Communist agitation even began to stir up rebellion among the colonial peoples. The Communist world revolution was progressing.

In this manner global power politics expanded during Stalin's last years, stretching the Soviet sphere of action far beyond what it had been during the 1930s, while adding to its vulnerability. The aging Stalin had reason not only for reimposing strict socialist discipline enforced by terror, but also for resuming his patriotic drive to match the eminence of the United States, now standing, according to Churchill, "at the pinnacle of world power." Yet even the United States had become vulnerable because in August 1949, several years earlier than predicted, the Soviet Union tested its first atomic bomb.

Be Careful, It's Nuclear, late 1950s—*Struck by the awesome potential of nuclear energy, Stalin launched the Soviet atomic program in the early 1940s, enlisting the support of Western spies. In 1949 the first Soviet atomic bomb was tested, four years after the Americans had dropped atomic bombs on Hiroshima and Nagasaki, Japan. An intensified drive to catch up to the Americans led to the first Soviet hydrogen bomb in 1953, a mere nine months after the Americans had tested their hydrogen bomb. Beyond its destructive use, however, atomic energy was also used for electrical generation. Although efficient and cheap, the use of atomic energy posed dangers to the environment and citizens living near nuclear plants. This danger became reality on April 26, 1986, when a reactor exploded at the Chernobyl nuclear plant near Kiev. Deadly radiation was released, killing hundreds and causing mutations in animals and humans, as well as rendering the surrounding landscape barren.*

II.

Soviet espionage had tracked the development of nuclear technology in England and the United States since 1941, recruiting a number of effective agents, including Julius and Ethel Rosenberg and, most significantly, Klaus Fuchs. The latter, a refugee from Nazi Germany and a Communist by conviction, was a physicist engaged in atomic research in England. After the German attack on the Soviet Union, he informed Soviet agents of what he had learned on the subject. In 1943 he was transferred to the Manhattan Project, the American atomic weapons center, reporting to his Soviet contact about the work in progress. At that time Soviet physicists began designing an atomic bomb, although Beria, their political

boss, was skeptical of the information received from spies. When briefed by a scientist, he snapped: "If this is disinformation, I will put you all in the cellar." Immediately after the United States dropped an atomic bomb on the city of Hiroshima, Stalin recognized the value of the deadly weapon. He commanded that under Beria's authority a Soviet bomb be built as quickly as possible, regardless of the costs (including radiation sickness among scientists and Gulag prisoners involved in the project). Soviet expansion into Czechoslovakia and East Germany provided badly needed uranium, while German scientists also came to help.

But by 1947, Soviet physicists were under criticism for their "unjustified admiration for foreign culture" implicit in the copying of American bombs. For a time attacks on bourgeois science threatened the hardworking Soviet physicists. But then Stalin stepped in, telling Beria: "Leave them in peace. We can always shoot them later." In any case, while the first Soviet atomic bomb tested in 1949 essentially copied the American plutonium bomb, the subsequent development of the more powerful thermonuclear (hydrogen) bomb was largely the result of Soviet efforts. It was tested in August 1953, nine months after the first American thermonuclear test.

By the early 1950s, the scientific community in charge of the Soviet atomic bomb project had achieved impressive results. Despite the enormous strains of the postwar years, it had created an advanced industry which undergirded the Soviet Union's role as a superpower. Somehow, in its last years, the Stalinist system had lived up to its guiding ambition: to match, in a key aspect of global power, its American rival. It possessed vitality amidst continuing weakness.

III.

Convinced that the core of Soviet weakness lay in industrial and technological backwardness, Stalin had already launched a new Five-Year Plan immediately after the end of the war. It promoted heavy industry, strengthened by new technologies developed during the war, all supplied with the essentials: steel, oil, and coal. In 1946 Stalin set ambitious targets for the essential industries: within fifteen years, steel production was to increase more than four times, while oil and coal production would increase three times (all the goals were actually surpassed by 1960).

As in the past, the peasants gained least under the new Five-Year Plan. The discipline of the collective farms was tightened, and the peasants' incomes reduced. The benefits of the revived economy were instead passed to the urban population. Rationing ended in 1947. More goods became available. Above all, towns and cities were rebuilt with impressive speed by dedicated workers.

Funeral of Mikhail Kalinin, 1946—One of the early Bolsheviks to have survived the purges of the 1930s, Kalinin(1875–1946) died of natural causes. Among the dignitaries carrying his bier are Stalin (front left), Vyacheslav Molotov (front right), and Beria (middle right). Molotov (1890–1986) had a prestigious political career, serving as the Soviet prime minister from 1930–1941, and as Commissar for Foreign Affairs from 1939–1949. In this role he was responsible for the Molotov-Ribbentrop nonagression pact, signed between the Soviets and the Nazis in 1939, stating that both sides would remain neutral in the event of a third-party attack, and dividing Poland between the two nations. Molotov served in this post a second time from 1953–1957; he was stripped of his party membership after he had taken part in the attempt to oust Khrushchev. He served as ambassador to Mongolia, and subsequently Vienna, until his retirement in 1962.

The urban ambiance improved, raising the standard of living and expectations of an easier life. Meanwhile, as its weapons were updated, the Red Army was significantly reduced, releasing badly needed manpower into the economy, but also downgrading the role of the popular wartime generals. Marshal Zhukov was assigned to a low-level post. Public admiration was monopolized by the Communist Party.

Amidst these postwar changes Stalin prepared his defense against the most subversive danger: the lures of Western life. As his current confidant Zhdanov, now transferred from Leningrad to Moscow, proclaimed in 1946: "Does it become us, representatives of advanced Russian culture, Soviet patriots, to play the role of worshippers of bourgeois culture?" Thus began the Zhdanov era with its intense search for cultural saboteurs. Leningrad was especially suspect because of its provocative civic pride and the brilliance of its intellectual elite. Among its leaders Anna Akhmatova, long admired for her poetry, suddenly found herself called "not exactly a nun, not exactly a whore, but half nun and half whore, whose whorish ways are combined with praying." The satirist Mikhail Zoshchenko was attacked for his "mischievous hooliganlike representations of our reality" and his anti-Soviet attacks. He had written a story about a monkey who found life in a Soviet city too confusing and therefore wanted to return to the jungle or the zoo. Was he inciting other monkeys? These two literary figures, like other well-known writers, were blamed for

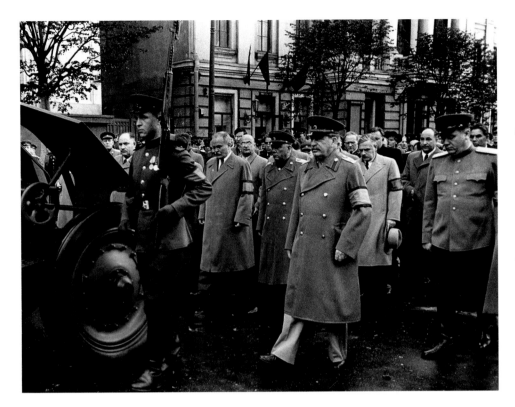

Funeral of Andrei Zhdanov, September 1948—*Zhdanov (1896–1948) was the Communist Party boss of Leningrad and an influential shaper of culture in the postwar Soviet Union. Zhdanov was the main proponent of exorcising Westernism and cosmopolitanism from Soviet thought, under strict government control. He was also one of the developers of the Cominform, which was charged with disseminating Communist propaganda throughout the world. He died under mysterious circumstances; some believed that Stalin ordered him killed.*

disorienting Soviet youths and poisoning their consciousness.

The new socialist rectitude, laced with anti-Semitism, also condemned the latest style of Western art. Modern music in Zhdanov's ear sounded like the screeching of a dentist's drill. Even Shostakovich was discredited, while jazz was outlawed. Soviet aesthetic tastes remained decidedly old-fashioned. Xenophobic Russian nationalism thus became the official party line. Stalin himself reacted strongly against foreign luxuries, including perfumes. Contact with foreigners, let alone marriage, was strictly forbidden, as was travel abroad; foreign news was tightly censored. Famous French writers including Jean-Paul Sartre, once admired by Communists, found themselves characterized as "pimps and depraved criminals."

When in 1949, after Zhdanov's death, the antibourgeois pogrom climaxed, the Leningrad intelligentsia was virtually wiped out, together with the Leningrad party organization, including Zhdanov's former associates; all records of the siege were sealed. In this manner, the "Leningrad affair" destroyed thousands who had survived the German blockade. The terror proceeded quietly, without show trials. Its victims included the prominent economist Nikolai Voznesensky, once praised by Stalin, whose textbook on the Soviet economy had become a classic.

Conflicting with the new emphasis on science-based technology, admiration for Western science was under attack. As Stalin observed in 1947: "If you

The Genes of Stalinism, 1948—
*Trofim Lysenko (1898–1976) was
the leading Soviet biologist of the
Stalinist period. An ardent follower
of Zhdanovism, Lysenko led a
movement against Western genetics,
arguing that socialism would be the
driving force behind superior plant
species. His theories stood at the
forefront of Soviet science until the
late 1950s when many of Lysenko's
theories were discredited and
orthodox genetics was restored.*

take … the scientific intelligentsia, professors, physicians, they have an insuffi-ciently educated feeling of Soviet patriotism. They have an unjustified admira-tion for foreign culture. … A simple peasant will not bow for anything, take his cap off, but these people do not have enough dignity or patriotism, do not under-stand the role that Russia plays."

Antiforeign agitation was especially keen in the field of biology. Here Trofim Lysenko emerged as the leading light, attacking Western genetic research with dubious arguments and faked experiments. It was not the inherent structure of genetics that determined plant life, he argued, but the physical environment. As human nature improved under socialism, so superior species of plants could be bred by changes in agricultural techniques (a contemporary painting shows Stalin outlining his plan for "the transformation of nature," no less). Stalin was pleased to have a biologist confirm Marxist dialectics; he enthroned Lysenko as the lead-ing scientist, who could pit socialist science against decadent capitalist science. No

more subservience among Soviet scientists to Western scientists! No more kow-towing in Soviet society to bourgeois culture in dress, words, feelings, and certainly not in politics! The Soviet Union was headed toward superiority.

IV.

In the postwar years it even gained a subtle measure of influence over its ever denounced but secretly all-powerful model, the United States; rivals always leave their mark upon each other. Ever since the end of World War I, communism had rattled conservative Americans afraid of any threat to their heritage. Now, confronted with an assertive and seemingly all-powerful Soviet Union, their apprehension revived, especially as American public opinion was caught in novel uncertainties. Never before had the United States, hitherto secure in geographic and political isolation, been so inescapably involved in world affairs. Americans felt unsure about their new global role. Was the cohesion of the American polity sufficiently strong for the new responsibilities? Was there a need for ideological and political mobilization in coping with the challenges posed by the other, the Communist, superpower?

In 1945 fear of communism, long kept alive in the FBI under its director J. Edgar Hoover, prompted the U.S. House of Representatives to create the House Un-American Activities Committee (HUAC), bent on tracking down Communist spies and sympathizers in the government and American society (including Hollywood). By 1950 it had cast its investigative eyes on a million Americans, with the help of kindred organizations, such as the American Legion and the Committee on the Present Danger, all engaged in an anticommunist crusade of ferreting out subversive elements.

Meanwhile the U.S. government had been alerted by George Kennan's messages from Moscow. Echoing Stalin, Kennan pleaded for "every courageous and incisive measure to solve internal problems of our own society, to improve self-confidence, discipline, morale, and community spirit." In 1947 President Truman followed suit by instigating a security clearance within the ranks of the government with the help of secret agents; government employees now had to swear allegiance to their country. The new Central Intelligence Agency (CIA), advised by the National Security Council, aggressively monitored American society in search of Communist agents. In 1948, under government auspices, a Freedom Train advertising the American heritage toured the country, promoting patriotic loyalty.

In 1950 the National Security Council issued its most alarming warning: "Conflict ... is waged on the part of the Soviet Union by violent or nonviolent methods in accordance with the dictates of expediency. ... With the development of increasingly terrifying weapons of mass destruction, every individual faces the

Paul Robeson, 1949—*Robeson (1898–1976), a graduate of Rutgers University, was one of the greatest actors of his day, having starred in Broadway productions of Show Boat and Emperor Jones. His leftist politics, however, made him a pariah in the United States, especially in the age of McCarthyism. He was more warmly embraced in the Soviet Union, and in 1953 received the Stalin Prize at the Teresa Hotel in Harlem for promoting peace between the United States and the Soviet Union.*

ever-present possibility of annihilation. … The issues that face us … [involve] the fulfillment or the destruction not only of this Republic but of civilization itself." In the same year Senator Joseph McCarthy began to stir up the American public with wild charges against Communist moles in their midst, 205 of them in the U.S. state department and thousands of others scattered in important positions throughout society. His special targets were the liberals who tried to promote peace by lowering the ideological and political barriers between the superpowers. According to a public opinion poll in 1954, half of the American public agreed with McCarthy. Had Stalin evoked an imitation of Soviet practices in a country adamantly opposed to Soviet methods?

Admittedly, the United States still benefited from its humane traditions and its geographic safety from foreign invasion. Its new insecurity was minimal compared with the precariousness of Soviet statehood. The terror of McCarthyism did not claim innocent human lives; only Ethel and Julius Rosenberg were executed as Soviet spies. Yet fear of the Soviet Union was now part of the American state of mind, producing a stronger and more security-conscious state, while restricting traditional democratic liberties in whose name America continued to subvert Soviet totalitarianism.

V.

There was no end to the glories bestowed on Stalin during his last years, the climax of "the cult of personality." He was called "beloved father," "our dear guide and teacher," "dear and well-beloved Stalin," "the greatest leader of all times and all peoples," and even "the greatest genius of mankind." On holidays his portrait tied to a balloon hung over Moscow, illuminated at night by searchlights. Photographs of him, duly retouched to enhance his appearance, decorated walls in public offices and homes. Novels and stories praised him; scholars quoted him in their monographs. His godlike omnipresence was the cement that held the fragile Soviet polity together.

It did not, however, impress outsiders such as Milovan Djilas, Tito's emissary in Moscow, who beheld Stalin amidst the splendor of the Kremlin as "an ungainly dwarf of a man," quite paunchy, with irregular black teeth, surrounded by marshals heavy with fat and medals and drunk with vodka. Persons closer to Stalin took an even dimmer, more apprehensive view. Khrushchev remembered that already during the war Stalin "was not quite right in the head." Subsequently, it became obvious that he was weakening mentally as well as physically. At his seventieth birthday in December 1949, he seemed old and tired, annoyed by the guests' cheers at the banquet in his honor: "They open their mouths and yell like fools," his daughter Svetlana heard him say. Aware of his frailty, he would not let

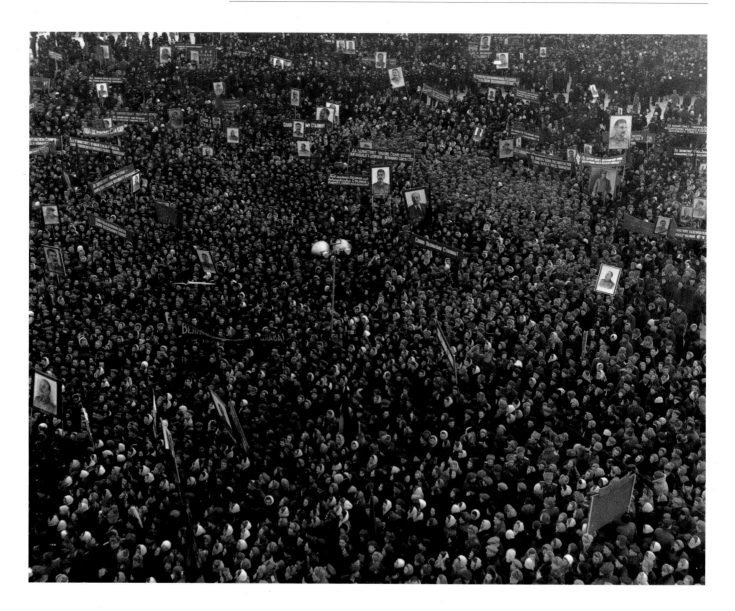

Election of Stalin to the
Supreme Soviet, Moscow, 1950

his ego be boosted by what he assumed to be hypocritical acclaim.

There was no family to comfort him. Svetlana had ceased to be close to him; her two brothers never counted. Stalin's older son, captured during the war, had been killed by the Germans. The younger one, Vasili, rapidly promoted by the air force to please his father, ended up as a hopeless alcoholic. As Stalin's loneliness heightened his sense of insecurity, his fears of assassination led to irrational precautions wherever he traveled. Even at his excessively guarded dacha he was afraid of being offered poisoned food. This weakness offered Beria, a fellow Georgian twenty years younger than Stalin and full of political savvy, his opportunity. Beria knew how to offset Stalin's inner uncertainties through flattery. "Plump,

Dinner Break in a Moscow Plant, 1952—*Baltermants's photographic prowess was not limited to images of war and industry; he was also a master of staged photography. In this image, a supervisor and a worker gather around a copy of* Pravda *to discuss the main issues of the day, reinforcing the image of equality in the workplace.*

greenish pale, and with soft damp hands … and bulging eyes behind his pince-nez," and well-supplied with young girls for his pleasure, Beria was known for his ruthlessness in interrogating a political suspect. As he once told Khrushchev: "Listen, let me have him for one night, and I'll have him confessing he's the king of England." He was an energetic and tireless worker, and was acknowledged, even by his enemies, to be a first-class administrator. In charge of domestic security in the Soviet Union, he became Stalin's tool in the cutthroat world of Kremlin politics during his master's last years.

Thus reassured, Stalin continued to work, often during his dinner parties with his closest comrades, including Molotov, Beria, Georgi Malenkov, Nikolai

Bulganin, and Khrushchev. Held late at night, their talks lasted amidst much food and drinking into the early morning (Stalin liked to see his companions drunk to the point of indiscretion). Always alert himself, he was on guard against political enemies at home, while also monitoring the rise of communism in China, the Korean War, and the progressive integration of western Germany into the European community; and he was always aware of the possibility of an imperialist attack. But how then did he find time and energy in 1950 to write a lengthy essay, *Marxism and Linguistics,* attacking a deceased Soviet linguist dominating that field? While offering no striking conclusions, that essay still showed a well-informed lively mind willing to engage in public debate.

Extravagantly praised as usual, the aging Stalin, however, was wracked by deep uncertainty about himself. Overworked, no doubt, he muttered sometime in 1951 within earshot of Khrushchev: "I am finished. I trust no one, not even myself." Obviously, underneath his outward show of masterful superiority he had retained a trace of self-doubt. His craving for power served foremost his country, not his ego. He kept control of himself, however, getting ready for the Nineteenth Party Congress to be held the following year.

In preparation he wrote another theoretical essay, longer than the first, concerned with a projected economic textbook and entitled, *Economic Problems of Socialism in the USSR.* At the end he reaffirmed his socialist creed: "The aim of capitalist production is profit making." By contrast, "The aim of socialist production is not profit, but man and his needs." Stalin's view of capitalism certainly was highly one-sided, but did it not contain an element of truth? As for socialism, he was obviously deluded by the utopian vision of transforming his huge backward country into a model of superiority. Yet the extravagant praise bestowed on his rather shallow last essays ("a new stage in the development of Marxism," "of world historical importance") concealed all shortcomings.

The Nineteenth Congress of the Communist Party, reluctantly authorized by Stalin, met in October 1952, thirteen years after the last congress. Malenkov, widely considered Stalin's successor, gave the major report, while Stalin sat in silence totally apart from the delegates; he did not attend to business. No major decisions were taken, except that some younger officials less ruthless than the old Bolsheviks rose to high positions. At last, on the final day, October 14, Stalin, seemingly in good health and austerely dressed in his gray tunic modestly adorned with the gold star of a Hero of Socialist Labor, briefly addressed the delegates.

Speaking without notes, rather slowly, with somewhat shaky diction but with some warmth, he greeted the assembled Communists. He especially cheered the foreign "brother parties" who had not yet risen to power. Looking back to his own beginnings, he assured them that they had an easier task than the Bolsheviks

Pioneers, 1953—
In addition to controlling the curriculum of the schools, the Communist Party also established voluntary youth groups to prepare young people for eventual party membership and leadership. Similar to the Boy and Girl Scouts, these groups emphasized cultural and civic duty under the aegis of communism, and were divided into three subgroups based on age: the Octobrists (7–9 years), the Pioneers (10–14 years), and the Komsomol (older than 14).

in 1917. Now the banner of democratic freedom, abandoned by the bourgeoisie, was to be raised by the Communists and their allies dedicated to creating a peaceful world. Frequently interrupted by bursts of applause, Stalin ended his words amidst tumultuous jubilation. The crowd stood up, shouting its adoration for Stalin, the leader of the world revolution and of the forces of peace among nations. The ovation, rising to the point of hysteria, lasted longer than the speech. By his grandfatherly manner Stalin had touched the hearts of his listeners.

Two days later, however, speaking to the party's Central Committee, he resumed his usual style, admonishing his yet unknown successors in the difficult times ahead: "Don't flinch, don't retreat, don't capitulate." At the same time, re-

The Announcement of Stalin's Death (The Dynamo Factory), March 6, 1953—*One day after Stalin had died of a cerebral hemorrhage, the announcement of his death was made across the Soviet Union. This photo, a composite of three negatives, captures the reaction in a Moscow factory. Across the nation, workers and citizens halted their activities, listening in grief to the news that their great leader had left them.*

vealing his inner uncertainty, he offered to resign as the party's general secretary, throwing his audience into shock. How could the country function without him? What were his reasons? Now, under Stalin's rising paranoid irrationality, a time of nightmarish uncertainty stalked his country.

In November, on Stalin's sickly suspicions, the Kremlin physicians, including his personal doctor, were accused of plotting the destruction of the party's leadership. Supported by extorted confessions of guilt from the victims (two of them died under torture), Stalin shouted at his associates: "You are like blind kittens. ... The country will perish, because you do not know how to recognize enemies." Since some of the physicians were Jewish, the "doctors' plot" set off a wave of anti-Semitism throughout the country. Suspicion also extended to Stalin's inner circle: were its members foreign agents? Inclined to panic, people expected another terror purge, or even war. And who would take Stalin's place when he died? But no matter how persistent the fears and rivalries among Stalin's close companions, no matter how sick he himself was, nobody dared to touch the magic of his authority. Unlike Hitler or Mussolini, he ruled over a victorious regime to the end of his life.

Incapacitated by a stroke at his dacha on March 1, 1953, he died on March 5. Transferred to Moscow, his body, dressed in his marshal's uniform, was put on display for the benefit of a deeply moved public. An estimated five million people from Moscow and the provinces tried to see him for the last time, crowding the streets leading to the hall where he lay in state and crushing adults and children to death where the streams of mourners converged. Stalin was their hero; he had

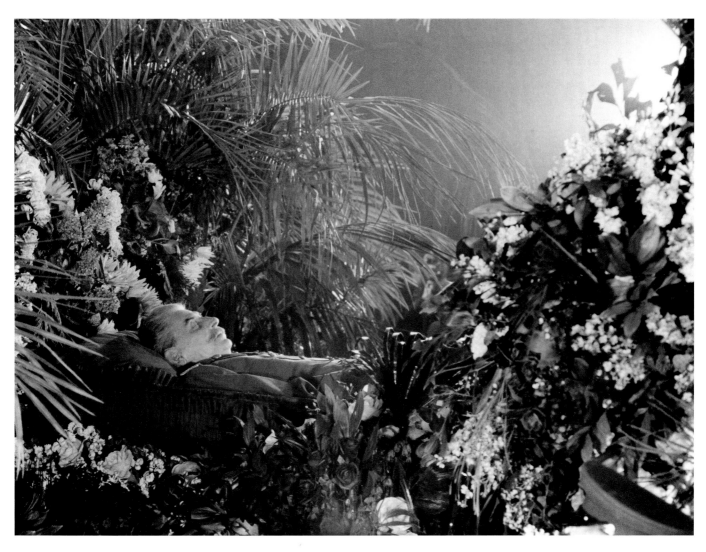

given meaning to their lives in excruciatingly harrowing times. He had saved his people from foreign enslavement and transformed his country into a super-power. He was greater than any tsar, and yet his style of living was closer to that of the common people; patriots had cause to be proud of him. After a grandly staged funeral, with a thirty-gun salute, he was placed next to Lenin, in the mausoleum on Red Square.

But there simmered, among the surviving victims of the terror and even in the ranks of Stalin's closest associates, an undercurrent of doubt, which subsequently turned into a torrent of revulsion. How then should we judge this fiercely controversial "Man of Steel"?

Stalin on His Death Bier, March 1953—In his almost thirty years of power, Stalin left a mixed legacy. He had mobilized the Soviet Union economically and industrially, establishing it as one of the world's great powers. He had success-fully led the country out of the devastation of the Great Patriotic War. But his reforms, his paranoia, and his terror emasculated the nation, leaving millions of victims in their wake. This photo was also used on the cover of Ogonyok *in 1993, commemorating the 40th anniver-sary of Stalin's death.*

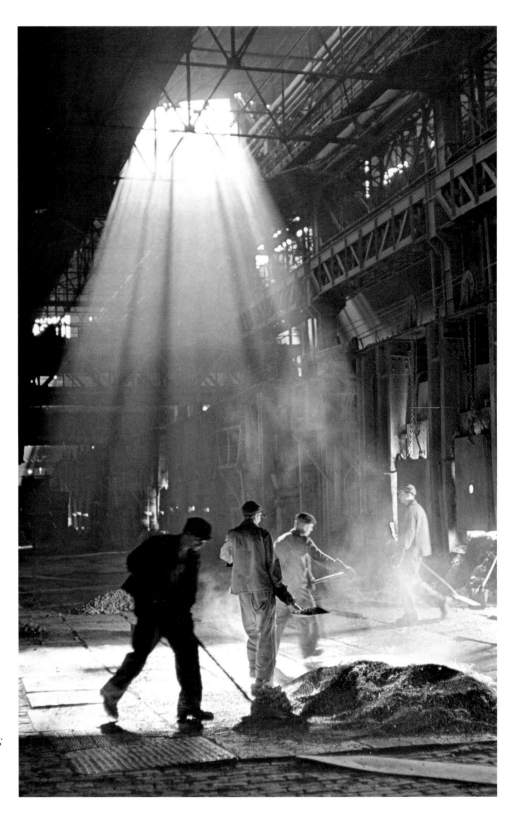

In a Steel Mill, 1949—
*A great socialist-realist composition;
the steelworkers seem to be illumi-
nated by an ethereal, almost
heavenly, light as in a cathedral.*

VI.

Stalin certainly was one of the most remarkable human beings of the twentieth century, outstanding in his energy and command over the destiny of the largest country in the world. Even Khrushchev, who ousted him from the Lenin mausoleum on Red Square, admitted: Stalin "was a man of outstanding skill and intelligence. He truly did tower over everyone around him. … He demonstrated

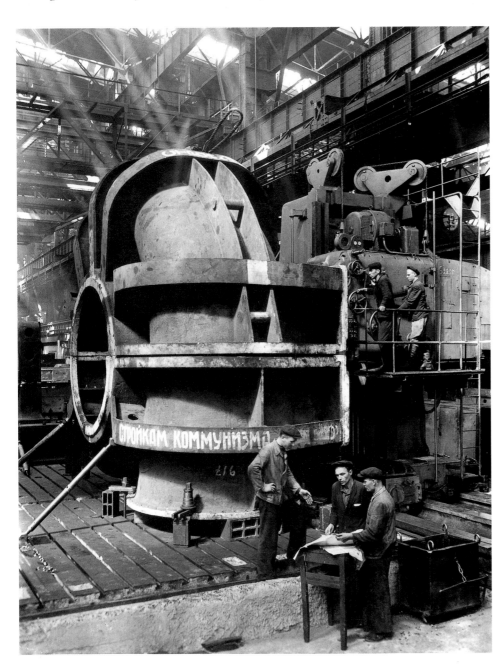

Building Communism, 1948—
When Stalin took over as the Soviet leader in the 1920s, the nation was backward both agriculturally and industrially. Within three decades, at the cost of millions of lives, Stalin had mobilized the Soviet Union to become one of the world's greatest economic and industrial powers. The Communist experiment was proving to be a success.

his superior skill in subordinating and manipulating people—there was something admirable and correct as well as something savage" in his dictatorship. Whatever the effects of his savagery, for a quarter of a century he guided the Soviet Union through its most critical years, endowed with a sense of rationality in the essentials of global politics. Working in critical times under inhuman personal strain in a highly divisive society, he, even more than the leaders of World War I, disregarded the high cost of lives sacrificed for his country's survival. Lives were especially cheap in Eurasia.

And he carried his huge burden in bitter solitude. Apart from his housekeeper he had no friends. The members of his inner circle, so sumptuously treated at his late-night dinner parties, never knew whether they might be arrested the next day. His public deification did not overcome the insecurity simmering in his inner self. And his outward life, preserving the puritanism of the early Bolsheviks, remained surprisingly simple. His official position entitled him to many privileges, but they offered him little personal indulgence; after his death no treasures of any kind were found in his quarters.

What dominated his lonely life was the power to conduct the grandest political experiment of the twentieth century: reculturing his vast country in the shortest time possible and thereby assuring its survival in the keen competition of the new globalism. Inevitably such unprecedented experimentation led to appalling mistakes and overreactions, but it also scored impressive results. Between the late 1920s and the early 1950s he transformed backward peasants into a nascent urban-industrial society proud of its science and technology. Literacy, education, and social welfare were greatly improved, and the standard of living raised, under civic interdependence enforced by the Communist Party. Above all, he had converted the collapsed tsarist empire into a global superpower, giving it a measure of external security unprecedented in Russian history.

Auto Workers,
Factory Moskvich, 1949

Yet the price of the Stalinist experiment had been staggering; indeed the methods used for overcoming backwardness had perpetuated it. The haste to catch up had led to extensive environmental damage. The human damage was even worse, amounting to millions of lives lost or wasted by the horrors of the Gulags, not counting the miseries inflicted on the peasants or the hardships of people caught in uncomprehended change. Above all, Soviet totalitarianism had stymied the development of individual creativity and spontaneous civic cooperation; people had to submit to an alien way of life that lacked roots in their history. As Stalin's daughter observed a decade after his death: "No revolution ever destroyed so much of value for the people as our Russian revolution. ... The spirit of skepticism has taken over—skepticism and indifference to all that is most precious and vital." Soviet reality seemed artificial; it had no emotional depths.

Why then, some critics have asked, did Stalin enforce such overly rapid change? By gradually adjusting popular motivation, a slower pace could surely have avoided the extreme compulsion through terror. Or would it have perpetuated the country's traditional quarrelsomeness just when the foreign danger was at its peak? Yet, Stalin's critics in his own country and abroad seem hardly aware of the cruel temper of international relations at the time, nor of the anarchy of Eurasian society (which even after the collapse of the Soviet system impedes civic cooperation). The key source of Stalinism, in short, was the threat of another world war to a highly vulnerable country. As he had said in 1931: "If we do not mobilize our society in ten years, we will be wiped out." Enslavement by Hitler's Germany would have been infinitely more cruel than Stalinism. Victory in 1945 provided the ultimate justification for Stalin's ruthlessness in the 1930s. His country's continued weakness and social instability warranted the perpetuation of his system even in the postwar years.

The roots of Stalinism, therefore, do not lie predominantly in Stalin's personality, as is commonly assumed, but in the historic circumstances that shaped him and his methods of government. He was a product of his times, of the megalomania started in the late nineteenth century and of the carnage of World War I and the Russian civil war that followed it. Conditioned by the brutish life in his country, he had to work with the human raw material available, aided by many little Stalins. For Russian intellectuals, backwardness amounted to a painful psychological humiliation engendered by the ever-present superior West. Let us never forget the power of that Western model over the Soviet state of mind, over Stalinism.

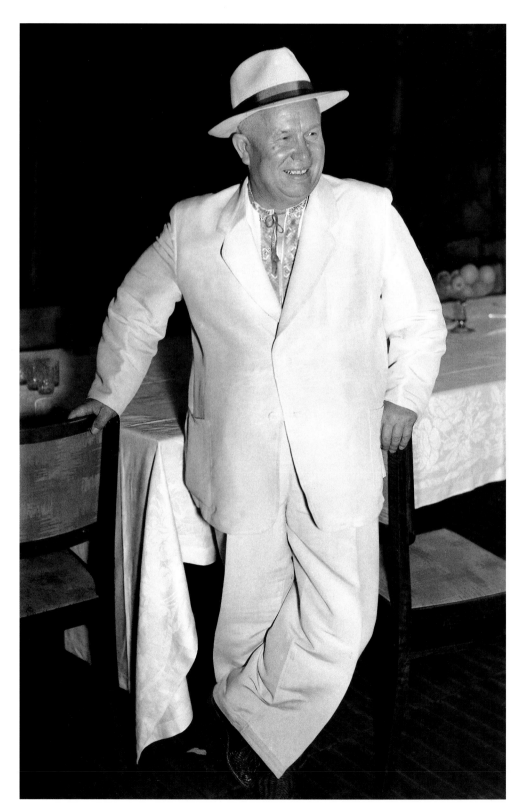

Khrushchev, summer 1955—
Shown at his dacha shortly after consolidating his power, the ebullient and dynamic Khrushchev was a stark contrast to the stolid, dangerous Stalin. Under Khrushchev, reforms were initiated, creating a measure of openness in an otherwise closed society. His impatience to overtake the United States led to ill-considered schemes that ultimately caused his downfall.

Khrushchev: A New Era Begins

With Stalin's death, a major turning point was reached in the history of the Russian Empire and the Soviet Union. Tensions diminished, and life continued more peacefully and more humanely. Thanks to its atomic weapons, it had achieved an unprecedented external security; it was no longer in danger of aggression or invasion so dreaded in the past. And more: as a superpower the country had gained global eminence as a rival to the capitalist West, and foremost to the United States. It now set a universal model for ambitious leaders in backward countries eager to escape from poverty and humiliation. Stalin's successors had cause to be proud of their country.

More embarrassingly, its traditional weaknesses still persisted. The Soviet system provided minimal material security for almost everybody, which was a source of civil stability at a time of systemic change. But the gap between the Soviet Union and the West in standards of living and personal freedom became ever more painful. Few Soviet citizens could resist the elemental appeal of capitalist materialism. Even more ominously, they yearned for the right to assert their ethnic (or national) identity. All were attracted by the abstract Western ideal of freedom, utterly ignorant of the invisible personal and collective discipline that gives substance to this ideal. Taken out of its cultural context, freedom promotes anarchy. Here lay the challenge to Stalin's successors.

The Soviet Union now faced a more subtle but equally deadly threat in the global power competition of invidious comparison between Western capitalism and Soviet socialism. Could the Soviet Union hold its own by translating its ideological claim to superiority into fact, or would defeat in this struggle aggravate the disunity and discontent among its peoples and thereby threaten collapse from within?

I.

The first Soviet leader confronted with the problems of the country's superpower status was Nikita Sergeyevich Khrushchev, an exceptional individual testifying to the creative resources of Russian society hidden amidst its disorderliness. Born in 1894 in a Russian peasant family living near the Ukrainian border, he grew up in the coal mining area on the lower Don River. His father shifted from farming in the summer to work as a miner in the winter. His son at age sixteen became a mechanic in the small town of Yusovka (named after the Welshman, John Hughes, who had started the mining industry). Nikita turned into a model worker and thus escaped military service in World War I. In 1918, at age twenty-four, he joined the Communist Party; he was an ardent believer in Marxism-Leninism ever thereafter. During the cruelties of the civil war raging through the Ukraine—he lost his first wife in the famine of those years—he fought as a commissar, subsequently suppressing miners' strikes and advancing in the Communist Party organization. As a young man of unusual promise he attracted the attention of a prominent Bolshevik, Lazar Kaganovich, who soon drew him to the Ukrainian party headquarters in Kiev. There he became a Bolshevik *apparatchik* of rare distinction. Rather than dictate from his office, he traveled around the countryside, talking to peasants and workers on their own terms with an irresistible earthy vitality that became one of his major assets.

In 1929 Kaganovich took this thirty-five-year-old model Bolshevik to Moscow as a student at the prestigious Industrial Academy. In his party work he met Stalin's wife, a fellow student, who called her husband's attention to him. After becoming involved in Moscow city politics, Khrushchev never finished his studies. Although politically highly alert and of a bright mind, he remained a somewhat boorish man close to the common people; he never turned into an intellectual. Impressed by him, Stalin promoted him in 1934 as the political boss of Moscow. In this capacity he supervised the construction of the Moscow Metro, that extravagant showpiece of Soviet superiority. Irrepressibly energetic, he joined the workers deep underground, standing knee-deep in water, promoting labor discipline. As a member of the Bolshevik leadership he also was inescapably involved in Stalin's terror during 1937–1938. Sent back to Kiev in 1938 as the Stalinist boss, he purged the Ukraine of all "enemies of the people." After Hitler's attack in 1941 he supervised the transfer of industry from the western parts of the country to safety in the east. Subsequently he served at various army headquarters (including Stalingrad) as a vibrant source of patriotic morale, before starting to rebuild the devastated Ukraine after the war.

In 1949 Stalin recalled Khrushchev to Moscow as secretary of the party's Central Committee. In this capacity he—the ambitious ex-peasant at Stalin's din-

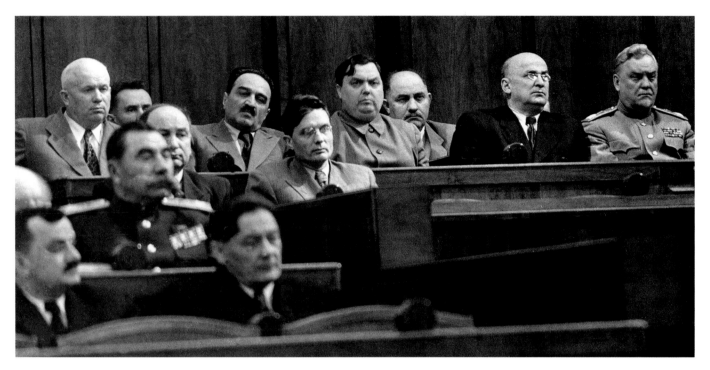

ner table—turned into a promoter of Soviet agriculture, which had been grossly neglected during Stalin's industrialization drive and in urgent need of attention during the postwar miseries. In 1950 Khrushchev boldly advocated the consolidation of collective farms into agro-towns, an ill-considered scheme soon to be abandoned. He survived its failure, building up his support within the party organizations instead. Stalin's loyal servant to the end, he was moved to tears when his master died. Now, at age fifty-nine as ebullient as ever (and more pudgy in appearance), he patiently watched for his opportunity.

After Stalin's death Malenkov, long considered the heir apparent, headed both the government and the Communist Party; Khrushchev ranked behind Bulganin, Molotov, and Beria. All of Stalin's henchmen, practicing collective responsibility, agreed that Stalinism had been carried too far. Surprisingly, the deeply feared—and hated—Beria took the lead, uncovering the fabrication of the doctors' plot and suggesting liberal reforms. An amnesty was declared for all short-term inmates of the prison camps, while some long-term prisoners were rehabilitated, free to tell their tales to an incredulous public. In late March Malenkov, concentrating on his government work, turned over the party leadership to Khrushchev, providing him with a secure power base. On June 28 Khrushchev and his colleagues suddenly arrested Beria. After a trial as "an agent of international imperialism," he was executed in December; all these actions took place behind closed doors and without any fanfare, showing signs of a more stable political order.

Our Leaders, 1953—*Khrushchev, Anastas Mikoyan, Malenkov, Beria, and Bulganin are shown shortly after Stalin's death. Within four years, Khrushchev and Mikoyan were the only members of this political elite— all close associates of Stalin— to retain any power. Mikoyan (1895–1978) was the greatest political survivor of the Soviet Union, serving in every administration from Lenin to Brezhnev and keeping himself immune from the Stalinist purges. From 1937–1955, he was Deputy Chairman of the Council of Ministers, and First Deputy Chairman from 1955–1964. A skilled diplomat, Mikoyan worked with Fidel Castro in removing Soviet missiles during the Cuban Missile Crisis of 1962. After serving as Chairman of the Presidium from 1964–1965, Mikoyan was allowed to retire with honor, a rarity for Soviet politicians.*

Aware of the post-Stalinist government's need to rally popular support, Malenkov and his colleagues recognized the urgency not only of relaxing the Stalinist terror but also of raising the standard of living. In December 1953 Khrushchev started a campaign for growing corn in the American fashion to provide a major supply of food for hungry people and cattle. In the following spring he launched a massive drive for opening the virgin lands in Kazakhstan and southern Siberia—"considerably better lands, on the whole, than in the Ukraine," as he boasted in early 1955—for large-scale agricultural production. Enlisting almost three hundred thousand volunteers, mostly young idealists, to start planting fields in the distant arid steppes, he expected 20 million acres of grain to be harvested in the first year. It was a risky venture, but Khrushchev threw himself into it body and soul, touring the entire country, appealing to his audiences in the novel terms of their material self-interest. He realized that all political agitation and propaganda was wasted unless the party could deliver a higher standard of living.

The year 1954 established Khrushchev as the leading figure in Soviet politics. Unlike Stalin, who had remained secluded in the Kremlin, Khrushchev, fifteen years younger, thrived among the crowds, an ebullient speaker close to popular language and temperament, sometimes exploding in fury. He was also a solid family man who walked with his grandchildren on the streets of Moscow. But now he also had to reach out into the larger world, under circumstances far more reassuring than in Lenin's or Stalin's times, but still a bold venture.

Late in 1954 he traveled to China, establishing comradely ties with Mao Zedong. The following year, after forcing Malenkov to step down in favor of Bulganin, his favorite, he attended the Communist Party conferences in Warsaw and Prague, as the most prominent Communist in the Soviet bloc. He traveled to Yugoslavia to restore good relations with Tito, whom Stalin had threatened to overthrow. Stopping in Bulgaria on his way home, he openly criticized Stalin, still the Communist idol. Next, for the first time, he turned west, when he attended with other top Soviet leaders the first postwar summit meeting held in Geneva, facing—with a Russian inferiority complex—President Dwight D. Eisenhower, Britain's Prime Minister Anthony Eden, and France's Prime Minister Edgar Faure. Khrushchev was pleased by the friendly reception accorded to the Soviet representatives. Toward the end of that year he even toured India and Burma, relishing public applause like an American politician. Posing now as a global statesman, he pleaded for peaceful coexistence between the superpowers, while also consolidating the Soviet hold over Eastern Europe in the Warsaw Pact, a military alliance countering NATO.

Meanwhile at home agitation mounted against Stalin's brutal heritage.

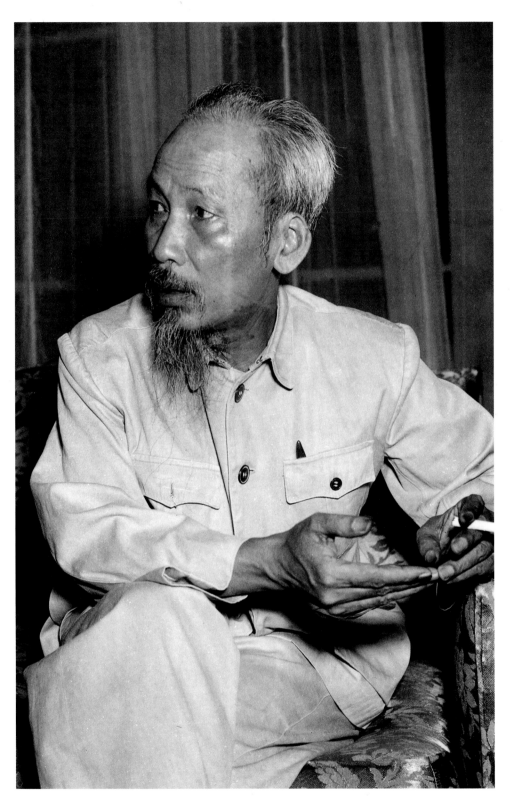

Ho Chi Minh, Hanoi, 1955—
A founding member of the French Communist Party, Ho Chi Minh (1890–1969) sparked a successful revolt against the French colonialists in 1954, ultimately driving them out of Indochina. As president of Communist North Vietnam, Ho led an insurgent battle to establish communism throughout Vietnam, leading to the Vietnam War between his troops and the U.S.-backed South Vietnamese.

Which Way to
Hanoi? 1955

Land Reapportionment,
Vietnam, 1955

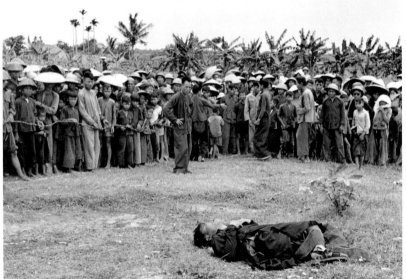

Execution of a Vietnamese Landowner, 1955—
Shortly after taking control of North Vietnam, the Communists collectivized property, destroying individual ownership. In this series of photos, Baltermants captures two generations examining the division of land tracts, along with the execution of a landowner and a small boy picking up the new Communist flag shortly after the execution.

The Youth Will Carry the Flag, Vietnam, 1955

The Flute Player, Vietnam, 1955—*Although well-known for his political and war photos, Baltermants was also an outstanding artistic photographer. This photograph, taken while he was in Vietnam, is one of Baltermants's first purely artistic photographs showing the growing artistic freedom under Khrushchev.*

Khrushchev and Mao, 1959—
In 1949 Mao Zedong (1893–1976)
led a Communist revolution in
China, toppling the Nationalist
government of Chiang Kai-shek
(1887–1975), who fled to the island
of Taiwan, establishing the Nation-
alist Republic of China. The
Peoples Republic of China became
the most populous Communist
nation in the world. With the
infusion of Soviet aid, the Peoples
Republic expanded agriculture and
established nationalized industries.
Although the United States feared
that the Soviet Union and China
would establish a unified Commu-
nist bloc, relations between the
USSR and the Peoples Republic
were often cool, due largely to
differences in ideology. By the early
1970s, China would become the
first of the Communist giants to
embrace the West.

Dance Is Politics Too, 1959—
In a move akin to Zhdanovism,
Mao Zedong outlawed dancing
as "bourgeois" and Western after
the Communist takeover in China.
This did not keep him from the
dance floor. According to his
personal physician, Mao held
dancing parties weekly, after which
he would escort his "partner,"
one of several adoring
young ladies, into a private room
next to the dance floor.

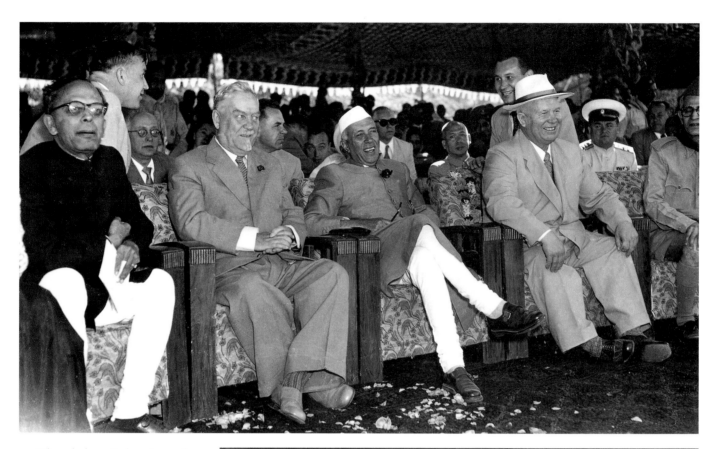

Khrushchev, Bulganin, and
Nehru in India, 1956—*Upset at
U.S. support for Pakistan, Indian
Prime Minister Jawaharlal Nehru
(1889–1964), flanked by Nikolai
Bulganin and Khrushchev, made
overtures to the Soviets for support;
ultimately, India remained a
nonaligned nation. Bulganin
(1895–1975) had served as Minister
of Defense under the brief
Malenkov regime, and was Soviet
Prime Minister from 1955 until his
retirement in 1958.*

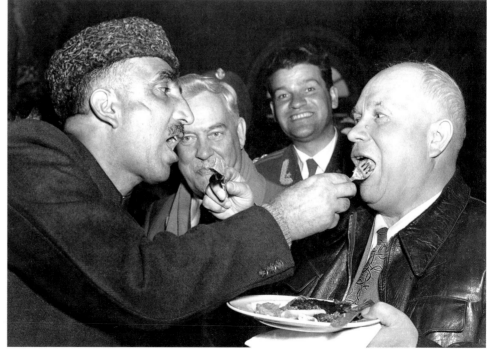

The Politics of Dinner,
Kashmir, India, 1956

II.

Resentment of the Soviet system had always simmered in the depths of Soviet society. Now it cautiously surfaced, testing the authority of the Communist Party. The first sign of dissatisfaction was a short novel, *The Thaw,* written in 1954 by Ilya Ehrenburg, a prominent journalist known for his steadfast loyalty to the regime. It described, in a rather lusterless fashion and without reference to political events, the unsatisfactory life of middle-level functionaries in a provincial town. Alert readers no doubt noticed an ambiguously phrased passage skillfully hidden amidst the colorless detail: "We have taken a lot of trouble over half of the human being, but the other half is neglected. The result is that one half of the house is a slum." After quoting Gorky—"We need our own Soviet humanism"—the author continued: "Now is the time we tackled it." Ah, the time had come to clear the Marxist-Leninist slum of its garbage and recover the human soul—subversive advice indeed.

The official Union of Soviet Writers soon denounced the book. It was devoid of any "ideological, class-social judgments universally recognized in our literature"; it lacked the Marxist-Leninist idealism. Yet it circulated widely. Obviously many readers hoped for a political thaw releasing the innate creativity of the people thwarted too long under the soulless ideology of Marxism-Leninism. These stirrings from the depths were bound to increase.

In 1955 a more subtle protest appeared. The young poet Yevgeny Yevtushenko published a story in the form of a long poem called *Zima Junction.* It was named after a place in Siberia, to which his great-grandfather had been exiled after a peasant rebellion and where he himself had spent much of his childhood. Living now in Moscow he had become uneasy about his unthinking life:

> *but at twenty I reassessed everything—*
> *what I said, and wasn't supposed to say,*
> *what I didn't say and should have.*

In this mood he decided to return to Zima Junction in search of what he honestly should say.

He found little evidence in the village of loyalty to the Communist Party. The few officials who make an appearance in the poem are arrogant and overbearing. As for the villagers—they are caught in the drift of the times, making compromises to stay afloat, vaguely disappointed with their lives and wondering "what else is there?" The poet hears an anguished question when he spends a night in a barn with some berry pickers and a woman whispers to a friend:

Ah, Liza, Liza,
You don't know what my life is like!
Yes we have rubber plants, and well, a Dutch oven,
even a good zinc roof,
everything cleaned, scoured, polished,
and the children and my husband, but doesn't the soul count?

As his poem testified, Yevtushenko relished the peacefulness of nature and the neighborliness of the traditional community. But even in Siberia he could not escape the drift of the times. After a concert at Zima Junction our poet has a sudden revelation:

I've thought about what's true and false,
and the metamorphosis of the authentic into a lie.
Think on it. We are all guilty
for masses of trivial irritations,
for vacuous verses, for endless quotations
in the standardized endings of speeches
..
We don't need a blind love for Russia,
but a thinking, steady love

..
I want to fight with courage,
but so that in everything that I fight for,
truth alone will be on fire,
for which I will never waive my rights.

At the end of the poem, the voice of Zima Junction speaks to him:

Hang on, watch closely, listen carefully,
and explore, explore. Travel the whole world over.
Yes, truth is good, but happiness is better,
but nonetheless without truth there is no happiness.

And thus that voice bestowed its blessings on the ambitious young poet. A Russian patriot within the Soviet system, he was going to play the game of survival, but with a courageous obligation for moral integrity; he could hide his subversive views behind the charms of his poetry. *Zima Junction* was published in 1956. Ferociously attacked but widely read, it inspired other youthful seekers.

A more subtle example of the anti-Soviet groundswell was embedded in the conclusion to Pasternak's *Doctor Zhivago*, also written in 1955 (but not published in Russia until 1989). Five or ten years after the end of World War II, Zhivago's closest friends, sitting one evening by a window overlooking Moscow, assess the state of their country: "Although the enlightenment and liberation which had been expected to come after the war had not come with victory, a presage of freedom was in the air throughout these post-war years, and it was their only historical meaning. … This freedom of the spirit was there, … on that very evening the future had become almost tangible in the streets below, and … they had themselves entered that future and would, from now on, be part of it." What an inspiring vision! But could this vision become true in a country still struggling to escape from its backwardness?

Khrushchev certainly never entertained such extravagant hopes. His patriotic pride, his very ego, was welded to the Soviet Union's role as a superpower, searching not for soul but for up-to-date material benefits produced by people geared to social cooperation that transcended their personal selves. To this end Stalin's heirs first had to restore confidence in the government.

After Stalin's death a party commission had been established to probe into the Gulag system, revealing its horrors to Khrushchev and other Soviet leaders. Even they had not known the full truth; it had not been their business. And now that the appalled public was listening to the released *zeks,* the government had to respond. It certainly could not allow the revelations about Stalin's atrocities to undermine public trust in the Soviet system.

III.

In February the Twentieth Party Congress was held, the first since Stalin's death. No important decisions were taken, except for strengthening Khrushchev's control over the Communist leadership, the occasion of which he used for a startling surprise. After the Congress had been adjourned late on February 24, Khrushchev recalled the delegates, shortly before midnight, to hear, behind closed doors, a special report he had carefully prepared. The purpose of his report, he said, was not a thorough reevaluation of Stalin's life and activity, but an attack on the Stalinist "cult of personality" that had perverted party democracy and revolutionary legality. Throughout his long speech—it lasted four hours—he revealed the horrors of Stalin's arrogant and limitless power, contrasting it with Lenin's great modesty. In dethroning Stalin he restored Lenin as the supreme symbol of party unity and Soviet loyalty. And had not Lenin warned the party in his "Testament" (here for the first time openly revealed) about Stalin's excessive rudeness? Khrushchev even quoted Krupskaya's complaints about Stalin's vile invectives and threats to her privacy.

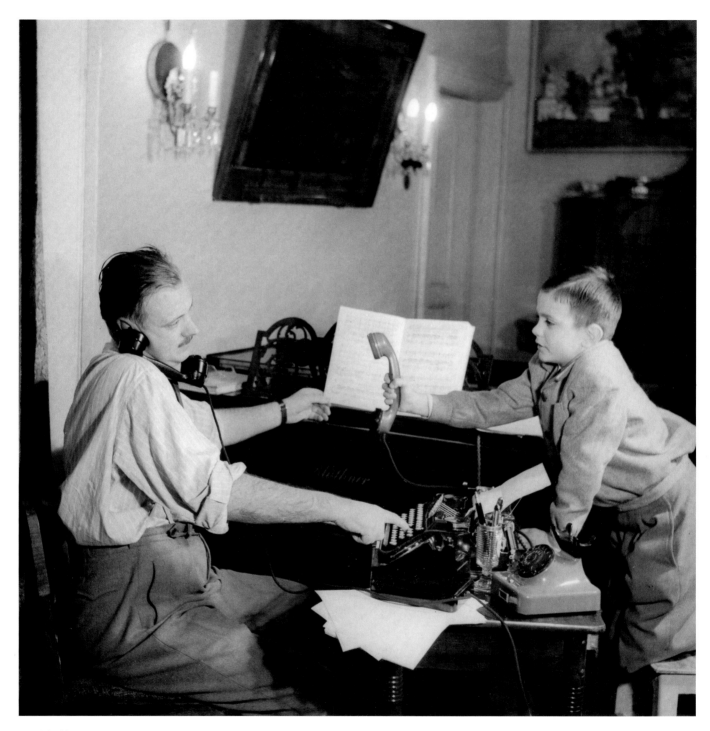

Mikhalkov and Son, 1952—*Sergei Mikhalkov was a prominent Soviet poet and playwright, winning Hero of the Nation awards for his work in 1941, 1942, and 1950, and serving as the writer of the text for the "Hymn of the USSR." He also served as the head of the Union of Soviet Writers. His son Nikita (1945–) is now a prominent filmmaker, winning the Academy Award in 1995 for the Best Foreign Film, for his work* Burnt by the Sun.

The negative characteristics of Stalin's character, Khrushchev went on, led to the grave abuse of power and the pointless mass terror between 1935 and 1938, at a time when "the Soviet state was already established and socialist relations were rooted solidly in all phases of our national economy, when our party was politically consolidated and had strengthened itself numerically and ideologically." As proof of Stalin's ferocity, Khrushchev referred to the recent investigation into the terror trials: "Of the 139 members and candidates of the party's Central Committee who were elected at the Seventeenth Congress, 98 persons, i.e., 70 percent, were arrested and shot (mostly in 1937–1938)." *(Indignation in the hall.)* "The same fate," Khrushchev continued, "met … also the majority of the delegates to the 17th Party Congress. Of 1,966 delegates … 1,108 were arrested on charges of anti-revolutionary crimes." *(Indignation in the hall.)*

Subsequently Khrushchev related in great detail the trumped-up charges made in the terror trials about German, Japanese, and Trotskyite conspiracies. To dramatize Stalin's inhumanities he referred to the sufferings of Comrade Eikhe, an old Bolshevik, who had testified at his trial on February 2, 1940: "In all the so-called confessions of mine there is not one letter written by me with the exception of my signatures under the protocols, which were forced from me. … I am not guilty. … I will die believing in the truth of party policy as I have believed in it during my whole life." On February 4, Khrushchev reported, Eikhe was shot. *(Indignation in the hall.)*

Khrushchev also called attention to Stalin's treacherous personality. He "was a very distrustful man, sickly suspicious; we know this from our work with him. He could look at a man and say: 'Why are your eyes so shifty today?' or 'Why are you turning so much today and avoiding to look me directly in the eyes?' … Everywhere and in everything he saw 'enemies,' 'twofacers,' and 'spies.' … A situation was created where one could not express one's own will." And he would not listen to informed advice. He disregarded the reports about Hitler's impending attack. He had not properly prepared Soviet industries for the war. He was responsible for the loss of more than one hundred thousand men encircled by the Germans in 1942 near the city of Kharkov, because he would not pay attention to his generals, nor to Khrushchev. When, after the war, Anastas Mikoyan mentioned at a politburo meeting that Khrushchev had been correct: "You should have seen Stalin's fury! How could it be admitted that he, Stalin, had not been right?" He never made any mistake. As for the stories and films praising Stalin as a military genius, Khrushchev burst out: "They make me feel sick."

Shifting back to Stalin's misdeeds, Khrushchev deplored the deportation of the Kalmyks, Chechens, and other Caucasus minorities, getting a laugh from his audience when he added: "The Ukrainians avoided meeting this fate only

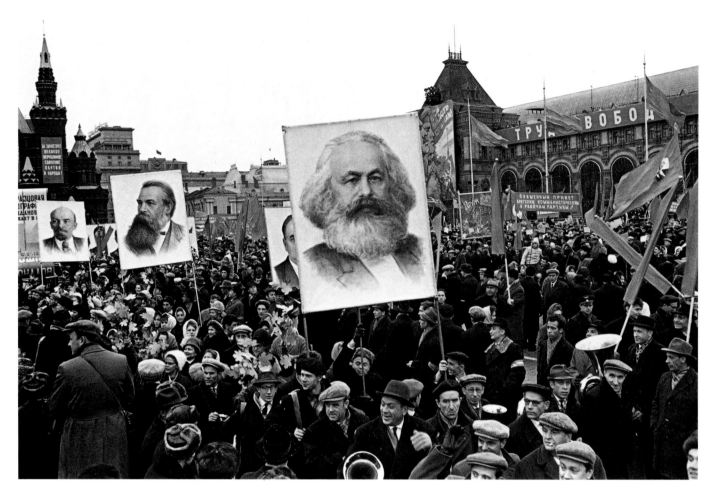

Parade, May 1, 1961—
Among the banners of great Soviet leaders, both past and present, was that of Karl Marx (front center), the father of communism. In 1848 Marx (1818–1883) and the German sociologist Friedrich Engels (1820–1895) published the Communist Manifesto, *stating their view that humanity would advance with the help of the working classes of the world.*

because there were too many of them and there was no place to which to deport them." Subsequently, when discussing Stalin's willfulness in the conduct of international relations, he treated his audience to an anecdote about Stalin's relations with Marshal Tito. After showing Khrushchev a letter he had written to Tito, Stalin observed: "I will shake my little finger—and there will be no more Tito. He will fall."

But there was also moving sadness in Khrushchev's speech, when he read from a letter sent by Comrade Kedrov to the party's Central Committee, before his execution in 1940, reporting the miseries to which he had been subjected:

> Everything … has its limits. My torture has reached the extreme. My health is broken, my strength and my energy are waning, the end is drawing near. To die in a Soviet prison, branded as a vile traitor to the Fatherland—what can be more monstrous for an honest man? … I am firmly certain that, given a quiet objective examination, without any foul rantings, without

any anger and without the fearful tortures, it will be easy to prove the baselessness of the charges. I believe deeply that truth and justice will triumph. I believe. I believe.

Finally, after attacking Stalin's self-glorification and ignorance of facts, Khrushchev raised the crucial question: "How could it be?" How was it possible that this terrible man went unchallenged to his very end? Khrushchev's answer showed the dilemma he faced. Yes, "Stalin headed the party and the country for thirty years and many victories were gained during his lifetime. Can we deny this?" But then he shifted ground; the question could be properly answered only in the Leninist manner: "Our historical victories were attained thanks to the organizational work of the party, to the many provincial organizations, and to the self-sacrifice of our great nation … they are not at all the fruit of the leadership of Stalin."

But a few minutes later he raised an even more embarrassing question: "Where were the members of the Political Bureau of the Central Committee? Why did they not assert themselves against the cult of the individual in time? And why is this being done only now?" Ah, back to Stalin's merits, especially in the early years: "Stalin was one of the strongest Marxists and his logic, his strength, and his will greatly influenced the cadres and party work." All through his career his associates were afraid of him. Khrushchev quoted Bulganin: "It has happened sometimes that a man goes to Stalin on his invitation as a friend. And, when he sits with Stalin, he does not know where he will be sent next—home or to jail." Obviously, this put "every member of the politburo … in a very difficult situation"—and they were in awe of him, too.

As Khrushchev, still in awe of Stalin, frankly admitted: "Stalin doubtless performed great service to the party, to the working class, and to the international workers' movement." Stalin was convinced that all the evils here recounted had been "necessary for the defense of the interests of the working classes against the plotting of enemies and against the attacks of the imperialist camp. … We cannot say that these were the deeds of a giddy despot. He considered that this should be done in the interest of the party, of the working masses, the name of the defense of the revolution's gains. In this lies the whole tragedy!" From the tragedy of Stalinism, Khrushchev immediately turned back to Lenin, "the living personification of modesty," advising that Stalin's name, as well as that of other leaders, be removed from cities, industrial enterprises, and collective farms named after them.

Khrushchev's long speech ended around 4:00 A.M. on February 25 with an affirmation of the principles guiding his own leadership: no cult of personality, collective responsibility at the top, no abuses of power by party leaders, the prac-

tice of criticism and self-criticism, and above all awareness of the "great moral and political strength of our party." At Khrushchev's proclamation: "Long live the banner of our party—Leninism!" all delegates rose to their feet, tumultuously cheering him. It had been a historic occasion.

But, for a light touch, was it true, as some wag told the story, that after Khrushchev had finished, a delegate passed a note to him, who read it aloud: "What were *you* doing during the terror?" Khrushchev asked the author of that note to give his name. Waiting through a long silence, Khrushchev then said: "Now you know what I was doing."

Khrushchev's speech quickly became known worldwide, despite his warnings toward the end against washing dirty linen in public and providing ammunition to the enemy. In the Soviet Union the speech was discussed at all party meetings, causing considerable anxiety among the faithful. How were they to react? A British journalist reported a revealing incident. Asking a youthful Soviet diplomat at an official reception for his opinion, he was stared at in alarm: "How can you possibly ask me that?" With tears in his eyes the young man fled from the room. Throughout the country, people who had been Stalin's agents now shuddered at their cruelties; some of them committed suicide. But the hard-line apparatchiks showed no such embarrassment—Khrushchev's speech was a threat to the Soviet system. As for the doubters such as Yevtushenko, Khrushchev had not gone far enough. And the majority, caught in between, drifted in bewildered uncertainty, wondering what would come next.

One wonders how Dmitri Baltermants reacted. He worked for *Ogonyok,* an attractive but conservative weekly magazine, benefiting from his close contacts with top party officials, who allowed him to take pictures at important party gatherings and to accompany them on their travels abroad. We do not know what he thought; he never discussed politics with his family. Like other privileged professionals he took advantage of his job, avoiding any confrontation. Whatever his hidden sentiments, there were good reasons for pictorially supporting the positive aspects of Soviet rule in troubled times.

In any case, Khrushchev's speech had made a profound impression. He had taken the initiative in revealing the Stalinist inhumanities, and had projected a more civilized and productive future rid of dictatorial compulsion and capable of enlisting broad public support. He had replaced the deadly Stalinism with a more humane Leninism, a symbol encouraging collective responsibility at the top and active cooperation from all Communist Party members. There was no guarantee that his prescription would work; loosening the Stalinist controls might undermine the entire Soviet system and its ambition for global eminence. But with his boundless vitality and drive, Khrushchev was ready to improve the

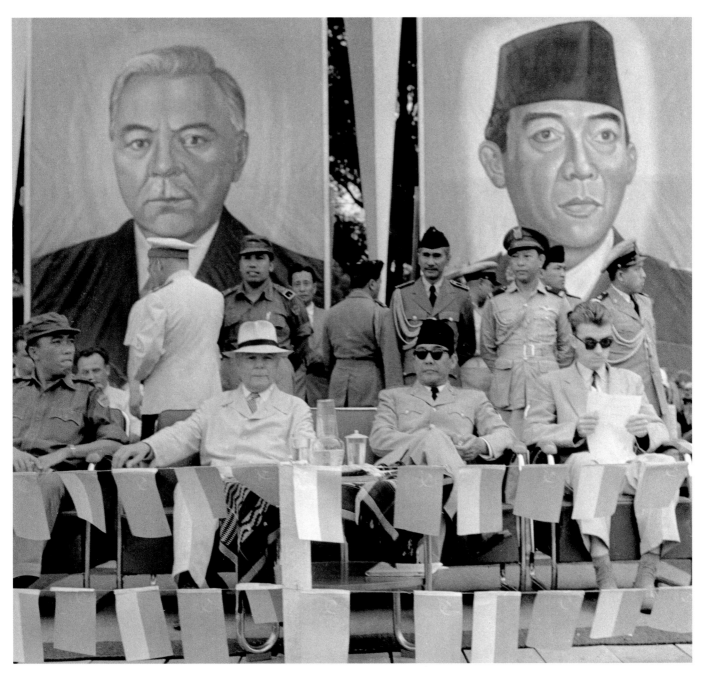

Voroshilov and Sukarno in Indonesia, 1957—*One of the dominant trends of the cold war were the efforts by the United States and the Soviet Union to increase their spheres of influence among Third-World nations. In southeast Asia communism advanced. Sukarno (1901–1970) led the Indonesian fight for independence from the Dutch after World War II; he remained in power, aligning Indonesia with the Communist bloc, until 1965. Kliment Voroshilov (1881–1969) was one of several Soviet leaders dispatched around the world to spread Soviet influence. A onetime marshal of the Soviet Union, Voroshilov served as Chairman of the Presidium from 1953–1960. In 1961 he was stripped of his party membership by Khrushchev for having aligned himself with anti-Khrushchev forces.*

Soviet system by broadening its popular base. Thus he started an uncertain adjustment within the Communist experiment, taking his chances.

IV.

Having dropped his oratorical bomb, Khrushchev moved more carefully, trying to limit the damage without abandoning his commitment to reform. While releasing large masses of Gulag inmates (although by no means all of them), he softened his anti-Stalinist stance, aware of the hard-liners' opposition; loyalty to Stalin was still widespread. In order to strengthen his support, he appointed loyal followers to important positions in the party, keeping the country quiet. Except for riots among Georgian students protesting the demotion of Stalin, their Georgian idol, his speech stirred up no trouble among his people.

It was otherwise in two key satellite countries, Poland and Hungary, which misinterpreted Khrushchev's speech as an intimation of liberalization. In midsummer 1956 Polish workers in the city of Poznan rioted for better pay and working conditions. Their bloody suppression spread anti-Soviet agitation throughout the country, raising Wladyslaw Gomulka, a patriotic Polish Communist, to prominence. He wanted greater self-determination for his country within the Soviet bloc. In October Khrushchev and Bulganin, thoroughly alarmed, rushed to Warsaw, threatening military intervention. Yet realizing the depth of Polish resistance, they eventually granted Gomulka's demand for equality in Polish-Soviet relations. Thereafter Poland, safely surrounded by other Communist states, gained a measure of independence in running its internal affairs.

Anti-Soviet protest, inspired by events in Poland, took a more tragic form in Hungary, a country that bordered dangerously on the free world. In October students went on strike in Budapest, stimulating demonstrations and pulling down the towering statue of Stalin. Thus encouraged, Imre Nagy, just risen to prominence as a Hungarian Nationalist rather than a Communist, demanded the withdrawal of the Soviet forces stationed in Hungary. After calling for free elections, he even denounced the Warsaw Pact and removed Hungary from the Soviet bloc. Outraged, the Soviet leaders unleashed their army to crush the Hungarian bid for liberation, installing a harsh dictatorship under János Kádár. Nagy was hanged in 1957.

These rebellions among key satellite countries, conveniently blamed on the Western powers, embarrassed Khrushchev, who had not anticipated such results from his speech. For a time he lay low; he defensively invoked Marxist dialectics when he boasted to the Western ambassadors at a Kremlin reception in November: "History is on our side. We will bury you" (a phrase that struck anticommunists as a threat). More pointedly he praised Stalin in his New Year's Eve message:

"When it is a question of fighting against imperialism we can state with conviction that we are all Stalinists." Subsequently, in 1957, he adjusted his anti-Stalinism to historical reality:

> Let us recall what Russia was before the victory of the Great October Revolution. It was an economically and culturally backward country, reduced by Tsarism to the position of a semicolonial state. Look what the land of Soviets is today! The Soviet Union is a great and mighty socialist power exerting a decisive influence on the course of world history. ... The great successes in the development of our country were achieved under the leadership of the Communist Party and its Central Committee, in which J. V. Stalin played the leading role.

Obviously, Khrushchev wavered back and forth between accepting and rejecting Stalin as circumstances demanded.

Interceptor Pilots Protecting Our Skies, 1961—*Although no longer at war, the Soviet Union used military images to convey messages of bravery and valor. Throughout the cold war, Soviet pilots became renowned for their expertise in the Mig-17 fighters, casting a fearful shadow over NATO allies in Europe.*

Where Should Mayakovsky Be?
May 1956—*In a sign of reform and
openness, Khrushchev began
allowing the citizens of the Soviet
Union to be heard in some matters
of public discourse. Here, various
wooden "dummies" of a statue
saluting the great Soviet poet
Vladimir Mayakovsky (1893–1930)
were placed at different locations,
in order to solicit opinions as to the
final placement.*

In February 1957 Khrushchev resumed his liberalizing offensive, proposing to divide the country into a number of administrative regions, each charged with stimulating both industry and agriculture, with the initiative given to local officials familiar with local conditions. The Moscow bosses disliked being transferred to the provinces, but the people agreed to the changes, after Khrushchev—eager to break the "spell of outworn concepts, bookish schemes, dogmas and formulas"—had toured the country in boisterous support of his plan. In May it was accepted by the party.

In that month he renewed his agitation for enlarging agricultural production, predicting: "We will overtake the United States in the per capita production of meat, butter, and milk in the near future." His enthusiasm ran high indeed: "The Twentieth Party Congress showed that our country now has all the necessary conditions for accomplishing the USSR's principal economic task in an historically short time—to catch up with and surpass the most highly developed capitalist countries in per capita output." "Overtake and surpass" became a slogan in his effort to raise the Soviet living standard. "Are we equal to it?" The skeptics, he replied, "do not understand the soul of our people, do not believe in their inexhaustible forces."

Alas, the hard-liners in Moscow agreed with the skeptics. In June, while Khrushchev was visiting Finland, the old bosses—led by Malenkov, Molotov, and Kaganovich (Khrushchev's former sponsor)—conspired to oust him. After his

Khrushchev in East Germany, 1955—*An endless supporter of agricultural reform, Khrushchev was fascinated by the agricultural capacities of other nations. The possession of farm animals, in this case a large pig, was an indication of a cooperative's success within the socialist system. Standing with Khrushchev is Walter Ulbricht (1893–1973), deputy prime minister and later head of the German Democratic Republic.*

return they abruptly demoted him from the party leadership. Molotov told him to "Talk less and give people more to eat," while they all attacked his wild talk about "milk-and-butter communism" and catching up to America. But Khrushchev struck back. Convening the full membership of the party's Central Committee, staffed with his own supporters, he created a new party Presidium loyal to him and threw out his opponents. But, rather than execute them Stalinist fashion, he banished them to humiliating positions: Kaganovich to administer a cement factory, Malenkov to head a power station in distant Siberia, and Molotov to serve as ambassador to Outer Mongolia (he ended up as an ambassador in Vienna).

By the end of the summer Khrushchev was the undisputed master of Soviet politics. His prestige soared in October when *Sputnik,* the world's first artificial satellite, circled the earth; in November he gloried, when fellow Communists from around the world, including Mao Zedong, gathered in Moscow. In 1958 Khrushchev completed his triumph. After Bulganin retired, Khrushchev combined the leadership of the party with the presidency of the Soviet state, controlling all parts of the government. Not surprisingly, a new cult of personality evolved around his portly figure.

But there still remained the doubts simmering in the anti-Soviet undercurrent. In 1957 they cropped up again in the novel *Not by Bread Alone.* This rather colorless novel, written by Vladimir Dudintsev, described the miseries of a bright young inventor of a superior steel pipe, trying to promote his technology amidst

Before Sputnik (Launching a
Stratospheric Balloon), 1954

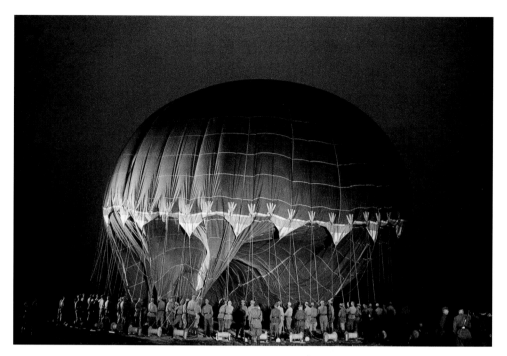

Space Dog, 1960—*The success
of the* Sputnik I *satellite in 1957
was the first step toward putting a
human into space and, ultimately,
on the moon. In November 1957
the Soviets launched a second
Sputnik, carrying the dog
Laika; the vessel burned up
during re-entry. In 1960 two other
dogs, Belka and Streika, were
launched and successfully retrieved
after 18 orbits.*

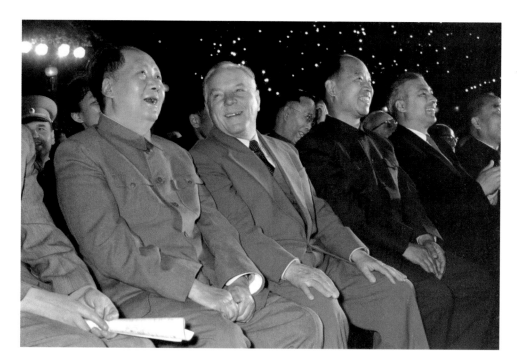

Voroshilov and Mao Zedong, 1957—*According to his personal physician, Mao's teeth were covered with a "heavy, greenish film," a likely by-product of his consumption of green tea.*

the arrogant technical bureaucrats protecting their turf. The hero, spurning all material rewards—and even love—perseveres through endless setbacks, all demonstrating the stagnation and deceit permeating the Communist establishment. He finally prevails, a symbol of devotion to technological advance. His frustrations were familiar, no doubt, to many Soviet professionals. Sergei Korolev, the inventor of the rocket propulsion technique that sent Sputnik circling the earth, had spent time in a Gulag for not sticking to conventional engines.

The popularity of Dudintsev's novel compelled Khrushchev into bitter denunciation. It "deliberately exaggerates and takes malicious delight" in the shortcomings of the Soviet system, contrary to party policy that opposed "resolutely and irreconcilably, a one-sided, unfaithful, mendacious depiction of our reality in literature and art." Khrushchev felt that his anger was justified: how could the Soviet experiment succeed without radiating the grandeur of socialist labor through the artistic media? Thus Dudintsev's novel was discredited in party meetings throughout the country, inspiring the ever irreverent Yevtushenko to mock:

> *Again a meeting, noisy, dying, half colloquium, half co-lying.*
>
> ..
>
> *The majority reeks.*
> *They are not Bolsheviks, just bullshitviks.*
>
> ..

Khrushchev's Dilemma,
Tashkent, 1961—*Following
Khrushchev's 1959 trip to the
United States, where he saw field
after field of maturing corn, his
enthusiam for the virgin land
project grew. His dilemma: he
would have to continue with the
project in areas too dry to grow
corn, or he would have to abandon
the unsuccessful venture. Either
way, his reputation would suffer.*

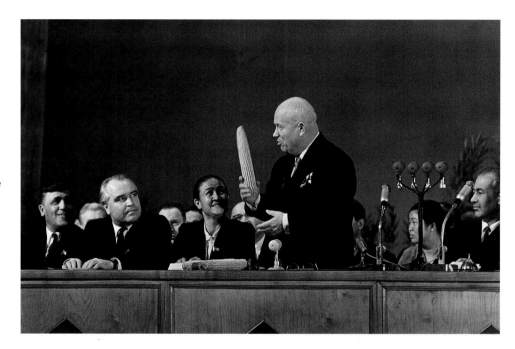

In 1958 the party stalwarts had an even weightier target: Boris Pasternak's *Doctor Zhivago,* the most powerful testimony yet of anti-Soviet thinking. Pasternak had been prohibited from publishing his major work in the Soviet Union. Sent to an Italian publisher, it had not only become a bestseller in Western Europe but also earned its author the Nobel Prize in literature. Outraged Communist patriots immediately reviled the novel as "an artistically poverty-stricken and malicious work … full of hatred for socialism." Its author was branded a traitor who was blind to the glorious transformation of his country into a superpower. Under pressure Pasternak renounced the Nobel award. Reduced to utter misery, he nevertheless rejected emigration; he would never leave his beloved Russia. Humiliated, but still appreciated as a poet, he died in 1960, a tragic figure.

Having secured his power, Khrushchev promoted a long list of reforms designed to raise the quality of Soviet life. He vigorously promoted the projects he had started earlier, pushing his corn campaign to provide food for humans and animals, which was aided by a study commission sent to the United States in 1955. Khrushchev, now dubbed *kukuruznik* (the corn wizard), argued that a crop that had done so well in the United States should also succeed in the Soviet Union. He intensified the virgin lands campaign at the expense of the traditional agricultural areas, disregarding soil conditions, lack of rain, and unsuitable methods of cultivation. At the same time he advocated a broad change "from asphalt to farm," moving the Moscow-based Ministry of Agriculture and related research institutes back to the soil; the experts and the peasants should learn from each other. He also decreed the fusing of the Motor Trac-

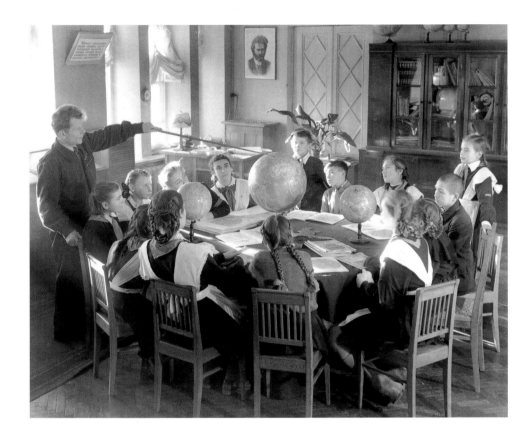

The Globe (Society of Young
Geographers), 1950

tor Stations with the collective farms, believing the farmers would benefit from han-
dling the mechanized equipment themselves.

Eager to broaden people's minds, Khrushchev also reformed the school sys-
tem, introducing coeducation and adding an eleventh year for manual training at
a nearby factory or on a farm. For the same reason he pushed for electoral reform.
Officeholders were to be replaced after three terms (only two for low-level posi-
tions); administrative experience was to be shared by more people.

All these were worthy projects, promoting creative interaction among its self-
centered individuals. But they also called for considerable capital investment, strain-
ing "the inexhaustible resources" of the Soviet masses. It was comparatively easy for
the Soviet government to produce spectacular successes in space technology, a much
favored project employing relatively few highly trained experts—in 1959 the Soviet
Union sent two space capsules around the moon, preparing for Gagarin's space flight
around the earth in 1961. It was an infinitely more difficult effort welding more than
two hundred million Eurasians into creative citizenship.

But Khrushchev was aggressively impatient. At the Twenty-first Party Con-
gress in January 1959, he launched a Seven-Year Plan promising, yet again, that
"by 1965 the USSR would overtake the United States in basic industrial output."

Cosmonaut, 1961

Khrushchev and His Inner Circle, 1961—*By 1961 Khrushchev was at the height of his power. He had successfully put down an attempted ouster, consolidated his internal control, and was still overseeing an expansion of communism abroad. Leonid Brezhnev, who would take over after Khrushchev's fall in 1964, stands to Khrushchev's right. Andrei Gromyko (1909–1989) stands at the far right. Gromyko, a political survivor much like Mikoyan, served as the Soviet foreign minister for longer than any other person (1957–1985). Over the span of almost thirty years, he became well known to Americans as the chief spokesman for Soviet international interests.*

Socialism had been achieved, he announced in his major address. The Soviet Union was now advancing toward communism, enlisting the broadest strata of the population in the management of all affairs of the country and promoting the fullest development of popular initiative in self-government—without reducing the role of the Soviet state (or the party). Obviously, the West was ever on his mind. But the United States was not the yardstick for Soviet achievements; look at the

millions of Americans unemployed! Surpassing the United States was merely "a way station on the road to communism." He ended his confidence-inspiring prediction by invoking the vitality of nature: "The ideals of Marxism-Leninism have the same power as sunshine and warmth have for plants, for life on earth." What illusions!

V.

His speech showed how Khrushchev's ideology helped him to disarm the ever-present threat of Western superiority. But how would he react, when he en-

countered the West face to face, with the Soviets always afraid of humiliation in the power struggle of envious comparison? Fear and suspicion had traditionally barred Soviet citizens from visiting the West; in Khrushchev's time, space engineers and nuclear scientists were kept at home, lest they betray vital secrets. And what did the occasional Soviet visitor understand of foreign life? After a brief visit to Denmark, for instance, a scientist

Khrushchev and East African Leaders, Moscow, May 1964

commented on the poverty of the Danes. The shops were full of goods, but there were no lines in front of the stores (as in the Soviet Union); obviously people had no money to go shopping. In venturing out, Khrushchev had cause for concern mentally and psychologically.

On his visit to Geneva in 1955 he had uncomfortably contrasted the small Soviet plane on which he had arrived with the large planes used by the Western statesmen. Coming to England in 1956 on a battle cruiser, he was alarmed by underwater espionage. He furiously walked out of a dinner given by the British Labour Party after a Labour member of Parliament had criticized the Soviet Union. And now, in 1959, he had to come to grips with American reality.

It happened first in a small way. In July Vice President Nixon, visiting Moscow during the first exhibition of American life and culture, encountered

Khrushchev and Harold Macmillan, 1956—*Although Khrushchev's international travels focused on Communist bloc nations, he also visited Western nations where his message centered on nuclear disarmament and peaceful coexistence. These travels gave Baltermants an opportunity to see the West, a rare privilege for any Soviet citizen. Macmillan (1894–1987) served as British prime minister from 1957–1963, during which time he sought to improve relations with the Communist nations of Eastern Europe.*

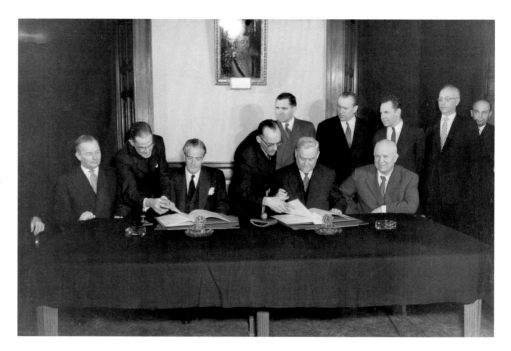

Khrushchev examining a lemon squeezer. Khrushchev called it "an insult to our intelligence"; why waste time when it could be done so easily by hand? He also derided the American model home, saying: "We build for our grandchildren"; Americans merely produced built-in obsolescence in order to keep the real estate market going. Obviously, Soviet housing was superior—in the face of the decrepit buildings visible all over Moscow.

And then in mid-September Khrushchev toured the United States for almost two weeks, with many initial misgivings. Flying into Washington, he was afraid of being late, which would be "a blow to our prestige." About to land, his nerves were strained with excitement. The United States had at last recognized the necessity of establishing closer relations with the Soviet Union, now "transformed into a highly developed country." But he was worried, facing the agony of crossing a crucial cultural boundary. He was to meet President Eisenhower at Camp David. Camp David? The term "camp" raised evil associations in his mind. Nobody had told him that it was Eisenhower's dacha.

As it turned out, he was well received. He met prominent and ordinary Americans with his Russian sense of humor, but occasionally exploded in fury when attacked. His audiences got a good view of the tempestuous Soviet leader. When the mayor of Los Angeles charged him with wanting to bury America, Khrushchev threatened to fly right home. In San Francisco he had a lively exchange with Walter Reuther and other prominent labor leaders. At one point, red in the face, he shouted at Reuther: "You represent capitalist lackeys." Next, in reply to Reuther's protest that the Soviet

Union did not permit a free flow of ideas, he—in a sudden inspiration—switched to a burlesque imitation of the cancan dancers he had just seen in Hollywood, raising their skirts in a manner impermissible by puritan Soviet standards; he implied that the free flow of ideas under capitalism promoted pornography. On his way east, he dropped by the Garst farm in Iowa, where he lectured his host—in his Soviet one-upmanship—on better ways of planting corn. But his trip was a success. As he reported to a Soviet audience just after his return, he was given "a reception worthy of our great country, our great people." The prospects for peaceful relations with the other superpower were excellent.

In the spring of 1960 Khrushchev made further progress in his enlightenment about the West during an eleven-day visit to France. Greatly impressed by the sights of Paris, he established common ground with President Charles de Gaulle, and talked to prominent industrialists as well as French Communists. Delighted by the friendly attitude of the people he met, he realized "why everything is always so neat in the West; it is a matter of good production discipline, strict standards, and well-designed processes. … It's just a higher level of culture in the West." But at his core, he could hardly surrender his faith in the ultimate victory of communism. As head of the Soviet state he was committed to its strength and security as a superpower. And its strength and security were soon to be challenged.

During his American trip a summit meeting had been planned for the heads of state. President Eisenhower, British Prime Minister Harold Macmillan, President de Gaulle, and Khrushchev were to discuss nuclear disarmament and peaceful relations. But two weeks before the mid-May date set for the gathering in Paris, an American U-2 spy plane was shot down deep inside the Soviet Union. Soviet opinion was outraged by this evidence of secret espionage. Arriving in Paris, Khrushchev threatened to cancel the summit, unless President Eisenhower offered a formal apology. When Eisenhower refused, Khrushchev demonstratively returned home after holding an angry press conference in which he charged the United States with an act of aggression against the Soviet Union, "economically the world's second nation, and politically and culturally the first nation of the world." After the U-2 incident, Soviet-American relations cooled down.

In September the cold war reescalated when Khrushchev attended the United Nations General Assembly in New York, one of many delegates from

Peace March, May 1, 1960—
On this date, American U-2 pilot Francis Gary Powers was shot down over Soviet soil, where he was conducting an intelligence-reconnaissance mission. The incident led to Khrushchev cancelling a summit meeting with President Eisenhower two weeks later. Ironically, on that day, Soviet citizens were holding a peace march in Moscow, calling for international peace and cooperation between the two superpowers.

Castro and Khrushchev, 1963

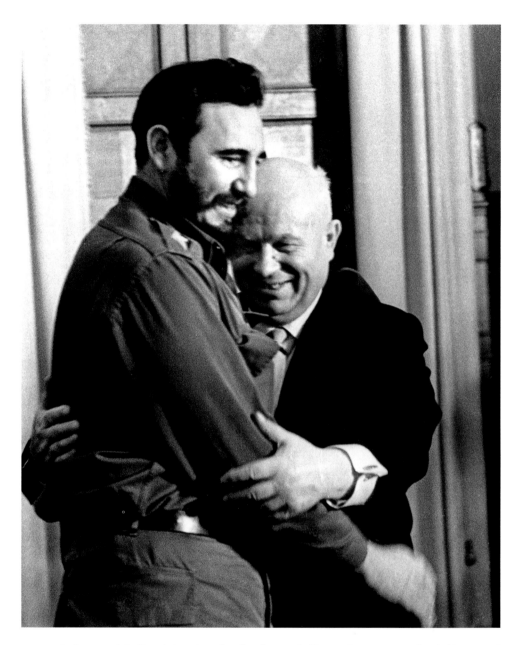

around the world. Participating in the heated discussion over colonialism and decolonization, he blew up at one point, attacking "the reactionary bloody regime" of the Spanish dictator, General Francisco Franco. When reproached by the Spanish delegate, he took off his shoe and banged it on his desk, causing quite a stir. But why not demonstrate his outrage to all the oppressed peoples around the world? He also publicly embraced Cuba's Fidel Castro, a recent convert to Marxism-Leninism, when visiting him at his run-down hotel in a black New York City neighborhood, which Khrushchev critically observed. American race

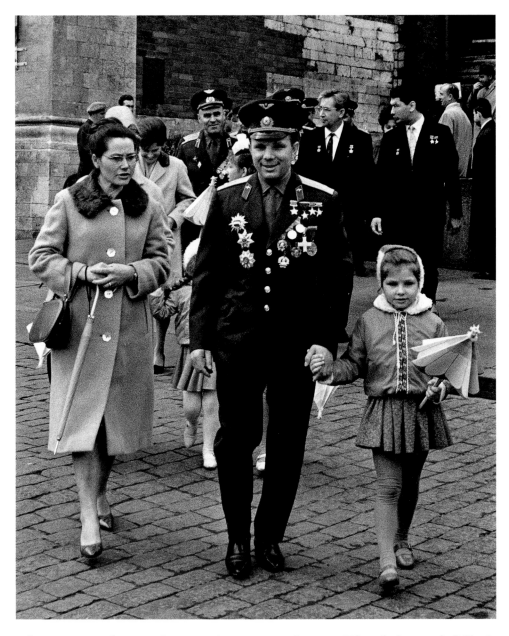

Yuri Gagarin after receiving the Hero of the Nation award, April 1961—*On April 12, 1961, aboard the space capsule* Vostok I, *Gagarin became the first human propelled into outer space. The Soviets, who had taken the early lead over the Americans in the space race with the launching of* Sputnik I *in 1957, had again beaten their cold war enemy. For his efforts, Gagarin was given the Order of Lenin and named a Hero of the Soviet Union, inspiring a whole generation of Soviet youths and mobilizing the Soviet cosmonaut program. In 1967 he was tragically killed in a test flight; a hero to all Soviets, his ashes were interned in the Kremlin wall.*

relations were always a Communist propaganda asset. Khrushchev took full advantage of the UN gathering, which did not endear him to the American media.

The next Soviet-American confrontation, with Khrushchev calling the shots from Moscow, occurred in the summer of 1961 over the status of Berlin. Postwar Germany had been divided between the Western-oriented Federal Republic and the Soviet-dominated German Democratic Republic (GDR). The former German capital of Berlin, surrounded by the GDR and similarly divided into a western and an eastern zone, had long been a source of political tension. East Germans, dissatisfied

Khrushchev's Last Party Congress, October 1961— *Although Khrushchev remained in power until 1964, the Twenty-second Congress, held in October 1961, proved to be his last. Although he had shown signs of strength abroad, Khrushchev began coming under fire at home. In response to this criticism, Khrushchev resorted to the tactic that had given him so much support earlier: attacking Stalin and his followers, many of whom were named as being part of the attempted overthrow of Khrushchev in 1957. This Congress was also the first attended by a young Mikhail Gorbachev.*

with their Communist masters, could easily move from East to West Berlin and hence to freedom in West Germany. The drain of skilled manpower alarmed Communist leaders. Suddenly on August 12 they erected a high wall, cutting off all contact between the two zones. The "Berlin Wall" (retained until 1989) nearly caused a military clash between Soviet and American troops. Eventually calm returned, with Khrushchev dreaming of the GDR becoming "a showcase of moral, political, and material achievement" admired in the Western world.

Soon after, however, he faced some embarrassing criticism at the Communist Party's Twenty-second Congress in October 1961, where he was accused of being too subservient to the capitalists. In response he reverted to a tough line: "In the face of direct threats and the danger of war, the possibility of a non-peaceful transition to socialism must be kept in mind"; the testing of Soviet nuclear weapons must be continued. Thus the arms race escalated. In addition he affirmed his belief that "the socialist system, in times not far off, will surpass the world capitalist system. ... The Soviet Union is now literally and figuratively storming the

Lenin/Stalin Mausoleum, 1957—*Upon his death in 1953, Stalin was interned with Lenin in the large mausoleum in Red Square. Within five years, following the Twentieth Party Congress, Stalin was vilified by the party leadership. The city of Stalingrad was renamed Volgograd. In 1961 his remains were removed from the mausoleum and buried nearby.*

sky." In April Yuri Gagarin circled the earth once in his space capsule, followed by his fellow astronaut Gherman Titov who orbited seventeen times in August.

Khrushchev also attacked the antiparty group that had tried to overthrow him in 1957, mentioning its leaders by name. But above all, he again played his trump card, attacking Stalin with revelations even more shattering than those made in 1956. He revealed that millions had been sent to the Gulags, with Stalin himself signing hundreds of death warrants. He proposed that Stalin be removed from the Lenin mausoleum. The party voted that he be buried below the Kremlin wall. Yet, as Yevtushenko observed in a poem printed in *Pravda:* "We removed him from the mausoleum./But how do we remove Stalin from Stalin's heirs?" His former henchmen were still around, hating "a time when prison camps are empty,/and auditoriums, where people listen to poetry, are overfilled."

Reassured by support from the Congress, he engaged in his most dangerous confrontation with the United States over Cuba. In 1959 Castro had taken command of Cuba, and was soon driven by American hostility into close association

Castro on Sled, 1963—In October 1962 the future of the world hung in the balance, as the Soviet Union and the United States squared off over the placement of Soviet missiles in Cuba. At the end of thirteen tense days, the Soviets capitulated and agreed to remove the weapons; to appease Castro, they brought him to Moscow in 1963 for a "goodwill" tour. Castro (1926–) first came to power in 1959 after ousting American-backed dictator Fulgencio Batista (1901–1973). He has proved to be a resilient leader, outlasting the fall of the Soviet Union and serving as a thorn in the side of the United States.

with the Soviet Union. Would the Americans tolerate this Communist outpost so close to their shores? After thwarting an ill-prepared American invasion supported by President John F. Kennedy—the Bay of Pigs fiasco—Castro asked for Soviet help. In the fall of 1962 Khrushchev secretly based rocket-equipped missiles in Cuba positioned to attack American cities, if Cuba should be invaded. After all, the Americans had stationed nuclear warheads in Turkey close to the Soviet border; the Soviet Union felt entitled to reciprocate by defending an endangered Communist ally. American intelligence agencies quickly uncovered the Soviet move, causing panic in the White House, which at once declared a naval blockade of Cuba.

For a couple of days at the end of October, the Soviet Union and the United States were at the brink of nuclear war, until common sense prevailed. The Americans promised to respect Cuban territorial integrity, while the Soviet Union withdrew its missiles. The compromise earned Khrushchev little praise at home. Pulling its weapons out of the Western Hemisphere was a setback for the Soviet Union. But peace had been preserved on American terms.

Cake Man, Cuba, 1970

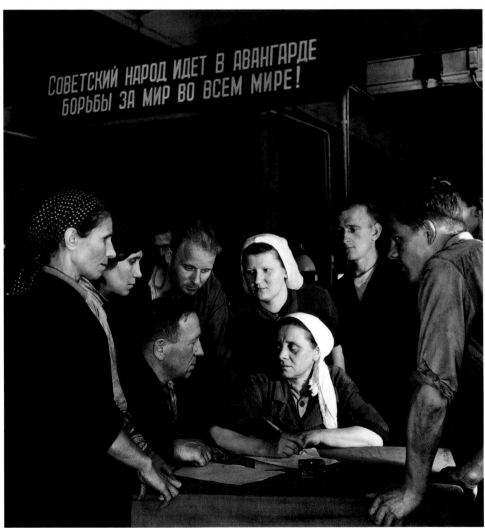

Signing the Declaration of Peace, 1960—*While the cold war intensified under Khrushchev, there were signs that the Soviets were as peaceful as the Americans believed themselves to be. Here, workers sign a pledge, committing Soviet industry to a world of peace and cooperation.*

VI.

In the months following the Twenty-second Party Congress, de-Stalinization progressed. In literary circles, generally of liberal persuasion, people talked of ending the censorship. Writers circulated their works illegally, and often had them published abroad, while the party hacks were subdued. In this relaxed political climate an unknown science teacher from a provincial town south of Moscow submitted a manuscript for publication entitled, *One Day in the Life of Ivan Denisovich*. It described in stark detail a day's routine in one of Stalin's Gulags. Its author, Alexander Solzhenitsyn, knew from personal experience the deliberate cruelty inflicted upon political prisoners as well as their heroic endurance. At this time enough was known about the horror of the Gulags, but never before had they been described in such powerful terms.

After some hesitation, publication was approved, backed even by Khrushchev. In contrast to Dudintsev's *Not by Bread Alone*, which had criticized contemporary practices, Solzhenitsyn's story dealt with a discredited past, and projected, through Ivan Denisovich, strength for the future. While the party hacks griped about his lack of ideological dedication, Solzhenitsyn suddenly emerged as a literary celebrity. His book earned him fame also in the West, where any revelations about the Gulags served as propaganda ammunition in the cold war (and thereby justified Solzhenitsyn's denigration by his Communist enemies).

Solzhenitsyn, June 1995—*One of the greatest and most prolific Soviet writers, Alexander Solzhenitsyn (1918–) first came to international attention in 1962 with the publication of* One Day in the Life of Ivan Denisovich, *which told the story of life in a labor camp. He won the Nobel Prize for Literature in 1970. He was expelled from the Soviet Union in 1973, due largely to the international attention paid to his* Gulag Archipelago. *He relocated to the United States in 1976 and returned to his homeland in 1995, becoming the host of a short-lived radio talk show. (Photograph by Abramochtin, courtesy of Agency Novosti.)*

Soon after his success with *Ivan Denisovich,* Solzhenitsyn managed to publish a short story called *Matryona's House.* Here he wrote about his life after his rehabilitation, when as a teacher in a small community near Moscow, he was lodged in an elderly widow's ramshackle hut. Its occupant, Matryona, emerged as a saint, who in utter poverty and isolation was selflessly dedicated to help others until she died. As Solzhenitsyn concluded: "We had all lived side by side with her and never understood that she was that righteous one without whom, as the proverb says, no village can stand. Nor any city. Nor our whole land." Here he revealed the deep spiritual core of his message, contrary to Marxist materialism and to the popular craving for material goods—contrary, one might even say, to global trends. How could life in the Soviet Union produce such un-Marxist convictions?

Witness to the spiritual undercurrents flowing in Russian life, Solzhenitsyn was born in southern Russia near the Ukraine soon after the Bolshevik revolution. His father, a tsarist officer, was accidentally killed soon after Alexander's birth. His mother, raised in a well-to-do landed family, had to earn a living in the turmoil of the rising Soviet order, handicapped by her social origin. He spent his childhood in poverty and deprivation; as a teenager he turned into a Communist idealist as a member of the Young Communist League. In school and at the university he proved a superb student, concentrating on mathematics and science. He wrote stories at an early age, gifted with an impressive power of observation and retentive memory.

In World War II he rose to the rank of an artillery captain, advancing with the Soviet army into East Prussia, writing stories as well as fighting. Through

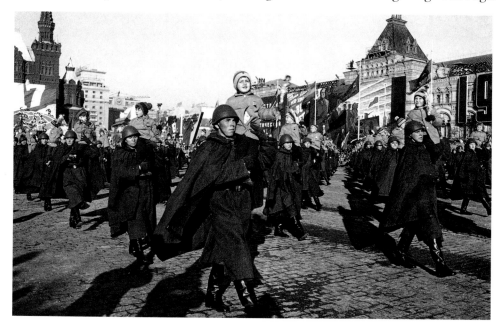

The Next Generation, May 1, 1964

163

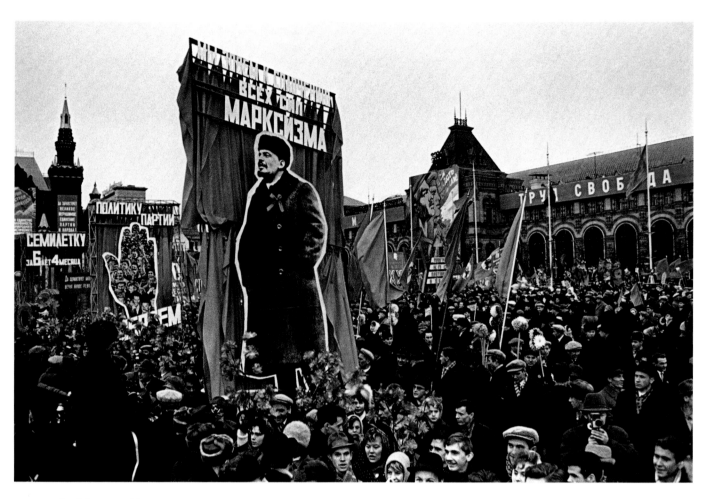

Red Square, 1961

letters he kept in touch with friends who, like him, deplored the bureaucratic pettiness as well as excessive cruelty prevailing in the army. They facetiously talked of "the war after the war," hoping to promote the civility that amidst the rawness of Soviet life was still part of their heritage. Alas, the secret service read their letters, and in February 1945 Solzhenitsyn was arrested as "an enemy of the people."

He spent the next eight years in a Gulag, fortunately not one of the worst. He fought with utter determination, and with the help of religion, not only to survive but also to record secretly the hideousness of the Gulags. The years from 1945 to 1953, from his late twenties to mid-thirties, shaped the rest of his life, hardening his resolve to reveal the inhumanity of the Soviet system from the perspective of a Gulag survivor. In 1953, looking at the world through reproachful sad eyes, he was released, condemned to permanent exile in Central Asia. Surviving a bout of cancer, he was rehabilitated in 1957, and after spending time in Matryona's village, landed a job as a science teacher in Ryazan, where he concentrated on his teaching and writing. While inwardly protesting against the rude,

conceited, and stupid bureaucracy, he outwardly behaved as a model Soviet citizen, but was not an easy person to live with.

The success of *Ivan Denisovich* inspired a host of letters from other Gulag survivors telling their own tales. With their help and his own research he began to compile the three volumes of *The Gulag Archipelago,* the most powerful condemnation of the Soviet system. But because he was raised during his country's most isolationist years and was riveted to his Gulag experience, he, like Pasternak, never comprehended the global setting that shaped the society in which he lived. Matryona's saintliness certainly could not have saved his country from Hitler's assault.

VII.

In that larger context, Khrushchev had cause for apprehension. What effects would this liberalization in literature and the arts have upon the cohesion of the Soviet system? Unrestricted critical creativity would undermine its very foundations. This was Khrushchev's dilemma: loosening up the Stalinist rigidity might destroy the Soviet experiment of reshaping Eurasian backwardness into a superior modernity.

And how could he cope with modern art? His own gut feelings exploded when in late 1962 he visited an exhibit of modernist abstract paintings by Soviet artists. Addressing all these "parasites and pederasts," he shouted: "The people and government have taken a lot of trouble with you, and you pay them back with this shit."

In March 1963, at a Kremlin conference of party leaders and writers, he took a more formal stand: "We must bring all the party's ideological weapons, including such powerful instruments of Communist education as literature and art, into combat order"; everyone had to abide "unswervingly by the party line." He even went out of his way at this occasion to speak affectionately about Stalin, admitting merely his "personal shortcomings." In addition, he complained about the flood of manuscripts submitted after the success of *Ivan Denisovich:* "Take my word for it, this is a very dangerous theme. It's the kind of 'stew' that will attract flies like a carcass, enormous fat flies; all sorts of bourgeois scum from abroad will come crawling all over it." Suspecting a spiritual source in the anti-Soviet undercurrent, he now launched a campaign against religion more drastic than any undertaken in Stalin's times. Obviously, the political climate turned again in favor of the hard-liners, while Khrushchev's fortunes sagged.

His well-meant reforms were failing, and the standard of living declined. His ambitious but ill-informed agricultural policies could not cope with a serious drought in 1963. In the semiarid virgin lands wind erosion and overintense culti-

Khrushchev Against the People, early 1960s—*On one occasion, Baltermants was assigned to take photographs of the tree blossoms around the Kremlin. What resulted was one of Baltermants's more controversial photos, showing the Soviet leader walking alone and unrecognized through the Kremlin.*

vation reduced fertility; harvests declined. And as for corn, many parts of the Soviet Union were climatically unsuited to it, and the peasants turned against it. In 1964 the Soviet Union, so rich in agricultural land, had to import food—a disgrace after all the dreams of overtaking the West in the near future. At the same time Khrushchev's effort to stimulate the economy by separating industrial and agricultural administration caused endless confusion. In his foreign policy, too, Khrushchev had failed. His efforts to gain the goodwill of Mao Zedong's Communist China had gone sour. Overall, the prestige of Moscow among the world's Communists had declined, while the arms race with the United States continued.

Not surprisingly, frustration and disillusion spread around the country. Khrushchev himself, nearing his seventieth birthday, talked of retiring from his overtaxing responsibilities. On October 24 his colleagues in the Presidium of the Central Committee, his own men, anticipated his decision by quietly dismissing him from office on account of his fading health and advanced age, or, as they talked behind his back, of his harebrained schemes and subjectivism. They had

Khrushchev's Last Time on the Lenin Mausoleum, May 1, 1964

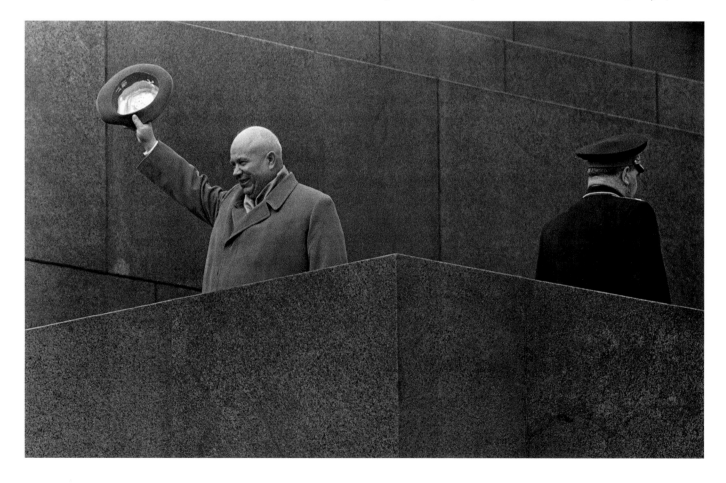

Khrushchev and Daughter Rada
Visiting Red Square, 1965—
Although forced to retire in 1964,
Khrushchev was not villified like
earlier Soviet leaders who were
forced out of political and party
positions and died in obscurity.
Living on a comfortable pension,
Khrushchev worked on his mem-
oirs, which were published abroad
in 1971.

ample justification; he had outlived his usefulness. He was allowed to live a comfortable but obscure life, dictating his memoirs for publication abroad before he died in 1971.

Khrushchev's experiment of revitalizing the Stalinist system had failed. His unfulfilled extravagant promises had increased public cynicism. Although remarkably intelligent and impressively vital, he had been an ideological simpleton carried away by his Marxism-Leninism, which conveyed no sense of the cultural obstacles encountered by enforced modernization. The necessity of strengthening the Soviet superpower, or merely of raising the standard of living in a reasonably short time, required all-knowing guidance from an elite at the top of the government. But the Soviet system was incapable of training such an elite. Under Khrushchev it hurriedly produced remarkable technological and industrial innovation (at the expense of the natural environment), but it made no progress in raising the quality of citizenship.

And yet, there were some significant improvements in daily life, as observed by the foreign correspondent, Harrison Salisbury. When he returned to Moscow in 1959 after a five-year absence, he found a friendlier city. More at ease with each other, people were no longer afraid to talk to a foreigner. Not everything

had changed, but there was less tension, less force, less strain, and a better life for the Russians. He even spotted soft-drink vending machines on the streets—Coca-Cola® was coming. In the summer local folks looked like Americans, wearing sport shirts. He was surprised by the widespread craving for wealth. Officers' wives traveled back and forth from East Germany to sell fancy Western goods—clothing, perfumes, hi-fi records from Paris or New York—for lots of money which they spent on splashy jewelry. Despite these changes, Salisbury could not help noticing also the underside of Communist society: drunkenness, prostitution, begging. He also watched the *buzinesmeni* on the black market and the young people responding to rock and roll, hopefully counting on the withering away of the state. The trend was unmistakable: the door to the West had been pried open, for better or worse, while Marxism-Leninism was still the ruling ideology.

Baltermants and Harrison Salisbury, Williams College, 1985—*Salisbury (1908–1993) was one of the preeminent journalists of his time. As a foreign correspondent assigned to Moscow in the postwar years, he befriended Baltermants, a friendship that would blossom while their respective nations were engaged in the cold war.*

Gromyko, Brezhnev, and Mikoyan together for the first time on the mausoleum, May 1965—
Following the fall of Khrushchev, Leonid Brezhnev became the head of the Communist Party.
By the time of his death in 1982, Brezhnev had served as the Soviet leader for a longer period than anyone but Stalin, presiding over
the nation during its final period as a global superpower.

The Brezhnev Years

After the fall of Khrushchev a third phase in the Soviet experiment of raising the peoples of Eurasia—and the Russians foremost—to global prominence began under the leadership of Leonid Brezhnev. By its end, however, serious flaws were undermining its momentum.

The Brezhnev regime made a good start. The Soviet Union matched the United States in its nuclear arsenal and military strength. Its defense budget was the largest in the world, with its warships plying the Pacific, the Indian Ocean, and the Mediterranean. Its political presence extended around the world through diplomacy, Communist parties and, in some countries, military aid. Everywhere it was respected and feared. It won more medals than any rivals in the Olympic Games. It was also admired in the West for its ballet dancers and musicians. It was ahead of the world in the production of steel, pig iron, oil, and cement, as well as sugar and honey. Above all, the threat of political collapse and foreign domination that had inspired the Soviet experiment was gone for good. The humiliation of political weakness had been replaced by pride in the country's superpower status.

Yet the very success of the Soviet experiment also undermined it. Why during good times was it necessary to work so hard? Why submit to the uncongenial discipline imposed by the party under an ideology that was losing its savor? As the Marxist-Leninist militancy faded and Western ways intruded, the unruliness of the Soviet peoples revived. The anti-Soviet protest grew stronger and more politically oriented, agitating for respect of human rights. What the country needed, so leading members of the intelligentsia argued, was more democracy. Understandably Brezhnev and the party leadership stuck to the Bolshevik distrust of the unruly masses. While trying to raise the people's civic capacities, their leaders still

Woman Worker Atop the Hotel Ukraine, May 1953— *One of the major guidelines of socialist realism was that workers had to be portrayed enjoying great physical labors, not only with success but with happiness as well, like this worker. Another of Baltermants's photographs, showing a steelworker with beads of sweat rolling down his face, was censored, as it showed work to be a difficult and trying task.*

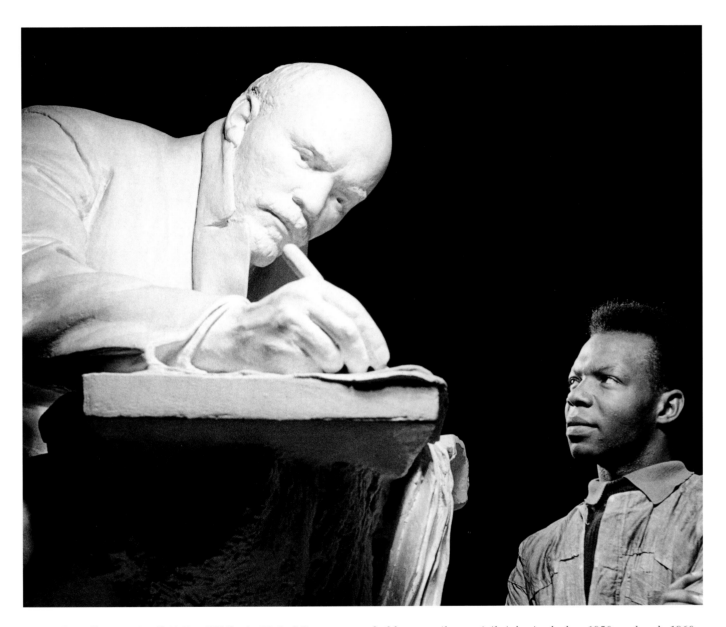

Lenin for All Men, April 1961—*While the United States was racked by turmoil over civil rights in the late 1950s and early 1960s, the Soviets wanted to show the world that they were a classless society, open to peoples of all races from around the world. This message is displayed in this photograph of an African student visiting Moscow. As with all propaganda, the truth was somewhat distorted; the Soviet Union had its own minority groups, which it often held in low esteem.*

needed to control them. The traditional Russian sense of insecurity persisted, as the country's impressive military power was offset by its diverse people's persistent backwardness and disunity.

These were the years of Dmitri Baltermants's prime. Fifty-three years old in 1965 and on the editorial board of the conservative *Ogonyok,* he benefited from the opportunities offered by the relative calm of the Brezhnev regime. After the harrowing times he and his contemporaries had lived through since childhood, he could now enjoy his career as a distinguished photojournalist increasingly recognized abroad.

I.

The new phase of the Soviet experiment began under a novel collective leadership, with Leonid Brezhnev heading the Communist Party, Aleksei Kosygin running the government, and Nikolai Podgorny acting as president of the USSR. Approaching old age—all three had been born between 1903 and 1906, when the tsarist government was shaken by its first revolution—they had risen from working-class families through industrial apprenticeships and party work in the Stalin years to political prominence under Khrushchev. Brezhnev, despite an undistinguished military record, reached high military rank during World War II and in the 1950s was put in charge of the virgin lands project in Kazakhstan. An experienced administrator, he had also traveled abroad. Kosygin, a nonideological incorruptible pragmatist, had risen as a textile engineer to the position of Khrushchev's economic troubleshooter. Podgorny, the oldest of the trio and a Ukrainian, rose from the food industry to the party Secretariat. Their collective style, in contrast with Khrushchev's impetuous and ever shifting improvisations— let alone with Stalin's dictatorial arrogance—was remarkably consensual. They aimed at order and stability through cooperation and compromise, a novel feature in Bolshevik political culture.

Their first job was to reverse Khrushchev's destabilizing innovations and to establish firm control over the government, thereby reassuring the entrenched bureaucrats. Tightening censorship, they repressed political opposition, staging a public trial of two writers who had published their work abroad. Stalin's merits were again recognized. Yet at the same time, Kosygin tried to liberate industrial managers from initiative-stifling centralized control. He also promoted increased openness toward the West by drawing on its technological innovations.

Soon, however, Khrushchev's successors were jolted by events in Czechoslovakia. Inspired by the memory of Khrushchev's reformism, a Moscow-trained Slovak Communist, Alexander Dubček, took over the party leadership in his country early in 1968. He ended press censorship and relaxed political controls in pursuit

Building Moscow, 1966

of democracy and human rights, while still stressing his loyalty to the Soviet Union. Yet Dubček's daring innovations alarmed governments in neighboring Communist countries and foremost in Moscow. His "socialism with a human face" constituted a threat to the entire Communist system. After some hesitation, Soviet troops, supported by East German and Polish units, occupied Prague in late August, subduing hostile demonstrations with minimal bloodshed. Dubček was briefly imprisoned in Moscow, but then was restored to his office in Prague, before being assigned in 1969 to an insignificant diplomatic post and deprived of his party membership; he ended up working for the Slovak forestry administration. The "Prague Spring" ended in a prolonged but relatively mild Communist winter under Gustav Husák. Red Army troops remained stationed in Czechoslovakia. Soviet interference was legitimized by the "Brezhnev Doctrine," which allowed Soviet intervention in the internal affairs of any Soviet satellite.

Inevitably, Soviet repression in Czechoslovakia outraged opinion in the West, but even there a change of attitudes was underway. The West German government, since 1969 headed by the Social Democrat Willy Brandt, was eager to normalize relations with the East German government and its Soviet master. In the Moscow Treaty of 1970, the final settlement of World War II, the boundaries of West Germany, East Germany, and Poland were officially recognized, opening a new era in East-West relations, with increased opportunities for mutually beneficial contact. West Germany could help now to modernize Soviet industry in return for Soviet natural gas. In the same year President Nixon scaled down the ideological contest between the superpowers, observing that "the Marxist dream of international Communist unity has disintegrated." The threat of the Communist world revolution was replaced by the shared dread of nuclear war. And in this respect the superpowers had begun to face up to their responsibility. In 1968 they began their Strategic Arms Limitation Talks (SALT I). In 1970 they signed a nuclear nonproliferation treaty.

II.

Under these auspicious circumstances, Brezhnev, the least impressive among Soviet leaders, rose as the dominant personality in the Soviet political scene. Taller and less bulky than Khrushchev, radiating calm dignity from a face marked by dark bushy eyebrows, he inspired confidence and stability. Unlike Khrushchev he was rather boring in public, but he lent an air of assurance and experience to the Soviet leadership, avoiding any open confrontation within its ranks, while feeding his voracious appetite for decorations, titles, and prizes. Like his predecessors he reaffirmed the central conviction supporting the Soviet ego, the belief in "the universal triumph of the cause of socialism." He was the high priest of the

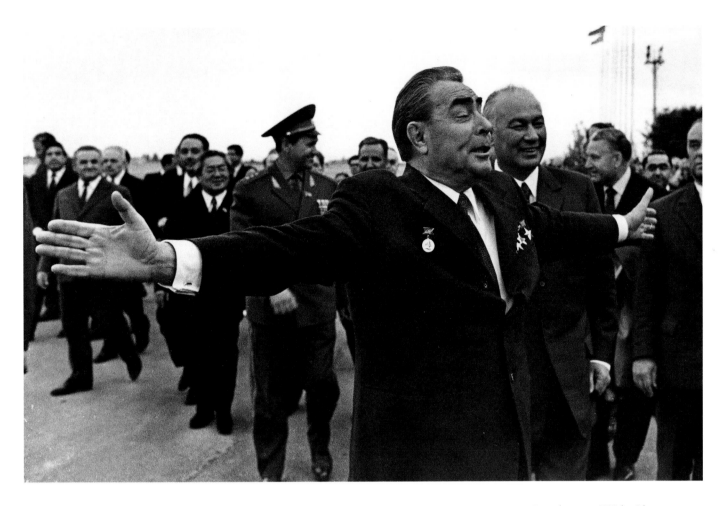

Brezhnev, a Wide Character,
1979

creed sustaining the Soviet experiment which involved by 1970 about 240 million people, the third-largest number in the world after China and India.

Yet that experiment was undergoing considerable adjustment under the guidelines of "developed socialism," as outlined in the 1970s by his party theorists. After Khrushchev's ideological extravagances, it represented a more sober phase in Soviet thinking, envisaging a prolonged series of slow and cautious reforms, which used the latest innovations in science and technology—such as computers and automation—combined with better management techniques. What mattered henceforth was not only precipitous industrial growth, but advances in the arts, education, and public services. The intelligentsia was to rise to the fore, without reviving the class struggle. The distinction between manual and intellectual labor was bound to disappear, as would the differences between nationalities.

The state, rather than wither away as predicted by Marx, would expand down to the lowest administrative levels and deal with a growing number of non-governmental agencies as well. Both party and state, like all citizens, were bound

Kindergarten, 1949

Milkmaid of the Year, October 1971—*In addition to showing images of political leaders and party events,* Ogonyok *produced photoessays on the "everyday" citizens across the Soviet Union. Each year, the government selected workers in various industries as models in their field, as examples of the Communist work ethic. In 1971 Valentina Andrukova, shown with her daughter, was selected as the nation's best milkmaid.*

The Insulator Factory,
1948

to obey the law under the Constitution; individuals had the right to go to court over a violation of their rights. Obviously, the theory of "developed socialism" imitated the West in a subtle form, offering hope for an effective modernity. But did it have a chance? Meanwhile, world events had turned in Brezhnev's favor.

By the early 1970s a significant change in the balance of power between the superpowers had taken place. In military power and atomic weapons, the Soviet Union now equaled the United States. Never before had the country achieved such eminence in the tools of war or space exploration; while Americans had landed on the moon, Soviet space exploration was not far behind. It was also catching up in material respectability. Moscow, its capital, displayed a cosmopolitan air. The Kremlin, now open to the public, attracted a stream of tourists to its Hall of St. George, a gloriously decorated relic of tsarist days. Its people were experiencing a welcome improvement in their material life; they had never lived so well in Soviet times. Now they could buy television sets (black-and-white), refrigerators, and even private cars produced by Russian firms and by Fiat. Brezhnev himself proudly displayed the Cadillac, Rolls-Royce, Mercedes, and Citroën limousines given to him by foreign governments—who, secretly, did not wish to live like a capitalist? Hopes ran high for a continued rise in material prosperity with the help of Western credit and technology.

Missile on Parade, May 1964— *One of the enduring images of the Soviet Union was the May Day procession of weaponry and rocketry through Red Square. Part propaganda, part display of pride, these images were regularly shown abroad. These grandiose parades are now a remnant of the nation's past.*

Allende, July 1972—
Dr. Salvador Allende Gossens
(1908–1973) became the first
Marxist elected to a major office in
the Western Hemisphere, winning
the Chilean presidency with thirty-
six percent of the vote. He national-
ized industries and destabilized the
economy. As a result, he was
overthrown and assassinated in
1973 by a military coup backed by
the United States.

While the Soviet Union was upward bound, the United States was slipping from its postwar self-confidence. From the mid-sixties onward, domestic turmoil combined with the escalating involvement in the futile war against North Vietnam sharply divided American opinion. After 1972 the Watergate scandal discredited the presidency of Richard Nixon. In addition, the American economy declined. What counted, according to Nixon and his foreign policy advisor, Henry Kissinger, was not the universal mission of democracy and human rights, but constructive relations with the totalitarian states of China and the Soviet Union.

Thus began the brief era of détente, an interlude of relaxation in the cold war.

 In May 1972, at the height of the bombing of North Vietnam, President Nixon was received in Moscow with open arms. He and Brezhnev agreed that in the nuclear age no alternative existed to peaceful coexistence. And they readily prepared for economic cooperation. The Soviet Union at last paid its debts accumulated under the Lend-Lease Act of World War II. It opened its markets to American goods, including Pepsi-Cola® (available from vending machines on Moscow streets). The Soviets, suffering again from crop failures, purchased four hundred million tons of U.S. grain. American and Soviet companies started joint development of Siberian oil and natural gas. Hordes of American capitalists flocked to Moscow investigating the Soviet market, while *The New York Times* declared Brezhnev its "Businessman of the Year." The new chumminess distressed the advocates of human rights in both countries. But what did the maltreated Soviet dissidents count when there was money to be made? The Soviet Union, too, needed extra money to finance its allies: Cuba, pro-Communist regimes in the Third World, and Communist parties everywhere.

Nixon and Brezhnev, 1972— *In one of the ultimate political ironies, the anticommunist, former "Red baiter" President Richard Nixon (1913–1994) became the first postwar American president to visit the Soviet Union. The two leaders got along well, paving the way for détente in the form of the Strategic Arms Limitations Talks (SALT) and opening the Soviet Union to American industry.*

Nixon and Brezhnev at
San Clemente, California,
1973

The political and economic embrace continued through 1973 and 1974, and reached its climax in July 1975 at the Conference on Security and Cooperation in Europe (CSCE), held in the Finnish capital of Helsinki. That conference brought together thirty-five states representing the Eurasian Soviet Union and all European states east and west, plus the United States and Canada from across the Atlantic. The CSCE was a huge loose-knit agency, scheduled to meet regularly into the foreseeable future, to "broaden, deepen, and make lasting" the process of détente for the common benefit through increased trade, travel, and communications, and by promoting respect for the fundamental freedoms of thought, conscience, religion, and belief. Although the Soviet Union signed the Helsinki Accords, it was obviously not prepared to carry out all the provisions. Yet while the conference was in session, American astronauts and Soviet cosmonauts joined in space high above the earth, exchanging greetings in each other's language, before sharing lunch in the Soviet space capsule—a cosmic symbol for an organization uniting all states embroiled in Europe's hot and cold wars since 1914.

III.

While it lasted, détente was plagued by the conflict over human rights that was sparked by the repression of dissent in the Soviet Union. Sporadic dissent, part of the anti-Soviet undercurrent, had festered for a long time. Invigorated by Khrushchev's anti-Stalin speech, it now began to enlist members of the intellectual elite, including writers and scientists. Resentful of being bossed around by dogmatic bureaucrats, they wanted to be heard. They added excitement to the dull politics of the Brezhnev regime.

Their anger cropped up in written protests. Typed in secret, these protests were distributed among trusted friends and sometimes passed on to foreign correspondents for transmission to Western radio stations broadcasting to the Soviet Union, such as the BBC, the Voice of America, and Radio Liberty. Called *samizdat* (self-edited), the protests reached a growing audience in the Soviet Union, at a risk to their authors. A samizdat statement published in the West could get them into trouble, since discrediting the Soviet Union was a crime.

In 1966 two authors had been tried in public and sent to jail. Declaring the trial a farce, the dissidents now offered sophisticated legal arguments. The Stalin Constitution of 1936 guaranteed freedom of thought (which was never acknowledged in Soviet practice). So did the UN's Universal Declaration of Human Rights

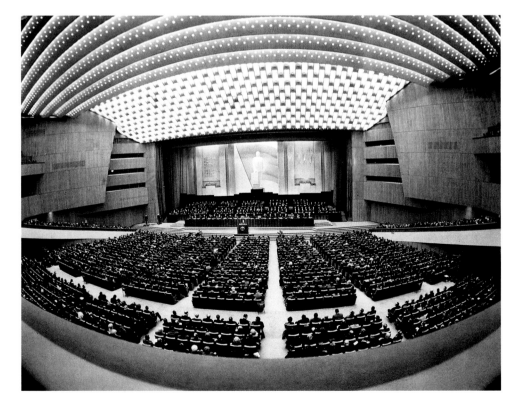

Inside the Supreme Soviet, October 1972—*This photograph was one of Baltermants's first using a "new" technology from the West—the fisheye lens.*

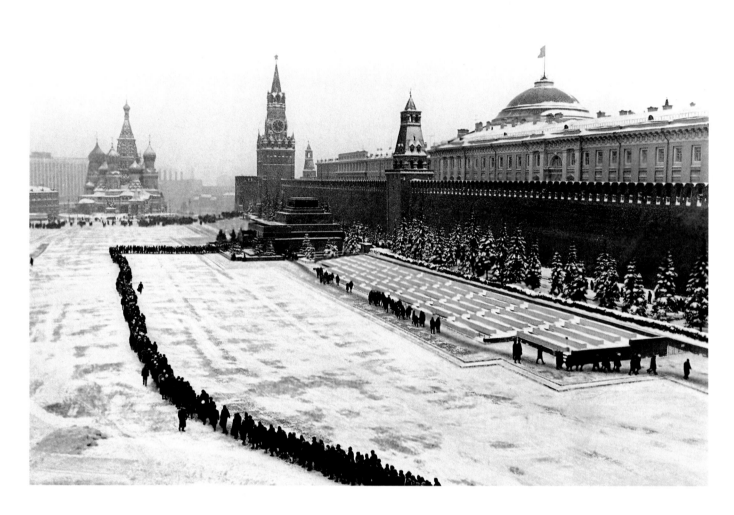

Queue at Lenin's Tomb, 1961—
One of Baltermants's great socialist-realist photographs, a reverent line of devoted Soviets winds snakelike toward Lenin's tomb on a bitter winter afternoon.

signed by the Soviet Union. According to these documents, protest against the government's violation of civil rights was legitimate. Alarmed, the government in 1967 appointed Yuri Andropov, eventually Brezhnev's successor, to lead the secret service (commonly known as the KGB) in repressing the troublemakers. He had limited success.

At the time of the Prague Spring in 1968, a secret gathering of prominent dissidents—hoping they were not bugged by the KGB—decided to start a publication, the *Chronicle of Current Events.* It was a samizdat venture whose history allows a glimpse into the secret world of anti-Soviet dissent. Natalia Gorbanevskaya, a remarkable woman who epitomized the creative energies that existed among Soviet dissidents, informally—and heroically—took charge.

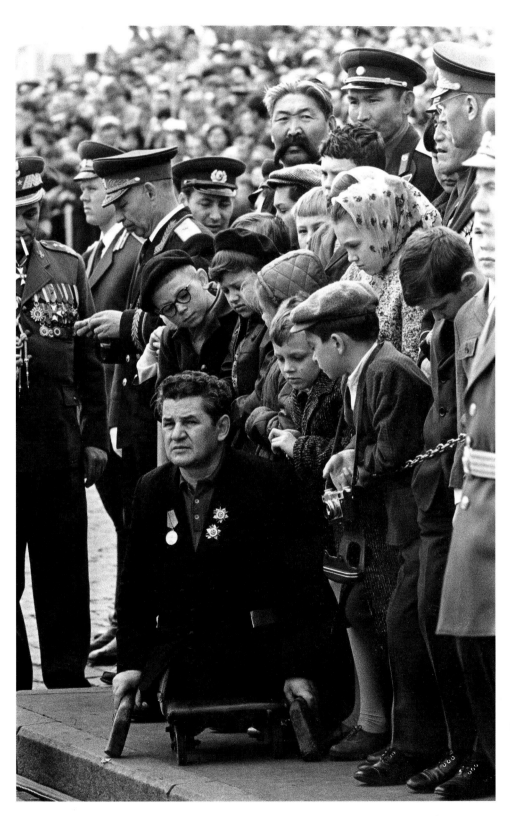

And Once There Was War, May 9, 1965—*Taken at a parade in 1965, this photograph of a disabled veteran did not appear in print until 1971. When it was finally published, it became the first photograph in* Ogonyok *to show an "imperfect" Soviet person.*

Thirty-eight years old, of inconspicuous appearance and pregnant at the time, she lived with her mother and little son (with no husband) Moscow-style in one small room, sharing kitchen, bathroom, and toilet with resentful fellow tenants. Her energies were drained by exhausting shopping trips on busy streets. As a participant in the protest movement she had been punished in February with a week's confinement in a mental hospital (then a common form of repression). And yet, by mid-April, she had edited the available information, producing on a second-hand German typewriter a solid twenty-page document, the first issue of the *Chronicle.*

Gorbanevskaya slipped less than a dozen copies to trusted friends (including a foreign correspondent), who secretly typed as many copies as they could for further distribution. Each recipient was responsible for repeating the process, until hundreds, or even thousands, of copies were circulating. Selections from the *Chronicle* broadcast by foreign radio stations spread its message even further. In return, dissidents passed relevant items from their own experience, by word of mouth or writing, all the way back to Gorbanevskaya. Normal communications were avoided, since telephones were bugged and letters were censored; Big Brother KGB was closely watching. When her room was suddenly searched, one of Gorbanevskaya's associates dumped material for the *Chronicle* into a pot of borscht cooking on the stove. One had to be constantly on guard; Gorbanevskaya did not even tell her mother what she was doing.

Arrest was likely any moment. In August 1968, after participating—with her three-month-old baby—in the demonstration against the Soviet occupation of Czechoslovakia, she was declared "mentally disturbed" at a psychiatric clinic, before being released to the care of her mother—and to edit further issues of the *Chronicle.* Altogether she produced eleven issues prior to her detainment in December 1969 as a person "of an unsound mind" and subsequent imprisonment for two years at a mental hospital in a distant city. Returning to Moscow in 1972, she again worked among the inner circle of the dissidents before emigrating, like many of her disillusioned associates. In 1975 she settled in Paris.

The *Chronicle* gradually broadened its coverage to human rights' violations around the country. The biggest issue proved to be the prohibition of Jewish emigration, a natural response to the widespread anti-Semitism. Publicizing it, the *Chronicle* helped to stir up Western pressure on the Soviet government. The U.S. Congress subsequently threatened to revoke the trade benefits recently negotiated. Eager to preserve détente, the Soviet government lifted the restrictions and allowed a large Jewish exodus to Israel or the West.

At the start of détente, in January 1972, the KGB managed to suppress the *Chronicle;* its revelations might discourage foreign businesspeople. It reappeared in late 1974 to last until 1981, increasingly voluminous but of shrinking appeal at

a time of political passivity. It was tolerated by the KGB because it afforded an opportunity to monitor the dissident movement and allowed a semblance of conformity to "developed socialism." In any case, the KGB had to cope with more weighty dissidents: Andrei Sakharov and Alexander Solzhenitsyn, the two most attention-catching individuals in the Brezhnev era.

IV.

Sakharov, born in 1921, was another symbol of the heroic creativity found among the Russian people, although an unusually privileged one. He was raised in a physicist's family which, protected by the prestige of science, carried basic values of the tsarist intelligentsia into the Soviet era. He was educated at a private school in Moscow at the height of Stalin's terror. During the war, having been evacuated from Moscow as a university student and excused from military service because of a heart condition, he continued his studies before putting his ingenuity to work at an armaments factory. After the war, he was drafted into the scientific team working on the Soviet atomic bomb. Here he made his mark as the key scientist developing the Soviet hydrogen bomb, watching its test explosion in August 1953. Thirty-two years old in the uncertain year of Stalin's death and Beria's downfall, he had equipped his country with the crucial weapon that raised it to equality with its American rival. He was duly rewarded with membership in the Soviet Academy of Sciences, a Stalin Prize, and worldwide fame. His visibility not only gave him access to the Soviet leadership (even though he refused the join the Communist Party) but also provided him in later years with unique immunity from annihilation.

He broadened his perspectives through contacts with liberal-minded fellow scientists in Europe and the United States who were aware of the dangers of nuclear war and soon also of environmental pollution. In 1968, tuned to Western progressive trends, he took a mental quantum leap from nuclear physics to a global overview, feeling compelled "to speak out on the fundamental issues of our age," no less.

Forty-seven years old now, radiating from his face a warm gentle smile, his eyes glowing brightly underneath his large domed forehead, he conveyed an image of heroic determination, summed up in two lines of Goethe: "He alone is worthy of life and freedom/Who each day does battle for them anew!" In this spirit Sakharov wrote an essay pointing to the grave perils threatening the human race: thermonuclear war, ecological catastrophe, famine, population explosion, alienation among people, and, with an obvious reference to his own country, "dogmatic distortion of reality." The remedy lay in convergence between the two superpowers and the creation of a scientifically governed democratic pluralist society free of intolerance and dogmatism.

Sakharov Addressing the Supreme Soviet, 1987—*The "father of the Soviet H-bomb," Andrei Sakharov (1921–1989) became internationally known for his movement for peace and cooperation between the superpowers. With his wife, Elena Bonner (1923–), Sakharov was also an eloquent spokesman against human rights' abuses in the Soviet Union, causing him to be banished from Moscow from 1980–1987. Under Gorbachev, former dissidents like Sakharov were allowed to speak out against these abuses and were no longer fearful of government reaction.*

Thus Sakharov was launched on a new career as an intellectual agitator, diligently watched at home and abroad. His essay was published in *The New York Times* and circulated in samizdat, conferring upon him a perilous new visibility. The government responded by demoting him at his research institute and cutting his salary, thereby further strengthening his resolve to battle for "life and freedom." He now became a symbol of liberation from Soviet inhumanity.

In 1970 he helped found a human rights committee, denouncing the persecution of dissidents, the suppression of religious worship, and the prohibition of free movement across the country's borders. He also denounced the death penalty. In the following year, joined by another physicist and a reform-oriented historian, he addressed a lengthy "Appeal for Gradual Democratization" to Brezhnev and his colleagues. It was a landmark document filled with startling arguments.

The appeal started with praise for Soviet progress, but then quickly moved into a grim prediction of the Soviet future. In economic productivity the country lagged behind the United States quantitatively and qualitatively. The fault, according to Sakharov, was not caused by the socialist system, but by "peculiarities and conditions of life which … are hostile to it." He continued:

> Truthful information about our shortcomings and negative manifestations is hushed up on the grounds that it "may be used by enemy propaganda." Exchange of information with foreign countries is resisted for fear of "penetration by an enemy ideology." Theoretical generalizations and practical

proposals, if they seem too bold to some individuals, are nipped in the bud without any discussion, because of the fear that they might "undermine our foundations." An obvious lack of confidence in creatively thinking, critical and energetic individuals is to be seen here.

The remedy, Sakharov asserted, lay in democratization carried out systemtically and scientifically by the Communist Party. It implied the end of censorship, amnesty for political prisoners, freedom to travel abroad, independent courts, and *glasnost* (openness) in all discussions of government actions and political events. Such measures would also enhance the international appeal of communism.

Sakharov obviously was aware of the disruptive elements in Soviet society. Given its inherent unruliness, respect for human rights and free speech would instantly produce growing disorder. But like Western liberals, he counted on the natural cohesion in a functioning democracy. In any case, there was no other solution. "What is in store for our nation if it does not take the course toward democ-

Stalingrad (now Volgograd), late 1950s—*Utterly devastated during World War II, Stalingrad and its resilient citizens rose from the ashes to become one of the Soviet Union's most important industrial centers sprawled along the Volga for sixty-five kilometers. A modernized city by the late 1950s, it became a major production center of steel, chemicals, and oil.*

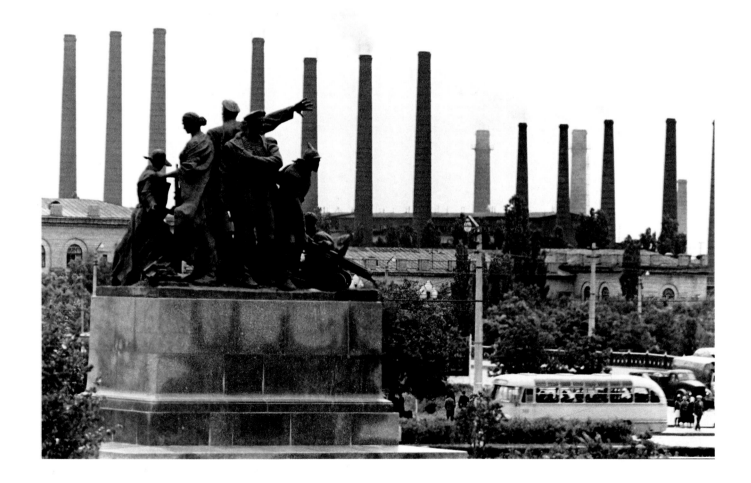

ratization? The fate of lagging behind the capitalist countries and gradually becoming a second-rate provincial power." In addition, Chinese totalitarian nationalism loomed dangerously in the east. It was a common fear at the time. There had been armed border clashes in 1969.

Reflecting on Sakharov's eloquent mixture of loyalty and subversive criticism, one wonders: did it make sense? If democratization was to be promoted by the Communist Party, the party obviously had to retain its authority—unlikely, if its controls over public affairs were to be removed by the progress of democratization. A pioneer of westernization among Russian intellectuals, Sakharov was guided by Western political theory and values with little appreciation of the historical realities shaping Soviet society. The Soviet system could not be scientifically remodeled according to Western guidelines (as the collapse of the Soviet Union less than twenty years later would show).

Not surprisingly, Sakharov himself was suspended in distressing uncertainty. Asked by a journalist about the major shortcomings of Soviet society, he mentioned great internal inequalities and lack of freedom, admitting: "We are a society on the decline." But what could be done? "Almost nothing could be done." Socialism did not offer a new theoretical plan for a better social order; tiredness, apathy, and cynicism prevailed everywhere. Why then did he continue protesting? His somewhat confused answer revealed the tragic agony of reform-minded patriotic liberals in the Brezhnev era: "Well, there is a need to create ideals even when you can't see any way to achievement, because if there are no ideals then there can be no hope and then we would be left completely in the dark, in a hopeless blind alley."

Wavering between hope and hopelessness Sakharov battled on, supported by his wife Elena Bonner, an equally heroic long-time protester against Soviet oppression. While restating his views in critical essays on Soviet conditions, he relentlessly denounced the violations of human rights in the treatment of dissidents in court and prison, keeping in close touch with the contributors to the *Chronicle,* as well as with international human agencies. During Nixon's Moscow visit in 1974, Sakharov even staged a six-day hunger strike to dramatize the plight of political prisoners. For him, human rights took precedence over détente. Still a privileged member of the Soviet Academy of Sciences, he was nonetheless subject to denunciation by fellow academicians, vicious attacks in the Soviet press, and death threats against his wife's children and grandchildren.

In Europe and the United States, however, he was famous as the voice of reason and moral righteousness in the Communist wilderness. In 1975 Western admiration earned him the Nobel Peace Prize, an embarrassment to his government (which prohibited his attendance at the award ceremony; his wife accepted

the prize on his behalf). Morally reassured, Sakharov continued his agitation, subject to even worse harassments, until he exhausted the KGB's tolerance. In early 1980, protesting the Soviet invasion of Afghanistan, he suggested to *The New York Times* that this violation of international law warranted the cancellation of the Olympic Games to be held in Moscow later that year. As punishment, he was banished to the city of Gorky (now again called Nizhni Novgorod), an industrial center three hundred miles from Moscow and closed to all foreigners. His fame at home and abroad fortunately protected him from the brutality commonly meted out to lesser heretics. In Gorky he spent the next seven years, still in contact with the outside world thanks to his wife. Meanwhile political ideas resembling his own began to simmer in Gorbachev's mind. There was some hope, after all—more than for his rival in fame, Solzhenitsyn.

V.

Thanks to Khrushchev, Solzhenitsyn had achieved widespread popularity with his book *One Day in the Life of Ivan Denisovich.* But the Brezhnev regime's offensive against dissent set him back. In 1965 the KGB confiscated his manuscripts and archive of letters; it was a blow as painful as the arrest in 1945 that had sent him to the Gulag. Subsequently, with an ex-zek's skill, he learned to protect his tracks. He kept his movements secret, sticking to his austere routines of writing one remarkable novel after another—while completing *The Gulag Archipelago*—and always with a transistor radio by his side, listening to the news. He still hoped for publication in the Soviet Union, despite vicious defamation based on excerpts from his confiscated manuscripts. At the same time he relished the success of his books abroad, where he was praised as the contemporary master of his country's great literary tradition. Of modest height and lean body, his face framed by an ever-larger beard, and with a penetrating gleam in his eyes, he radiated a power beyond words.

Unwilling to join the rising tide of dissent, but in close touch with its leading figures, he occasionally spoke out, always impressing public opinion. In 1967, on the fiftieth anniversary of the Bolshevik revolution, he protested at a big Soviet Writers' Congress against the censorship that prevented Soviet writers from expressing their convictions and tampered with their writings. As a result, all of world literature was suffering, since Soviet authors could not continue their valuable contributions. In 1969 he took issue, in a somewhat hectoring manner, with Sakharov and the westernizing advocates of freedom and democracy. Freedom was no remedy for the world's ills, he argued. Look at what it had done to the West: "crawling on hands and knees, its will paralyzed, uneasy about the future, spiritually racked and dejected." It was time for the Russian people to rise above

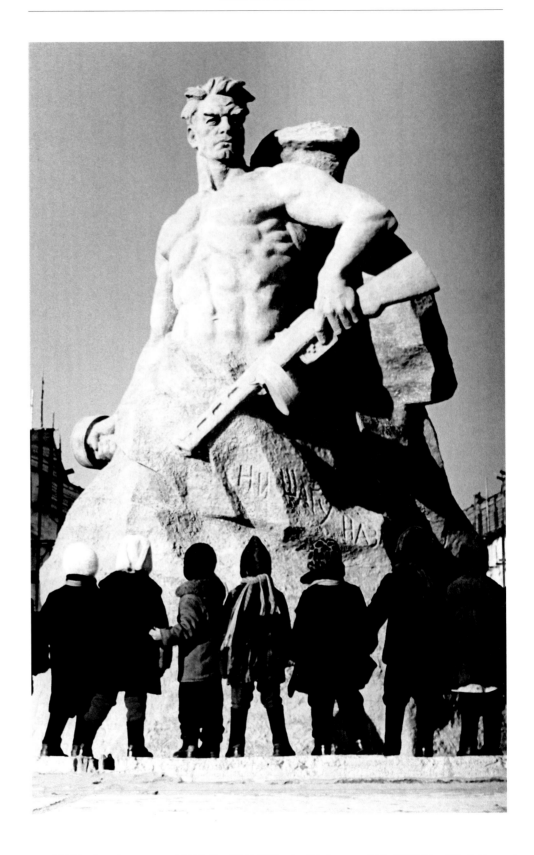

Stand Until Death,
Volgograd, 1970

Western principles. Yet regarding human rights, he and Sakharov were on the same track.

In 1969, when he finished *The Gulag Archipelago,* an awe-inspiring account of Stalin's labor camps, he was expelled from the Writers' Union of the USSR, membership in which had given him many privileges. He was accused of be-smirching "our motherland" by publishing critical novels abroad, and to such applause! In 1970 his popularity in the West earned him the Nobel Prize in litera-ture, "for the ethical force with which he has pursued the indispensable tradition of Russian literature." At home, however, this darling "of reactionary circles in the West" was more than ever subjected to harassment and even threats of death. Undeterred, Solzhenitsyn continued writing and ventured some thoughtful ob-servations, as in an interview with *Le Monde* in 1973.

In good times, Solzhenitsyn contended, people will shy away from human suffering at the periphery of their existence, in order to prolong their well-being. "Yet a man who is approaching the last frontier, who is already a naked beggar deprived of everything that may be thought to beautify life, can suddenly find in himself the strength to dig in his heels, ... surrender his life but not his prin-ciples." Thanks to the latter quality, "mankind has pulled itself out of all kinds of bottomless pits." The future, he theorized, lay not with the degenerate complacency of the West, but with the crisis-ridden East, guided by prophets such as himself.

Thus he approached "the last frontier" (though not as a beggar thanks to ample royalties from Western publishers), when in March 1973 the KGB discov-ered a copy of *The Gulag Archipelago* smuggled into Leningrad. An instant suc-cess in the West, it had found its way back into Soviet society, the most subversive book imaginable. Solzhenitsyn, like other Soviet listeners, could even hear ex-cerpts from it transmitted by foreign radio stations. In anticipation of some ca-lamity Solzhenitsyn spent the next months outlining his state of mind at the height of détente in his *Letter to the Soviet Leaders.* It dramatically showed his far-roving imagination defiantly taking issue with the Brezhnev crew.

At the outset of the *Letter,* he warned them of the chief dangers in the fore-seeable future: "war with China; and our destruction, together with Western civi-lization, in the crush and stench of a befouled earth." But to reassure the Soviet leaders, he praised the brilliant success of Soviet diplomacy which had raised a country riven by civil strife to a superpower (as though diplomacy had accom-plished that feat). The Western world and Western civilization were beset by a catastrophic weakening. The enlightenment was a "dead-end street"; the idea of eternal progress a "nonsensical myth." In any case, Russia had followed Western technology too long. It had spoiled Russia's natural beauties, including "our be-loved Moscow," where life had become intolerable, like all urban life.

Baikalo-Amurskaya
Railroad Workers, 1974—
*The railroad from Lake Baikal to
the Amur region ran through
rugged terrain in the far eastern
part of the country. Note the use of
a double layer of tracks, necessitated
by the region's permafrost.*

And what of the present state of affairs in the entire country? "People don't put any effort at all into their official duties and have no enthusiasm for them, but cheat (and sometimes steal) as much as they can and spend their office hours doing private jobs (they are forced to, with wages as low as they are today). ... Everybody is trying to make more money for less work. And everybody is drinking too much vodka. Leisure time is wasted on television, or card or domino playing. If anybody reads, it is either sports or spy stories. The party's control of intellectual life is committing 'spiritual murder.'" Thus Solzhenitsyn boldly admonished the party leaders to throw off their threadbare, flawed ideology, "the grim jest of the twentieth century," which "clogs up the whole life of society—minds, tongues, radio, and press—with lies, lies, lies."

But the novelist Solzhenitsyn also offered a positive, if distant, vision: the northeastern parts of Russia—Siberia—were the country's reservoir of hope. Here Russia could escape the crisis of Western civilization, humbly putting its own house in order, in healthy silence amidst village-based small-scale production thriv-

ing (astonishingly) on appropriate high technology. The open spaces of Siberia would also provide ample agricultural resources (in a cold climate amidst poor soils?).

How then could the present system be changed? Solzhenitsyn hoped for an authoritarian order based on love of the whole people, without secret trials, psychiatric violence, or labor camps. For this purpose he considered Christianity the best force capable of spiritual healing. In conclusion Solzhenitsyn asked the party leaders: "What do you have to fear from this proposal? You have the army, the police, and industrial strength. All you have to do is let the people breathe—let them think and develop."

He mailed his *Letter* to the Kremlin, naively—or arrogantly?—expecting an answer, before publishing it abroad. The official reply came in January 1974, when *Pravda* condemned his career under the title "The Path of a Traitor." And in February he was arrested, stripped, searched, and dressed in a white shirt and tie (contrary to his sartorial habits), before being put on an airplane to Germany. On landing in Frankfurt, utterly bewildered, the KGB handed him an elegant overcoat, a cap, and five hundred deutsche marks, before the German immigration authorities drove him to the house of the German author Heinrich Böll, an old acquaintance. Thus began his exile in the decadent West, a fate he had once denounced as "spiritual castration." Eventually he withdrew into deep seclusion in a well-guarded country house among the Vermont woods, a touch of Siberia for a literary idol lost in soulful unreality. Meanwhile Mother Russia was moving in a different direction.

VI.

Russia, the vital part of the Soviet Union, passed through an elemental transformation during the Brezhnev years. The air of satisfaction relaxed the rigorous discipline imposed by the Soviet regime. As a result, its endeavor to create a cohesive society capable of enhancing the country's strength was doomed.

The Soviet government had certainly made an impressive effort to serve its peoples and to overcome their lack of spontaneous unity. Now it had to cope with the cultural change it had accomplished by transforming, in less than half a century, its soil-bound peasants into an urban-industrial society. By the 1970s more than 65 percent of its peoples lived in an urban environment, with Moscow counting nearly eight million inhabitants and Leningrad about five million. But peasant habits still lingered among the newly urbanized masses thrust into an unaccustomed modernity.

Under these conditions—and despite pervasive poverty—the government had created a social system that guaranteed everybody a job, plus housing and

The Classroom, 1949

social benefits, such as free health care and subsidized higher education. It had also made a determined effort to promote social bonding through participation in socializing organizations throughout life, ranging from the Communist Party and its auxiliaries, through professional associations and recreational activities at the place of employment, to interaction in people's courts judging work performance or illegitimate pregnancies. It had diligently promoted sports as a means of creating team spirit (and Olympic triumphs). It had boosted patriotic pride by creating grandiose monuments and symbols of the country's achievements, with increasing use of the media—especially television in the Brezhnev years. All along, it provided plentiful popular entertainment, at concerts, theaters, movie houses, and circus performances. Life certainly had become less monotonous in the Soviet Union, especially after the two-day weekend was introduced in 1967.

And yet, the new ease, combined with increasing opportunities for comparison with capitalist prosperity, discredited the Soviet ambition to achieve

socialist superiority. The latent anarchy of Russian/Eurasian life began to resur-face. Marxism-Leninism, the central creed of the Soviet vision, lost its appeal. With it went the patriotic idealism enshrined in it. According to a young Com-munist organizer who reflected the prevailing attitude: "No one believes in ideol-ogy any more, no one needs it"; by general agreement it "tasted like stale bread." People still mouthed the old platitudes—they had to—but without conviction. And as for the prevailing work habits, Solzhenitsyn's testimony to the Soviet leaders was correct—why should anybody work hard? As people joked: "They pretend to pay us, and we pretend to work." There was much loafing at the workplace; among shop girls, inattention to customers was notorious. People preferred to spend their energies on making money in the black market, by moonlighting, or through outright theft from the government or from each other. People also used their official connections to make illicit deals. Corruption was rampant, even in the Brezhnev family. Any trick would do: in order to get a residence permit for Moscow,

Pensioners Reading the News—*One of the necessities of a Commu-nist society is the control of the news.* Pravda *("Truth") served this role in the Soviet Union. Originally founded as a Bolshevik newspaper in the early part of the century,* Pravda *was the main newspaper of the Central Committee, spreading carefully scrutinized information across the Soviet Union.*

Lady Workers on Break

one would arrange a sham marriage with a willing Muscovite. Observers noted a widespread eagerness to become rich, and be able to afford a private apartment, a car, a dacha, or fashionable foreign clothes.

The privileged layers of Soviet society—nuclear scientists, engineers, top party officials—set a tempting target. They lived at a high level of material comfort and enjoyed extensive perquisites, including access to special stores, privileged housing, holidays at Black Sea resorts, or even travel abroad. Soviet society was markedly unequal (though not as much as Western society), with best-selling authors (who were no literary geniuses) turned into millionaires. Obviously, the puritan austerity of the original Bolsheviks was out of fashion.

While the momentum of the Soviet drive slowed down, the run of citizens, whatever their reservations about their government, still depended upon government services, including a reasonably peaceful social order which allowed everybody to pursue his or her own self-interest. People passively complied with party

Bridge on the Dnieper River—
*Although work was the focus of
Soviet life, there was also time for
recreation. Once a popular beach
area near Kiev, this site has become
contaminated by fallout from the
Chernobyl nuclear disaster in 1986.*

Oil Worker, Near the River Ob, 1971—*One of Baltermants's great socialist-realist photographs, the worker here is shown boldly standing atop two pipes like a statue, a hero of his labors and the world around him.*

Woman at Her Loom—
One of the main goals of postwar socialist realism was displaying the diversity of industry within the Soviet Union. Although Stalin's greatest push came in the area of industrialization and modernization, there were plenty of traditional small-scale industries throughout the Soviet Union employing artisans and textile workers.

policy, a major accomplishment of the Soviet system. Except for nationalist agitation in border areas, there was no penchant for violence, nor even a hankering for a change of the regime. The dissidents, much praised abroad, had no appeal at home in the face of the common attitude: "There is nothing I can do."

Sensitive intellectuals led divided lives, torn between cynical conformity and their own residual moral convictions. According to the dissident Andrei Amalrik, "They thought one thing, said another, and behaved in a third way," to the detriment of honest communication. Yevtushenko wrote a poem about a character (on his alter ego) called "Kompromise Kompromisovich," "who, because he's a soft and polite little rat,/bit by bit eats us up." Yevtushenko stayed in the party's good graces in order to become what he wanted to be: the ambitious roamer in "my damned beloved universe," proclaiming: "I would like to be born in every country/have a passport for them all/to throw all offices into panic." At the price

of perpetuating the pervasive dishonesty, Kompromise Kompromisovich Yevtushenko was permitted to travel open-eyed around the world, a lucky exception among Soviet citizens.

Foreigners were forever amazed by Russian Eurasian life. They found no pessimism, except among a few intellectuals. But what baffled foreigners most was the sharp contrast in people's behavior: Russians seemed half savages, half saints. While a nasty indifference prevailed among strangers, friends related to each other with a human warmth unknown in Western society. Oh those marvelous depths in the Russian soul! Afraid of xenophobia when crossing cultural boundaries, foreigners were always surprised by that emotional generosity.

How then were they to react to the discouraging views of Russian culture held by a dissident insider? As Amalrik wrote in 1969: "It is preposterous to the popular mind that the human personality should represent any kind of value," adding that the prevailing attitude among urbanized peasants was: "Nobody should live better than I. … Bring your own neighbor down to your level rather than do better yourself." Given that state of mind, Amalrik concluded, freedom meant anarchy, with grim prospects for the future. He had made his forecast in his book, *Will the Soviet Union Survive until 1984?*, echoing the title of George Orwell's novel. He foresaw a major war with China, which, given the decrepitude of the Soviet system, would destroy the Soviet empire. His subversive insights, published abroad in 1969, landed him in prison camp, but the question hung in the air, summing up the uncertainties in Soviet society as the Brezhnev regime began to decline.

VII.

After 1975 the discrepancy between the Soviet Union's global ambition and its internal resources became more glaring. Its presence in the world turned more assertive, while its domestic condition deteriorated.

Encouraged by the advances recorded in the earlier years of his regime, Brezhnev continued in a Khrushchevian optimistic mood. In 1976 he called capitalism "a society without a future"; socialism was the most dynamic force in the world—statements contrary to the spirit of détente. To prove his point among his own peoples, he infused the fading Marxism-Leninism with a touch of Russian nationalism. He praised "the great Russian people" and promoted their language among non-Russians, trying to counter nationalist separatism, especially in the Ukraine. In Central Asia elites loyal to the regime were given more local power, but no effective presence in Moscow. Cheered at the party Congress in 1976, he helped prepare the first post-Stalin constitution, issued the following year. It encoded (on paper) the promises of "developed socialism," while affirming the role of the party.

Sixty Meters Underground
(Moscow Subway–
Komsomolskaya Station)

Without Looking Back (The Two Lenins), October 1972— *An unspectacular party member prior to his assumption of power in late 1964, Brezhnev followed Stalin's model, surrounding himself with cronies. He enhanced his prestige with medals and honors, such as the Order of Victory in 1978, the highest military award in the Soviet Union. He became the first head of the Communist Party to serve also as Chairman of the Presidium (the head of the Soviet state).*

At the same time, the Soviet government reached out into the world. It equipped its Cuban ally with military resources to take over the African country of Angola, which had just been evacuated by its Portuguese masters. Soon, Soviet presences were also established in Somalia and more durably in Ethiopia. In Latin America, apart from the Soviet stronghold in Cuba, Nicaraguan Communists rattled the Americans eager to keep capitalist control of their hemisphere. In Asia, India was a Soviet ally, while Soviet diplomacy assertively meddled in the Mideast. And in late 1979, in his most dramatic move, Brezhnev sent the Soviet army into Afghanistan. The obvious reason was the Afghan civil war which seemed to threaten the Soviet Union's southern border; but it also reflected the Soviet desire to assert its military presence in Asia and its political might in the world. It was a profound miscalculation.

Brezhnev on His Death Bier, Kremlin, November 1982

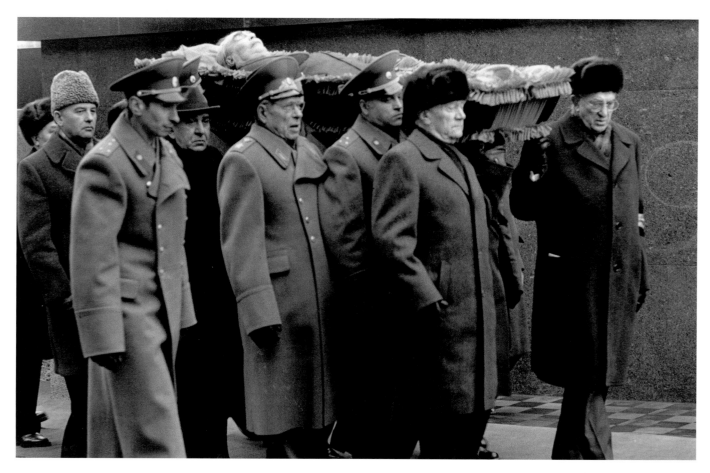

Brezhnev's Funeral, November 1982—*Among the dignitaries carrying Brezhnev's casket are Yuri Andropov (left side of casket), head of the KGB and Brezhnev's successor; Minister of Defense Dmitri Ustinov (right side of casket, third from front); and Mikhail Gorbachev (right side of casket, first from back). Ustinov (1908–1984) gained prominence during World War II, when he reformed the Soviet armaments industry. Under his leadership, the defense ministry became the most important and most organized of all the state ministries.*

Détente had already faded in 1975 as the United States withdrew from the Vietnam War. The Soviet invasion of Afghanistan, followed by the election of the anti-Soviet President Ronald Reagan in the United States, resumed the cold war. Americans canceled their participation in the Olympic Games held in Moscow in 1980 and reduced their economic aid. Subsequently, the arms race escalated, a burden on both the Soviet and American economies. Admittedly, the high prices for Soviet oil exports paid for agricultural imports, expanded arms production, and foreign policy ventures. But the civilian economy, the most vulnerable part of the Soviet system, suffered, especially after a disastrous crop failure in 1975. Economic productivity was steadily declining because of inadequate entrepreneurship, low work morale, administrative rigidity, military priorities, and government inaction, just when increasing contact with the West raised consumer expectations. Brezhnev himself in his remaining years at last admitted that the party's key task was to provide more consumer goods. But by then it was too late.

Seventy years old in 1976, ravenously adding new titles to his name—Marshal of the Soviet Army, Leader of the Communist Party, and President of the

Soviet Union—he rapidly deteriorated in health and vitality, surrounded by aging assistants like himself clinging to their jobs. At his last party Congress in 1981, no new faces were added to the party's top echelon; its average age was 69.3 years. At the head of this gerontocracy, Brezhnev in his final years merely worked a few hours a day, while the pressure of foreign affairs increased, in Afghanistan, and in 1980 in Poland. There, disgruntled workers, under the leadership of Lech Walesa, formed an independent union, called Solidarity, demanding better pay and a voice in the government and threatened Communist rule. With the Soviet army poised on the Polish border, the Polish army restored order. But how solid was a Communist regime repudiated by its proletariat?

How solid was the Soviet system itself, when in 1978 the top Soviet delegate to the United Nations, Undersecretary General Arkady Shevchenko, defected to the United States? Obviously, discontent was widespread even in the party's higher ranks. Dissidents and apparatchiks had come to agree: the Soviet system was paralyzed, its peoples in disarray. The need was to get the country moving again. The initiative had to come from the top. But how?

In November 1982 Brezhnev died, having been in power seventeen years, longer than Franklin Delano Roosevelt, Churchill, or de Gaulle in their respective countries. Unbeknownst to Brezhnev, he had presided over the Soviet Union during its transition from striking success to eventual collapse, unable to reorient the Soviet experiment from preoccupation with external security to the even more difficult task of promoting internal consolidation. That challenge has overburdened his successors as well.

Memories

Gorbachev and the
Collapse of the Soviet System

The momentous changes initiated by Gorbachev, leading to the breakup of the Soviet Union, warrant a final evaluation of the Soviet experiment. As shown in the Brezhnev years, the human exertions responsible for the Soviet advance could not be sustained. While the country's external security persisted, Western values subtly penetrated into Soviet society, subverting the Soviet experiment. Judging the Soviet future by Western standards, critical observers would agree with Sakharov that the Soviet Union might shrivel into a second-rate provincial power. Gorbachev privately agreed in 1985 with his close associate Eduard Shevardnadze that "Everything is rotten through and through." Yet what could be done?

Thus began another collective experiment, a counterexperiment as vital for the Soviet Union's future as its Stalinist predecessor, but more civilized. Gorbachev wanted to cultivate among his peoples the creative initiative needed for keeping up with the rapid economic progress of Western Europe, the United States, Japan, and the "Little Dragons" on the Pacific Rim. In addition, he hoped to advance the norms of civilized life: human rights, personal freedom, and democracy—all desired, at least in the abstract, by the intellectual opposition. Gorbachev's experiments, like Stalin's, oriented itself by the West, but only by imitating the West's more subtle forms of power—its cultural standards. And even more than Stalin, Gorbachev had to be concerned with the global framework dominated by the West, in order to promote peaceful relations for the sake of rebuilding his country's, and his people's, resources. It was a bigger challenge than any ever faced by Western statesmen, and more risky.

However enlightened and well-intentioned, Gorbachev moved ignorantly into an unknown future. Conditioned by the Stalinist system as modified by

Khrushchev and Brezhnev, he and like-minded collaborators had insufficient command over the realities they confronted; they still were apparatchiks at heart. The Soviet masses were even more trapped in the mentality enforced for decades by the Communist Party and still handicapped by pre-Soviet traditions. How could their behavior be reshaped to match the civic skills evolved under far more favorable circumstances in the West? An even greater threat was posed by the growing nationalism among the non-Russian members of the Union of Soviet Socialist Republics. And what of the loyalty of the Soviet satellites in Eastern Europe? All these problems were set into the context of the global cold war. Could Gorbachev end the arms race and elicit the Western support needed for westernizing Soviet society without endangering the continuity of Soviet rule?

Alas, by loosening the Stalinist administrative rigidity, Gorbachev's counterexperiment unhinged the institutions that held the country together. It was a gradual process, kept peaceful thanks to Gorbachev's statesmanship, but beyond his control.

I.

Mikhail Sergeyevich Gorbachev's rise to power demonstrated the opportunities open to young people with leadership talent, despite the regimentation of Soviet rule. He was born in 1931 into a family of Cossack peasants in the fertile lands north of the Caucasus Mountains (Cossacks were famous in Russian history as militant border guards against hostile heathens; Cossacks were more energetic and ambitious than ordinary peasants). Baptized a Christian, he grew up in a poor village amidst the hardships of collectivization (his grandfather was arrested and put in Gulag) and a few months of German occupation during the war. Adventurous at an early age, he walked to a good school in a town ten miles away on Monday mornings, returning home for a weekend of labor in the fields. An outstanding pupil, he became a leader of the Young Communist League, starting his political career. As a teenager, he also advanced to the position of assistant manager of a nearby motor tractor station serving a number of collective farms, for which he was awarded the Order of the Red Banner of Labor. His success at school and work earned him, the nineteen-year-old upward-bound country boy, admission to the Moscow State University, the academic pinnacle of the Soviet Union.

Intelligent, hardworking, and honest, he stood out in that competitive environment as a natural leader, advancing through the Young Communist League to membership in the Communist Party. As a student of law he broadened his mind, even studying the Western legal tradition and the U.S. Constitution (which was permitted at Moscow University during the late Stalin years). At a class on

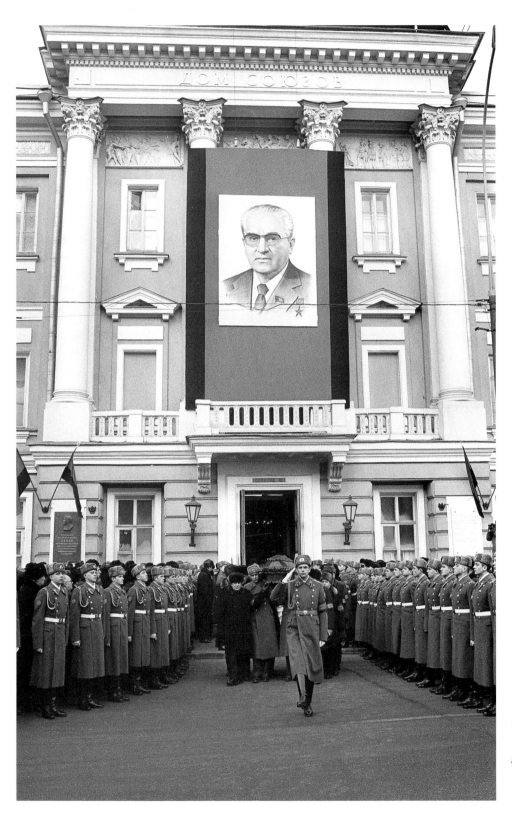

Andropov's Funeral, February 1984—*Yuri Andropov (1914–1984) was the natural choice to succeed Brezhnev after the latter's death in 1982. As head of the KGB from 1967–1982, Andropov was responsible for the strong repression of dissidents under Brezhnev, a marked contrast with the Khrushchev era. As in the case of his successor, Konstantin Chernenko, poor health and old age caused him to be ineffective as general secretary. He was, however, an early sponsor of Gorbachev.*

The Slow Walk to the Table (Will He Make It?), 1984— *Following the short tenure and sudden death of Andropov, Konstantin Chernenko (1911– 1985) was appointed as general secretary of the Communist Party in 1984. A lifelong bureaucrat and onetime head of propaganda for the Central Committee (1956–1960), Chernenko was a lifeless head of the Soviet Union, due in large part to poor health.*

ballroom dancing, he met—and subsequently married—an intelligent and cultivated beauty from Siberia, Raisa Titorenko, a fellow student, as ambitious as himself, who polished his manners. Together they absorbed the political ferment surfacing after Stalin's death, making an effective team which attracted attention wherever they went.

After five years of study in Moscow, Gorbachev settled in Stavropol, the capital of the north Caucasus area. Life there allowed more leeway for personal initiative and development than a career among the corrupt Moscow bureaucracy. During his twenty-three years in Stavropol, Gorbachev advanced in the local party organization, in charge of agriculture (the area's main economic resource) and eventually as the local party boss. In that capacity he routinely met the top party leaders vacationing in the nearby spas. He particularly impressed Yuri Andropov, the head of the KGB, who was looking for young talent to counteract the lethargy of Brezhnev's leadership. Indicative of the trust Gorbachev enjoyed in the party, he was allowed in 1966, after attending Communist Party business, to travel with Raisa freely through France and subsequently through Italy, eye-opening experiences beyond the reach of other high-ranking Communists. A model apparatchik—

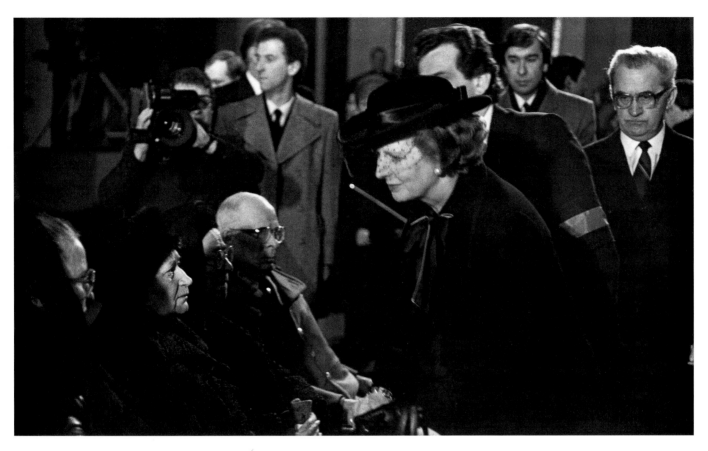

honest, unpretentious, and of a remarkably open mind—he was endowed in addition with a special gift for attracting personal attention. In 1978 he was called to Moscow to join the inner circle of Soviet power as a protégé of Andropov, and was placed in charge of Soviet agriculture. As head of the KGB, Andropov had become aware of the weaknesses of the Soviet system, afraid especially of catastrophic economic decline. After Brezhnev's death in 1982, Andropov was chosen as Brezhnev's successor, but unfortunately Andropov was too old and sick to accomplish any change. But he allowed Gorbachev a major privilege: a week's tour of Canada in May 1983, affording yet another glimpse of the outside world. Andropov's successor, Konstantin Chernenko, a decrepit Brezhnevite, granted Gorbachev (and Raisa) an even more prestigious journey to England in 1984. He made a striking impression on English television. The English had never before observed such an attractive Communist official, elegantly dressed and open in his speech—and accompanied by such a glamorous wife; both seemed to be more European than Russian. After a personal meeting, the prime minister, Margaret Thatcher, exclaimed: "I like Mr. Gorbachev. We can do business together." That visit also raised his prestige at home, contributing to his appointment as general

Margaret Thatcher at Chernenko's Funeral, March 1985—*As Prime Minister of the United Kingdom from 1979–1990, Thatcher (1925–) reasserted England's role as one of the dominant European powers. Upon meeting Gorbachev in 1984, she noted that "We can do business together." She played a prominent role in garnering Western support for Gorbachev and his reforms.*

secretary after Chernenko's death in March 1985. Highly educated, articulate, self-confident, and independent-minded, he was the most qualified leader since Lenin, ready to cope, through trial and error, with unknown realities, come what may.

II.

Gorbachev was elected general secretary by his fellow Politburo members by a slim margin. Before leaving for England, he had given a speech introducing his key concepts—*perestroika* (restructuring) and *glasnost* (openness)—and implying a profound transformation of the Soviet system by addressing all citizens "in the language of truth" contrary to party practice. But his message was largely ignored; the Brezhnevites were scared. After coming to power, Gorbachev faced a long battle with the bureaucratic establishment. Aware that "politics is the art of the possible," he skillfully maneuvered between Soviet tradition and his vision of an updated Soviet Union. A Marxist-Leninist both as a hard-liner and a radical innovator, he was secretive, deceptive, accommodating, generous, ever willing to shift his stance, and always eager to talk to the people around the country.

His boldest move at the outset was his campaign against alcoholism, and the consumption of vodka was sharply curtailed. But would a people committed to drunkenness ever change their habits? Sugar quickly vanished from the stores, used for the private production of liquor. Further, what could not be brewed at home, could be obtained from the black market. The ineffective restrictions were lifted in 1989, an evil omen for perestroika. The Soviet people could not be restructured in their psychic depths.

In foreign policy, however, Gorbachev scored some success. He moderated President Reagan's suspicion of "the evil empire" and established a sense of personal trust at the Geneva U.S.-Soviet summit in November 1985. The good feelings, reinforced at their Reykjavík meeting in October 1986, helped to scale down the arms race. Reagan had deliberately escalated it in order to increase the strain on the Soviet Union.

At home, meanwhile, the Communist Party showed little enthusiasm for Gorbachev's program. Although at its Twenty-seventh Congress in February 1986 it brought some fresh blood into its ranks, including the radical reformer Boris Yeltsin as party chief in Moscow, it gave little encouragement to Gorbachev's plans for introducing a limited market economy. Two months later, he was confronted by the nuclear explosion at Chernobyl, which spread deadly radiation beyond the Soviet borders into Scandinavia and aroused strong anti-Soviet sentiments in western Europe. Gorbachev reacted like a traditional Soviet leader, playing down the damage and refusing for three weeks to visit the disaster area. By July, how-

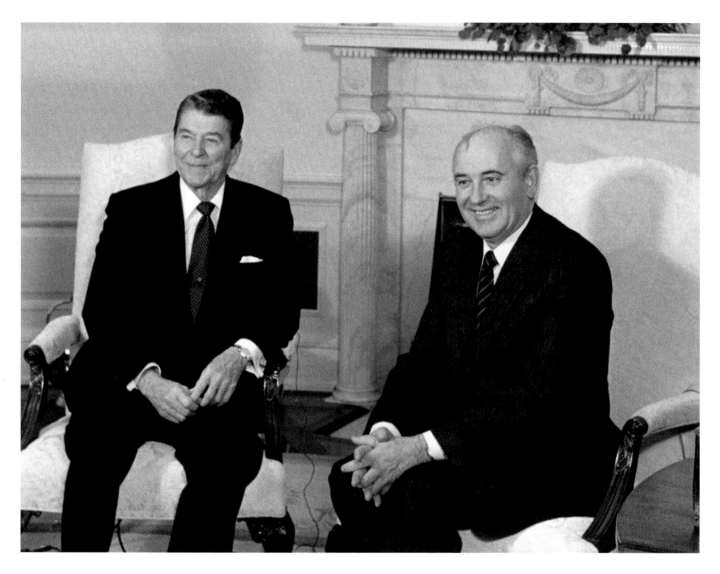

ever, he began to apply glasnost, letting the costly facts be known. Chernobyl is claiming victims to this day.

During 1986, however, his message, supported by the influx of Western ideals, began to loosen up the media and became part of public opinion. In December, Gorbachev, having recently denounced Sakharov, allowed him, embattled as ever, to return to Moscow and political activity. At the same time, other political prisoners were released. But, at an important party meeting in January 1987, Gorbachev had cause to complain: "The further we go with our reorganization work, more and more unresolved problems inherited from our past appear"; the Soviet Union was "in a grave state." When the party leadership proved unresponsive, he proclaimed on television: "We need democracy like air."

Gorbachev and Reagan, December 1987—*In November 1985 President Ronald Reagan (1911–) met with Gorbachev for the first of three summits. These meetings led to the reduction of both nations' nuclear arsenals, a new era of friendship between the former adversaries, and the end of the cold war.*

In May an adventurous German youngster, Matthias Rust, landed his little airplane on Red Square in Moscow. How did he manage to evade the elaborate air defenses protecting the capital? Rust's daring allowed Gorbachev to dismiss many generals who were hostile to his reforms, a lucky break. The June party conference at last sufficiently backed him up, inspiring him with some cautious hope: "We are learning. Our political culture is still inadequate. Our ability to respect the point of view of even our friends and comrades—that too is inadequate. We are an emotional people, but we'll get over it. We will grow up." But could he really restructure his people's quarrelsome emotions for the future glory of the Soviet Union?

After the conference he took a long holiday at a Caucasus spa, spelling out his political philosophy in *Perestroika: New Thinking for Our Country and the World*. No other statesman, burdened with supreme responsibility for his country, had produced such a masterful portrait of his state of mind, as he wrestled with the ambiguities of a perilous experiment with global implications.

III.

From the start Gorbachev left no doubt that perestroika grew out of intense loyalty to the Soviet tradition. Lenin was "the inexhaustible source of dialectical creative thought," Marxist-style. Gorbachev also took pride in his country's rise from "a backward, semicolonial, semifeudal empire" to "one of the mightiest countries in the world" where "the Western system was unacceptable." Through its economic planning and humane concerns, socialism would surpass capitalism. What was now needed was more of the creative essence of socialism.

In order to stimulate the creativity of the masses, the individual had to be uplifted, his "inner world" respected. Public life had to be revitalized from below, through democracy and innovative initiatives in socialist enterprises. He also aimed at reculturing his people, replacing the artificial social discipline imposed by Stalin with a spontaneous inward motivation comparable to the civility of Western society. He was aware that this would take time, possibly to the end of the century.

All along, perestroika had to revamp the study of political economy, philosophy, sociology, and history. Education had to be radically transformed. Perestroika implied a profound revolution in people's thinking, among the leadership and the masses, calling for boldness, high ideological standards, moral purity, and even sacrifice, especially among the old-timers.

The necessary economic changes, he realized, were a highly complicated matter, and would take years to accomplish. They required "democratic centralism," an unlikely combination of control from the top with vigorous initiative from below (a persistent concept in Gorbachev's thought). Aiming at scientific

Man Talk

and technological progress and improvement in human relations, these changes were to help the Soviet Union catch up with the advanced countries. The Soviet system, while not egalitarian, allowed no human exploitation or division between rich and poor; it provided basic services to all: jobs, free education, medical care, and support for the old. The Communist Party still was central, acting as the guarantor of perestroika, but was now committed to promoting democracy within its own ranks.

Numerous obstacles stood in the way, the chief one, alas, embedded "in our thinking." As he confessed, "We still lack a political culture" and "the inner stimuli for self-development." Throughout his reflections Gorbachev confronted the most crucial challenge: How to combine the personal interest of the lowly masses with the requirements of collective life in the outer world of modern times? It was the biggest unresolved question anywhere in the twentieth century: How to lift the sense of individuality to the reality of global interdependence? It had special urgency among the peoples of the Soviet Union. Gorbachev's oxymoron of "democratic centralism" could hardly solve it. Only a Marxist-Leninist would believe that the traditional unruliness of the Soviet peoples could produce the consensus needed to carry out the revolutionary transformation he had in mind.

As an ideological optimist Gorbachev treated the ethnic and national diversity in his country as an asset. The non-Russians had enriched Soviet society and world culture. Admittedly, there existed the danger of narrow nationalism, but socialism could solve all problems through equality and cooperation. The Soviet record was unique in the history of civilization, showing the benefits of interaction and rapprochement. Even the smallest ethnic groups had the right to their own language, with Russian serving as the common medium. All of the Soviet peoples were proud, he inaccurately asserted, that they belonged to one big international family, "part and parcel of a vast and great power which plays such an important role in mankind's progress."

Thus reassured, Gorbachev turned to the challenge of the West, sharply disparaging its superiority. "We will believe in the democratic nature of Western societies when their workers and office employees start electing the owners of factories and plants, bank presidents, etc. … and start discussing the real processes inherent in Western countries, rather than only engage in an endless and useless argument with politicians." And to counter Western doubts about perestroika, he predicted: "We will achieve the goals we have charted. … The Soviet Union is a vast country rich in minerals and skilled manpower, with great scientific resources. So do not rush to toss us into the 'ash heap of history.' " But he humbly added, "We need lasting peace in order to concentrate on the development of our society." From this admission of Soviet weakness he distilled a promise of global harmony: "a nuclear-weapon-free and nonviolent world," affirming "civilized standards in interstate relations."

In this spirit he took a closer look at the contemporary world, arguing that the growing worldwide interdependence demanded international cooperation. Nuclear wars were unwinnable, while colonialism was out of date. The nations of the world were "like a pack of mountaineers tied together by a climbing rope"; woe if ideological intolerance snapped that bond. And then he made a startling concession, renouncing the Communist world mission: "We don't claim to be able to teach others." Gorbachev disclaimed any Soviet responsibility for mass uprisings against oppression anywhere in the world. World revolution was not its aim. In any case, the world had grown more complex since Lenin's days. Today's politicians must be aware of the intellectual potential of other countries and peoples. Gorbachev was eager to know their opinions (and even criticism). He envisaged dialogue in foreign affairs, and more democratic participation. Gone was the traditional arrogance of Soviet foreign relations. As for the developing countries, they had the right to choose their own ways. The West must abandon its colonialism, indeed all ambition for world domination. The new world order was based on equality for all, with due regard for everyone's interests.

Why Sasha Is Late for School, 1966

The Nation's Chief Timepiece,
1964

Yet having denounced the West, he suddenly shifted his perspectives, proclaiming: "We are Europeans," despite all the ideological and military confrontations. "Europe is our common home," stretching from the Atlantic to the Urals (what about Siberia, Central Asia, and the Far East?). NATO, to be sure, was a "chariot of war," but he welcomed the Helsinki Accords, approving of America's participation in it. Otherwise he deplored the influx of American mass culture into Europe; he did not like "to see Americans at the head of the European table." Europe with its vast possibilities and experience was central in world politics, and Gorbachev obviously counted on its help.

And what, finally, about the United States? Relations were not good, being overly shaped by ideology. The "city on a hill" driven by "an almost missionary passion for preaching about human rights and liberties," suffered from a host of unresolved problems itself. Therefore, Gorbachev advised, let the United States and the Soviet Union each take care of its own affairs. He also warned the United States not to try to exhaust the Soviet Union economically by escalating the arms race. The Soviet economy was not about to crumble, and, as he presciently observed, the United States would suffer, too. What mattered for both countries was national security in its broadest sense, including economic, ecological, and humanitarian aspects.

Returning in conclusion to the prospects for the immediate future, Gorbachev foresaw unconventional moves ahead, from hostility and suspicion to a balance of reason and goodwill, from narrow nationalist egoism to cooperation.

Motivated, as he wrote, by the ideas of Lenin, he had set forth a grand message marred by inconsistencies and contradictions in regard to his own country, but distinguished by its constructive aims in foreign policy. Perestroika's global vision terminated the ideological warfare between capitalism and communism and, even more significantly, the costly confrontations of the cold war.

IV.

While tied to world affairs, Moscow-centered Soviet politics still claimed priority, confronting Gorbachev with mounting challenges. Aiming at revitalizing state and society by arousing creative initiative among the people, perestroika, reinforced by the influx of Western ideas and ideals, elementally revived the popular unruliness carefully held in check by Stalinist compulsion. The artificial Soviet monolith was in danger of crumbling into a pile of sand, as the dread of the KGB began to vanish.

From 1988 onward the new openness—combined with freedom of expression—enlivened newspapers, radio, television, and movies, incidentally revealing the grim reality of daily life: drunkenness, drugs, and gangs of young toughs on Moscow streets. More significantly, the news stimulated the diversity of public opinion as never before; anti-Russian ethnic and national resentments stirred. A profusion of action groups sprang up, covering the political spectrum from right-wing anti-Semitism, and nostalgia for the last tsar, to democratic radicalism, most of the groups eager to explore hitherto censored issues. Books formerly banned—Pasternak's *Doctor Zhivago,* Solzhenitsyn's *The Gulag Archipelago,* and others like them—appeared on the market, as did forbidden foreign works. Baltermants's *Ogonyok* changed into an investigative liberal periodical. An allegorical film *Repentance* turned its viewers against the Stalinist past.

Western lifestyles and entertainment crept into urban society, while Western values began to revise Soviet attitudes. The long-simmering anti-Soviet undercurrent, enriched by easy access to the West and reinforced by a spate of revelations about Stalin's crimes, became the intellectual mainstream, achieving a profound change in historical perspective. The dread of foreign conquest which lay at the root of the Stalinist system, had evaporated among forward-looking intellectuals and especially among the young generation eager to copy Western ways. For them, the Soviet past was a source of embarrassment.

And yet, attachment to that past still lingered among people benefiting from the security offered under the old order; how would they fare in a more competitive system? Resistance to perestroika was especially strong among the legions of apparatchiks who had risen to power and comfort in the ranks of the Communist Party. On their behalf a woman's voice rang out in March 1988. Nina Andreyeva,

The Weightlifter, 1964—
One of the greatest successes of the Soviet Union in the postwar world was its athletic dominance. Athletes trained long and hard, often in near-primitive conditions; the rewards for success, however, were many. Yuri Vlasov was the Olympic heavyweight weightlifting champion (1960), the European champion (1959–1962, 1964), and the World champion (1959, 1961–1963). After retiring, Vlasov became a journalist and politician, serving in the Duma from 1993–1995.

On Holiday, Outside of Red Square (opposite page).

Lenin Statue and Sculptor—*For almost seventy-five years, Lenin and bolshevism were praised throughout the Soviet Union, serving as the focal point for much of the nation's art and culture. In 1991, after the fall of communism, many of these icons fell, both in esteem and in reality, as statues throughout the Soviet Union were toppled and carried away to the graveyards of obscurity.*

a lecturer at Leningrad University, published a letter attacking the trends of the times, such as the loss of political conviction, the nihilistic attitude of the students, and the ideological confusion caused by the variety of political views mushrooming among the public. She especially deplored the defamation of the Soviet regime as nothing but a succession of mistakes and crimes. By contrast, she praised "the greatest achievement of the past and the present, the industrialization, collectivization, and cultural revolution which brought our country into the ranks of great world powers." Her letter, much publicized as an attack on Gorbachev, dramatized the conservative apprehension about the political and cultural disorientation now spreading throughout the country.

Andreyeva certainly had some justification for her protest. The heroic sacrifice by a whole generation of nameless patriots, plus Stalin's leadership (quite popular at the time) which guided the country through an unprecedented constructive transformation, deserved to be appreciated in the collective memory. Instead, people, suddenly applying imported Western standards to their past (though hardly to their current conduct—they were still Russians), called for a memorial in Moscow commemorating the victims of Stalinism. There was a tragic incompatibility between the Stalinist past and the state-of-mind promoted by perestroika and by the Western impact generally. Tragic also was the prevailing incomprehension of the realities shaping life in Eurasia. While dreading the collapse of the Soviet Union as a result of perestroika, Andreyeva, and the conservatives generally, could offer no remedies for their country's humiliating decline in a world prospering through individual enterprise in reasonably free societies. Their Soviet system was discredited.

What then of the remedies proposed at the other end of the political spectrum, by such dissidents as Sakharov or Western-oriented intellectuals, academics, and journalists? Projecting the Western model into the ideological vacuum created by the fading away of Marxism-Leninism, they called for far-reaching reforms, including a multiparty system and the end of the dictatorship of the Communist Party, democratic government under elected officials, a market economy, and private ownership of land instead of collective farms. Yet, how could these institutions be transferred into a Eurasian society devoid of any comparable experience and in times of growing economic hardship? As perestroika progressed, the Soviet economy steadily declined; for example, the harvest of 1988 was a disaster. Gorbachev's faint efforts to loosen the controls of central planning had little effect; he was no economic reformer. Material adversity hardened people's tempers just when the times called for greater flexibility and expanded sociopolitical awareness.

Proponents of radical reform found a sympathetic supporter in the inner circle of power: Boris Yeltsin, soon to emerge as Gorbachev's rival. Born in the same year as Gorbachev into a poor working-class family living near the industrial city of Sverdlovsk (now Yekaterinburg) in the Ural Mountains, he was another example of the talent for political leadership simmering among the Soviet masses. A bright student, he was subsequently trained as an industrial engineer and recruited into the Communist Party, where he rose to the top leadership in Sverdlovsk before being selected as the party boss of Moscow in 1985, with membership in the party's Central Committee. Tall and good-looking, but earthy in his manners and speech, he deliberately stayed close to his humble origins; rather than use his official limousine, he took the bus to his office. Ambitious for power and a ferocious infighter, he was a master of public relations, close to the masses and their discontent, with his attention focused on local politics. Always attacking the privileges of the apparatchiks, he endeared himself to his followers in Moscow, representing the left flank of perestroika, impatiently pressing for more democracy.

In November 1987, at the Central Committee's seventieth anniversary celebration of the Bolshevik revolution, he committed a major blunder, which signaled the breakdown of Communist discipline. He bluntly attacked Gorbachev and the party at this solemn occasion. Gorbachev in his peroration had characteristically hedged on Stalin. He admitted Stalin's indispensable contribution to the struggle for socialism, but also declared Stalin's guilt, "enormous and unforgivable," mentioning his thousands of victims (why, some critical listeners wondered, not the actual millions?). The moment he had finished, Yeltsin, obviously unimpressed by Gorbachev's speech, abruptly asked why after two or three years of perestroika no results had been achieved. He stated that people were losing faith in it. He especially denounced the adulation shown for the general secretary (meaning Gorbachev), which, he argued, smacked of "the cult of personality." Realizing that he may have acted too brashly, he then offered his resignation.

Most members of the Central Committee were outraged by his behavior. Nobody had ever disrupted the decorum of their meetings. Within days Gorbachev demoted Yeltsin from the Central Committee to a lesser appointment. But Yeltsin's popularity in Moscow continued to grow. In the eyes of his followers Gorbachev was betraying perestroika.

How then was Gorbachev, acclaimed for the message of his book (published in November 1987 at home and abroad), to maneuver between the party hard-liners and the radical democrats? The Communist Party was still the political backbone of the country. If threatened, its Central Committee might oust its secretary general; Gorbachev was aware of what had happened to Khrushchev.

On the opposite side, the democratic radicals, while well represented in the media and on the streets—and boosted by the prestige of their Western goals—lacked effective organization. Trying, in pursuit of perestroika, to reconcile the Communist traditionalists with the radical innovators, Gorbachev faced awesome difficulties in building support among his disoriented, volatile, and unruly people who longed for a better life amidst growing hardships.

V.

Confronted by adversity on all sides, Gorbachev in the spring of 1988 advanced his experiment of liberating Soviet society, as he artfully phrased it, "from everything that is alien to its *humane* nature" [italics added], while also promoting peaceful foreign relations.

In February he at last ended the disastrous war in Afghanistan, preparing the withdrawal of Soviet troops. Relations with the United States warmed up, when President Reagan paid a pleasant visit to Moscow at the end of May. Later that summer Soviet experts, under the auspices of the Intermediate Nuclear Force Treaty, inspected American nuclear installations in California, while Americans looked at similar Soviet weapons sites—what a change from the paranoid military secrecy previously prevailing!

Meanwhile at home Soviet society displayed both the positive and negative effects of perestroika. The Orthodox Church was reinstated in its traditional glory. Its Easter Service was broadcast on television. Subsequently the celebration of the millennium of Christianity in Russia, attended by Raisa Gorbachev, took place inside the Kremlin, hitherto the bulwark of Communist atheism. But at the fringes of the country, trouble was brewing. In the Baltic republics, which had been sovereign states between World War I and World War II, agitation for independence spread. In the south, Christian Armenia and Muslim Azerbaijan fought over the Armenian enclave of Nagorno-Karabakh in Azerbaijan; the enclave was a source of perpetual tension between these two republics. In Central Asia ethnic riots flared. And at the center, in Moscow, a big battle took place over the future government of the Soviet Union, with Gorbachev on the offensive.

In June a crucial Communist Party conference was held, with a pioneering open discussion that restored Yeltsin's position and revealed new evidence about Soviet backwardness (including the fact that in infant mortality the Soviet Union ranked fiftieth worldwide). Here Gorbachev charged ahead, proposing a drastic reorganization of the Soviet government. The "supreme body of power" in the future would be the Congress of People's Deputies. Its 2,250 members were to be elected by secret ballot, but not quite democratically—one-third of its membership was reserved for the party and its affiliates. The Congress then would elect

Gorbachev, 1989—
*Baltermants's photograph of
Gorbachev at the height of his
power proved to be the last political
photo Baltermants took. He died at
the age of 78 in 1990.*

the much-smaller Supreme Soviet which would conduct the daily business of government under its chairman, the president of the Soviet Union.

In November Gorbachev combined the power held by the party's general secretary with the leadership of the Supreme Soviet, making himself the official president of the Soviet Union. Liberals such as Sakharov were shocked—the public had not been consulted. Was Gorbachev headed for a new dictatorship? Gorbachev's leadership wavered between authoritarianism, which was part of his political training, and his determination to promote democratization. At any rate, countrywide elections for the Congress of People's Deputies were set for the next March, with its first session scheduled for June. But before that Gorbachev had other important business.

In December he traveled to New York to address the General Assembly of the United Nations. His message, delivered somewhat stumblingly, foreshadowed a profound change in the global balance of power, with unforeseen consequences for his own country. The Soviet Union, he said, hitherto closed to the outside, was now willing to cooperate in an open world, abandoning all ideological illusions; what counted was the common interest of all humanity. Renouncing the use of force in international relations, he proclaimed the right of every country to go its own way. As proof of his sincerity he announced the unilateral reduction of the Red Army by half a million men within two years, including a pullout of Soviet troops from Eastern Europe. (Did he thereby indicate that the Soviet satellites might throw off the Soviet yoke?) He dismantled, for the whole world to see, the Stalinist heritage in Soviet foreign relations.

American conservatives such as Henry Kissinger dismissed Gorbachev's speech as clever propaganda, but Western opinion was impressed. At home, his generals accused him of weakening his country's security. And on the day of his UN address, a disastrous earthquake struck Armenia, killing tens of thousands of people and devastating life-supporting facilities for many more. In response, the Soviet Union, in another startling innovation, invited foreign help, most of which was wasted; people did not know how to deal with foreigners. Like the Chernobyl accident, the Armenian earthquake put an extra burden on perestroika, on the eve of the memorable year 1989.

VI.

Obviously, Gorbachev's experiment was eluding his grasp, as the elemental groundswell of liberation it had set off escalated. The assertively expressed longing for freedom, self-determination, and democracy, even for national independence and the end of Communist rule, dominated the news throughout the Soviet lands. Political agitation, aggravated by deteriorating living conditions, spread

like a wildfire, slowly at first and ending up in a conflagration racing through Eastern Europe, piling up more troubles for Gorbachev, in a rapid sequence of unsettling events.

In January the Baltic republics required that Russians living there learn the local languages; Central Asian republics soon followed their example. Hungarians staged demonstrations in favor of free elections. In February the Polish Communists recognized the long-banned Solidarity movement led by Lech Walesa. In March seventy-five thousand Hungarians took to the streets in Budapest in favor of democracy, while Soviet citizens prepared themselves for electing the members of the Congress of People's Deputies. Campaigning for support, Gorbachev asserted that the entire country was committed to reform, while reassuring his fellow Communists by calling a multiparty system "rubbish." He also revealed to them the misery of Soviet agriculture; a "green revolution" was needed, with greater reliance on market forces—empty promises! Gorbachev could not change deeply engrained habits, and economic conditions grew worse.

At the end of the month, as promised in the previous year, the first reasonably free election in the country's long history took place, resulting in a humiliating defeat for the party hard-liners and a resounding victory for Yeltsin in Moscow. Obviously, the Soviet public was advancing to a novel political awareness. They elected a few radicals such as Sakharov (and even Yevtushenko, no political pundit). Perestroika was making progress, while Gorbachev declared himself pleased with the results. Members of the Communist Party, though of diverse opinions, were still in the majority.

In early April, while the election was in the news, more than ten thousand Georgians in Tbilisi, their capital, demonstrated in favor of greater autonomy for their republic. Nineteen people were killed when troops restored order (in pursuit of perestroika?). And in Poland plans were announced for a general election to be held in June, with Solidarity challenging the Communist Party. The next month, on May 2, the Hungarians opened their border with Austria, encouraging thousands of East Germans to seek freedom in West Germany (where they were not admitted until the fall). At the same time Hungary adopted a multiparty system, spawning more than fifty parties by the end of the year. In the same month Lithuania and Estonia declared their sovereignty; they were determined, short of independence, to be guided by their local laws. Latvia soon followed suit.

With these events on their minds, the newly elected members of the Congress of People's Deputies officially gathered on May 25, electing Gorbachev as chairman (and president). He had just returned from Beijing, where he was hailed by the students at Tiananmen Square as a champion of democracy. Now he had to practice democracy at home. The proceedings appeared live on television, eagerly

The Statue of the Two Soviets—
*Built in 1937, this statue of a
"worker" man and a "peasant"
woman is an homage to the Soviet
working classes.*

watched by two hundred million people shamefully neglecting their work. Industrial productivity fell by 20 percent during the twelve-day session, but glasnost advanced, lifting forever the fear of repression that had kept people silent for so long. Never before had the Soviet people watched such open, and sometimes raw, talk about politics. Attacks on the KGB mixed with sneers at the liberals. At one point Gorbachev himself told Sakharov to "shut up."

Not surprisingly, the proceedings suffered from a sense of confusion or even chaos, given the size of the assembly, the diversity of views, and the news pouring in. The headlines told about an ethnic pogrom in Uzbekistan and, even more upsetting, about the victory of Walesa's Solidarity in the Polish election—the Polish Communists having been disastrously defeated. Poland was going its own way; this sent reassuring signals to eager observers elsewhere in Eastern Europe (and in the Soviet Union, too).

Meanwhile the Congress of People's Deputies, dominated by its moderate majority, picked the five-hundred-odd members of the Supreme Soviet, the legislative body in charge of the government under Gorbachev's presidency; it emerged as a rather conservative body. Yeltsin at first was kept out, because of his radicalism: he favored a multiparty system, the open election of the president, and a market economy. Once admitted, he made his voice heard.

At any rate, a new but far from democratic structure of government had been created for the Soviet Union. While allowing for the first time free expression of opinion, it did not involve public participation as promised by perestroika. At the conclusion of this memorable event, Gorbachev, now the executive head of the state, praised the debate and compromise prevailing among the deputies, but also acknowledged that the Communist Party would continue as the vanguard of Soviet society, ruling out a multiplicity of parties. But the televised proceedings had done their share in intensifying the loosening up of Soviet society, and also in strengthening the cause of the liberals. Radicals in the Congress, including Sakharov, organized themselves into what they called "the Inter-Regional Group," carefully avoiding the term "party." They stood for Yeltsin's program and soon gained control of key cities besides Moscow, yet exercised little influence over the formation of the government organized by the first session of the new Supreme Soviet.

In July coal miners in Siberia, and soon also those in Russia and the Ukraine—perhaps influenced by what they had watched on television—caused some trouble by striking for higher pay. By making cautious concessions, Gorbachev avoided further labor unrest. For once he was lucky: amidst the escalating political tensions and material hardships his people surprisingly stuck to the security of their work routines. On the whole, basic services continued—a tribute to Stalin's transformation of Eurasian society—while the Soviet empire unraveled.

In August the Polish Communists, with Gorbachev's approval, surrendered to a noncommunist government, the first in Eastern Europe. At the same time massive anti-Soviet demonstrations raged through the Baltic republics. Hundreds of thousands of people formed a human chain linking Lithuania, Latvia, and Estonia. The protests were denounced in Moscow as antisocialist and intolerable. Gorbachev urged restraint, because perestroika did not permit the dissolution of the Soviet Union.

As autumn advanced, the atmosphere in Moscow turned tense and gloomy, as perestroika caused more embittered divisions in Moscow and around the country. Gorbachev likened the political scene to a pool of gasoline waiting to be ignited; talk of a coup or even of civil war was in the air. At times he himself was losing his temper, furiously attacking critical journalists and calling the Inter-Regional Group "a gangster group." Obviously he was overburdened, constantly traveling at home and abroad, while under exhausting pressure to maneuver between warring factions, devise constructive legislation, and above all carry the supreme responsibility for his disintegrating country.

His popularity was declining. Critics observed a cult of personality. They objected to his privileged lifestyle and to Raisa's expensive clothes. The common people called him a chatterbox. He was always giving the same speech about remodeling the entire system, along with improving the moral and spiritual atmosphere, without any relevance to the evermore sordid realities of daily life. Not surprisingly, the self-confidence with which he had started vanished. And yet he had to carry on.

Early in October he attended East Germany's fortieth anniversary celebration and encouraged its leader, Erich Honecker, to adopt Soviet-style reforms. A few days later fifty thousand people rallied in the city of Leipzig in support of democracy. Honecker was subsequently ousted by his own party on October 18. On November 9 the Berlin Wall dividing East and West Berlin and also symbolically East and West Germany, fell amidst jubilant crowds. This doomed the East German Communist government. Later that month in Czechoslovakia Dubček, the hero of the Prague Spring in 1968, was cheered by a quarter million people, and in December the Communist regime caved in.

In early December Gorbachev traveled to Rome to meet Pope John Paul II, promising to permit freedom of conscience in the Soviet Union. On the island of Malta, Gorbachev met with President George Bush, who promised American aid for the Soviet Union's ailing economy—what a humiliation for old-time Stalinists! Returned to Moscow, Gorbachev faced a bitter debate at the second meeting of the Congress of People's Deputies. The foremost issue was Article VI of the Soviet Constitution, which read: "The leading and guiding force of Soviet society

and the nucleus of the political system, of all state organizations and public organizations, is the Communist Party of the Soviet Union." Did the preeminence of the Soviet Communist Party make sense now that all Communist parties in Eastern Europe were on their way out? At the session on December 12 Gorbachev rudely hounded Sakharov from the podium, when the latter suggested a debate on Article VI and the end of restrictions on private property. The subsequent vote upheld the party monopoly by a majority of three. Two days later Sakharov died, a remarkable man properly honored at his funeral.

At that time Yeltsin, in an interview, quipped: "Those who still believe in communism are moving in the sphere of fantasy," to which Gorbachev replied at the Congress of People's Deputies: "I am a Communist, a convinced Communist. For some this may seem a fantasy, but for me it is my main goal." And that at the time when communism in Eastern Europe was all but defunct!

In December communism collapsed in Romania; the ruthless dictator Nicolae Ceaușescu and his wife were tried and shot on December 25. The next day the Yugoslav Communists announced a transition to a multiparty system. Three days later, Václav Havel, the hero of anticommunist resistance and a man of unusual wisdom, was elected president of Czechoslovakia. At the end of 1989 all of Eastern Europe was rid of Communist regimes, except for Albania, where the transition took more time. The Soviet empire created by Stalin after World War II had collapsed. While negotiations over nuclear arms reduction dragged on, the cold war was effectively ended; the Soviet menace was gone, the Communist ideology discredited. Immensely relieved, Europeans and Americans rejoiced. *Time* magazine declared Gorbachev "the Man of the Decade." "Gorbymania" gripped the public, which culminated in the awarding of the Nobel Peace Prize to Gorbachev in 1990.

The credit for the swift and peaceful end to the Soviet threat belongs to Gorbachev. In the face of Soviet weakness, admitted since the Brezhnev years, priority had to be given to domestic reform, which, together with the need to gain Western goodwill, ruled out military action. The only rational response to the anti-Soviet groundswell in Eastern Europe was political withdrawal, sweetened by perestroika's global vision of peace and cooperation. That was the essence of Gorbachev's statesmanship; it deserves an honorable place in history.

VII.

While the Eastern European countries were left now to their own devices in shaping their post-Communist destinies, the Soviet Union drifted toward its dissolution. In 1990, under the impact of the news from Eastern Europe, Gorbachev's experiment began to break down. In February, during a demonstration of two hundred thousand people in Moscow denouncing the Communist

Gorbachev and Yeltsin, 1990
*(Photograph by Chist Jakov
courtesy of Agency Novosti.)*

Party, shouts were heard: "Remember Romania!" Ceaușescu's fate had left its mark, as had the demise of other Communist regimes.

However reluctantly, Gorbachev had to make concessions to the groundswell of protest. In February, at a meeting of the party's Central Committee, he conceded the need for a multiparty system (rejected as "rubbish" the previous year), ending the party's privileged role under Article VI (still upheld two months earlier). The country's crisis, he admitted, was growing deeper and more serious. Ethnic violence intensified in Central Asia; Soviet troops fought in Baku. In August Armenia declared its independence. Elsewhere "sovereignty" became the goal, giving republic laws precedence over Soviet laws. By November all fifteen Union republics had formally turned into "sovereign" states, chief among them the Russian federation which rivaled, under Yeltsin's leadership, Gorbachev's Soviet government. In November Gorbachev circulated a draft of a new union treaty. The very structure of the Union of Soviet Socialist Republics had to be recast, with the balance of power shifting toward the republics.

Meanwhile the Communist Party was losing ground. Separate Communist parties were emerging in the republics, weakening the central leadership. In March the nationwide local elections scheduled the previous year resulted in a resounding defeat of the party hard-liners. During the May Day parade in Moscow a poster proclaimed: "Let the Communist Party live in Chernobyl." In July the Twenty-eighth Congress of the Communist Party—the last of its periodic gatherings designed to demonstrate its power—dramatically revealed the party's disarray and Gorbachev's weakened grasp of reality.

At the outset Gorbachev offered to this large and strongly conservative gathering a carefully balanced account of his work, mixing optimism with pessimism. Perestroika had created a genuine democracy with many parties and respect for human rights, "a society of free people"; but "We have not in fact been able to provide them with a worthy life." Perestroika had revived people's sense of their own dignity, but had also given rise to great expectations of rapid change for the better. If perestroika was not going forward, dismal times lay ahead. Reassuring his audience, he stressed his own Communist convictions and issued a warning about forces pushing the country down the bourgeois slope. But when he faced the secretaries from the city and regional party committees, who were bound to lose most from downgrading the party, Gorbachev took a beating. Rudely told to restore order as under Andropov, he walked out of the meeting.

On the fifth day Yeltsin stepped forward, lambasting the conservative majority. If open elections for this gathering had been held, he said, there would be a different crowd in this room. If the party did not reform itself, it would lose its role and its assets. He even threatened to put the party on trial for the damage it

had done to the country, suggesting at the end that it exchange its Communist creed for "democratic socialism." Yeltsin's unrivaled popularity cowed the conservatives, allowing Gorbachev to restate his familiar convictions. At the end of the Congress Yeltsin announced his resignation from the Communist Party, provoking widespread defection. Some people were indeed ready for change, while the hard-liners, dreading the disintegration of their country, whispered about overthrowing Gorbachev.

VIII.

Meanwhile perestroika was to go ahead. Gorbachev, warning of hard times to come, promised to reorganize the economy. In September his advisers issued a bold plan to take effect they hoped within five hundred days. Forty-six thousand industrial enterprises and seventy-six thousand wholesale and retail trade firms were to be offered for public sale. In addition, money-losing state and collective farms were to be turned over to peasant farmers. Ultimately 80 percent of the Soviet economy was to be privatized, with the help of a new banking system and a convertible ruble—what drastic changes on top of all the current disorder!

Not surprisingly, Gorbachev hesitated, claiming more emergency power for himself, while strengthening the state enterprises. Patently, the country was not prepared for a market economy; shortages increased and prices rose. Bread was scarce in Moscow, while in Leningrad food was rationed. Mafias and other gangs thrived; people were scared and angry. In November, at the anniversary parade of the Bolshevik revolution, somebody shot at Gorbachev. Exasperated, Gorbachev exclaimed at the end of November: "We have pushed on the button [for economic improvement], but forgotten about the safety mechanism; we have started the engine, but have not adjusted the brakes." Applying the brakes at the December meeting of the Congress of People's Deputies, he called for firm discipline and strong government in order to prevent the breakup of the Soviet Union. Censorship was tightened and the KGB and the army strengthened, as Gorbachev turned conservative. In disgust, his popular foreign minister and close ally Eduard Shevardnadze resigned from the government. Violent actions against secessionist republics followed, first in Moldavia with its strong Romanian minority, and more outrageously in Lithuania which was headed for independence.

In early January 1991 Soviet paratroopers and tanks attacked a television tower in the Lithuanian capital of Vilnius, killing at least fourteen protesters. The Soviet government blamed the Lithuanians, but crowds, incited by television reports of the bloodshed, demonstrated in the major Soviet cities, shouting: "Down with Gorbachev!" The public response was a major blow; it proved that the Soviet Union could no longer be upheld by force.

Gorbachev, at last recognizing the urgency of public support, organized in March a unionwide referendum asking: "Do you consider necessary the preservation of the Union of Soviet Socialist Republics as a renewed federation of equal sovereign republics?" The Baltic states refused to participate, so did Georgia, Armenia, and Moldavia. But the response was favorable among Russians, Belorussians, and the peoples of Central Asia, while the Ukrainians were divided. Next, in April a draft treaty of a new Union of Sovereign States was circulated, subject to constant revision in favor of the union republics; the latter avidly took over the functions and properties belonging to the central government.

In June Gorbachev's authority as self-appointed head of the Soviet Union suffered spectacularly, when Yeltsin—by popular vote—was elected President of the Russian Republic, the largest state in the union. As he assumed his office, he was blessed, in the manner of the tsars, by the patriarch of the Orthodox Church. A few weeks later, in July, he disqualified the Communist Party from work in all state organizations. Caught in the trend, even Gorbachev persuaded the Central Committee of the Communist Party to omit from its program all references to Marxism-Leninism, or even to socialism. What was happening to the ideological glue of the Soviet Union? Gorbachev's closest advisers, including the vice president, his prime minister, minister of defense, and foremost the head of the KGB, were deeply alarmed, unwilling to let the old order go. In August, while Gorbachev was on vacation in the Crimea, they took action.

On Sunday afternoon, August 18, the KGB guards at his vacation home broke into his room. Upset, Gorbachev rushed to the telephones—none of them worked. The intruders then demanded that he declare a state of emergency and turn over his power to his vice president. Gorbachev refused, dismissing them with a burst of profanity, before being cut off from all contact with the outside. That night the chief conspirators met in Moscow, tipsy or drunk, led by the head of the KGB. Informed of Gorbachev's reaction, they declared him sick and persuaded the vice president to assume Gorbachev's role.

The next day, the morning news announced the state of emergency for the entire Soviet Union, suspending all political activities and imposing censorship on the media. Troops moved into Moscow. The democratic leaders, including Yeltsin, were put under surveillance. Yeltsin's guards, however, allowed him to move from his dacha, where he had just been informed of the coup, to the White House, the Russian government's headquarters in Moscow. There, surrounded by troops unwilling to stop him, Yeltsin climbed on top of a tank, challenging the conspirators in a gesture of defiance, which became a symbol of liberation from Communist rule. While the troops stood by, crowds gathered, more than ten thousand during the evening, cheering Yeltsin. Observing the lack of public support, his

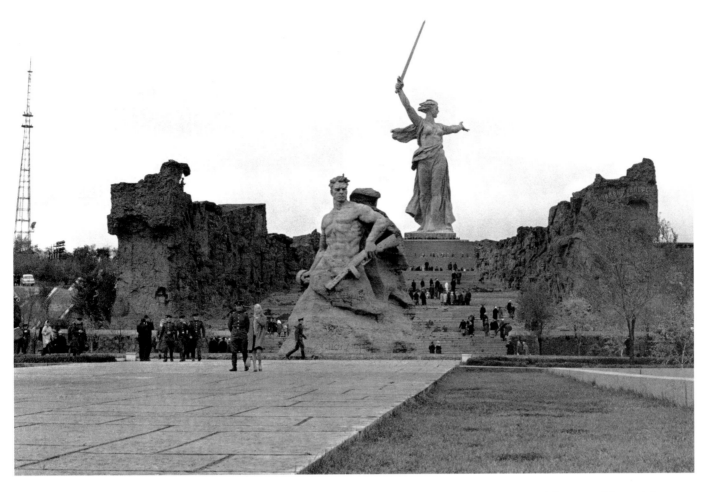

opponents lost their nerve. The emergency committee unraveled. The prime minister, dead drunk, dropped out.

Getting desperate, the head of the KGB ordered an assault the next day on the White House and Yeltsin's arrest, but nothing happened. Protest mounted around the country; the soldiers remained passive, except for an accidental shooting that killed three young men, the only casualties of the coup. And the day thereafter, on August 21, the minister of defense himself, one of the conspirators, ordered his troops to leave Moscow. Visibly shaken by his three-day seclusion in the Crimea, Gorbachev returned to the Kremlin that evening, while the conspirators were arrested or committed suicide. Their utter failure showed how far, even in the party ranks, faith in the Soviet mission had disintegrated; it was vodka more than Marxism-Leninism that had enabled them to make their stand, under political circumstances they had ceased to comprehend. But did Gorbachev grasp what had happened? At his press conference the day after his return he remarked that the Communist Party must be reformed and become the leading force in

Mamayev Memorial, Volgograd—Completed in 1968 to commemorate the sacrifice of men and women in the Battle of Stalingrad (1942–1943), the memorial contains two statues: "Motherland Calls" (right) and "Stand Until Death" (left).

241

perestroika. He, too, was behind the times. Perestroika was dead; so was the Communist Party.

The three-day coup, a minor political tremor, speeded the end of the hollowed-out and disastrously impoverished Soviet Union. While the outcome was still uncertain, Estonia and Latvia declared their independence (Lithuania had already done so the previous year). On August 24 the Ukraine followed suit; Belorussia the next day, and, at the end of the month, so did Moldavia, Azerbaijan, Uzbekistan, and Kyrgyzstan. By the end of September only Russia, Turkmenistan, and Kazakhstan (the latter with a large Russian minority) were officially left in the Soviet Union.

Meanwhile, at the center in Moscow, Yeltsin suspended all activities of the Communist Party, closing down the all-union party's Central Committee, from which Gorbachev himself had just resigned. The KGB was broken up. The Soviet legislature, the Congress of People's Deputies, after transforming the Union of Soviet Socialist Republics into a Union of Sovereign States, ceased to exist. The central government disintegrated, its functions absorbed by the seceding republics, and foremost by Yeltsin's Russia. Gorbachev, as president of the new union, desperately tried to preserve a semblance of the former USSR, accepting even a shift to a looser confederate structure, in vain. When at the end of November his efforts were thwarted, he walked out of the State Council, cursing its rebellious members: "I don't understand how you plan to get along. ... We are strangling in the shit as it is."

On December 1 the Ukrainians confirmed their previous declaration of independence by a referendum, ending their three-hundred-year inclusion in the Russian state and confirming the collapse of the Soviet Union. As the central government faded away, Gorbachev's presidency dissolved. He was not invited in early December to the negotiations in Belarus (the former Belorussia) which created the Commonwealth of Independent States (CIS), a highly informal organization of most members of the former USSR, designed to explore the possibilities of political and economic cooperation within the vastness of Eurasia. As an outsider he sent a message to the CIS supporters, gathered later that month at the capital of Kazakhstan for signing the agreement: "We shall begin a new era in the history of the country with dignity, in conformity with the standards of legitimacy. ... We have both the prerequisites and the experience needed to act in the framework of democratic rules." Nobody paid any attention; his rhetoric made no sense in the new era.

On December 25 Gorbachev officially resigned. The next day he found his office closed and the red flag with hammer and sickle traditionally flying over the Kremlin replaced by the white, blue, and red flag of the Russian Republic. His

experiment to civilize the Soviet system had failed. More significantly, the Communist superpower created by Stalin had passed nonviolently into history, changing the global balance of power profoundly in favor of the West. Assuming the political heritage of the Soviet Union, the Russian state under Yeltsin was caught in its own post-Communist travail. Its nuclear arsenal, inherited from Soviet days, granted it respect in global politics but otherwise, apart from its memory of Soviet greatness, it lacked the prerequisites of great power status. And Gorbachev, still worshipped in the West and benefiting from the royalties received there from his writings (which were passed on to charities), was now a political nonentity in his own country. He had guided the transition from the comforts of the Brezhnev era to political humiliation and economic misery. Yet was he to blame for the breakup of the Soviet Union?

All-inclusive analysis would rather assign responsibility to broad trends promoted by major Soviet policies. The Soviet system had raised a largely illiterate population to literacy and social awareness. There was little consciousness of ethnicity or nationality except in those parts that had enjoyed political independence between the two world wars. The federal constitution had set still vague national identities into territorial units, allowing the cultivation of local languages and custom, and even a measure of political autonomy. In addition, industrialization and modernization had raised popular expectations, incited by ideals such as freedom and self-determination as practiced within Western nation-states. In this manner the Soviet system had unwittingly prepared the cause of separatist nationalism; perestroika with its emphasis on local initiative intensified the trend. Thus, when the restraints of the Soviet dictatorship were loosened, nothing could stop the elemental disintegration of the multinational Union of Soviet Socialist Republics.

Chukotsk Woman—
*The federation of Russia comprises
more than eighty ethnic groups
spread across Europe and Asia.
The Chukotsk, from the northeast,
are relatives of the Inuit people
of North America, who live largely
in the northern arctic areas around
the Bering Sea. These people remain
to this day an indigenous group
living mostly as they have lived in
the past.*

Postscript

I.

In looking at the post-Soviet era from 1991 to the present and into the future, we have to keep the Eurasian context in mind (see map on page 249). The lands once united under Soviet rule are still geographically tied together, sharing the insecurity of living in vast open spaces without natural borders. All successor states are economically and politically interdependent. All of them are attempting to build within their borders a new political order allowing more civic freedom, while still coping with traditional adversities. Ethnic and cultural differences continue to divide them from each other as well as among themselves. Weakened by its unresolved problems, the Russian Federation, extending from the Baltic Sea to the Pacific Ocean, as before overshadows its former associates, linked in the Commonwealth of Independent States. All share the political instability historically pervading their vast territory, set now more than ever into the tensions of global politics.

In the Far East, Japan, an economic superpower, disputes the Russian occupation of the Kuril Islands. Gigantic China is a nuclear power determined to revive its imperial greatness, clash with Kyrgyzstan over border disputes. Further west, Afghanistan is enmeshed in the murderous civil war which divides Tajikistan and involves Russian troops. Iranian fundamentalists try to spread their militancy among fellow Muslims in Central Asia, while Turkey, despite its economic weakness, tries to gain influence among the Turkic-speaking peoples in that area. The biggest challenge, of course, comes from Western Europe, where NATO is trying to expand eastward, with the support of Russia's western neighbors. Russian patriots are alarmed, even by a projected organization called Partnership for Peace, peacefully linking Russia with NATO. All the Eurasian states are included in the Organization for Security and Cooperation in Europe, the successor of the agency

Chukotsk Fisherman, 1972

The Artist, 1951—*While state-sanctioned art in the form of socialist realism dominated, there was still room in Soviet society for nonpropagandistic artwork. This folk artist, Kamenkov (1874–1971), was best known for his sculptures of Pushkin, Tolstoy, and Gorky.*

founded in Helsinki in 1975 (OSCE). And all are members of the United Nations, involved as independent states in their worldwide responsibilities.

Eurasia is also evermore closely tied into the global economic network. Entrepreneurs from Japan, China, and South Korea are doing business in Siberia and the Central Asian states. Among the latter, Kazakhstan and Turkmenistan are eager, with the help of Western companies, to export oil or natural gas via long pipelines, either going through Russia or bypassing it. Russia itself is the target of foreign enterprise, including timber logging and oil drilling in Siberia. Eurasia is rich in natural resources but dependent on outside expertise for their development. It also suffers from profound environmental damage caused by the overrapid Soviet industrialization, careless nuclear experimentation, and disregard of nature's ways. One of the world's biggest ecological disasters is the drying up of the contaminated Aral Sea located between Kazakhstan and Uzbekistan. Now the wind blows its salt-laden dust far and wide, poisoning air, land, water, and people.

Never before have the peoples of Eurasia been so actively drawn into global interaction (see map on page 250). From Tashkent, the capital of once out-of-the-way Uzbekistan, they can now fly directly to the United States, Europe, or East Asia; the country is shifting to Roman script, while its citizens learn Western languages. All of Eurasia wants to be modern.

II.

Stretching across Eurasia, the Russian Federation, rather thinly populated with its 148 million inhabitants (slightly more than 80 percent of them Russian), claims worldwide attention. It represents a bewilderingly complex state, consisting of twenty-one republics, six territories, forty-seven provinces, ten autonomous regions, and two federal cities (Moscow and St. Petersburg). All testify to the country's deep regional and ethnic diversity (there are eighty non-Russian ethnic groups). All put local interests ahead of national concerns. Some units refuse to pay the taxes they owe to Moscow. Others stress their sovereignty, such as Tatarstan, a small area on the middle Volga, which dreams of restoring the Mongol Empire. The republic of Chechnya has actually seceded, at the price of war with the federal government. While officially committed to democratic freedom, Moscow can hardly afford to let the Russian Federation fall apart, as the Soviet Union did.

In charge of its far-flung lands at a time of profound transition, the Russian government faces insuperable problems. Given the traditional anarchy and divisiveness of Russia's fractured society, the removal of the enforced discipline of Soviet rule has not led to liberal democracy but to social, economic, and political decay. This breakdown of authority had been dreaded by Soviet leaders from Lenin to Brezhnev and avoided by totalitarian methods. In the absence of

Successor States of the Former Soviet Union

Russia's Autonomous Areas

Chukotsk

Koryak

Jewish

Agin Buryat

Sakha
(Yakutia)

Buryatia

Ust-Ordyn Buryat

Evenki

Tuva

Taymyr

Khakassia

Gorno-
Altay

Yamal-
Nenetsk

Khanty-
Mansiysk

Nenetsk

Komi

Bashkortostan

6

5

3

2 4

1

Karelia

MOSCOW

Kalmykia

Dagestan

Adygea

Karachay-
Cherkessia

Kabardino-
Balkaria

North Ossetia

Ingushetia

Chechnya

1 - Mordvinia
2 - Chuvashia
3 - Mari El
4 - Tatarstan
5 - Udmurtia
6 - Komi-Permyatsk

compulsion, how can an effective political consensus be established, or successful policies devised? These questions have persistently haunted Boris Yeltsin, who was popularly elected president in 1991, when Western influence ran at its highest. In April 1993 he introduced a democratic constitution, duly approved by a countrywide referendum. It created a new Duma as the voice of public opinion and a Federal Council representing the eighty-six members of the Russian Federation, yet it assigned a preponderant role to the president.

The new constitution was bitterly opposed by the Russian Congress of People's Deputies. When, in September, Yeltsin decreed the dissolution of that body, its antidemocratic majority fought back, supported by militant outsiders. On October 3–4 a battle developed around the White House, the seat of the parliament. Yeltsin, with the help of the army and supportive crowds, evicted the rebellious delegates. Not since 1917 had Moscow witnessed such bloody fighting; 140 people were killed.

In December 1993 elections took place under the new constitution, with some shocking results. The largest vote was cast for Vladimir Zhirinovsky, a patriotic rabble-rouser with preposterous aims. As authoritarian leader of his deceptively titled Liberal Democratic Party he wanted to expand Russia to the Indian Ocean and regain Alaska from the United States. Led by Gennadi Zyuganov, the Communists, de-sovietized but still effectively organized, also scored well. Both parties claimed less than one-half of the total delegates, but the warning was obvious: the appeal of liberal democracy was limited. Its weakness was revealed by the Duma election in December 1995, which produced a strong representation for both of these parties and established Zyuganov as Yeltsin's rival. Public opinion polls indicated a growing disillusionment with Western democracy as a model for Russia. A sizable majority felt that their country should follow "its own unique path."

Meanwhile, Yeltsin, under superhuman strain and handicapped by poor health, has tried to hold the country together. But his popularity plummeted, not only because of the cruel war with Chechnya, but above all because he has not delivered what the people crave: escape from economic misery, a secure society, and a convincing sense of national purpose. Drastic initial efforts by Russian economists and their foreign advisers to introduce a market economy liberating private enterprise as a source of prosperity, have failed; shock treatment did not fit the country's institutional and cultural heritage. Admittedly, small consumer-oriented businesses were soon converted to private ownership at a major risk, as it turned out, of exploitation by armed gangs, the mafias.

The chief obstacle, however, continues to lie in the big state-owned industrial enterprises. Most of them are technologically outdated and unable to compete in the world market, yet they still furnish, as in Soviet times, essential social

services to their workers. In order to avert mass unemployment and a breakdown of social order, the government has printed rubles for subsidizing these industries, thereby causing rampant inflation. Inflation has topped 4,000 percent since 1991; at one point a single dollar was worth five thousand rubles.

More viable industries were taken over by their ex-Communist managers for their private profit, at a loss to the government. Corruption pervades the economy; why pay taxes under the circumstances? No legal framework, and no effective law enforcement exists. Business is run by cliques of unscrupulous self-serving *biznesmeni*, making fortunes in the underground economy, often with the help of government officials—no wonder that people speak of the "criminalization of the economy." Moscow is full of millionaires proudly flaunting their ill-gotten wealth, derived in part from foreign loans designed to help the Russian government balance its budget. Much of that money is privately stashed away in inflation-proof foreign bank accounts ($50–80 billion in 1994), with all too little invested in domestic development. The budget continues unbalanced, and the country is deeply in debt to the World Bank.

Economic productivity, as measured by the gross domestic product, has declined by half since 1991; agriculture is in deplorable shape. Workers remain unpaid. People have lost their savings, and senior citizens their pensions. Health care, education, and cultural institutions are sadly underfunded. Popular interest in community affairs runs low, the young generation being least interested in public service. They too want to get rich quick; the country's great literary culture seems all but forgotten. Here and there observers detect a glimmer of hope, but basic indexes of population trends convey a grim reality: the birth rate is shrinking; the population is declining; and life expectancy for men is fifty-nine years, lower than that in many developing countries. Not surprisingly, nostalgia for the good old days under Brezhnev is widespread. As the presidential election of 1996 approached, Moscow, grateful to Yeltsin, boasted of its wealth, while the impoverished lesser towns and rural areas cheered Zyuganov.

In that election could Yeltsin, sixty-five years old, succeed himself for another term, or would Zyuganov (age fifty-one) take his place? The eight other candidates, including Gorbachev, had no chance. The chief rivals denounced each other Russian-style in the most intense election campaign in Russian history, appealing to a confused and cynical electorate scared by predictions of faked votes, economic collapse, and large-scale violence. Yeltsin, displaying a new vitality, promised to continue his previous course in favor of a market economy and democratization, with concessions to Russian patriotism and promises of immediate rescue to unpaid workers and pensioners. Zyuganov advocated greater government control of the economy, respect for the Soviet past, and protection of Russia from

foreign exploitation. Above all, he catered to the public's strong desire for economic security and national pride, trapped between recognition of his country's dependence on foreign economic support and the desire to escape from it.

As expected, neither Yeltsin nor Zyuganov scored the 51 percent of the votes cast required for victory. The runoff election will be held in July, with Yeltsin favored by current reckoning. But pity the winner! How can his promises be realized amidst the disorganization of the economy and the lack of political consensus? Worst of all, how is it possible, among the fragmented and impoverished Russian people surviving by hook or by crook, to create a regime of law and order based upon a sense of civic obligation? Alas, Russia faces a prolonged era of crisis.

III.

What role then can this disoriented and divided country play in world affairs? Russia is most closely tied to the "near-abroad," to the former republics of the Soviet Union, all of which have preserved their authoritarian regimes, in most cases somewhat relaxed by provisions for civil liberties. Russia maintains economic and military ties with its neighbors, and is involved in their ethnic disputes because of concerns over the fate of some twenty million Russians living among them. Aware of their country's preponderance in Eurasia, such patriots would like to reextend Russian rule over it. In March 1996 the Russian Duma passed a resolution questioning the legality of the dissolution of the Soviet Union, but the Russian Federation is in no position to restore Stalin's empire. Relations with the Baltic states, as with the Ukraine and other members of the Commonwealth of Independent States, will remain a source of tension, calling for mutual adjustment over a long time.

In the global setting Russia, no matter under what leadership, faces a profound readjustment. It has inherited the ambitions of the tsars and the Soviet leaders, eager to be recognized as a major power, but now with drastically reduced resources. Its economic weakness, political disunity, and general demoralization undermine the prestige that sustains great power status. Admittedly, Russia's nuclear arsenal matches its American counterpart, but apart from the arsenal's symbolic significance it has no practical value; as in the cold war, any nuclear conflict would be suicidal. Anti-Western currents may rise to the fore, offsetting the humiliation caused by the collapse of the Soviet Union. But any show of hostility will curtail badly needed Western assistance; left to its own resources, Russia would be even more backward. And by all indications, the Russian people are opposed to any new totalitarian mobilization. Given the fragility of Russian state and society, the Western countries should not be alarmed by the anti-Western rhetoric of Russian nationalists or communists; fear of Russian aggression seems unwarranted.

Approached realistically, the miseries of Russia call for a change of American attitudes in favor of ideological detachment. A constructive approach demands understanding the dynamics shaping domestic politics in that vast country, with due sympathy not only for the superhuman burden carried by any Russian president, but also for the average Russian facing miseries unknown in the United States. Committed to the human right of self-determination, we should encourage the Russians to work out their own unique path toward an effective government, economy, and way of life within global interdependence. Western-style democracy does not fit Russian realities. An enlightened authoritarianism, which provides a secure framework for evolving constructive citizenship through prolonged trial and error, may be more suitable. For that reason it may be the best policy for the United States and its Western European allies to avoid a revival of cold-war animosity and to hold back the expansion of NATO. Russians should feel at ease concentrating on their domestic turmoil.

Viewed in these broad perspectives, Russia—and all of Eurasia—offers a major challenge for constructively broadening the American outreach into the world. Rather than ignorantly impose American ways upon unprepared peoples, we should learn to see them compassionately through their own eyes, and thereby increase our command over the realities of the complex world in which we live. Dmitri Baltermants's photographs viewed in their historical context offer us a constructive opportunity for that worthy purpose.

Squatter Village, Near the Kremlin, August 1990—*In a show of protest against Gorbachev's reforms, which they blamed for their economic predicament, squatters set up an encampment behind the Hotel Racia, exposing their plight to Westerners and the Deputies of the Supreme Soviet staying at the hotel. These citizens, who came from every corner of the Soviet Union, felt that Gorbachev's government paid too little attention to the peoples of the several Soviet Republics, focusing reform on Moscow and western Russia. While these citizens would have once been herded up and sent to rehabilitation camps, perestroika allowed such protest. The sign next to the bearded man reads "Ladies and gentlemen. I have been suppressed by the Soviet Union. They have removed my rights. I have no work, bad health, death is waiting for me and my small daughter who is 5 years. We are hungry." (Photographs by Paul Harbaugh.)*

Notes

We have included books and articles that were used in writing this text, or from which we have quoted. We have only included page references in cases where a quotation cannot be easily found. In the notes for each chapter, sources for direct quotations come first, followed by books that we have consulted.

Throughout the writing of this text we referred to the following books: Valery Chalidze, *Criminal Russia: Essays on Crime in the Soviet Union* (Random House, 1977); Jerry F. Hough and Merle Fainsod, *How the Soviet Union is Governed* (Harvard University Press, 1979); Robert J. Kaiser, *The Geography of Nationalism in Russia and the U.S.S.R.* (Princeton University Press, 1994); Robert H. McNeal, *The Bolshevik Tradition: Lenin, Stalin, Brezhnev* (second edition, Prentice-Hall, 1975), and Alec Nove, *An Economic History of the U.S.S.R.* (Penguin Books, 1972).

In order to set the Soviet Union in the context of contemporary history, we drew upon Theodore H. Von Laue, *The World Revolution of Westernization: The Twentieth Century in Global Perspective* (Oxford University Press, 1987).

Introduction

The information on Dmitri Baltermants's life was supplied and written by his daughter, Tatiana Baltermants. Baltermants's life and work are explored in *Dmitri Baltermants* (Leipzig: V. E. B.-Fotokinoverlag, 1981), a book of photographs with an introduction by Wassili Peskow. Baltermants's most famous World War II photographs appear in Daniela Mrazkova and Vladimir Remes (eds.), *The Russian War 1941–1945* (Dutton, 1975).

Information on photography in the Soviet Union is from Sergei Morozov (ed.), *Soviet Photography: An Ace of Realism* (Greenwich House, 1984).

Chapter One

Chekhov's description of peasants comes from his short story "The Peasants," which is widely available. The quotation from Dostoyevsky is in *The Diary of a Writer* (Brazillier, 1954), p. 575. The extract from Sergei Witte's report is in Theodore H. Von Laue, *Sergei Witte and the Industrialization of Russia* (Columbia University Press, 1963). The British Ambassador's advice to the tsar appears in George Buchanan, *My Mission to Russia* (Cassell, 1923). Gorky's description of peasant atrocities is in R. E. F. Smith (ed.), *The Russian Peasant 1920 and 1984* (Case, 1977).

In the first three chapters we drew heavily on Theodore H. Von Laue, *Why Lenin? Why*

Stalin? Why Gorbachev? The Rise and Fall of the Soviet System (third edition, HarperCollins, 1993), a more scholarly account of this period.

Chapter Two

Lenin's writings, quoted in this chapter, are available in Robert C. Tucker (ed.), *The Lenin Anthology* (Norton, 1975), and Robert V. Daniels (ed.), *A Documentary History of Communism, Vol. 1. Communism in Russia* (revised edition, University Press of New England, 1984). We refer to Boris Pasternak, *Doctor Zhivago* (Pantheon, 1958) several times throughout the book for its insight into Russian sensibilities. The description of Lenin at Inessa Armand's funeral is in Angelica Balabanoff, *Impressions of Lenin* (University of Michigan Press, 1964). We have consulted Dmitri Volkogonov, *Lenin: A New Biography* The Free Press, 1994), a fascinating revisionist Russian biography.

Chapter Three

Stalin's writings and speeches, quoted in this chapter, can be found in *The Essential Stalin: Major Theoretical Writings, 1905–1952* (Anchor Books, 1972), and Robert V. Daniels (ed.), *A Documentary History of Communism, Vol. 1,* which includes Lenin's "Testament."

Mikhail Sholokhov's *The Quiet Don* has two volumes: *And Quiet Flows the Don* (Knopf, 1934), and *The Don Flows Home to the Sea* (Knopf, 1940). The tearful police colonel appears in Isaac Deutscher, *Stalin: A Political Biography* (Oxford University Press, 1966). Osip Mandelstam's poem is in Nadezhda Mandelstam, *Hope Against Hope* (Atheneum, 1970). We refer to Alexander I. Solzhenitsyn, *The Gulag Archipelago 1918–1956: An Experiment in Literary Investigations,* 3 vols. (Harper & Row, 1974–1978) several times throughout the text.

The biographies of Stalin we consulted, both for this chapter and for chapter five, are Robert G. Tucker, *Stalin as Revolutionary 1879–1929: A Study in History and Personality* (Norton, 1974), and *Stalin in Power: The Revolution from Above 1928–1941* (Norton, 1990); Adam B. Ulam, *Stalin: The Man and His Era* (Viking, 1973), and Dmitri Volkogonov, *Stalin: Triumph and Tragedy* (Grove Weidenfeld, 1988).

For Stalin's policies we used Robert. V. Daniels (ed.), *The Stalin Revolution: Foundations of Soviet Totalitarianism* (second edition, Heath, 1972); Naum Jasny, *Soviet Industrialization 1928–1952* (University of Chicago Press, 1961), and Alec Nove, *Stalinism and After* (Crane Russak, 1975).

The standard book on Stalin's collectivization is Robert Conquest, *Harvest of Sorrow: Soviet Collectivization and the Terror-Famine* (Oxford University Press, 1986).

Books on the terror are Robert Conquest, *The Great Terror: A Reassessment* (Oxford University Press, 1990); J. Arch Getty and Roberta Massing (eds.), *The Stalinist Terror: New Perspectives* (Cambridge University Press, 1993), and Roy Medvedev, *Let History Judge: The Origins and Consequences of Stalinism* (revised edition, Columbia University Press, 1989).

Stalin's victims are represented by those whose stories appear in Solzhenitsyn's *Gulag Archipelago* and by two remarkable women. Eugania S. Ginzburg's *Journey into the Whirlwind* (Harcourt, Brace & World, 1957), and *Within the Whirlwind* (Harcourt Brace Jovanovich, 1981), tell the story of her survival in the prison camps. The other woman, Nedezhda Mandelstam, wrote *Hope Against Hope* (previously cited) and *Hope Abandoned* (Atheneum, 1974).

As for what Stalin was really like, we drew from Svetlana Alliluyeva, *Twenty Letters to a Friend* (Harper & Row, 1967), and Nikita Khrushchev, *Khrushchev Remembers* (cited in notes for chapter six), who was a shrewd observer of his former master.

Chapter Four

Stalin's wartime speeches have been collected in Joseph Stalin, *The Great Patriotic War of the Soviet Union* (International Publishers, 1945). Baltermants's comment on wartime photography is taken from *The Russian War 1941–1945.* Hitler makes plans for the redskins in *Hitler's Secret Conversations 1941–1944* (Farrar, Strauss and Young, 1953). For Chuikov's description of battle, see Alexander

Werth, *Russia at War 1941–1945* (Dutton, 1964); his advice on room-to-room fighting is in Alan Clark, *Barbarossa: The Russian-German Conflict 1941–1945* (Morrow, 1965). The German lieutenant in Stalingrad is in Clark, *Barbarossa*. The Cossacks at Korsun are described in Milovan Djilas, *Conversations with Stalin* (Harcourt, Brace & World, 1962). The passage by Ilya Ehrenburg is in Werth, *Russia at War 1941–1945*. Casualty figures come from Omer Bartov, *The Eastern Front, 1941–1945; German Troops and the Barbarisation of Warfare* (St. Martin's Press, 1986). A CBS poll published in *The New York Times*, December 3, 1995, (section 4, p. 5), revealed American's ignorance of the war.

Our chief resource for World War II was Werth, *Russia at War 1941–1945*. He was a British journalist stationed in the Soviet Union during the war years and sensitive to the ground-floor sufferings of Russians. We supplemented this information with Clark, *Barbarossa*, written from the German perspective.

For German policies in the occupied territories we used Alexander Dallin, *German Rule in Russia 1941–1945: A Study of Occupational Policies* (Macmillan, 1957). Harrison Salisbury, *The 900 Days: The Siege of Leningrad* (Harper & Row, 1969), gives an excellent account of the outbreak of war, the years of the blockade, and the postwar "Leningrad affair." Vasily Grossman's novel, *Life and Fate* (Harper & Row, 1985), offers an experience of the battle of Stalingrad.

Chapter Five

In addition to the books cited in the notes for chapter three, the following material deals with Stalin's last years. The quotations from George Kennan come from "Telegraphic Message from Moscow of February 22, 1946," in George Kennan, *Memoirs 1925–1950* (Little, Brown, 1967). For Churchill's "Iron Curtain" speech see *Vital Speeches of the Day* (March 15, 1946, p. 329). For the National Security Council's warning see *NSC-68; A Report to the National Security Council by the Executive Secretary on United States Objectives and Programs for National Security, April 14, 1950*, reprinted in the *Naval War College Review* (May–June 1975). The description of Stalin comes from Milovan Djilas, *Conversations with Stalin* (previously cited); Djilas is also the author of the unforgettable description of Beria.

For foreign policy in these years we consulted Marshall D. Shulman, *Stalin's Foreign Policy Reappraised* (Atheneum, 1966). David Hollway, *Stalin and the Bomb: The Soviet Union and Atomic Energy 1939–1956* (Yale University Press, 1994), offers a comprehensive history of the Soviet Union's atomic program. Robert Charwell Williams, *Klaus Fuchs: Atom Spy* (Harvard University Press, 1987), provides information on atomic espionage.

For the "Leningrad affair" see Salisbury, *The 900 Days* (previously cited). American cold war anticommunism is documented in Kenneth O'Reilly, *Hoover and the Un-Americans: The FBI, HUAC, and the Red Menace* (Temple University Press, 1983), and in Lawrence S. Wittner, *Cold War America: From Hiroshima to Watergate* (Praeger, 1974).

Beria receives an evenhanded assessment in Amy Knight, *Beria: Stalin's First Lieutenant* (Princeton University Press, 1993).

Chapter Six

The main source for material and quotations in this chapter is Khrushchev himself, who bounces back to life in *Khrushchev Remembers*, with an introduction, commentary, and notes by Edward Crankshaw (Little, Brown, 1970), and Strobe Talbot (ed.), and *Khrushchev Remembers: The Last Testament*, (Little, Brown, 1974). The books are designed to fix the historical record in his favor, but contain fascinating information; the editors in both volumes supply needed objectivity. His speeches are in *Khrushchev Speaks: Selected Speeches, Articles, and Press Conferences 1949–1961* (University of Michigan Press, 1963). The quotation from Ehrenburg is in Ilya Ehrenburgr, *The Thaw* (Regnery, 1955). The poems "Zima Junction," "Again a meeting …," and "The Heirs of Stalin" are in Yevgeny Yevtushenko, *The Collected Poems 1952–1990* (Holt, 1991). The Pasternak quotation comes from *Doctor Zhivago*. The text of Khrushchev's secret speech on "The Crimes of the Stalin Era," is re-

printed in *Khruschhev Remembers* (1970). For the encounter with the young diplomat see Edward Crankshaw, *Khrushchev: A Career* (Viking, 1966). The novel *Not by Bread Alone* (Dutton, 1957) incurred Khrushchev's wrath while Alexander Solzhenitsyn's *One Day in the Life of Ivan Denisovitch* (Praeger, 1963) earned his approval. "Matryona's House" is included in Alexander Solzhenitsyn, *Stories and Prose Poems* (Farrar, Straus and Giroux, 1971) The observations on Khrushchev's Russia come from Harrison Salisbury, *To Moscow—and Beyond: A Reporter's Narrative* (Harper, 1959).

Apart from *Khrushchev Remembers,* other biographical sources were Crankshaw, *Khrushchev,* and Roy A. Medvedev and Zhores A. Medvedev, *Khrushchev: The Years in Power* (Columbia University Press, 1976). We also consulted Stephen F. Cohen and others (eds.), *The Soviet Union Since Stalin* (Indiana University Press, 1980). Beria's reforms and downfall are related in Knight, *Beria.*

In the sections on literature we used Yevgeny Yevtushenko, *A Precocious Autobiography* (Dutton, 1963); Ronald Hingley, *Pasternak: A Biography* (Knopf, 1983), and Michael Scammell, *Solzhenitsyn: A Biography* (Norton, 1984).

Chapter Seven

Andrei Sakharov's "Appeal for Gradual Democratization" is included in George Saunders (ed.), *Samizdat: Voices of the Soviet Opposition* (Monad Press, 1974). He discusses the problems of Soviet society in "Interview with Olle Stenholm" printed in the appendix to Andrei Sakharov, *Memoirs* (Knopf, 1990). The extract from Solzhenitsyn's interview in *Le Monde* is taken from Scammell, *Solzhenitsyn* (p. 806), and his "Letter to the Soviet Leaders" is in Alexander I. Solzhenitsyn, *East and West* (Harper & Row, 1980). Yevtushenko's poems "Kompromise Kompromisovich" and "I Would Like" are in *The Collected Poems 1952–1990.* Amalrik's views on Russian culture are in Andrei Amalrik, *Will the Soviet Union Survive Until 1984?* (revised edition, Harper & Row, 1971).

For the Brezhnev era we consulted the following books: Robert F Byrnes (ed.), *After Brezhnev: Sources of Soviet Conduct in the 1980s* (Indiana University Press, 1983); Robin Edmonds, *Soviet Foreign Policy: The Brezhnev Years* (Oxford University Press, 1983), and Wittner, *Cold War America* (Holt, 1978). For an excellent sense of Brezhnev's Soviet Union see Hedrik Smith, *The Russians* (Quadrangle/The New York Times Book Co., 1976). For *samizdat* publications see Saunders, *Samizdat,* and Mark Hopkins, *Russia's Underground Press: The Chronicle of Current Events* (Praeger, 1983).

Chapter Eight

Quotations from Gorbachev were taken from Mikhail Gorbachev, *Perestroika: New Thinking for Our Country and the World* (Harper & Row, 1987). Nina Andreyeva's letter is printed in the weekly periodical, *Current Digest of the Soviet Press,* 40 (April 27, 1988), p. 1.

For this chapter we drew on Theodore H. Von Laue, *Why Lenin? Why Stalin? Why Gorbachev?* (previously cited). We also consulted Dusker Doder and Louise Branson, *Gorbachev: Heretic in the Kremlin* (Viking, 1990), for biographical information; Robert G. Kaiser, *Why Gorbachev Happened: His Triumphs and His Failure* (Simon & Schuster, 1991); Zhores A. Medvedev, *Gorbachev* (Norton, 1986), and, Yegor Ligachev, *Inside Gorbachev's Kremlin: The Memoirs of Yegor Ligachev* (Pantheon, 1993), for the opinions of a hard-line conservative.

Two fat books commemorate the end of the Soviet Union: David Remnick, *Lenin's Tomb: The Last Days of the Soviet Empire* (Random House, 1993), and Jack F. Matlock, Jr., *Autopsy on an Empire: The American Ambassador's Account of the Collapse of the Soviet Union* (Random House, 1995).

Postscript

Matlock, *Autopsy on an Empire,* covers the years immediately following the end of the Soviet Union. We also drew from the *Current Digest of the Post-Soviet Press.*

Index

faces of a nation

All imagery electronically scanned.
Composed by Fulcrum Publishing, Golden, Colorado, in Adobe Granjon.
Printed and bound by Sung In Printing Company, Seoul, Korea.
Text paper is 150 gsm art matte finish.
All text images printed as 200 line screen duotones in black and PMS Warm Gray 10C.
Endsheets are 150 gsm woodfree, printed in PMS Red and PMS Warm Gray 7U.
Jacket is 150 gsm art gloss finish, printed in Black, PMS 186C and PMS Warm Gray 10C, with matte film lamination.
Book is bound on three millimeter binder's board, utilizing Cho Yank cloth, with head and foot bands, square-backed smythe-sewn, with red foil stamp on spine and black foil stamp on front.

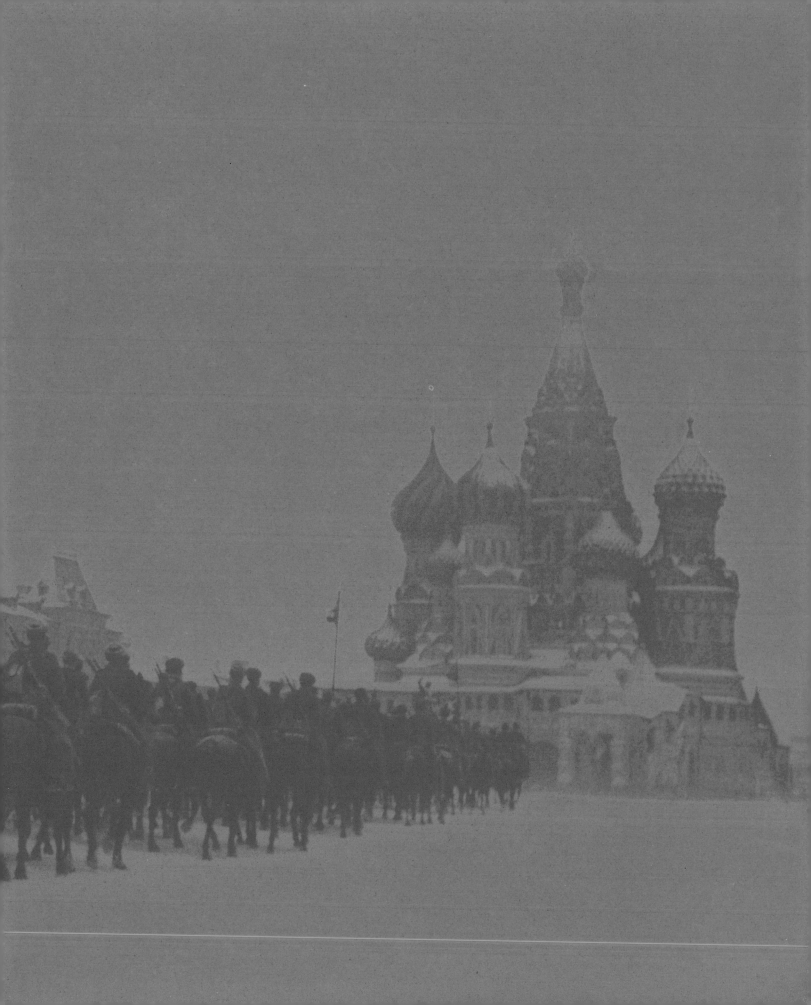

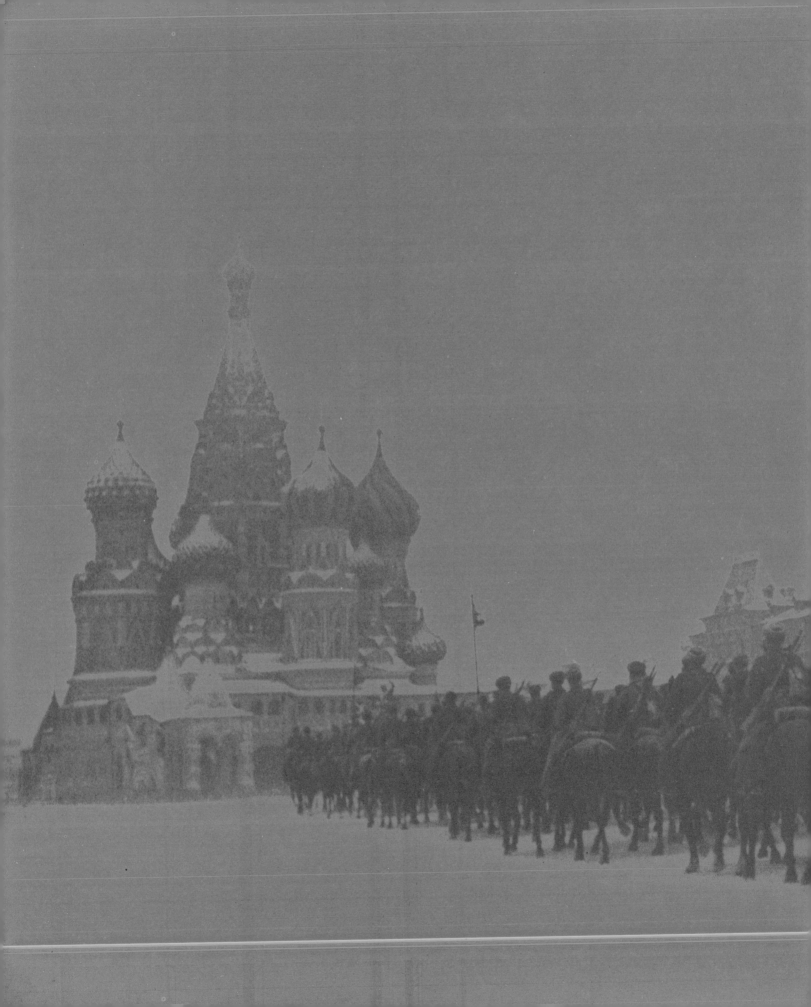